THE Cat IN Art

THE Cat IN Art

Stefano Zuffi

Translated from the Italian by Simon Jones

Abrams, New York

Cats are misunderstood because they refuse to explain themselves.

—Paul Morand

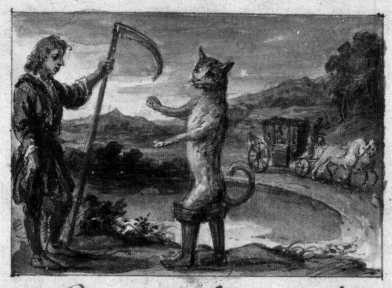

Le Maître Chat
ou le Chat botté

Conte

Vn Meunier ne laissa en
mourant pour tous biens a
trois enfans qu'il auoit que
son moulin, son asne et
son chat les partages furent
bientost faits, ny le notaire
ny le procureur qui auroient

CONTENTS

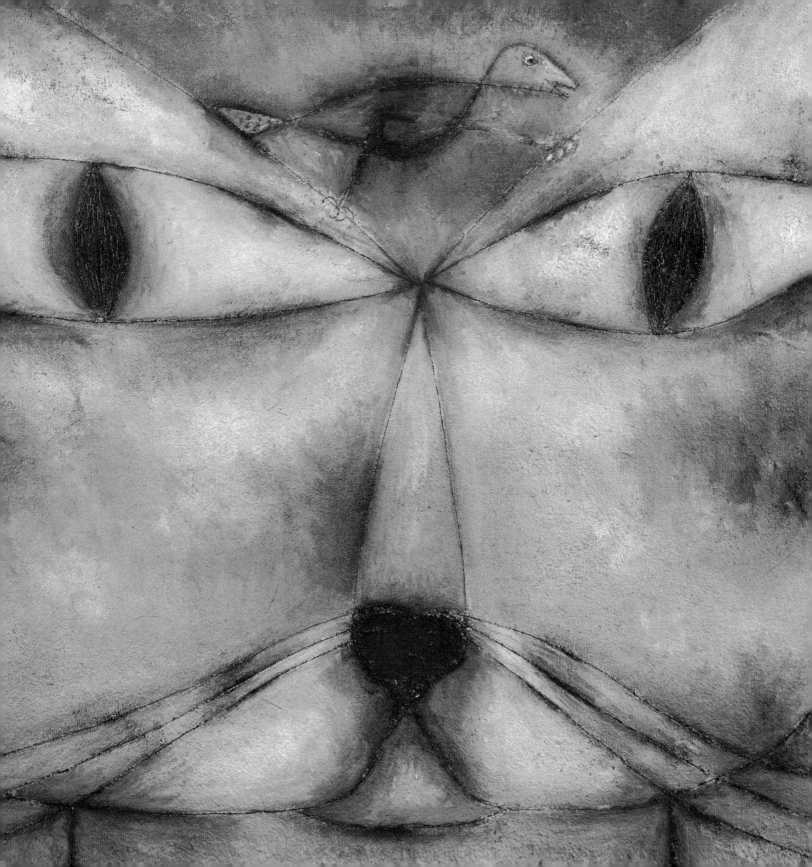

INTRODUCTION

For 5,000 years it has lived alongside us — perfectly at ease on all continents and at all latitudes, as comfortable in a peasant's cottage as in the most refined and exclusive aristocrat's salon. The cat dozing on an armchair is a lovable, soothing presence, almost a symbol of domestic peace. And yet, with extraordinary rapidity, it can spring up transformed into a demonic, terrifying beast. The cat is a domestic animal, certainly, yet not exactly a "domesticated" one. Capable of irrepressible independence and will, it can, in the blink of an eye, replace the most blissful, gentle calm with the darting aggression of the predator: the little pussycat's placid purring gives way to the malicious scratching of a miniature wild beast, well armed with teeth and claws. Indeed, according to an ancient Persian legend, the cat was born of a lion's sneeze.

An elusive, fascinating animal, the cat has earned itself an important place in culture and art, literature and fable. True to its nature, it rarely emerges as a protagonist: more often than not, we must look closely to detect its presence. However, this presence, especially in painting, is never a banal one. It has been given a rich variety of symbolic meanings, so much so that we can almost read them across centuries of masterpieces—a sort of history of art with whiskers and a tail, full of surprises.

"Mom, the cat's looking at me!" "Well, look right back at him." "But he's looking at me more!" This is one of the most illuminating of the many children's rhymes, proverbs, expressions, superstitions, and metaphors relating to cats. Every European nation and language possesses a rich selection, and the variety of popular sayings underlines the thousand faces of this animal, which remains elusive, fascinating, and mysterious.

No one questions that the dog is "loyal," to the extent that it has earned the epithet "man's best friend." Indeed, it has succeeded in adapting to its master's needs and expectations, taking on a considerable range of shapes and sizes, from the Chihuahua to the St. Bernard. By

contrast, it is impossible to apply a single adjective to the cat, which is always ready to astonish us. Sly? lazy? impudent? cuddly? curious? cunning? thieving? independent? All these descriptions are valid and are based on some truth, but all are unquestionably inadequate. The dog has developed a touching ability to "communicate" states of mind that can readily be compared to human emotions and feelings. Of a particularly demonstrative dog, people will often say: "If only he could talk!" On the other hand, it is extremely difficult to penetrate the silent, elusive psychology of the cat, which by its very nature cannot be grasped.

Throughout the millennia of cohabitation with man, the cat has not "learned" to do anything particularly useful, keeping itself loftily above the rank of helper, and shunning all specialization. Unlike dogs, there has been no selective breeding of guard cats, hunting cats, sheep cats, and the like. Comparative linguistics offers surprising confirmation of the cat's consistency: in various European languages, the dog "adapts" and molds itself to the society in which it is incorporated, becoming, for example, *perro, cane, Hund,* and *chien.* By contrast, in the Romance, Germanic, and Slavic languages, the word for cat has the identical root, almost as if to underline the animal's supreme indifference to attempts to "assimilate" it into a localized linguistic context. The cat (*gatto, chat, Katz,* or *koshka*) remains surprisingly consistent, with few variations, refusing to bend to new lexical forms. According to a reliable etymology, the word's origin is to be found in the region where the domestic cat originated—North Africa. The Berber *kadisha* is, according to scholars, at the root of the Nubian form *kadis,* the Syriac form *quato,* and the Arab form *quttah.* A partial exception—but one due to a charming recourse to onomatopoeia—is ancient Egyptian, in which the word for cat is *miu.* And when the cat finally crosses the Mediterranean and lands in Greece, it is called *katoikidios,* literally house or domestic cat. In Latin, too, after an initial absorption into the broader feline race (*felis*), from the imperial age onward the word *cattus* was typically used in spoken Latin as well as literature.

Returning to the rhyme cited previously, though its conclusion appears banal, it is in fact revealing: the cat "looks at us more," makes us feel uneasy, and seems to know arcane secrets and mysterious truths. It has been said, with a grain of profound truth, that the cat is "the only animal to have tamed man." Without exaggerating, ethologists claim that the cat "chose" to enter the human sphere, and not vice versa, adapting with ease to each continent, reaching some of them by ship as it accompanied the voyages of explorers and then of traders. Indeed, the cohabitation of felines and humans, begun some 5,000 years ago in the region of the Fertile Crescent, evolved through contrasting phases, which have left a vivid mark on the history of art and culture. The magnetic suggestiveness of those almond-shaped eyes, together with the marvel of night vision that imbues them with a flashing luminosity, at once fascinating and demonic, imbues the cat's glance with something truly supernatural. It is difficult to escape the spell of an animal whose bearing is highly elegant and sinuous, even provocative, and whose life is so elusive: is it not said that the cat has seven, or even nine, lives? The terrible superstitions attached to the "black cat" (extremely widespread, and not only in Europe), its identification with the witch or even the devil, and popular prejudices—all reflect the ambiguous relationship between humans and cats; and the latter are often innocent victims of atrocious persecution, even though they are utterly harmless. Nevertheless, the cat's regal demeanor has fascinated us for millennia, whereas its unpredictable, supple movements, its careful washing, the variations in its fur color, and its undeniable charm, which redeems and compensates for small domestic disasters, make the cat a fundamentally important character in family life, in fable, in nineteenth-century illustrated children's books, popular literature, and, during the twentieth century, in comic strips and animated cartoons.

This book addresses the fortunes of the cat in history and society, from the point of view of figurative art, especially painting. This is a privileged viewpoint, for it allows us to follow a long historical, social,

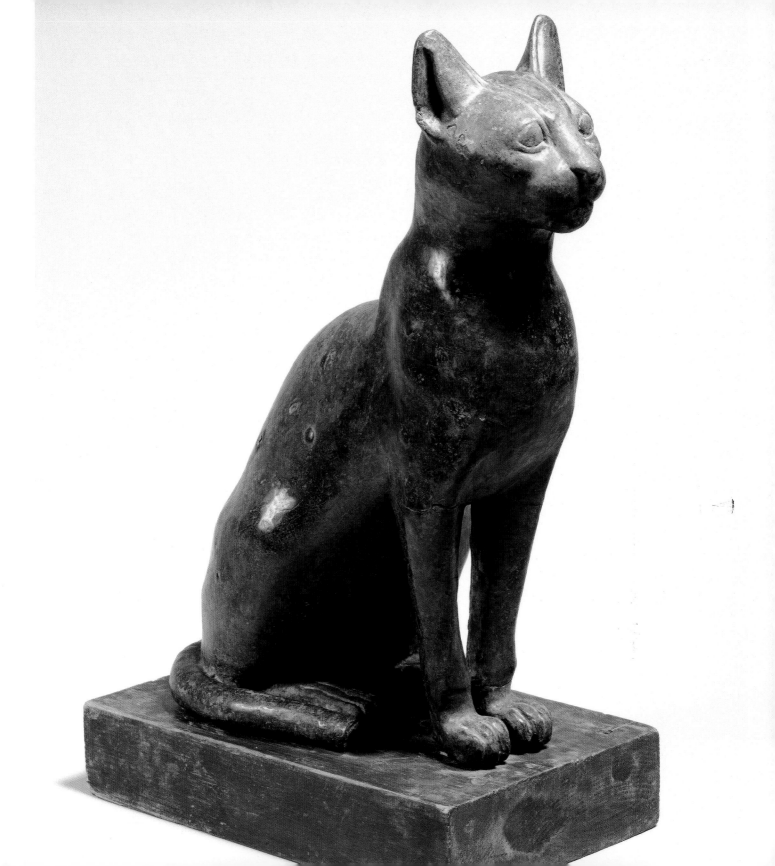

religious, and folk narrative told through images. The cat is not always the true protagonist. Quite the opposite: it often appears on the scene from a concealed position, just as in reality. The cat seems indifferent: it follows a mysterious path of its own, barely looking in on the action, and yet it often succeeds in leaving a powerful mark on it.

The beginning belongs, rightly, to ancient Egypt: this was the time and place when, almost beyond a doubt, the transition from wild feline to domestic cat took place. The abundant harvests, favored by the flooding of the Nile, along with the development of an urban civilization, led to the storing of grain and food, and consequently to the proliferation of birds and mice. It is at this stage that, emerging from the undergrowth of the Nile Valley, the wild cat made its appearance in human society, offering its skill as a hunter of rodents and birds, and receiving in return an impressive list of benefits. In Egyptian culture, the cat scaled the heights of fame, and frescoes from as early as circa 2000 BC show cats comfortably curled up and perfectly integrated into the domestic environment. The Egyptians cannot have helped but notice the great fecundity of cats, preceded by their nocturnal serenades. A female cat's gestation period is less than two months, and litters are often very numerous. Thus the cat readily became a symbol of prosperity, giving its face to the goddess Bastet, to whom amulets, statuettes, and talismans were dedicated, especially in the Third Intermediate Period and during the Ptolemaic period. This association with good omens was present also in China and Japan where bringers of good luck were represented as pottery figurines of little cats with their front paw raised, known as *Maneki neko*: the gesture refers to the help given to some samurai who were caught in a storm and led to shelter by a cat. At the same time and place, there also appeared the usual superstitions about witchcraft and sinister magic linked to cats.

Next, the cat's progress, and that of culture, lead us to ancient Greece and to Rome, where the cat is no longer endowed with the divine qualities attributed to it by the Egyptians, but consolidates its peaceful and

comfortable role as a domestic animal, periodically exhibiting in the home its usual talent as a hunter (or, in the pantry, as a petty thief). For the first time, Greek pottery and Roman sculpture depict the cat in the company, or even in the arms, of children, whereas in Egyptian art it is always associated with adults. It is interesting to note how the antagonism between cats and dogs begins to be portrayed, as the two animals vie with each other for the favors of their masters and for the best places in the home. This hostile relationship is to become a proverbial synonym for enmity (probably far more than is justified by the reality, given the countless instances of peaceful coexistence); it is constantly reappearing, to the extent that it has become a classic theme in animated cartoons, where the cat almost always plays the role of the loser.

Whereas on the one hand the Middle Ages confirm an essentially positive, everyday image of the cat, depicted as a skilled hunter of mice in the beautiful illuminated manuscripts explored later in this book, the rise of Christianity places the cat in the shadow of fear, superstition, and a suspicion of being in league with the devil. It becomes the witch's animal par excellence; indeed, the most horrible hags were believed to be reincarnated as black cats. The cat was literally persecuted: notable are the directives of Pope Gregory IX, who in 1232 urged the court of the Inquisition to keep an eye on black cats. Later, during his brief papacy, Innocent VIII found the time to decree, in 1484, that the cat was the favorite helper of the demon worshipped by witches. The order of the Knights Templar was accused of heresy in the form of cat worship, and an imaginative etymology even associated the name of the Cathars (a religious sect that was harshly repressed) with the word *cattus*, supposedly their object of worship. Some paintings of the Last Supper show the cat next to the figure of Judas, the painter thus making them accomplices in betrayal. The so-called cat festival in Ypres, Belgium, marks the acme of superstition and persecution: for centuries, cats have been hurled from the tower of the Gothic Town Hall, and only recently have live animals been replaced by puppets made of plush. To sum up, the

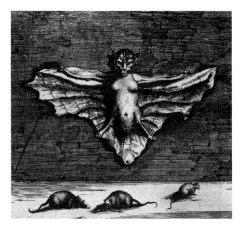

ABOVE: *A Bat Known as a Flying Cat.* From *China Illustrated* by Athanasius Kircher (1601–1680), 1667. Engraving, 17th-century Dutch School. The Stapleton Collection. This image, which follows the medieval tradition, clearly shows the cat's identification with a mysterious nocturnal creature such as the bat.

OPPOSITE PAGE: *The Fool Lets Himself Be Flattered to His Face and Mocked Behind His Back,* 1558. Engraving. Private collection. In this 16th-century Dutch engraving, the cat, once again identified with the devil, flatters the fool by licking him.

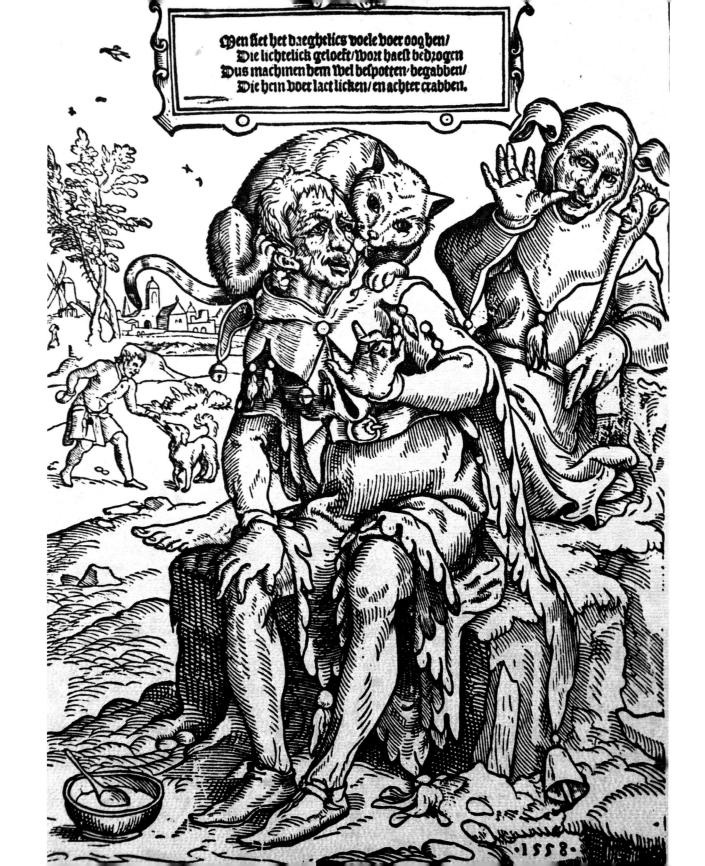

Men siet het daeghelics voele voer ooghen/
Die lichtelick geloeft/ wort haest bedrogen
Dus machmen hem wel bespotten begabben/
Die hem voer laet licken/ en achter crabben.

·1558·

cat, a self-sufficient, independent, nocturnal, and mysterious animal, has become the very symbol of heresy and paganism. In Norse mythology the goddess Freya, whose chariot is drawn, tellingly, by two cats, is ambiguously worshipped as the goddess of love and fertility on the one hand, but, on the other, also feared as goddess of war, magic, and prophecy. A long iconographic tradition, from the Middle Ages to the fantastic, explosive vision of the late-eighteenth-century Spanish painter Goya—demonic cats invade his famous engraving, *The Sleep of Reason Produces Monsters*, that opens the *Caprichos*—runs through the centuries of superstition and prejudice attached to cats.

Cats, however, know how to get their silent revenge. In spite of these fears, they continue to purr blissfully at home, becoming emblems of the comfortable pleasures of the household and family, an aspect of domestic stability and serenity. Anyone who lives with a cat knows very well that in every season it has the knack of positioning itself in the best spot in the house—warm in winter and well ventilated in summer. A large, and perhaps unexpected, section of this book is devoted to the art of the European Renaissance, demonstrating how the cat, with its habitual nonchalance and velvety tread, is a component of a veritable gallery of masterpieces. The greatest cat-loving artist was unquestionably Leonardo da Vinci, who asserted that even the smallest cat is a masterpiece; but Dürer, too, gave the cat a role that is anything but banal. During the sixteenth and seventeenth centuries, cats were periodically the victims of "pogroms" (at the hands of Catholics and Protestants alternately), but their presence in art is constant and strong, bearing witness to their firmly established position in European households. It must also be acknowledged that with the Counter-Reformation a tentative rehabilitation of cats got under way, and they were introduced increasingly as aspects of sweetness and domestic peace into paintings of the Annunciation or the Holy Family.

In 1620, the *Mayflower* brought the Pilgrim fathers—and with them, domestic cats—to the shores of America, thus beginning their dispersion

OPPOSITE PAGE: Leonardo da Vinci, *Madonna with Child Embracing a Cat* (facsimile), c. 1494. Drawing. Uffizi Gallery, drawing and print room, Florence, Italy.

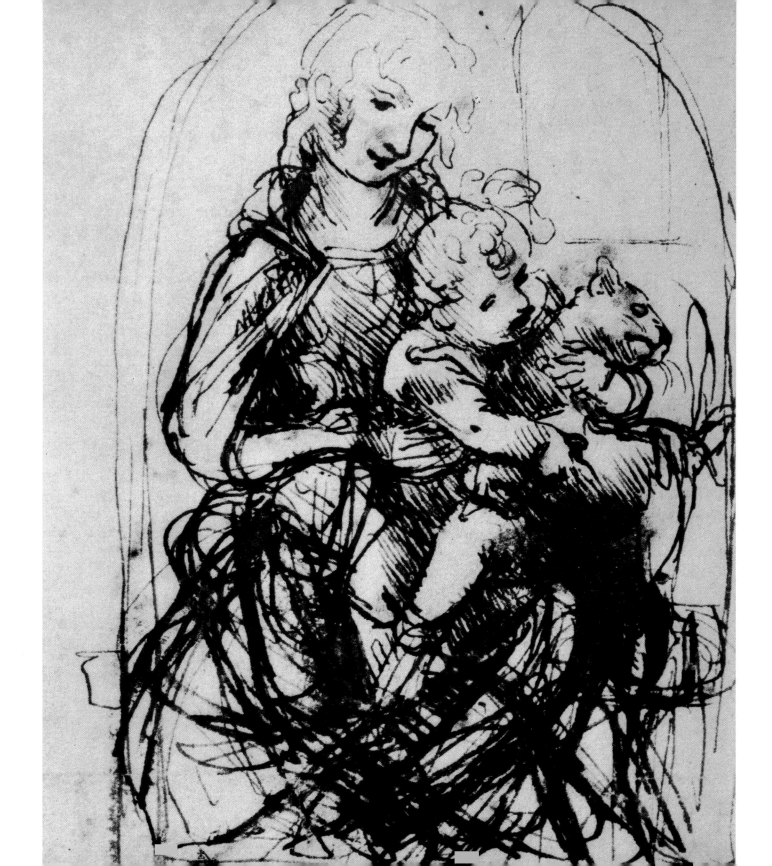

OPPOSITE PAGE: Jan Steen, *The Family Concert*, 1666. Oil on canvas. Art Institute of Chicago, USA.

throughout the New World. Indeed, cats by now had acquired a specific role as indispensable mouse-catchers in the galleys of ships—a role they retained for a long time and that was even made official during the Second World War, when British battleships were obliged by regulations to take on board three or four cats. In fact, this would have been the minimum number, given cats' well-known skill in hiding and then reappearing at the most unexpected time and in the most unthought-of places.

The great paintings of the seventeenth century, a golden age of European artistic achievement, afforded flashes of glory for cats, especially where tastes tended toward realism. Seventeenth-century Dutch art, for example, likes to look closely at domestic interior scenes, where the presence of a cat is the norm. Even Rembrandt introduces the reassuring figure of a purring cat into the most intimate scenes of the Madonna and Child. By contrast, a cheerful, vivacious painter such as Judith Leyster observes children playing with a cat along with the animal's reactions. Here is a rich narrative in which the cat is a protagonist; interpreted in fascinating ways by such diverse painters as Annibale Carracci, William Hogarth, and José del Castillo, this theme demonstrates the international nature of the genre. French art and literature, which produced the valiant Puss in Boots as an admirable parody of the musketeer, also offer a wide and varied range of treatments of the theme in painting.

During the eighteenth century, we see charming kittens in the boudoirs of the Rococo ladies painted by Boucher, and, at the same time, hard-to-catch little thieves in Chardin's paintings of kitchens. In this context, it is worth recalling the long history of cats in still-life and genre painting.

By the beginning of the nineteenth century, in a European culture calmed by the Enlightenment, the cat has almost completely lost its ancient demonic heritage and appears fully rehabilitated, apart from the occasional, unexpected twitch of the tail: who can forget the

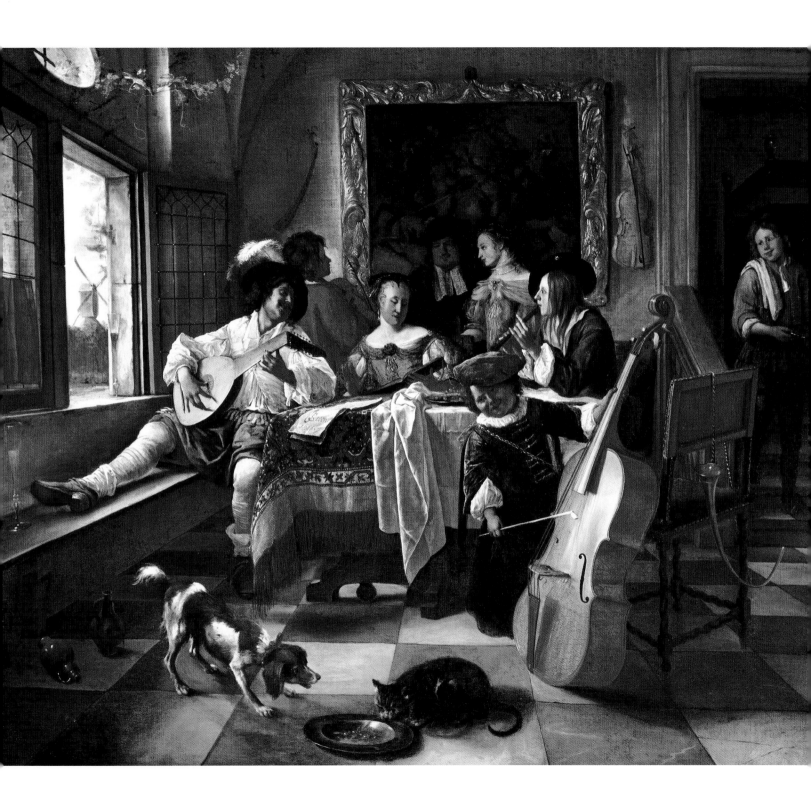

hypnotic fascination of the Cheshire Cat in *Alice's Adventures in Wonderland*, or the traps set by the Cat and the Fox for poor Pinocchio? Thus, from the serene Biedermeier interiors to Impressionism, we see the cat gradually climbing through polite society, establishing itself in salons, being picked up and cuddled by attractive young women, and enjoying increasing affection and privileges. From Manet to Renoir, and from Mary Cassatt to Bonnard, Impressionist and Post-Impressionist painting offer a vast and highly enjoyable series of veritable "homages" to the cat.

This success continues throughout the twentieth century, where we find unforgettable images of felines in the works of Picasso, Matisse, Kirchner, Marc, Miró, Chagall, Balthus, Lucian Freud, Warhol, and Hockney.

At the end of our journey, we can claim to have gathered together a convincing account of the exploits, adventures, and images of an adorable free spirit that, five millennia ago, made a conscious decision to become our fellow traveler. Let us hope it will not abandon us!

ABOVE (DETAIL) AND OPPOSITE PAGE: François Boucher, La Modiste (La marchande des modes le matin) (The Milliner), c. 1746. Oil on canvas. Wallace Collection, London.

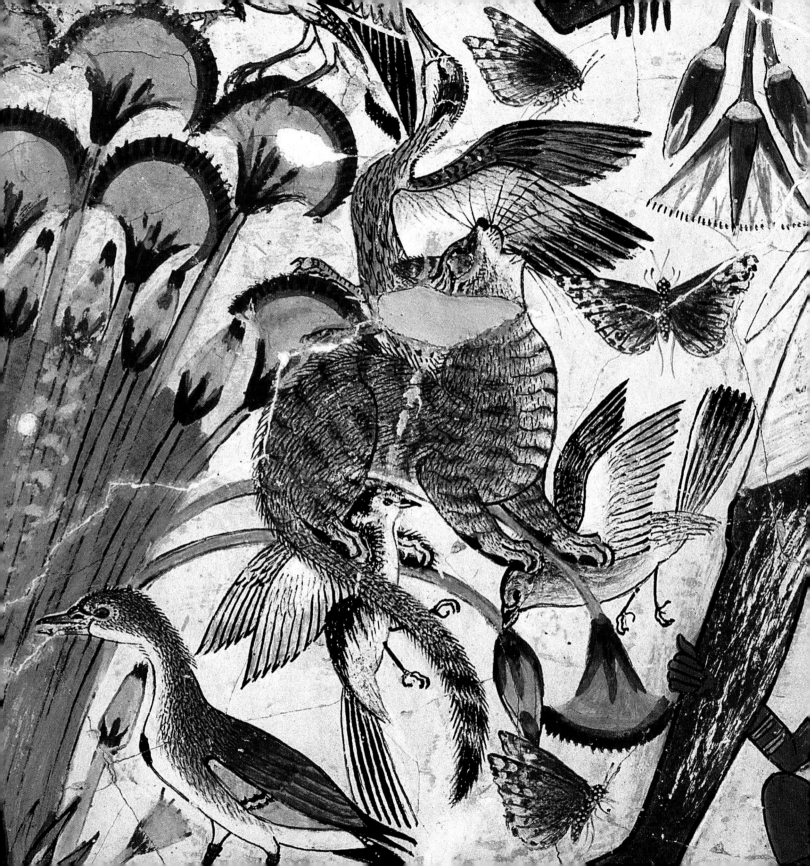

ANTIQUITY

From the Egyptian Goddess Bastet to the Mosaics of Pompeii:
The Glory and Exploits of Cats in Antiquity

EGYPT
TOMB PAINTINGS

SATYRICAL PAPYRUSES

THE GODDESS BASTET

CAT HEADS

THE CAT MUMMY

THE GRECO-ROMAN WORLD
BAS-RELIEFS

THE FRESCOES OF POMPEII

MOSAICS

PAGE 22: (Detail) *Hunting Scene in the Marshes* (see pp. 28–29); Egypt: New Kingdom, 18th dynasty, c. 1350 BC. Tomb painting from Nebamun. British Museum, London.

AS THE ENGLISH-BORN WRITER P. G. WODEHOUSE WITTILY PUT IT, "Cats, as a class, have never completely got over the snootiness caused by that fact that in Ancient Egypt they were worshipped as gods." However, it should be noted that they attained divine rank only after a long and patient process of drawing ever closer to humans and gradual cohabitation with ever more important strata and classes in Egyptian society—a period of time corresponding to the cat's transition from wild predator to domestic animal. Indeed, the identification of the cat with the benevolent goddess Bastet—lady of peace, protectress of cats, and dispenser of abundance and happiness—occurred at a fairly advanced stage in the history of Egyptian civilization. The cat-goddess was one of the last arrivals in its fantastic and zoomorphic Nilotic pantheon; previously, Bastet had taken the more regal yet formidable form of a lioness.

This relatively late arrival was amply compensated by the immensely rich, new devotional iconography of this goddess, to whom a great number of statues, reliefs, votive offerings, amulets, and ritual gifts were devoted, producing a multitude of images of the deified feline. Especially enchanting are the bronze statuettes of the cat suckling or affectionately looking after her kittens. Such images—clearly intended for ritual use but obviously derived from reality—demonstrate how the cat had become established in the customs of Egyptian society, already two millennia before it (or more precisely, she) became identified with the goddess Bastet, whose worship was centered in the city-sanctuary of Bubasti.

The cat's evolution into a domestic existence was not, of course, instantaneous, and perhaps in truth it has never been complete. The great ethologist Konrad Lorenz reminds us that the cat has remained an independent, wild little panther that does not consider itself to be man's prisoner and is prepared, at best, to forge a relationship of equals. In the most ancient graphic depictions, the semiwild cat of Nubia is represented in its role in hunting birds; and its bodily characteristics are still those of a small but ferocious predator, and certainly not a sweet little

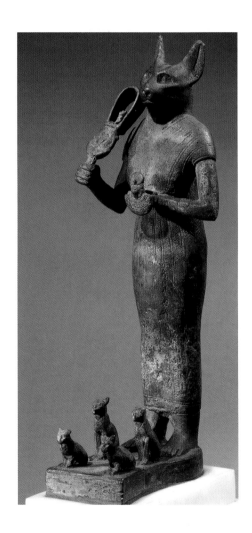

Bronze Statuette of the Cat-Goddess Bastet; Egypt: 7th century BC. Bronze. British Museum, London.

pussycat. With long ears, tawny dappled fur, a docked tail, and sharp claws, the cat—kept on a leash—takes an active part in flushing ducks out of reed beds. It also played a vital role in the ever-larger grain and food stores, keeping at bay the dreaded and voracious rats, or even treacherous snakes. In Egyptian frescoes, reliefs, papyrus illustrations, and paintings, the hunting cat is depicted as clearly satisfied, almost smiling. And it is for its original gift for aggression, almost for the pure pleasure it takes in chasing and catching its prey, and not for its loving care for its kittens, that the cat earned respect, renown, and popularity throughout ancient Egypt to the extent of performing a heroic feat: in some frescoes and in the papyruses of the *Book of the Dead,* a great cat is shown cutting off the head of the evil serpent Apophis. Cunning, victorious, sometimes even merciless with its victims, the cat appears to have neither enemies nor rivals. Such a character could not escape the darts of satire: as early as circa 2000 BC humorous paintings appear, sometimes popular in character, depicting the "world upside down," with the cat caught or mocked by birds and mice. This is the revenge of the eternal victim—an extraordinarily popular script that lasted through the millennia, passing seamlessly and essentially unchanged from the *ostraka*—painted pottery fragments—of ancient Egypt to medieval bas-reliefs, Renaissance miniatures, prints of the Baroque period, nineteenth-century lithographs, and today's animated cartoons.

Egyptian culture, which was religious and iconographic, tending to attribute human feelings and attitudes to animals, gradually prepared the way for the elevation of the cat to the rank of deity, as well as for the attenuation of its predatory nature. It is nevertheless significant that the Bible never refers to cats. In contrast to a typically urban and settled people such as the Egyptians, the Hebrews, who were destined to migrate in this early chapter of biblical history, did not succeed in forming a relationship with an animal that strongly dislikes migration or travel, and was certainly disinclined to follow their exodus under the leadership of Moses.

(Detail) *The Serpent-God Apophis Killed by the Sun-God Ra in the Form of a Cat;* Egypt: 19th dynasty (1295–1186 BC). Tomb painting, tomb of Inherkha. Deir el-Medina, in Egypt.

(Detail) *Satyrical Papyrus, with a Cat Driving Ducks* (see pp. 30–31); Egypt: New Kingdom, c. 1100 BC. Painted papyrus. British Museum, London.

In short, between the second and first millennia BC the cat became established in Egyptian households, gradually losing its more aggressive characteristics—including the physical—to become an indispensable companion of its masters both in life and in death. Many mummies of cats have been found in Egyptian tombs. With its claws clipped, the cat's image, anatomy, and behavior—already softened by satirical depictions—were gradually transformed into the figure of the placid, essentially inoffensive domestic feline. Then the more lovable and "feminine" aspect of the cat asserted itself, even in a religious sense, and as expressed in terms of courtship, amorous tussles, a short and generally successful gestation period, fecundity, and care of the young, along with the cuteness of kittens playing between their mother's paws.

In a less marked way, a similar process took place in the central and western Mediterranean civilizations: Greeks, Etruscans, and Romans adopted the cat initially for its skill in hunting harmful animals, and only later in its more peaceful guise of domestic animal. The most vivid images of Greco-Roman cats are beyond doubt the mosaics of Pompeii, where cats are depicted in a classic scene: stealing some food from the table and fleeing with their prizes in their jaws. Rarer, and for this reason more precious, are the images of cuddling and stroking: an important novelty in Greco-Roman civilization is the association between cats and children, who are playmates in games that are sometimes a bit crazy or cruel, but always marked by a reciprocal affection of which there is no trace in Egyptian art and culture. In these European cultures, more disenchanted and rational than image-prolific Egypt, the cat does not attain the pantheon of deities. Rather, and this is highly significant, the black cat begins to be associated with the nocturnal rites and sorcery linked to Diana, a tradition that would become deeply embedded in Western superstition and that would develop through the centuries.

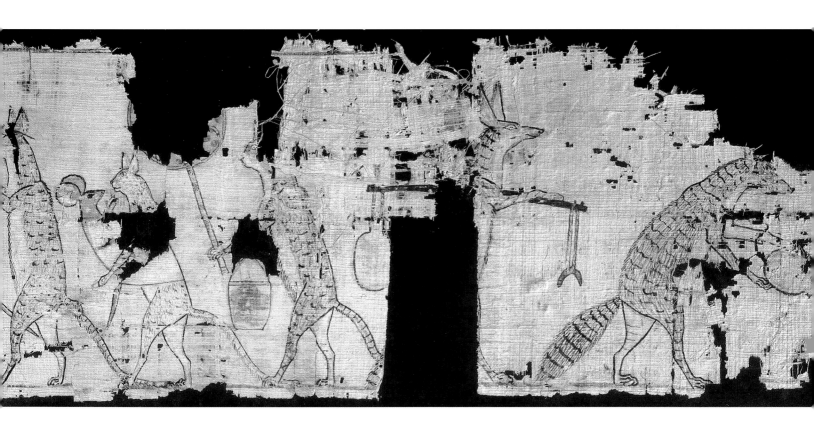

Satyrical Papyrus, with a Mouse Waited On by Cats;
Egypt: New Kingdom (1567–1085 BC). Painted
papyrus. Egyptian Museum, Cairo.

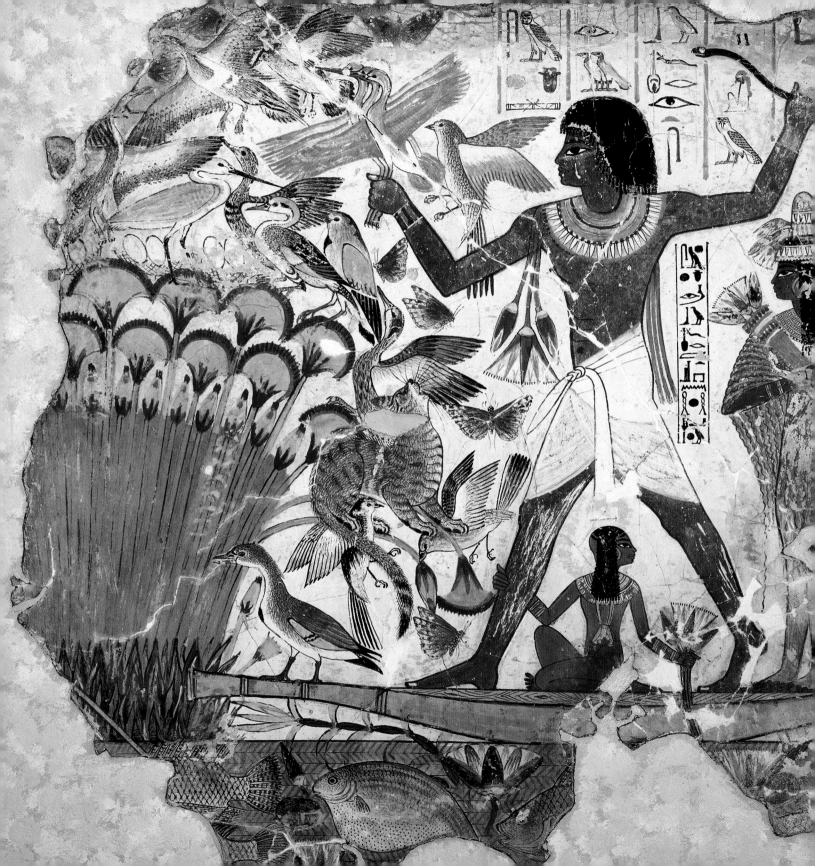

EGYPTIAN ART (New Kingdom, 18th dynasty)

Hunting Scene in the Marshes, c. 1350 BC

Tomb painting from Nebamun, (complete) 38 x 32 in. (98 x 83 cm)

BRITISH MUSEUM, LONDON

With this famous fragment of a fresco, a masterpiece of expressiveness as well as the ancient Egyptian love of color, the cat makes its triumphal entry into the history of art. The scene is marvelous; and, in contrast to the predominantly static quality of Egyptian paintings, it seems full of life and natural atmosphere. A group of young hunters enters the reed beds on the marshy banks of the Nile to hunt ducks. They have brought a cat with them, in order to make use of its predator's instinct to flush out their quarry. The cat depicted here appears still to be a semiwild animal: it looks bigger than usual, and its large pointed ears and striated fur recall the cats of the savannah. The hunting cat of ancient Egypt clearly enjoys pouncing on its prey. Here, art captures a moment of transition—from wild beast to the domestic animal the cat is soon to become. At the same time, the cat is undergoing a partial, gradual change in physical appearance, becoming somewhat "softer."

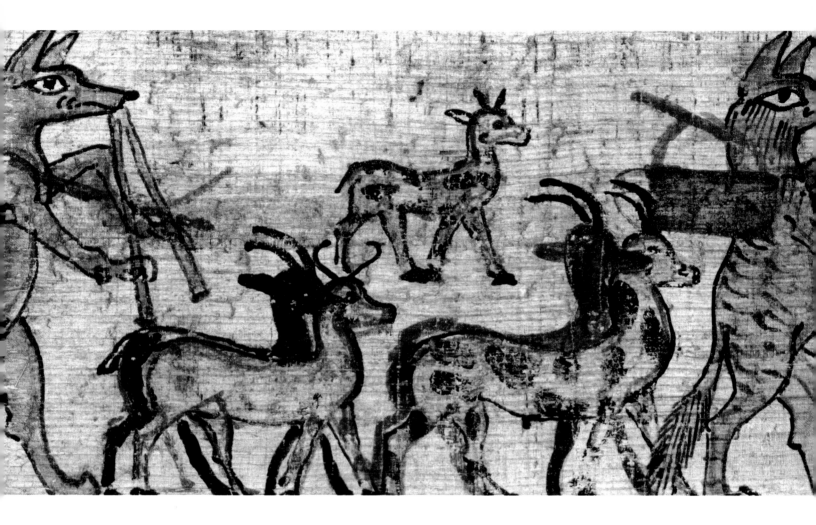

EGYPTIAN ART (New Kingdom, 20th dynasty)

(Detail) *Satyrical Papyrus, with Wolves Guarding Sheep, a Cat Driving Ducks, and a Lion Mummifying a Donkey,* c. 1100 BC

Painted papyrus, 23 x 6 in. (59.7 x 15.5 cm)

BRITISH MUSEUM, LONDON

The transition from the fierce hunting cat in the reed beds on the banks of the Nile to images of motherly love as represented by the goddess Bastet was, of course, a long, gradual process. In drawing close to the human world, the cat passed through a very special phase, during which it was put to the test, in a sense, by attributing specifically human attitudes and activities to it in a clearly comical and exaggerated way. The decorations on papyrus and *ostraka*—fragments of pottery depicting burlesque images—offer many examples. The "anthropomorphic" cat thus loses its more "animal" characteristics: mockery—often in the form of revenge taken by its usual victims—has the effect of defusing the cat's more aggressive qualities, rendering it more likable and vulnerable, and thus bringing it closer to pleasant, familiar domesticity.

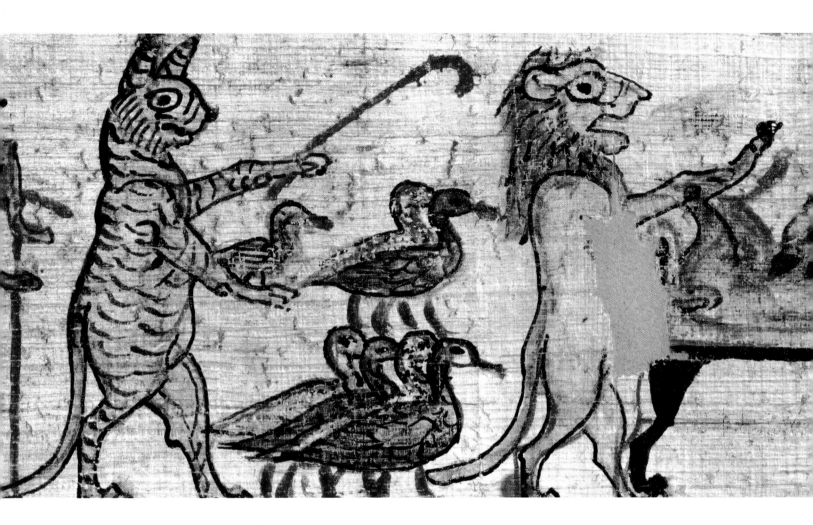

EGYPTIAN ART

(Third Intermediate Period)

Statuette of the Cat-goddess Bastet Suckling Her Kittens, 8th century BC

Bronze, width 23 in. (60 cm)

Musée d'Histoire Naturelle d'Archéologie et d'Ethnographie, Cherbourg, France

Unquestionably, the cat's finest hour in the history of art began in ancient Egypt around 1000 BC. The worship of the zoomorphic goddess Bastet, depicted with a cat's head, won a huge popular following, to which the existence of a great many votive statues, amulets, and propitiatory gifts bears witness. In an age when prenatal and perinatal mortality were high, Bastet was invoked in the hope of having a trouble-free childbirth and a postpartum period without complications. The identification of this goddess with childbirth evidently was linked to the affectionate, gentle care that mother cats show toward their kittens—touchingly depicted in the bronze statuette of a reposing mother cat suckling its lively offspring.

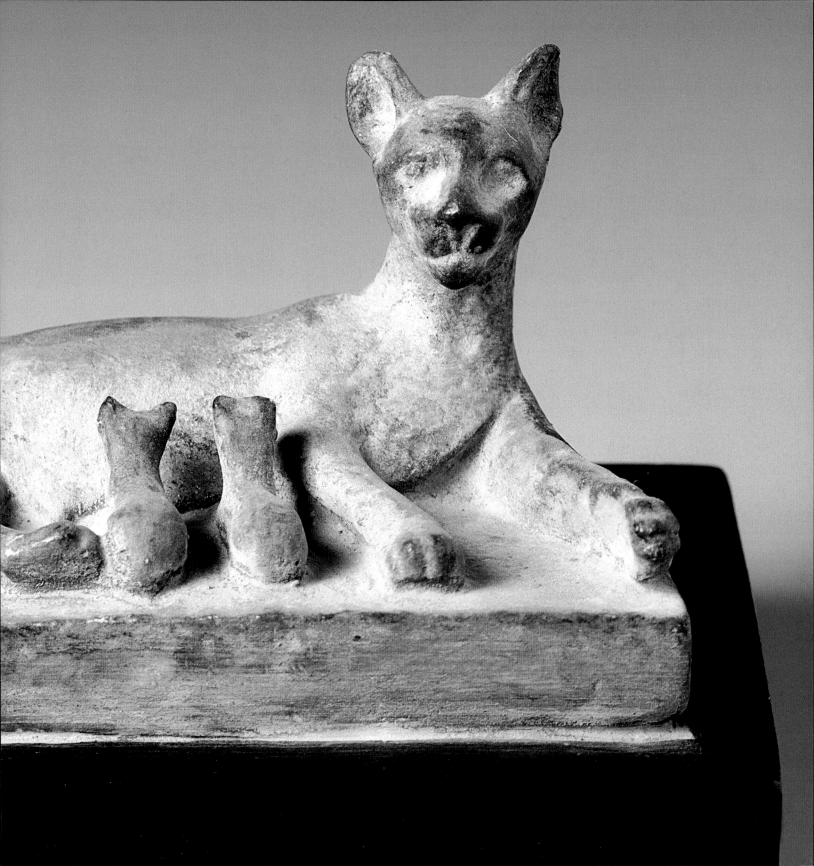

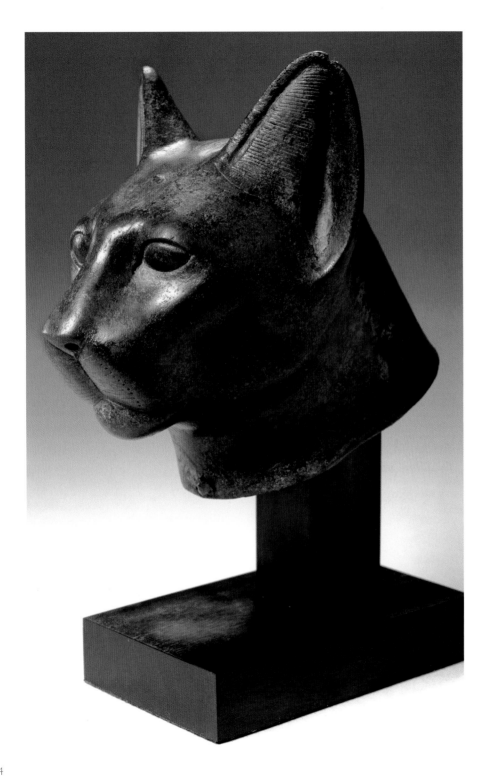

EGYPTIAN ART

(Third Intermediate Period,
26th dynasty)

Cat's Head, 664–525 BC

Bronze, height 5¾ in. (14.7 cm)

PRIVATE COLLECTION

It has been commonly asserted that ancient Egyptian art is often schematic and has barely evolved through the millennia. On the contrary, Egyptian artists had an extraordinary capacity for observing and depicting nature, although they frequently had to work with established formulae, especially in painting. Moreover, the zoomorphic nature of many Egyptian gods demanded that artists pay particular attention to the animal world. This exceptionally realistic cat's head is not only a masterpiece but also historical evidence of the widespread iconography of cats, reflecting worship of the goddess Bastet as well as the fact that cats lived in Egyptian households. The careful realistic depiction also emphasizes their gradual physical transformation from wild predator to domestic cat: the large ears, angle of the muzzle, and elongated nose are all characteristics that would soften over time.

EGYPTIAN-ROMAN ART

Cat Mummy from Abydos, 1st century BC
Height 17 in. (46 cm)
BRITISH MUSEUM, LONDON

The presence of mummified cats in Egyptian tombs can be considered the "fourth phase" of the cat's integration into Egyptian society. Initially a semi-wild animal used for hunting, the cat adapted to life in human homes; and the pursuit of ducks in reed beds gave way to the protection of granaries and food stores from mice. The opportunity to observe the habits of mother cats with their kittens inspired the worship of the cat-goddess Bastet, when the unity of human and animal could be said to be complete. And this is the fourth step: it is well known that the ancient Egyptians attempted to re-create the conditions of life on earth in their tombs, surrounding the deceased with furniture, food, and objects of all kinds. The presence of a mummified cat indicates that the animal had become a constant companion that would be kept at one's side for all eternity.

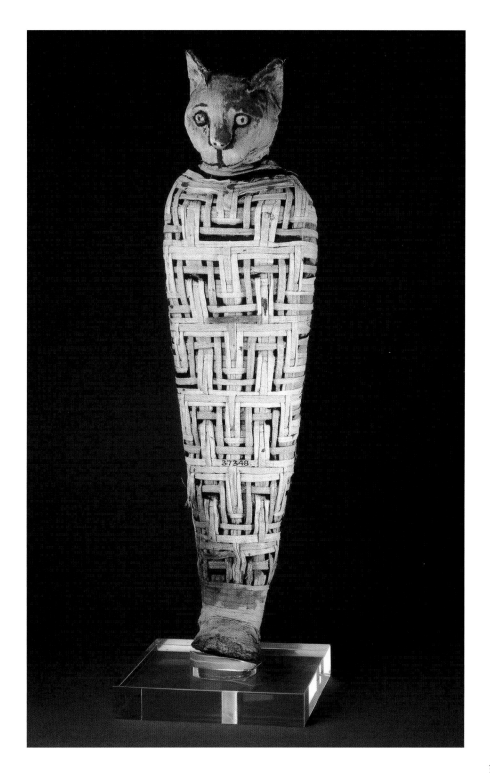

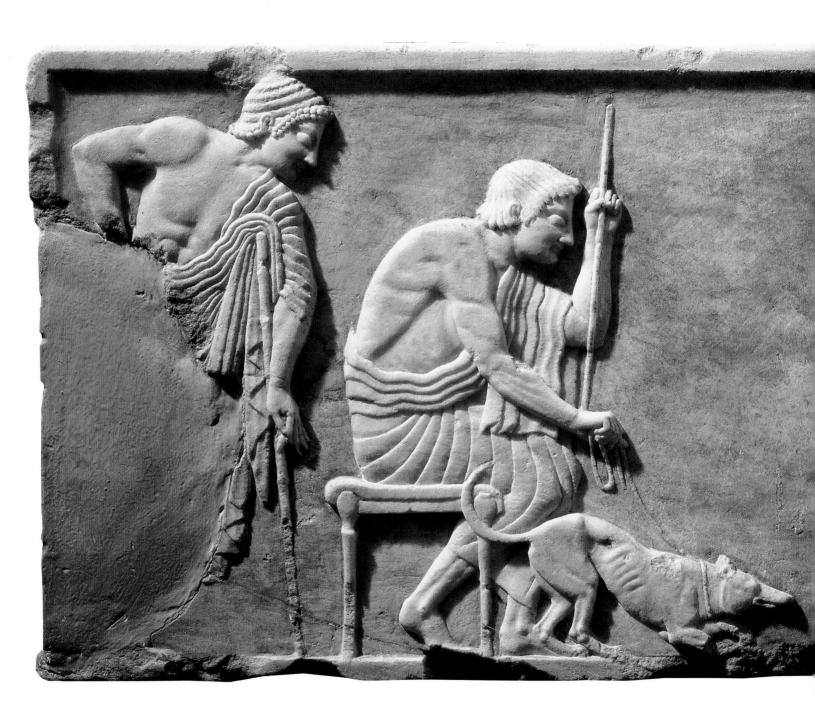

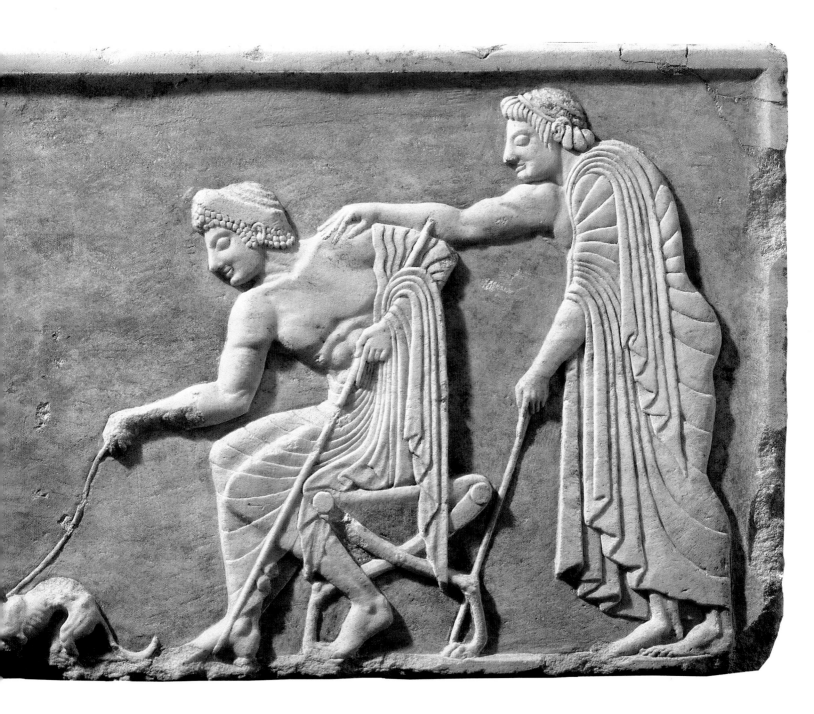

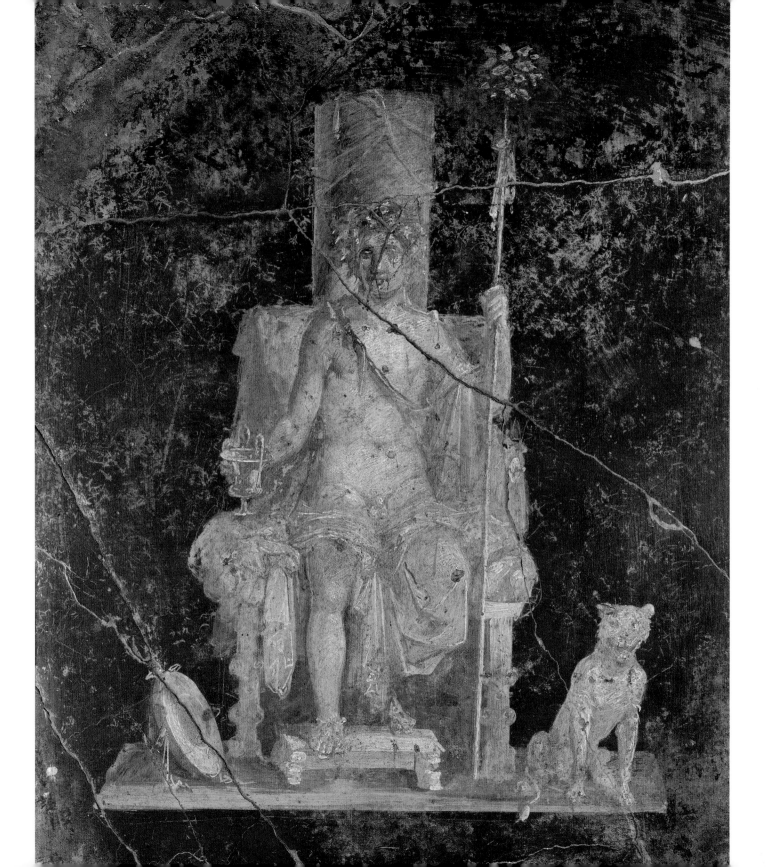

PRECEDING PAGES:

GREEK ART

Encounter Between a Dog and a Cat: Base of a Statue, c. 500 BC
Marble; width 23½ in. (60 cm)
NATIONAL ARCHAEOLOGICAL MUSEUM OF ATHENS, GREECE

This meeting between a dog and a cat—both on a leash and therefore considered private property—takes place in an atmosphere of caution on both sides. But while the dog seems more prepared to "get to know" the cat, the latter arches its back in the customary defensive posture. The men observe the scene with great interest, waiting to see what will happen. When cats first arrived in Greece, they must have aroused great curiosity; their relatively late arrival may have been due to the Egyptian ban on exporting what they regarded as a sacred animal.

ROMAN ART

Bacchus on the Throne, 1st century AD
Fresco in the Casa del Naviglio (House of the Ship), Pompeii, 31 x 23 in. (80 x 60 cm)
NATIONAL ARCHAEOLOGICAL MUSEUM, NAPLES, ITALY

Against a background of marvelous "Pompeii red," the radiant image of the god Bacchus sits on a throne like an emperor at the height of his splendor and power. This is one of the most rare and precious masterpieces of ancient painting, as well as an interesting historical document that underlines the spread of the worship of the god of wine, along with the Dionysian mysteries connected with it. The god's right hand holds a chalice containing nectar, and the perfect proportions of his throne would be a credit to any Renaissance treaty on perspective. On the right is a cat with markings on its fur, in an aggressive stance. It is a small panther, an animal closely connected to the iconography of Bacchus; it is hardly bigger than a common cat. The Egyptians may have worshipped Bastet, but at least Roman cats could console themselves with the honor bestowed on their exotic, wild cousin.

ROMAN ART

Cat and Ducks, c. second half of the 2nd century BC

Mosaic from the Casa del Fauno (House of the Faun), Pompeii, 20¾ x 21 in. (53 x 53.5 cm)

NATIONAL ARCHAEOLOGICAL MUSEUM, NAPLES, ITALY

One of the most famous depictions of a cat from classical antiquity, this animal is intent on catching a partridge, while beneath this scene is another composition consisting of ducks, fish, and shellfish. The realistic portrayal, complete with bright eyes focused on the prey and the aggressive, snatching claws, is the result of the artist's use of the technique of *opus vermiculatum*: the small size and fine quality of the rows of tesserae precisely captured the feline's attitude as well as the stripes on its coat, and even the hairs standing on end on its back and tail as it seizes the bird. In this "painting in stone," the use of an extremely rarefied color palette gives the scene practically the quality of a still life. This famous *emblema*, or small square mosaic, probably occupied the center of a floor, according to the Hellenistic custom of using such *emblemata* to convey the character of a room. Like other price-less mosaics (some of which also show cats), this comes from the Casa del Fauno, perhaps the most famous Pompeii dwelling from the second half of the second century BC and an authentic gallery of Hellenistic paintings and mosaics.

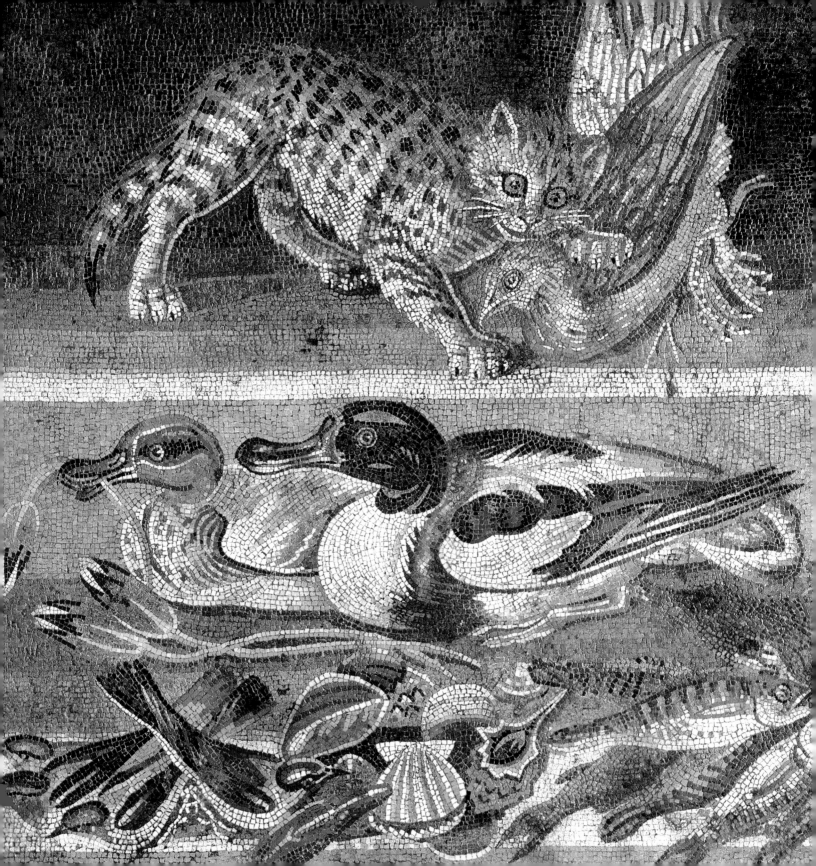

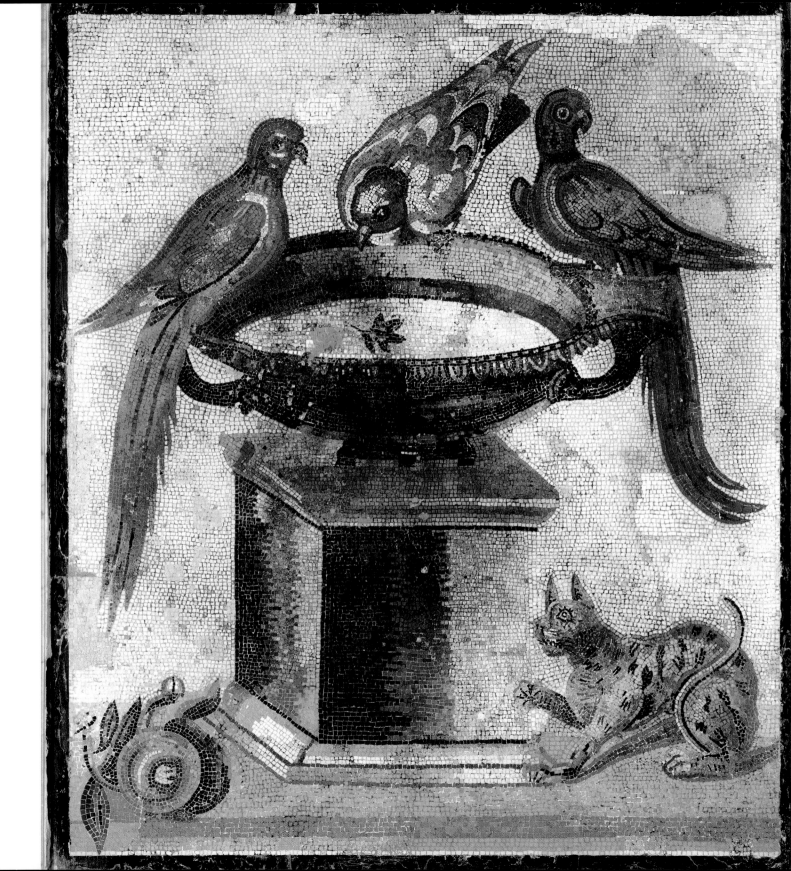

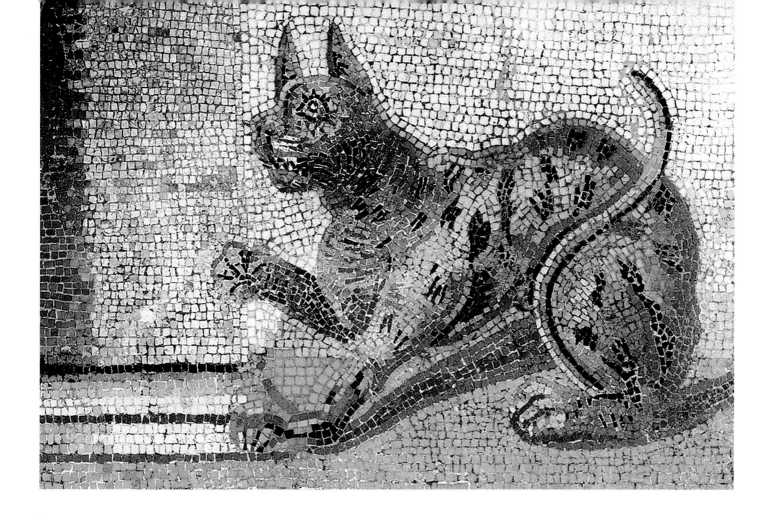

ROMAN ART

Fountain with Two Parrots and a Dove, 80–60 BC

Mosaic from Santa Maria Capua Vetere, 22¾ x 19½ in. (58 x 50 cm)

NATIONAL ARCHAEOLOGICAL MUSEUM, NAPLES, ITALY

It is very difficult to establish whether this is indeed a cat—albeit more idealized and stylized than its counterpart in the Casa del Fauno—or some wild feline. This animal is about to make an attempt on the life of a dove and two parrots perched on the edge of a fountain. Here, too, the use of the *opus vermiculatum* technique gives the scene that refinement and realism typical of Hellenistic mosaics. The theme of the cat hunting a bird is also of Alexandrian origin, for Oriental culture influenced the Romans both in their iconography and techniques. Although the execution is less careful than in the famous example from the Casa del Fauno, especially in the obvious lack of proportion between the various figures, this *emblema* is still to be admired for the entertaining interplay between the birds—blissfully unaware as they rest and drink—and the greed of the striped feline with the long tail, its right paw raised either in impotence (because the fountain is too tall) or in concentration as it prepares to spring.

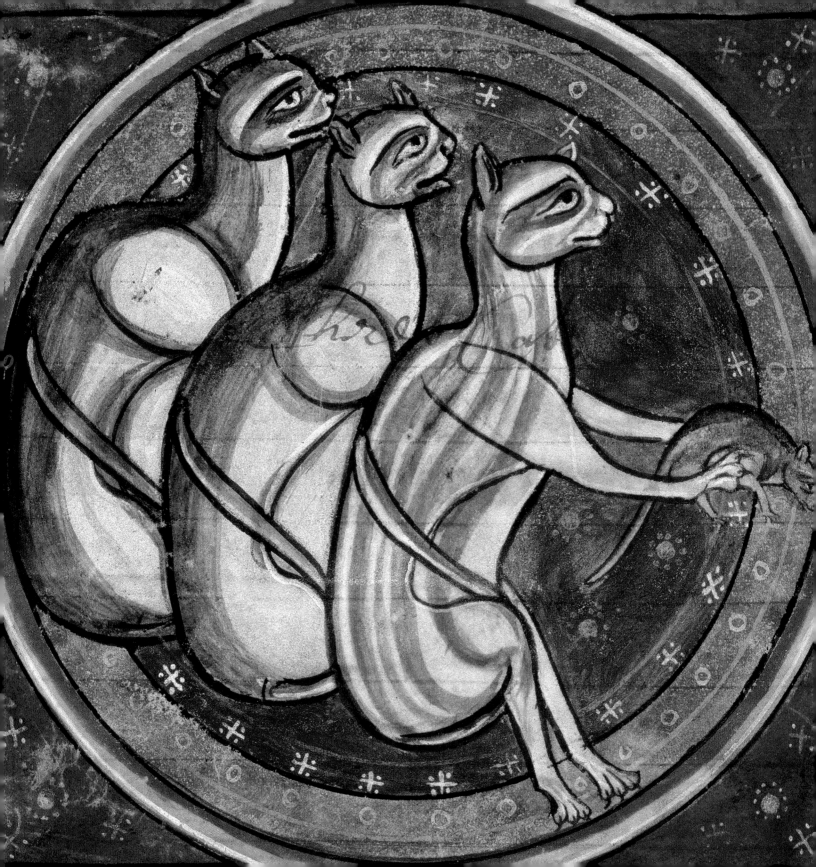

THE MIDDLE AGES

The Two Faces of the Medieval Era:
From Demonic Images to Benedictine Scriptoria

PAGE 44: (Detail) *Three Cats and a Rat/A Rat Eating,* 13th century (see p. 51). *Harleian Bestiary,* English illuminated codex. British Library, London.

THE ANCIENT WORLD COLLAPSED, ANCIENT MONUMENTS CRUMBLED, and cats became the new masters of temples and amphitheaters—a privilege they have jealously guarded for centuries. In a medieval society that suffered devastation, uncertainty, and reduced economic activity, that huddled in small urban or rural communities, with extremely limited opportunities for contact or exchange with the outside world, and that lived in constant terror of a new invasion or epidemic, the cat is a supreme example of adaptation and indifference to the evils of the world. It is an admirable "philosopher" animal, able to enjoy the most miniscule privilege: a sunlit corner, a caress, a fishbone to gnaw on. However, even medieval people were disconcerted by the sudden metamorphoses of this peaceful, cuddly animal, which could suddenly be transformed into an implacable hunter and aggressive wild beast, having no master and no sense of fear. The result is a dual development in the cat's iconography: on the one hand, the enviable, seraphic domestic little lord, jealous guardian of its own well-being; on the other, the nocturnal animal, elusive, fierce, and disturbing. The Middle Ages was an era of symbols, in which certain eloquent, metaphoric ways of representing the cat were established. For example, there was born the felicitous image of the quarrel between a cat and a dog under the table at the Last Supper: almost too schematically, the dog represents the loyalty of the Apostles, as opposed to the demonic "betrayal" of Judas, symbolized by the cat.

The negative, demonic vein, which will be analyzed in greater detail in the discussion devoted to the cat "possessed by the devil," soon becomes apparent, but at the same time there appear images imbued with gratitude or irony, associated with the hunting of mice and harmful animals. Pleasing images, stylized to the limits of caricature, are found in the apses, crypts, and capitals of Romanesque churches throughout Europe. Several carved cats serve as the metaphorical guardians of the oldest cemetery in Rouen, France, which is called in the local dialect *attràcats,* or the cats' enclosure.

Antefix with Cats' Heads, 12th century. English Romanesque art. Durham Cathedral, England.

In monasteries, cats prowled around granaries, the cellars, and the kitchen, and guarded the pantries; thus they were not merely an incarnation of the devil, but could be considered, beyond all superstition, as useful, affectionate animals, protecting the stores of food. The most attractive medieval images of cats are undeniably the miniatures produced within the austere walls of Benedictine scriptoria, where manuscripts were copied and illuminated; and there can be no doubt that a sort of identification is sometimes felt between monks and cats. Just as the cat adapts perfectly to every setting, including that of a monastery, so the monks observe and admire the cat's gifts: discretion, the enviable ability to pass instantly from sleep to wakefulness, and—this is not paradoxical—a gift for singing. Among the voices of mammals, the cat possesses one of the most varied and rich in modulation; it is no coincidence that the borders of illuminated antiphonaries and anthem books sometimes feature choirs of cats in concert. Moreover, as thinkers have known for millennia, to stroke a cat absent-mindedly while writing, pondering, or reading is a formidable aid to concentration. A cat walking through a library is never a nuisance. There are even those who insist that cats, which are endowed with ineffably good taste, would never curl up on a mediocre book. After all, rodents also pose a danger to ancient, dense parchments. This is a fact that should not be underestimated, and is confirmed in many medieval miniatures depicting extremely satisfied cats in the act of catching mice.

In short, among the many faces of medieval Europe, the whiskered, mocking face of the cat cannot be underestimated. On the one hand, undeniably, the insidious vein of superstition becomes stronger during this period; on the other hand, the benevolent image of the domestic cat also takes root, as a useful, discreet companion for a wide range of members of society, from the housewife to the scholar.

Another factor that may help to explain the cat's growing popularity in medieval Europe is the positive interaction with the various Muslim kingdoms of the Mediterranean, for Islamic culture seems indeed to

(Detail) *Adam Naming the Animals*, 12th century. *Aberdeen Bestiary*, North Midlands, illuminated codex (see p. 50). Aberdeen University Library, Aberdeen, Scotland.

prefer the silent wisdom of cats to the often indecorous liveliness of dogs. As an ancient Arab proverb has it, "The dog barks, but the caravan passes on its way." The modern visitor to the Alhambra in Granada, Spain, is greeted by a small legion of extremely affectionate cats. Apropos of the contact between the Christian and Islamic worlds, there is yet another aspect that involves cats. Many were taken on board the Crusaders' ships sailing for the Holy Land, to protect their storerooms, ever under threat from the omnipresent mice. As soon as they had disembarked, these cats were eager to unite with their Palestinian cousins, thus giving rise to new breeds with diverse traits in body shape, temperament, and fur color. The cat's gifts as a rat-and-mouse catcher have always been admired by sailors; and this, as well as the cat's delight in sea journeys, has given rise to unexpected preferences and scenarios. It is known for certain that the great Genoese admiral Andrea Doria was a cat lover; and until the Second World War, Britain's Royal Navy, as already noted, had at least three cats embark on every ship of His Majesty's fleet, and of course they soon became the crew's mascots.

To sum up, in an artistic and cultural context that tended not to reproduce reality directly, but rather to create modes of representation via metaphoric forms and symbols pregnant with suggestion, the figure of the cat gradually took on its characteristic ambivalence and ambiguity, advancing on its rich visual journey through the centuries, one that is substantiated by meanings and allusions to the present day.

ABOVE: (Detail) *Cat-and-Mouse Choir Stalls*, 13th century. Carved wood (see pp. 56–57). Poitiers Cathedral, France.

OPPOSITE PAGE: (Detail) *A Domestic Cat Playing with a Mouse*, c. 1340. Luttrell Psalter, illuminated codex (see p. 53). British Library, London.

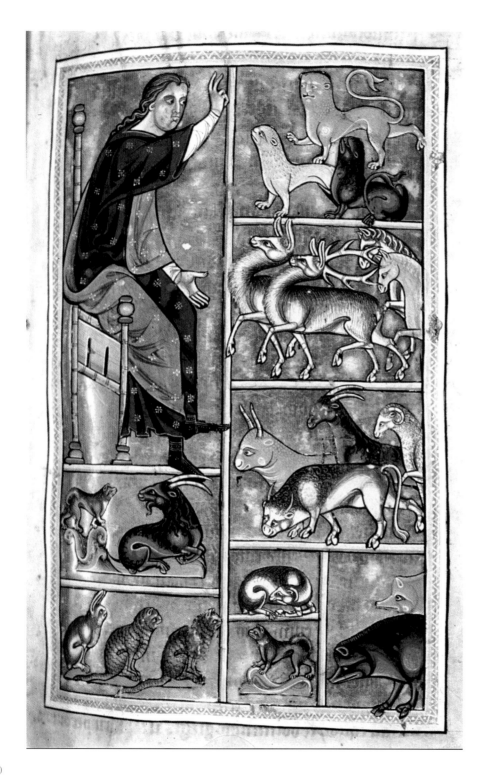

MEDIEVAL ILLUMINATED MANUSCRIPT

Adam Naming the Animals

From the *Aberdeen Bestiary*, North Midlands, 12th century

MS. 24 f.5

Illuminated codex, 12 x 8 in. (30 x 20.6 cm)

ABERDEEN UNIVERSITY LIBRARY, ABERDEEN, SCOTLAND

Obeying the command of God the Father, Adam gives names to all the animals that were created immediately before him. With this act, the first man lays the foundations of "learning," in the sense of knowledge of the names of things and the positions they occupy in the universe—a need that must have been particularly pressing at the time this manuscript was made. Bestiaries were popular in twelfth- and thirteenth-century England because they were considered a means to a general enhancement of knowledge, especially its scientific and speculative aspects. In this folio, each named species occupies its own segment of the illuminated page; included are various felines, ready to receive their names.

ENGLISH ILLUMINATED MANUSCRIPT

Three Cats and a Rat/A Rat Eating

From the *Harleian Bestiary*, 13th century

MS. Harley 4751, f. 30 v

Illuminated codex, 12 x 9 in. (30.8 x 23.2 cm)

BRITISH LIBRARY, LONDON

The mouse—and the rat even more so—is one of the most hated and feared animals in the history of human civilization. The alliance between cats and humans through the millennia has involved the hunting of these harmful little creatures. In this extraordinary medieval bestiary, the mouse, alongside the ornamental first letter of the text, is depicted as very fat, ugly, and insatiably devouring food—almost a living allegory of the deadly sin of gluttony. The three extremely elegant cats, in the image above, bear the captured mouse as if it were a holy offering. In direct contrast to traditional iconography, in which the cat is associated with the devil, these cats have the appearance of a benevolent band of avenging angels, who have defeated evil in the shape of the hapless mouse.

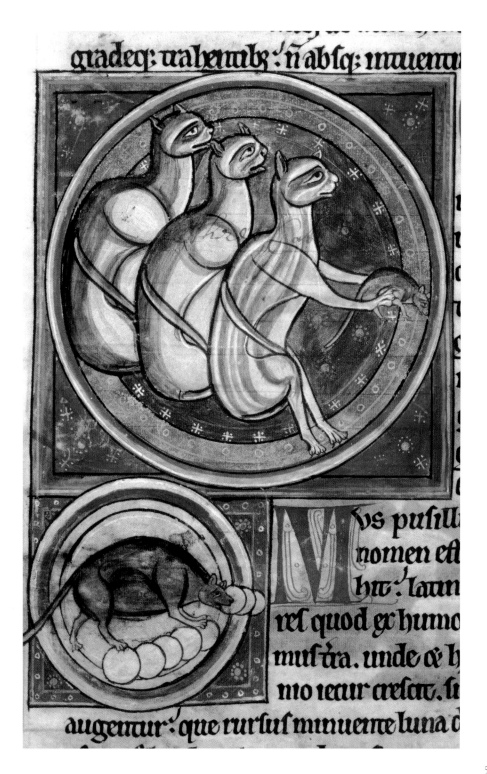

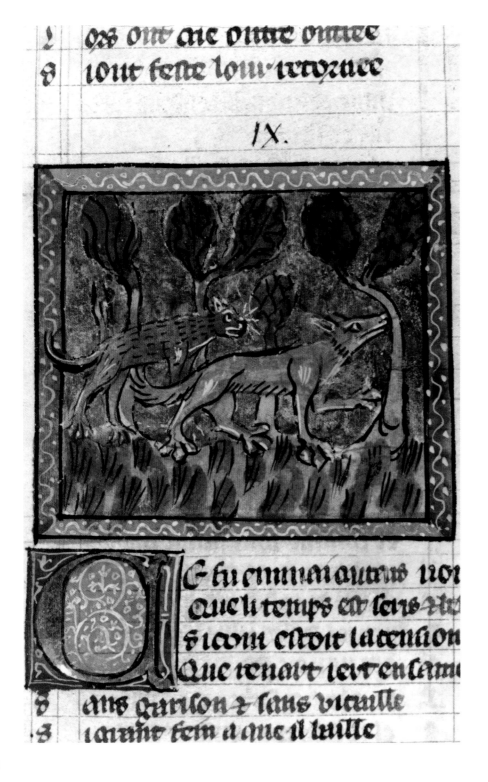

FRENCH ILLUMINATED MANUSCRIPT
Scene from the *Roman de Renart*, c. 1320
MS. Fr 1580 f. 93
Illuminated codex, 11 x 8 in. (27.8 x 19.5 cm)
Bibliothèque Nationale, Paris

In the *Roman de Renart*, one of the oldest medieval European story cycles, animal characters become truly human in ways typical of their peculiar characteristics: for example, the fox is cunning, the wolf stubborn and brutal, the lion regal. A mirror faithfully reflecting the vices and virtues of the era's feudal society, this world of aggression and instinct finds in the fox—or in middle-class intelligence, lacking in power but rich in ingenuity—its model, a faithful mirror of changing times. The cat Tibert is one of the main characters in these anonymous and enjoyable tales (probably a collection of writings by a number of different authors), and is distinguished by his incurable laziness, redeemed by flashes of wit and cunning.

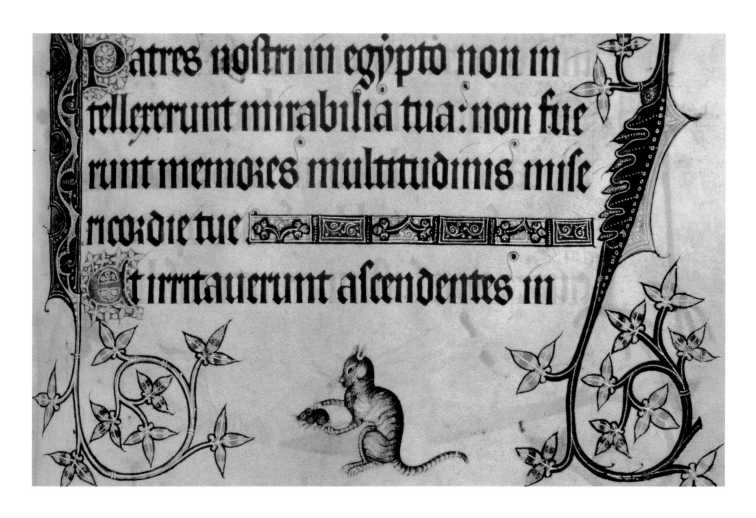

FRENCH ILLUMINATED MANUSCRIPT

(Detail) *A Domestic Cat Playing with a Mouse*

From the *Luttrell Psalter*, c. 1340

Written for Sir Geoffrey Luttrell of Irnham

MS. Additional 42130, f.190

Illuminated codex, 14 x 10 in. (35.5 x 24.5 cm)

BRITISH LIBRARY, LONDON

The borders of illuminated manuscripts often contain amusing notes, personal jottings, sketches, and ornamental improvisation that transcend convention and excessively limiting rules. Even in sacred texts and volumes of doctrine, small "out of context" scenes and figures, which have nothing to do with illustrating what is written, sometimes slip through. It has often been mentioned that in European scriptoria, the places in monasteries where manuscripts were illuminated, cats were very welcome creatures: there the miniaturist could focus on a handsome tabby cat that has caught a mouse and, with its customary subtle perfidy, revels in fondling and caressing its prey before killing it.

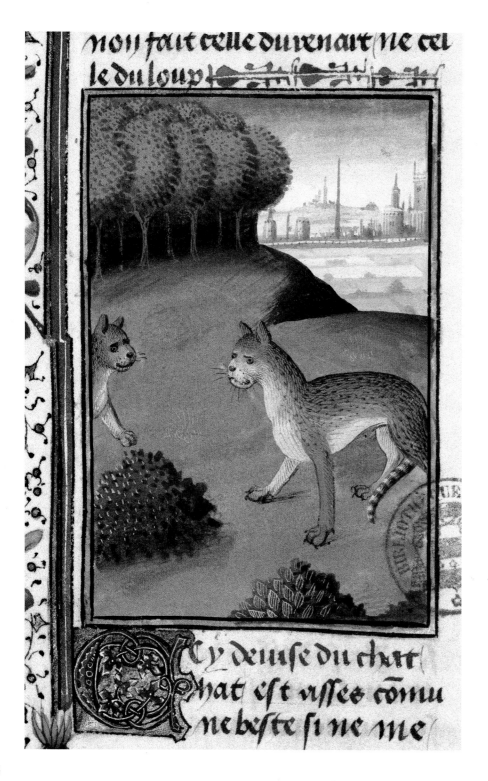

noil fait celle du renait ne cel
le du loup

Ly deuise du chat
hat est asses comu
ne beste si ne me

GASTON PHÉBUS, THIRD COUNT OF FOIX
(1331–1391)

Wild Cats

From the *Traité de Chasse (Treatise on Hunting)*, early 15th century

Illuminated manuscript, 10 x 9 in. (26.9 x 22 cm)

ARCHIVES CHARMET, BIBLIOTHÈQUE MAZARINE, PARIS

A typical feudal lord, Gaston Phébus of Foix is one of the emblematic figures of late-thirteenth-century French history. A skillful and unscrupulous politician, capable of looking after his private interests by exploiting relations between France and England, he was brave and ruthless, generous and depraved, yet also aware of his failings to the point that he wrote a book of prayers. His most famous work, which met with great success even in later centuries, is a treatise on hunting—a typical aristocratic pastime during the late Middle Ages—in which the author reveals his sincere love of nature. This miniature is from a marvelously illustrated copy of the treatise. Two large semiwild cats, teeth and claws much in evidence, emerge from the woods outside the city walls, reminding us of the still incomplete integration between cats and humans, and of the ferocious beast that always hides behind the peaceful façade of the domestic cat.

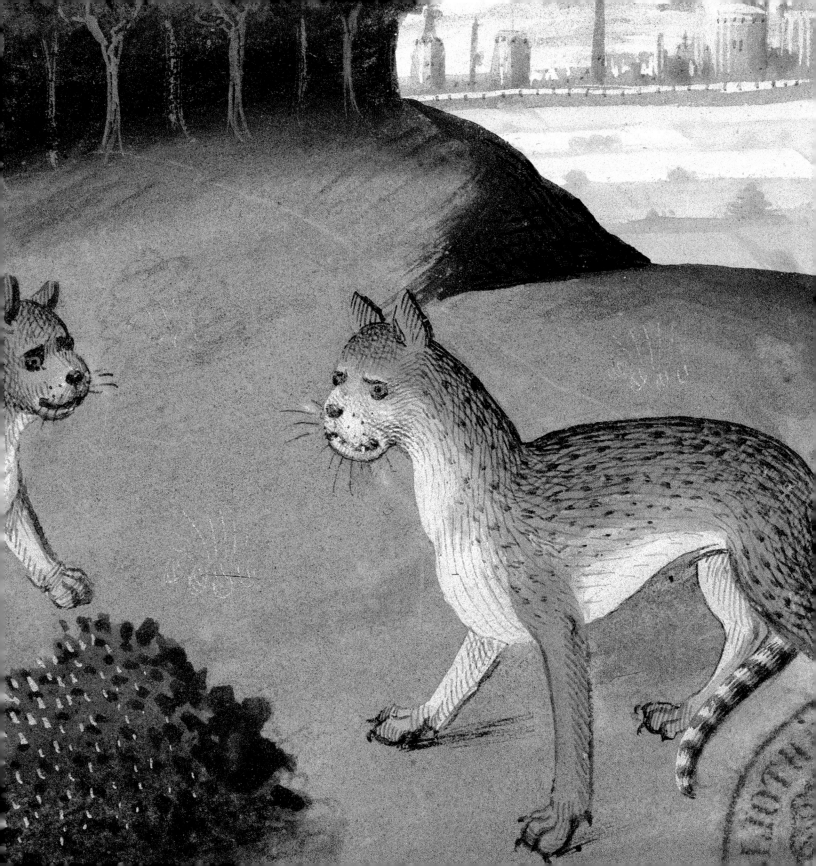

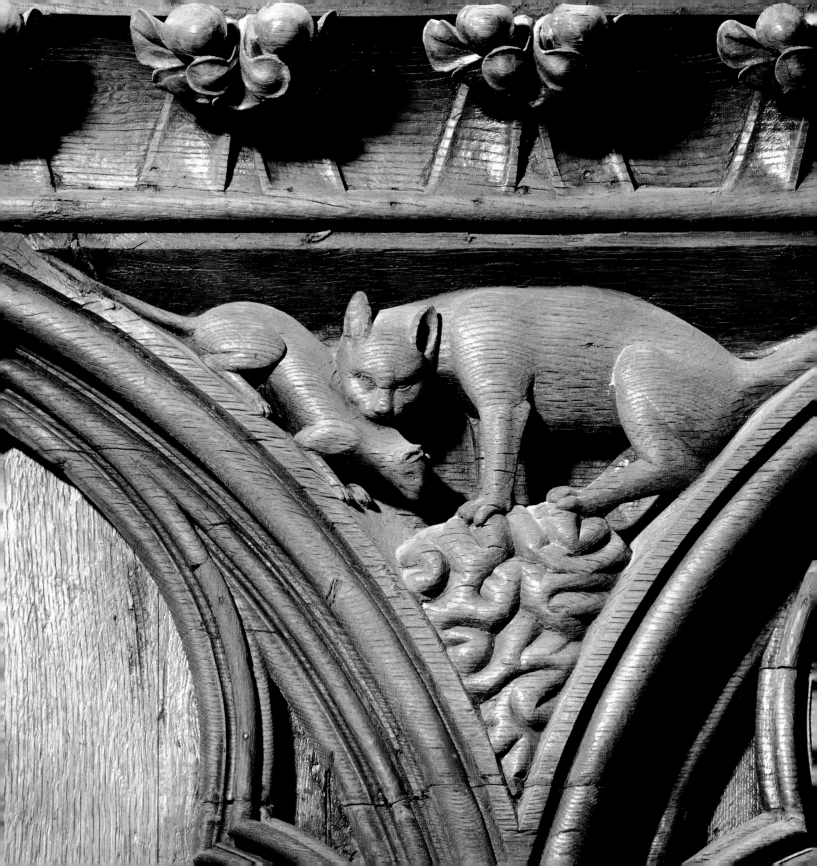

SCULPTURE (FRENCH SCHOOL)

(Detail) *Cat-and-Mouse Choir Stalls*, 13th century

Carved wood

POITIERS CATHEDRAL, FRANCE

In 1232, Pope Gregory IX established the Inquisition in order to root out heretics who worshipped the devil in the form of a black cat. This was the beginning of a long and bloody persecution that did not even leave cats unscathed. The presence of a cat in a church should not, however, surprise us; for it is only thanks to the cat's providential pursuit of mice that the latter are prevented from gnawing at the roots of the tree of life, symbolically depicted here on the backrest of this carved stall. In the Bible the mouse is seen as an animal of ill omen because it spreads pestilence; it is also despised by people for its capacity to reduce food stores to dust. It is very likely that the association of the mouse with evil and the demonic is due to these factors; it has always been considered hostile to man.

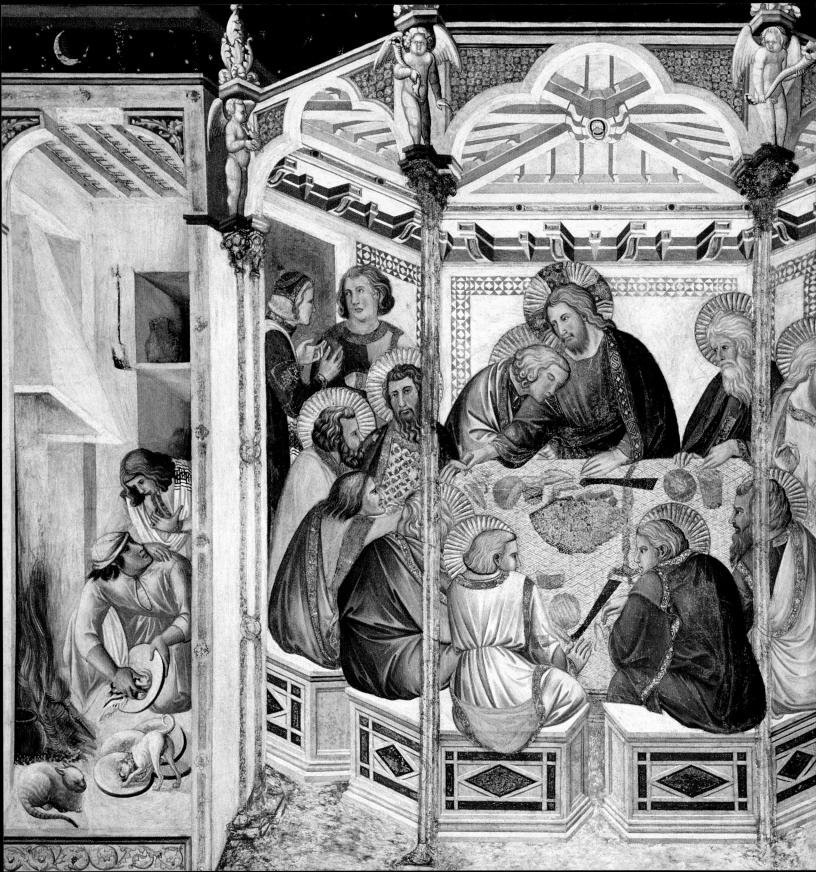

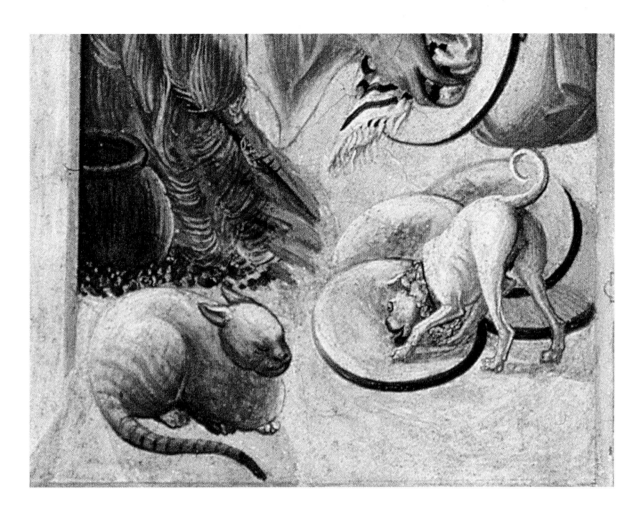

PIETRO LORENZETTI (c. 1284–after 1345)

Last Supper, 1315–19

Fresco (Episodes from the Passion of Christ), left transept

BASILICA (LOWER) OF ST. FRANCIS, ASSISI, ITALY

One of the oldest medieval depictions of the cat, that of Pietro Lorenzetti differs from similar examples in which the struggle between a cat and a dog for the scraps from the table is identified with the curse of Original Sin. Here, in order to achieve redemption, Judas must betray Jesus in the adjoining room and Jesus must sacrifice himself to save humanity. Only the dog seems intent on voraciously licking clean the bowls that the servants have filled with (apparently meager) leftovers; the cat, instead, seems more interested in enjoying the warmth of the fireplace. The two youths, however, are sinning, for they are ignoring the Gospel's warning not to feed remains of the sacred meal to the dogs.

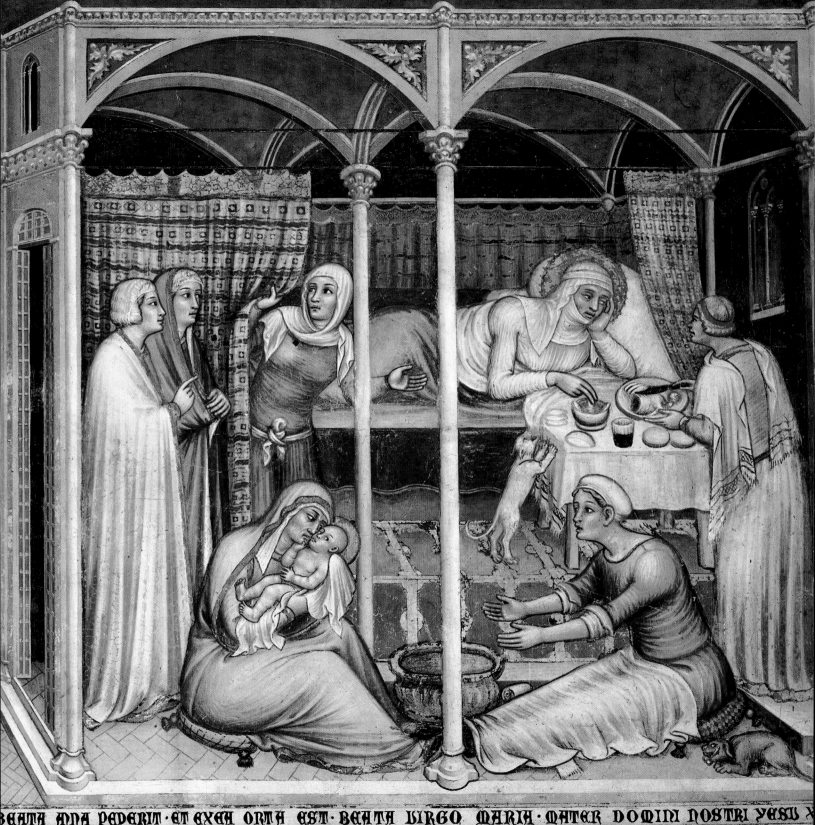

BEATA ANNA PEDERIT · ET EXEA ORTA EST · BEATA VIRGO MARIA · MATER DOMINI NOSTRI YESU X

UGOLINO DI PRETE ILARIO (14th century)

Birth of the Virgin, c. 1370–80

Fresco

ORVIETO CATHEDRAL, ITALY

The magnificent cycle of frescoes in the apse of Orvieto Cathedral contains many cats—some angry, others more placid. The painter and mosaicist Ugolino di Prete Ilario, a native of Orvieto who had already executed the decorations in the chapel of the Most Holy Corporal, introduced them into many scenes, from the Birth of the Virgin to the Annunciation. In this scene, domestic animals wander freely in the room where the mother has given birth—something current health regulations would certainly forbid. Yet none of the women present seems particularly concerned: even St. Anne, who must be exhausted, appears more intent on regaining her strength with a hot meal than in paying attention to the cat, demanding a morsel, that is tugging on the tablecloth and risks bringing the plates crashing to the floor.

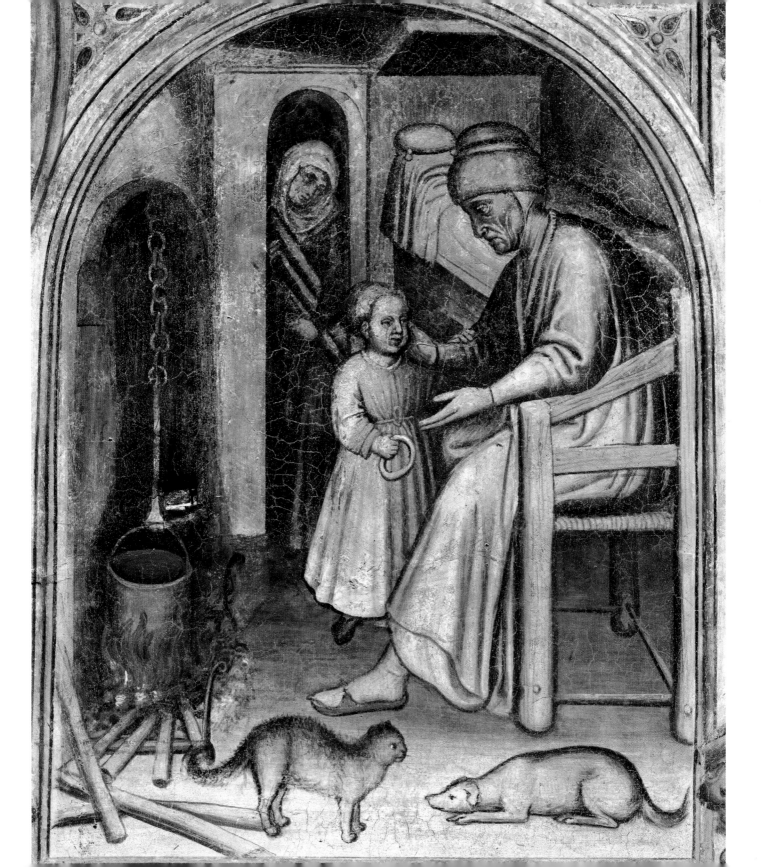

NICCOLÒ MIRETTO AND STEFANO DA FERRARA (15th century)

The Month of January, after 1420

Fresco

PALAZZO DELLA RAGIONE, PADUA, ITALY

One of the finest medieval cycles of secular paintings, the complex sequence of frescoes that adorns the Palazzo della Ragione in Padua can trace its iconographic lineage back to Giotto, with some help from the ideas of the philosopher, astrologer, and physician Pietro d'Abano. They were almost completely destroyed by a fire in 1420, and restored by Niccolò Miretto and Stefano da Ferrara, who resurrected the 333 scenes that illustrate the influence of the planets and signs of the zodiac on human affairs. The domestic scene depicting the month of January is inspired by the bas-reliefs on the door of St. Mark's Basilica in Venice: the old man resists the rigor of winter thanks to the warmth of the fire, assiduously stoked by the woman; the warmth of the child, who offers him a cake; and the presence of two domestic animals, a dog and a cat, which also are warming themselves by the fire. The cat does not seem to relish the presence of the dog, which appears to crouch in a position indicating submissiveness.

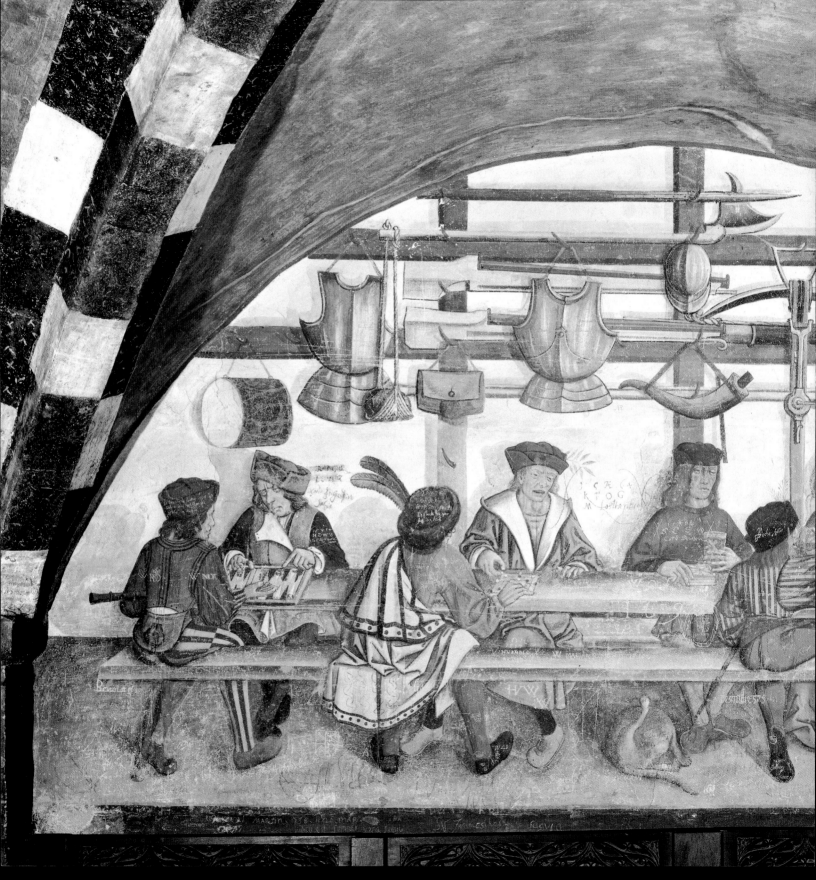

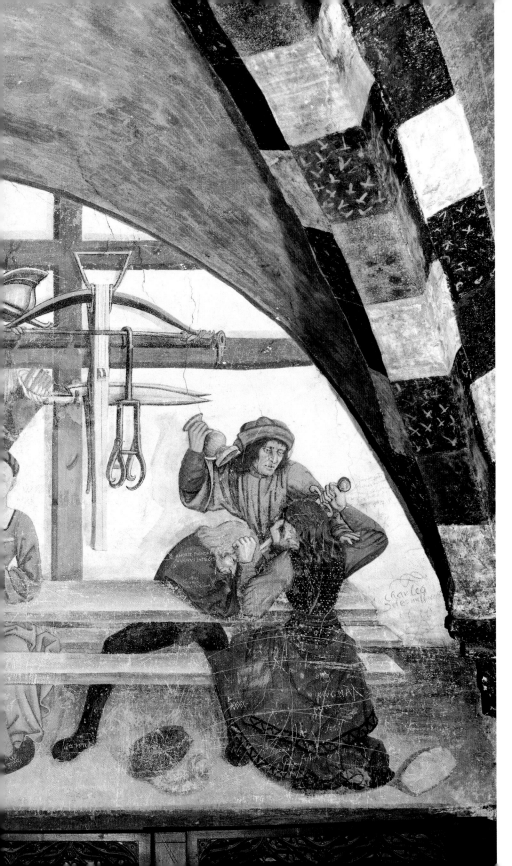

FRESCO FROM PIEDMONT OR SAVOY
(15th century)

Scene in a Guardroom, second half of the 15th century

Fresco

Courtyard of Issogne Castle, Aosta, Italy

Of medieval origin but substantially modified during the fifteenth century, the castle of Issogne belonged to the Bishop of Aosta before passing to the Challant family. It was only under Iblet of Challant that the manor house took on its present appearance, which combines pleasing late Gothic features with a prevalent early Renaissance style. Particularly expressive are the frescoes in the entrance portico, which represent scenes and episodes drawn from everyday life—the tailor's shop and the butcher's, the pharmacy and the market, the baker's and the sausage seller. For this very reason, our cat, too, must be present, since it is an integral part of everyday life. In the episode depicting the guards relaxing, their armor and weapons hung on the wall, a placid cat is dozing under the table just as a fierce scuffle breaks out among the men. This serenity confirms the cat's "philosophical" indifference, and its essential superiority to the banality of human life.

ANONYMOUS ILLUMINATED MANUSCRIPT

Annunciation, c. 1410

MS. Additional 29433, fol. 20

Illuminated codex, 13 x 9 in. (33 x 24 cm)

BRITISH LIBRARY, LONDON

This extraordinary page, a masterpiece of creative imagination and minute attention to natural detail, transforms Mary's house in Nazareth into a fabulous Gothic royal palace, with spires, galleries, porticoes, staircases, balconies, and terraces, from which ancient prophets look out and a variety of animals prance. From the architectural scene in the upper part of the page, the eye descends to the fantastic twirls of vegetation embedded with human figures, insects, and animals in a phantasmagoria of shapes and colors. There must be, in the most sacred and intimate part of the house, a dog and cat, in proverbial opposition. For centuries they have vied with each other for the privilege of living alongside humans, and here it seems that the cat may have the upper hand; it is even a bit bigger than the little dog. A detail (see p. 66): whereas the dog wears a collar, the symbol of submission (or perhaps of loyalty), the cat confirms its primal freedom from all restriction.

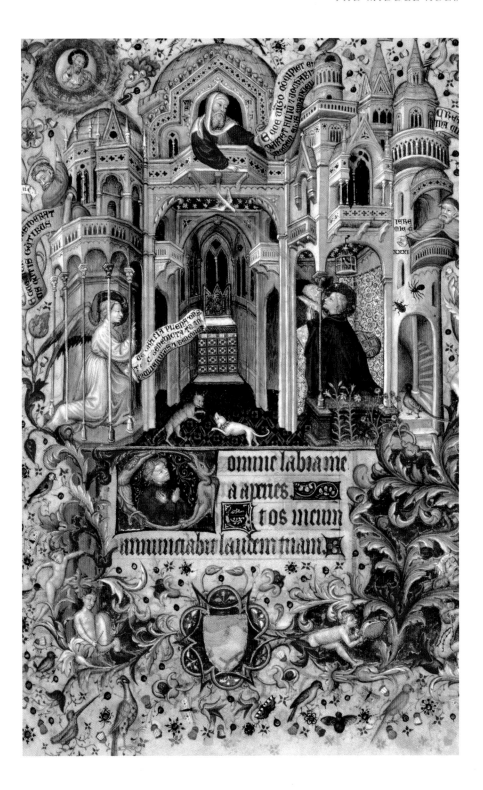

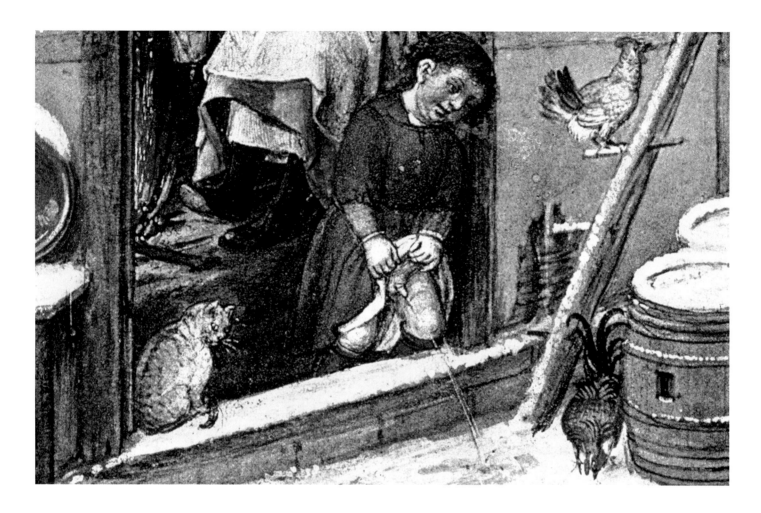

FLEMISH ILLUMINATED MANUSCRIPT

The Month of February

From the *Grimani Breviary*, 1510–20

Illuminated codex, 11 x 8 in. (28 x 21.5 cm)

Biblioteca Nazionale Marciana, Venice

The older model of the *Très Riches Heures du Duc de Berry* by the Limburg brothers was certainly an inspiration for the illuminators who created the breviary for Cardinal Domenico Grimani. The text and cycles of illustrations are preceded by a calendar of images, its scenes framed in late Gothic style. In this depiction of the month of February, as the Sun's chariot crosses the sky arching above the northern European landscape, a family takes shelter from the bitter cold in their cottage next to the chicken coop. The woman is busy spinning, the man warms himself by the fire, and the boy relieves himself as he observes a hen. A companion to people in the comfort and warmth of their home, a gray tabby cat appears on the threshold.

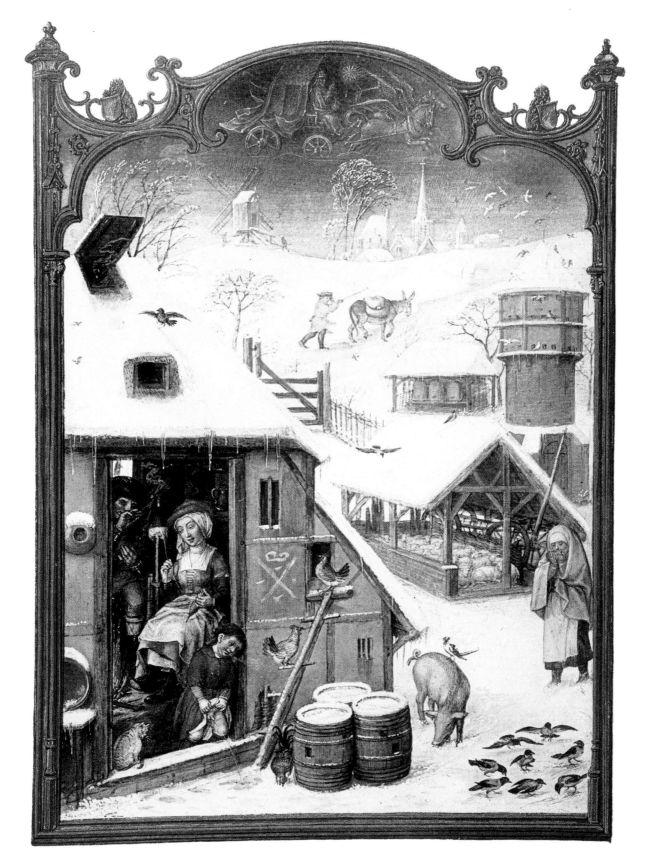

PARISIAN TAPESTRY

(Detail) *Reading*

From the series *La Vie Seigneuriale (Aristocratic Life)*, c. 1500

Tapestry, 111 x 111 in. (285 x 285 cm)

Musée Nationale du Moyen Age et des Thermes de Cluny, Paris

A cat and thread: an irresistible attraction. Skeins, balls, bobbins, tassels, ribbons, and yarn all provide favorite games for household cats, a predilection that begins with the minor disasters caused by kittens a few months old and lasts for the rest of their feline lives, until cloth is destroyed or thread inextricably tangled by means of the experience, application, power, and claws of the adult cat. In this masterpiece of the weaver's art, with its dreamy Gothic atmosphere of courtly love, the Parisian tapestry weaver has introduced flowers, herbs, fruit, birds, and other animals to produce the image of a luxuriant garden in springtime, scene of the encounter between the lady, spinning her thread, and the pensive young intellectual. An amusing, realistic touch is the little white kitten attacking the spindle, trying to hold it between its paws in a typical upside-down pose.

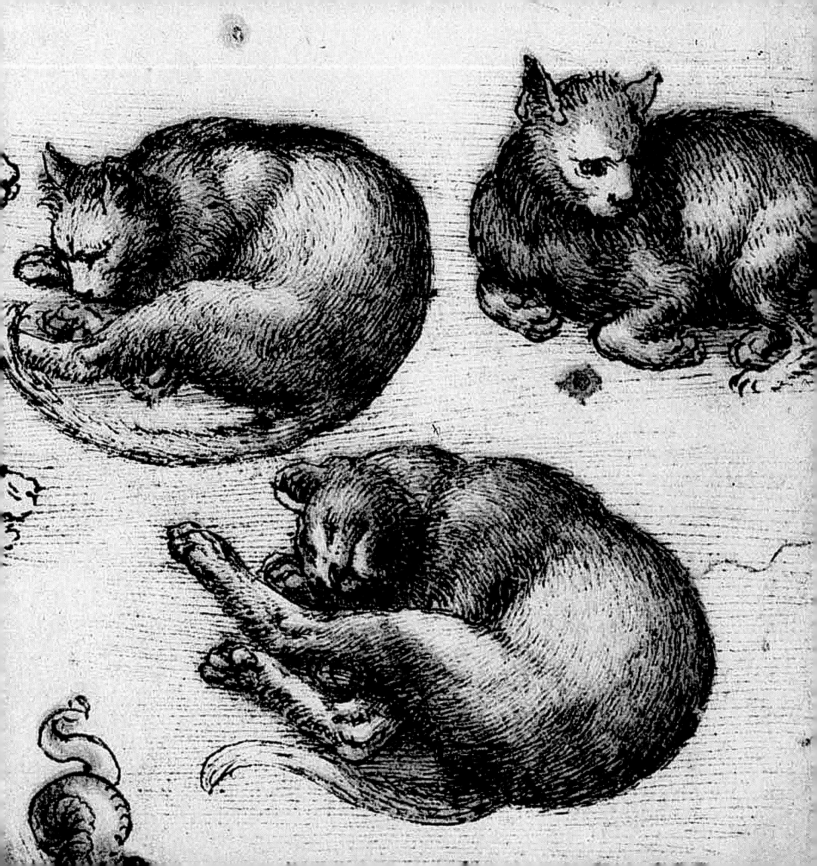

A FELINE RENAISSANCE

The Cat Rediscovered: From the Humanist's Study to Depictions of the Holy Family

JAN VAN EYCK

JAIME HUGUET

PETRUS CHRISTUS

ANTONELLO DA MESSINA

DOMENICO GHIRLANDAIO

COSIMO ROSSELLI

PINTURICCHIO

GIOVAN PIETRO DA CEMMO

HIERONYMUS BOSCH

FRA' RAFFAELE DA BRESCIA

LEONARDO DA VINCI

ITALIAN SCHOOL (DOSSO DOSSI)

HANS BALDUNG GRIEN

GIULIO ROMANO

JAN CORNELISZ VERMEYEN

FRANS POURBUS THE ELDER

JACOPO BASSANO

PAOLO VERONESE

TINTORETTO

FEDERICO BAROCCI

VINCENZO CAMPI

BARTOLOMEO PASSEROTTI

ANNIBALE CARRACCI

PAGE 72: Leonardo da Vinci, (Detail) *Studies of Cats*, c. 1513–15. Drawing (see p. 98). Royal Library, Windsor Castle, England.

ALTHOUGH FOR CENTURIES MEDIEVAL SUPERSTITION AND FEAR OF the devil cast a sinister light on the cat, the Renaissance rehabilitated its innate qualities of elegance, grace, and sensuality, as well as patience and calm. Thanks to the intervention of some of the great figures in art and literature, for cats, too, the Renaissance would be a true intellectual conquest, a cultural revolution, so to speak, in the now millennia-old story of their coexistence with human beings. This rehabilitation took place above all through the work of poets and painters of the fifteenth and sixteenth centuries. For the intellectuals of European humanism, the cat was neither a god nor a devil, and its practical role as mouse-catcher was virtually insignificant. Conversely, the cat was a continuous source of emotional and meditative stimulation, conveying at the same time a sense of freedom and peace, of independence and mystery. It became the animal of choice for the person who loved concentration, study, and quiet, but also a touch of delightful unpredictability. Thus we find a (white!) cat peacefully snuggled in the small study of St. Jerome, painted by Antonello da Messina as a paradigm of the scholar. Leonardo da Vinci, driven by a truly cosmic sense of the beauty of nature, is one of the most outspoken admirers of cats in history. Along with the phenomenal sketches in which he tries to capture their movements and flexible yet extraordinarily elegant and natural poses, Leonardo da Vinci planned many times to paint a Madonna and Child with a cat. Sadly, he got no further than some marvelous preliminary drawings, which were later adapted to produce the masterpiece *Lady with an Ermine* (1483–90), in which the animal in the arms of the bewitching young girl is indeed more the size of a cat than of a mink. We are also indebted to Leonardo da Vinci for categorically describing even the smallest cat as a "masterpiece."

The frequency with which the cat appears in Renaissance, late Renaissance, and Mannerist art, and naturally also the importance of the artists inspired by it, demonstrate as well how the cat's function as guardian of storerooms and granaries has definitively given way to that

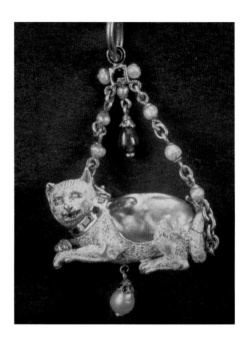

Renaissance pendant in the form of a cat, 16th century. Pearls, filigree, and precious stones. S. J. Phillips, London.

of a household and family pet. Religious iconography, from the early Renaissance to the second half of the sixteenth century—the time of the Counter-Reformation—has numerous cats of various sizes and colors popping up in the most varied of settings, from Annunciations to Last Suppers, episodes from the Old and New Testament to depictions of the Holy Family. More often than not, the cat, far from embodying evil omens or arcane demonic symbolism, simply serves to render the scene more prosaic and familiar. Literature, too, takes on the task of debunking demonic superstition, stressing, on the contrary, the almost therapeutic virtues of a cat's company. Michel de Montaigne, the great French humanist and man of letters, sows a pleasing doubt: "Who knows, when I play with my cat, whether she doesn't enjoy herself more than I do, using me as her pastime?" The poet Torquato Tasso, during the years of internal torment that led him to be interned in a lunatic asylum, found relief in looking into a cat's eyes, which seemed to him to be two sparkling stars, capable of restoring meaning and direction in the midst of the tempest raging in the soul.

These are extraordinary sentiments, confirmed by a vast range of fifteenth- and sixteenth-century works of art, from Spain to Germany and Flanders to Italy. Renaissance culture places humanity at the center of the world, the yardstick by which all things are measured. Soon the humanists, poets, and artists understood that if alongside a person there was also a cat, critical faculties could be continually tested, reason confronted by mystery, and passion by ineffability. However, under the sharp scrutiny of Renaissance intellectuals, the cat did not receive only praise. In the medical and psychological doctrine of the four "humors," derived from Aristotle and revived by the humanists, the fluids that flow through our body and correspond to the influence of the stars determine our health, personality, and physical appearance. The cat, sly and apparently sleepy but in reality ready to pounce or lash out with a claw, is associated with the phlegmatic type, unpredictable and saturnine, and artists readily identified with it. An example is the great Albrecht Dürer, the

Jan Provost, *Annunciation*, c. 1495. Oil on wood. Museo di Palazzo Bianco, Genoa, Italy. The cat "emerges" onto the scene of the Annunciation from the bottom left-hand corner.

OPPOSITE PAGE: Jacopo Bassano, (Detail) *God Rebuking Adam*, 1557. Oil on canvas (see pp. 110–11). Museo del Prado, Madrid.

greatest painter and humanist north of the Alps, who is fond of introducing a cat into the heart of complex, highly symbolic compositions, such as the print *Adam and Eve* or the marvelous drawing *The Virgin Among a Multitude of Animals.*

In general, however, the Renaissance cat asserts itself as the very symbol of domestic peace, intimacy in the household, and ties between the various family members, even when it allows itself to be teased in children's games, as in a memorable painting by Annibale Carracci. The pussycat sleeping, purring, or prowling about under the table, or which maybe causes some adorable, minor disaster with the sewing basket, is a part of everyday reality; Renaissance art not only bears witness to this, but also suggests that possessing a cat is one of life's small but intense pleasures.

The image of the cat at the heart of the household was to become a classic motif in painting during the following centuries, as the alliance with writers was to be confirmed over time and indeed strengthened. The cat was to remain a constant source of inspiration for writers, poets, and, in more recent times, singer-songwriters. Among the many quotations that could be cited here—some from the most unexpected sources—the assertion by Sir Walter Scott, prolific creator of the historical novel in the early nineteenth century, stands out: that there is more in the mind of a cat than we could possibly imagine. The last word on the cat's rising fortunes among intellectuals goes to Jean Cocteau, who suggested gauging a person's level of civilization according to how well he or she can understand cats.

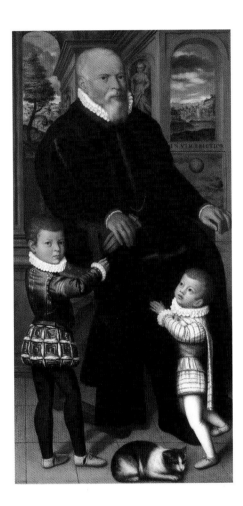

Lavinia Fontana, *Portrait of an Elderly Man with Two Children and a Cat*, 1592. Oil on canvas. Accademia Carrara, Bergamo, Italy.

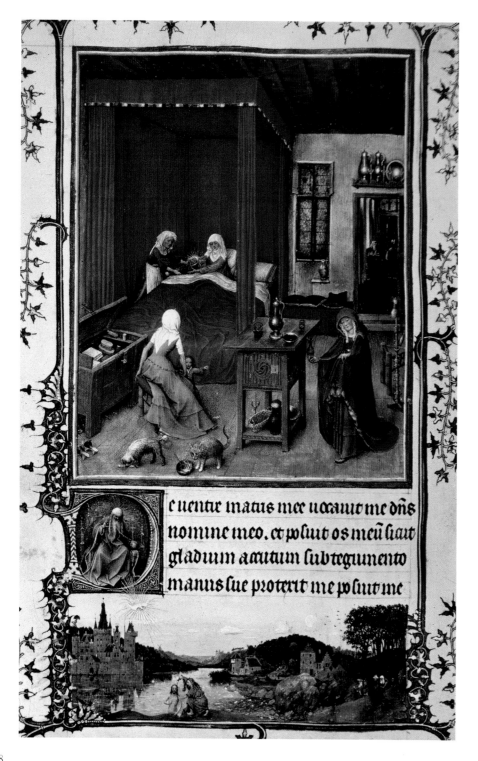

e uentir matris mee uocauit me dñs
nomine meo. et posuit os meũ sicut
gladium acutum sub tegumento
manus sue protexit me posuit me

JAN VAN EYCK (c. 1390–1441)
Birth of John the Baptist
From the *Turin-Milan Hours*, 1426–28
Illuminated codex, 5 x 4 in. (13 x 10 cm)
MUSEO CIVICO D'ARTE ANTICA,
TURIN, ITALY

With the great Van Eyck, the cat in
art makes a sort of qualitative leap.
The Flemish master, who is alert to
every aspect of reality, likes to depict
interiors in minute detail, patiently
revealing a microcosm of objects
and figures, which light lays bare
both in their physical nature and in
their symbolic value. Van Eyck
applies the same compositional
technique in his huge altarpieces as
in the pages of precious miniatures.
The miniature reproduced here is
part of an extraordinary cycle of
illustrations in which Jan van Eyck
balances, with unequalled skill, his
taste for truthful depiction with the
poetry of the sacred scene. The
Flemish master's realism has more
to do with situations and atmos-
phere than with individual details.
The presence of a cat in the room
where a woman is giving birth
is, indeed, highly unlikely, but it
gives the scene a pleasing sense of
everyday reality, leading us into the
interior of an orderly, well-to-do
household of the early fifteenth
century.

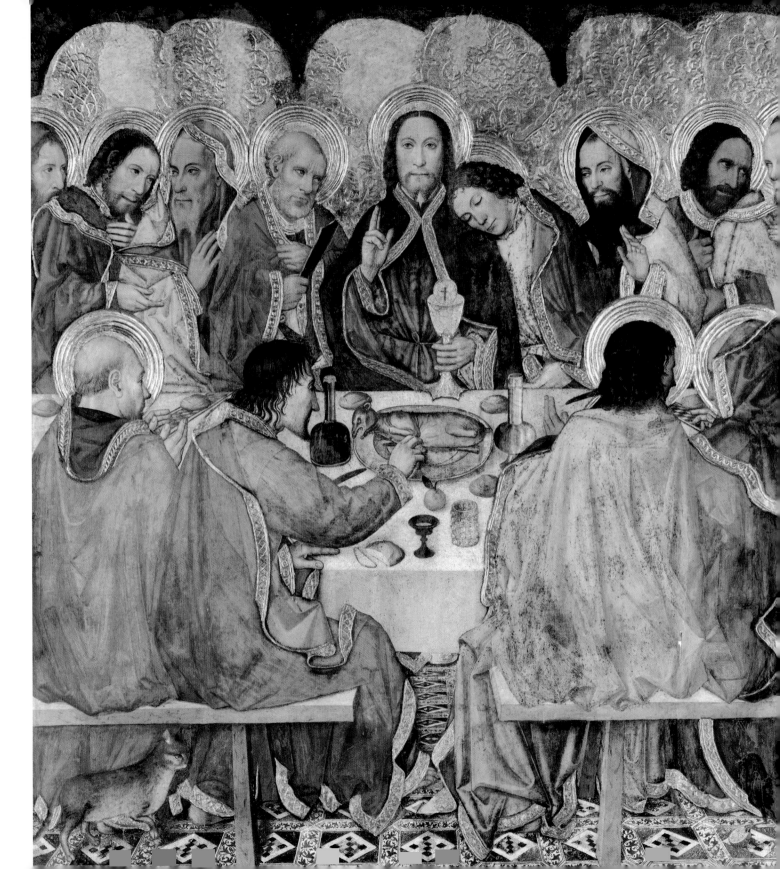

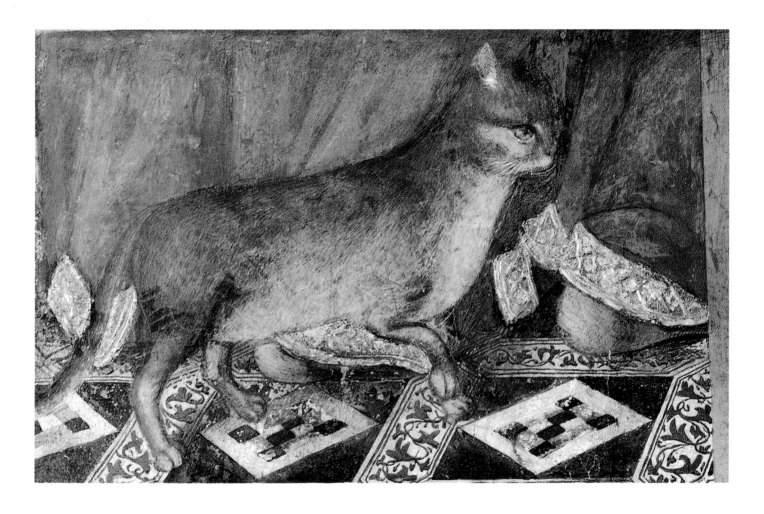

JAIME HUGUET (c. 1414–1492)
Last Supper, after 1450
Tempera on wood, 67 x 64 in. (172 x 164 cm)
Museu Nacional d'Art de Catalunya, Barcelona, Spain

The Catalan Huguet, an extremely interesting mid-fifteenth-century master, was a highly cultured painter. He knew, and could combine, many different influences—for example, Italian, Flemish, Iberian—over a rich substratum of a late Gothic flavor, apparent here, for example, in the wavy edges of the cloaks and in the opulent gold background, worked almost with a goldsmith's technique. This Last Supper also demonstrates Huguet's capacity for observing reality. The presence of cats in paintings of the Last Supper is certainly not uncommon, but here Huguet does not resort to a conventional image, such as the customary quarrel between a cat and a dog. His large, solitary cat rubs itelf against the apostles' legs, an unequivocal gesture soliciting cuddles and food.

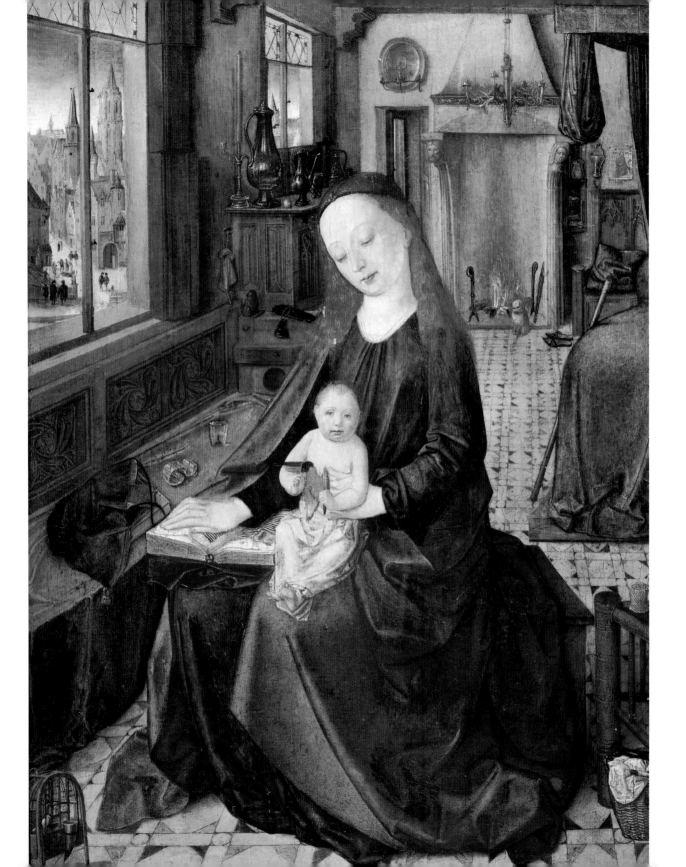

PETRUS CHRISTUS
(c. 1410–1472/73)

Madonna and Child, c. 1450

Oil on wood, 15 x 9 in. (38 x 22 cm)

GALLERIA SABAUDA, TURIN, ITALY

This little masterpiece, a perfect Flemish microcosm of order, tenderness, and pleasure in simple, everyday things, uses the pretext of a Madonna and Child to depict a domestic interior affectionately and in every detail. Such an intimate picture would not be complete without the warmth of a glowing fire. In front of the fireplace, in a martial pose, the household cat enjoys the glow. Petrus Christus, one of the most interesting masters of fifteenth-century Flemish painting, makes it clear to us that this cat is probably very affectionate, but also lazy. Indeed, while it stays placidly and quietly by the hearth, in the foreground to the left is what appears to be a mousetrap. Its last bit of ephemeral usefulness is gone: the household cat no longer hunts mice and, now devoid of any practical use, it is simply part of the family context.

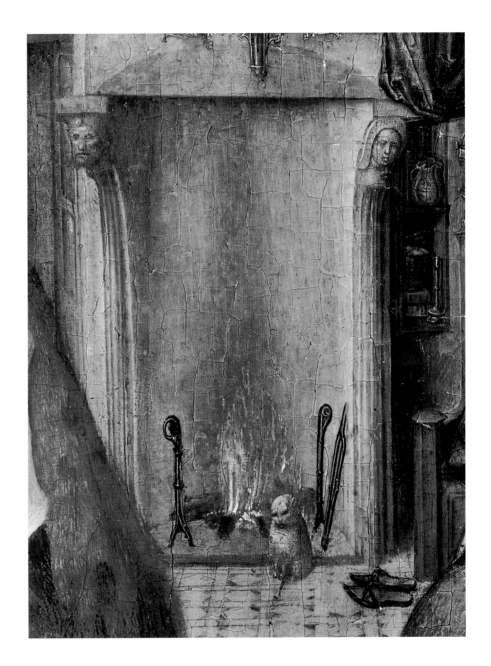

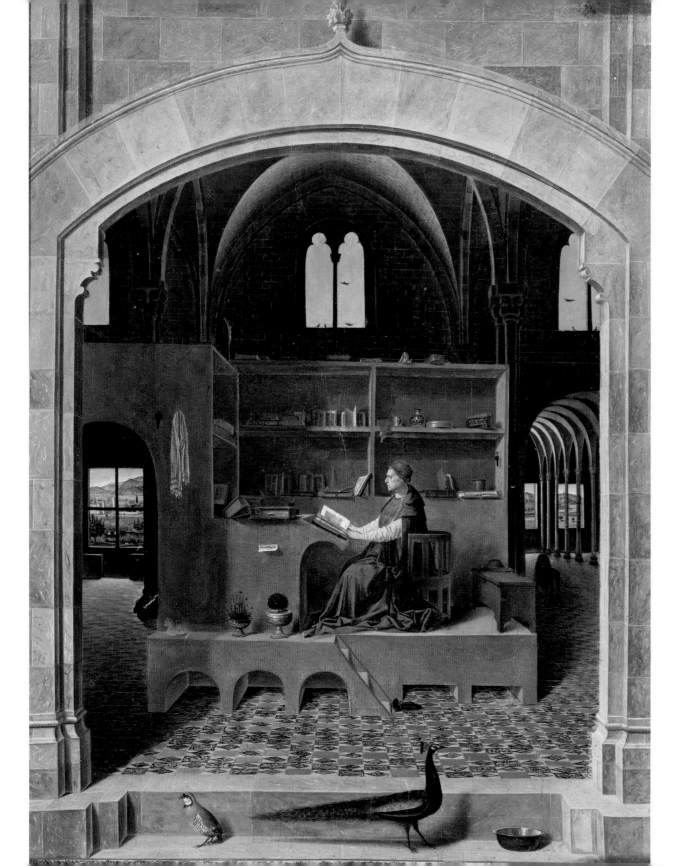

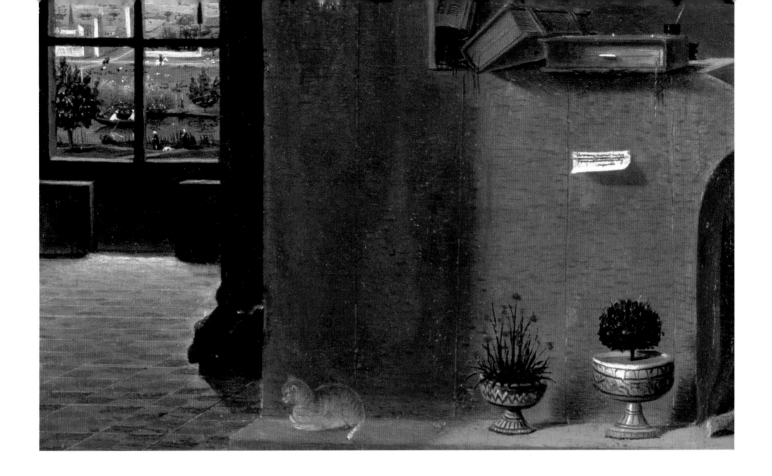

ANTONELLO DA MESSINA (c. 1430–1479)

St. Jerome in His Study, 1475

Oil on wood, 18 x 14 in. (45.7 x 36.2 cm)

NATIONAL GALLERY, LONDON

Into this extraordinary capsule of perspective, a magical masterpiece of luminous atmosphere showing a perfect balance between meticulous depiction of every detail and the supreme sense of an organic compositional whole, Antonello da Messina has introduced numerous animals, almost as if to invite us to look calmly at the painting, to gradually discover its every secret. Around St. Jerome, ideal model of the learned humanist, there are, first, two extremely elegant birds on the windowsill in the foreground. Then, as we proceed deeper into the quiet shade of the handsome rooms, there is the inevitable lion, symbol of the saint, in silhouette, calmly walking across the precious majolica tiles on the right. Through the mullioned Gothic windows, we can glimpse darting swallows. And where is the cat? This takes a bit of patience, even imagination. Antonello has painted a placid white cat on the platform of the study, to the left of the two small vases of aromatic herbs. Originally the painter had not planned to include the crouching feline in the picture, and he has added it using less durable, less saturated colors. Thus, with the passage of time the cat has become almost evanescent; however, to discern it alongside the scholarly saint is to fortify the alliance between intellectuals and cats, which becomes more significant from the beginnings of the Renaissance onward.

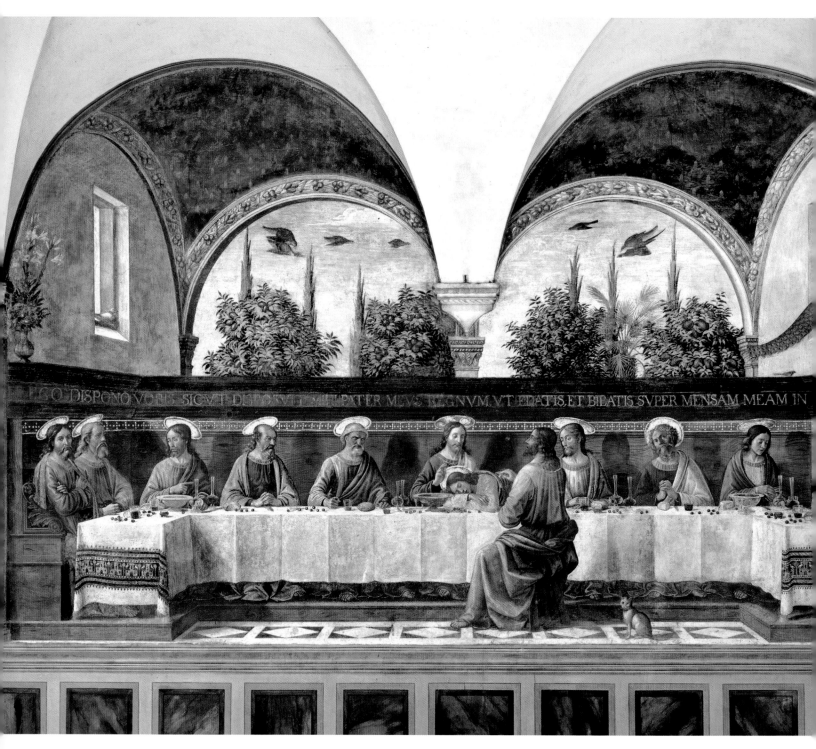

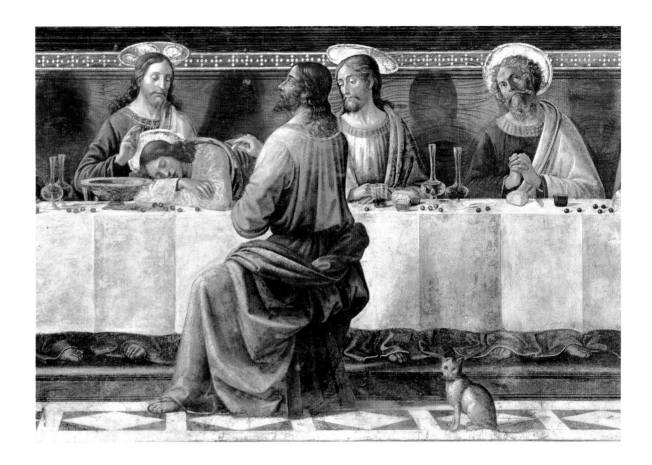

DOMENICO GHIRLANDAIO (1449–1494)

Last Supper, 1480

Fresco, (total width) about 26.2 ft. (8 m)

MUSEO DI SAN MARCO, REFECTORY, FLORENCE, ITALY

Ghirlandaio is one of the most representative masters of Florentine art of the second half of the *quattrocento*, as the fifteenth-century Italian Renaissance is often known. Through the years his style became ever richer, more imaginative and decorative, enhanced by realistic detail that rivaled even Flemish painting of the same period. Aided by a brilliant team of collaborators, including the very young Michelangelo, Ghirlandaio is known for a series of marvelous cycles of frescoes in Florence and elsewhere. The church and adjoining refectory of Ognissanti contain, thanks to the commissions ordered by the Medici and Vespucci families, several brilliant examples of Ghirlandaio's fluent ornamentation and dazzling capacity for narrative. It is quite common for a cat to appear under the table in a painting of the Last Supper; but in this case there is a parallel in a cycle of frescoes by Cosimo Rosselli in the Sistine Chapel, to which Ghirlandaio himself contributed as one of the principal painters.

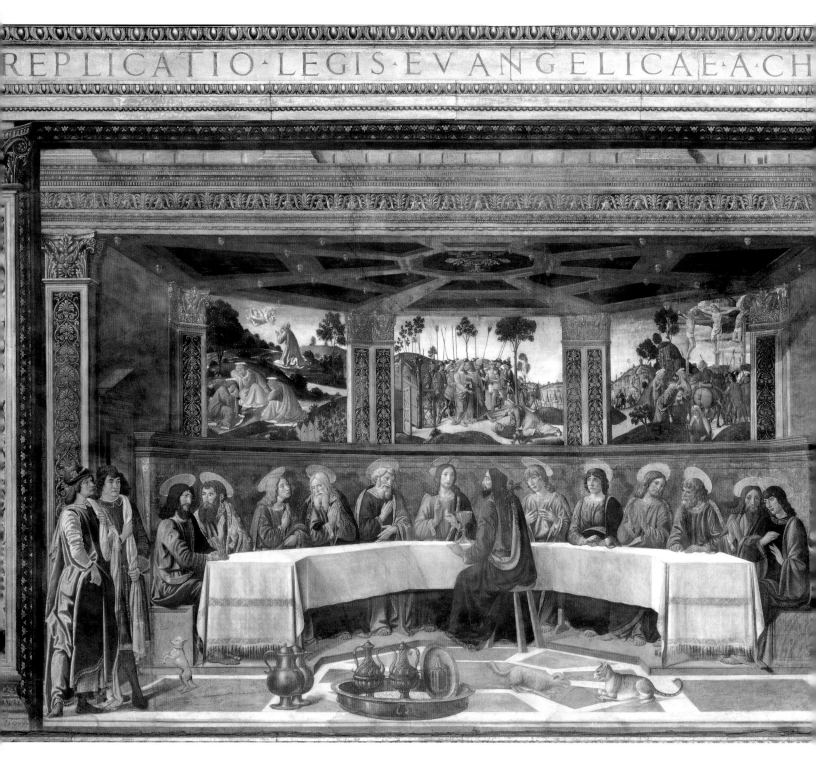

REPLICATIO · LEGIS · EVANGELICAE · A · CH

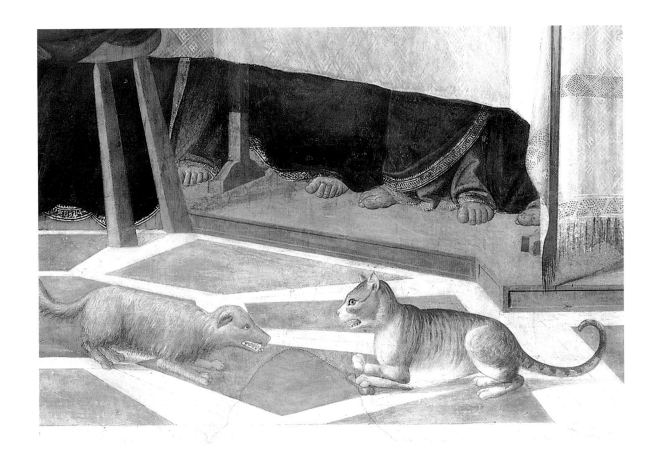

COSIMO ROSSELLI (1439–1507)

Last Supper, 1482

Fresco, 11.5 x 7.3 ft. (3.5 x 5.7 m)

SISTINE CHAPEL, VATICAN CITY

Rosselli is perhaps the least well known of the artists summoned to Rome by Pope Sixtus IV in 1481 to cover the walls of the newly built Sistine Chapel with frescoes. Botticelli, Perugino, Ghirlandaio, and Luca Signorelli were much more famous, and their frescoes far more highly regarded. However, it is to Cosimo that we are indebted for the presence of a cat in Catholicism's most sacred place, the space in which the most solemn papal ceremonies, including papal conclaves, are held. Under the table where Christ is inaugurating the sacrament of the Eucharist—here, in the cat's classic confrontation with the dog—is our protagonist. This is without doubt one of the most suggestive and realistic images of a cat in art from the second half of the fifteenth century. The color of its fur, with its white and gray stripes, and its aggressive pose toward the dog—which seems to want to steal the cat's bone—all hint at the new cultural significance that the cat, now freed from its medieval heritage, has acquired in humanist culture.

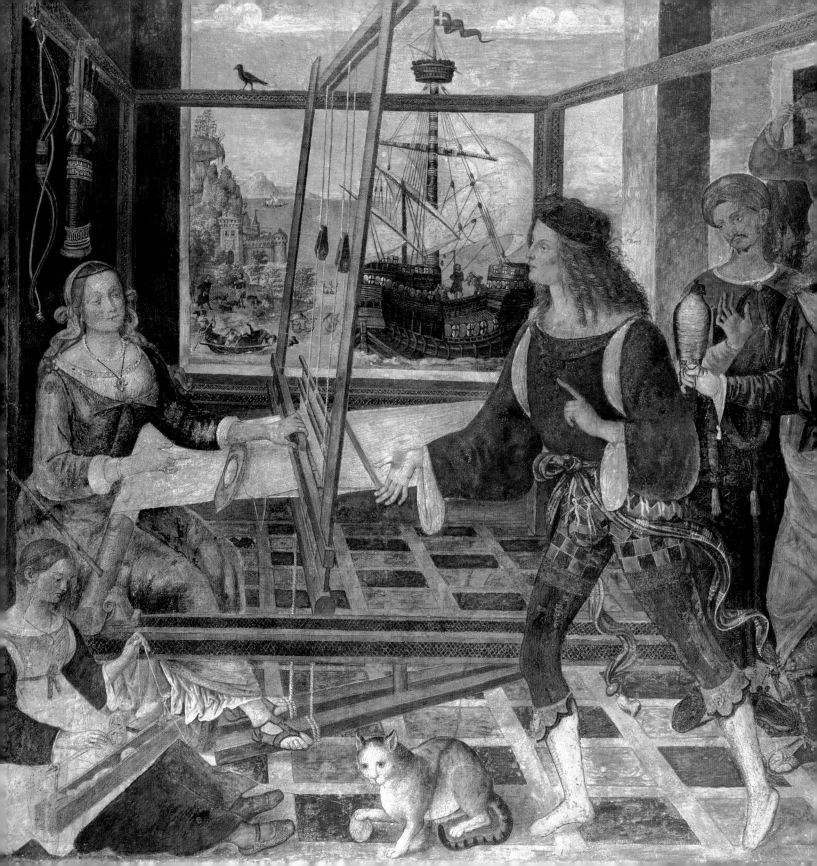

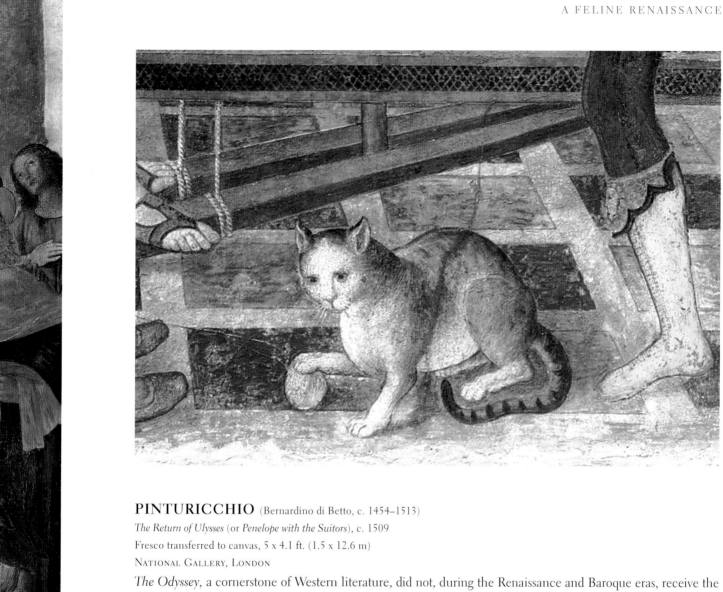

PINTURICCHIO (Bernardino di Betto, c. 1454–1513)

The Return of Ulysses (or *Penelope with the Suitors*), c. 1509

Fresco transferred to canvas, 5 x 4.1 ft. (1.5 x 12.6 m)

NATIONAL GALLERY, LONDON

The Odyssey, a cornerstone of Western literature, did not, during the Renaissance and Baroque eras, receive the attention from painters that its fundamental importance might have warranted. Pinturicchio's fresco exemplifies the transposition of Ulysses's story to a contemporary setting, with clothes and scenery that are much more reminiscent of an Italian Renaissance court than the palace in Ithaca. Penelope is shown at the loom, weaving a tapestry; a group of elegant but intrusive and presumptuous suitors enters the queen's chamber, demanding that she finish her never-ending work. Through the window, a ship can be seen at anchor in the harbor (an allusion to the return of Ulysses, who is still in disguise); indeed, the figure entering through the door in the background is believed to the hero himself, disguised as a beggar. However, one of the most important figures in the scene is the large cat in the foreground, delighted to have caught a ball of thread to play with. For him, clearly, Penelope's weaving is no problem at all.

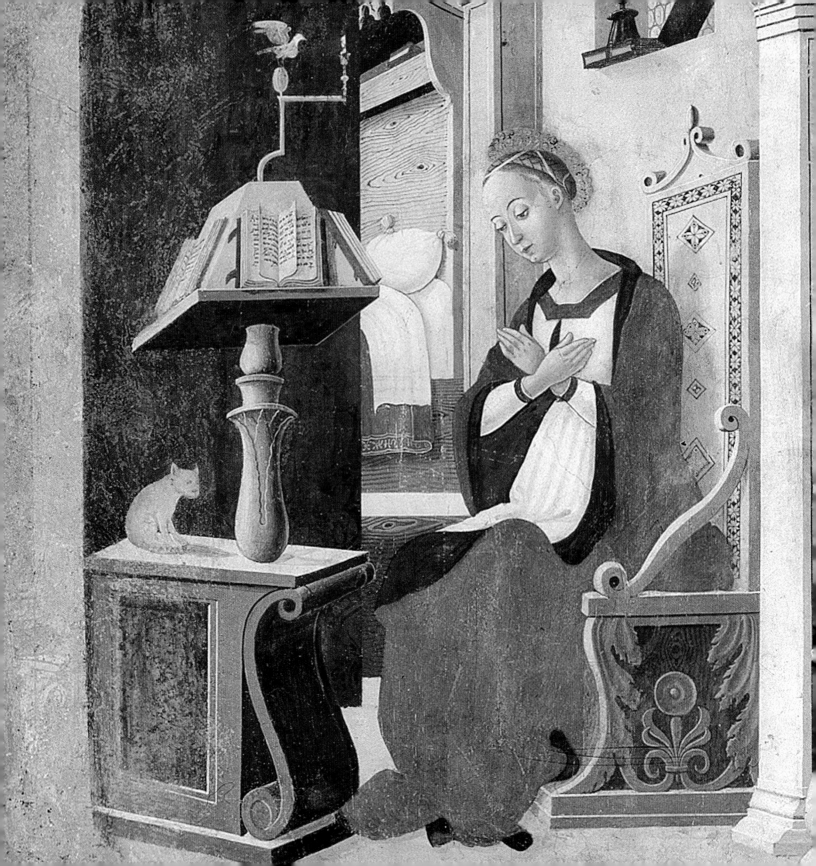

GIOVAN PIETRO DA CEMMO (15th century)

Annunciation, c. 1495

Fresco, height 18.7 ft. (5.7 m)

ORATORY OF SAN ROCCO, BAGOLINO (BRESCIA), ITALY

Looking through this book, the reader will come across works of art that are displayed in the world's great museums and, from time to time, frescoes or paintings that are in small or even tiny places, scattered in various corners of Italy. This is a feature of Italian art: it is dispersed to locations far from the main cultural and historical centers. Giovan Pietro da Cemmo was a Renaissance painter from Lombardy who specialized in cycles of paintings destined for a devotional audience of simple, ordinary people. His *Annunciation* conveys feelings of reserve, modesty, and serenity. Mary's little cat is engaged and curious; but, in contrast to the "diabolical" cat that crosses the scene in the *Annunciation* by Lorenzo Lotto (see pp. 340–41), this cat heightens the scene's intimate, domestic, and peaceful atmosphere. Even the color of its fur—white—has been chosen to arouse in the viewer a feeling of affection and tenderness.

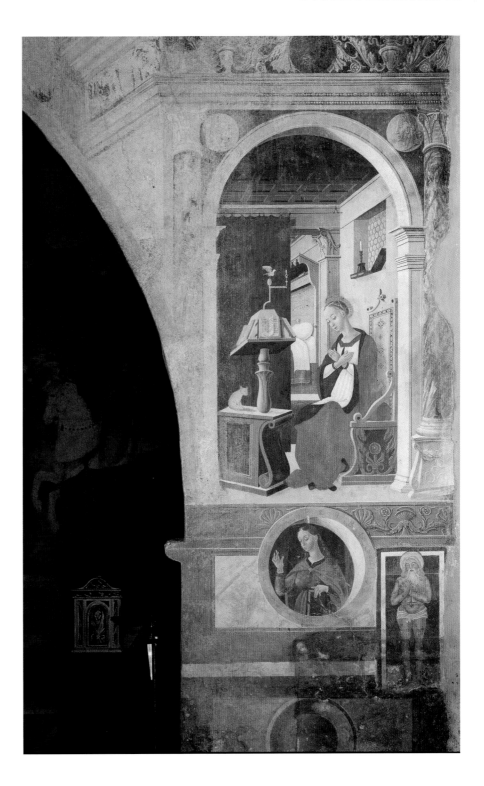

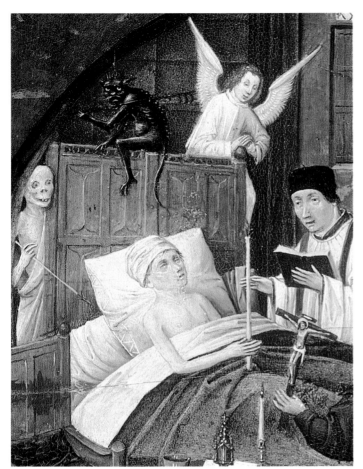

HIERONYMUS BOSCH (c. 1450–1516)

The Death of the Just Man, detail from *The Table of the Seven Deadly Sins*, c. 1495

Oil on wood, (total dimensions) 59 x 47 in. (150 x 120 cm); (detail) diameter 14 in. (36.3 cm)

MUSEO DEL PRADO, MADRID

The disturbing skeleton, symbol of imminent death, peeps out from behind the bed of the dying man, while the angel and the devil, perched at the head of the bed, are ready to battle for the deceased's soul. This *tondo* is part of a complex allegorical painting, one of Bosch's earliest masterpieces, focused on images of the Seven Deadly Sins and their forgiveness through the sacraments. In this case, the last rites administered by the priest and the small group of faithful at prayer would appear to ensure the dying man's salvation. Bosch attempts to render the picture peaceful by including, in the background, a little domestic scene with two women by a hearth. The presence of a happily seated white cat contributes to the reassuring aspect of the situation. It should be noted that Bosch, in other paintings, invests the cat with a disturbing diabolic quality.

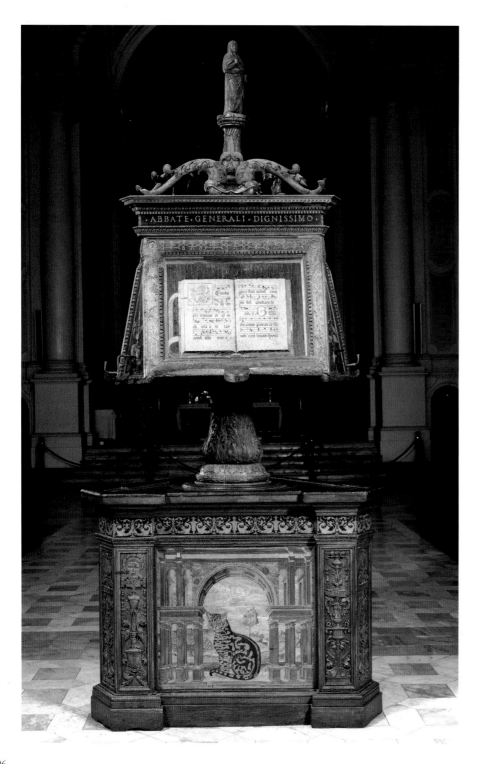

FRA' RAFFAELE DA BRESCIA (1479–1539)

Inlaid lectern, 1507

Wood, (total) height 90 in. (230 cm)

CHOIR OF THE ABBEY CHURCH, MONTE OLIVETO MAGGIORE, ITALY

A pupil of the great Fra' Giovanni da Verona in the precious art of marquetry (and, like him, a monk of the order at Monte Oliveto), Raffaele da Brescia complemented the choir of the main abbey of his religious order with a monumental lectern of colossal proportions, destined to support enormous volumes of anthems and contrapuntal music that could be read by more than a hundred monks. At the base of this glorious piece of sacred furniture, in a place where it has maximum impact, Fra' Raffaele did not hesitate to insert the image of a great, well-fed cat, probably the abbey's mascot: a splendid tabby whose distant descendants still roam the abbey complex half a millennium later. That the image is drawn from life is confirmed by the realistic detail of the tail, which embraces the cat's forepaws, thus ensuring a bit of warmth even in winter.

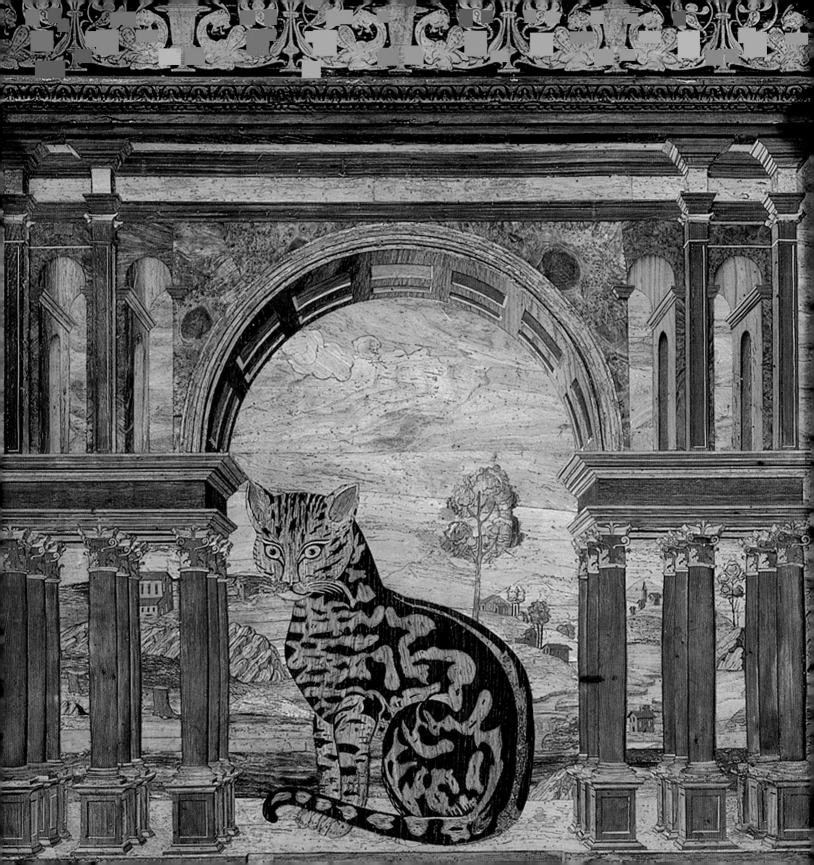

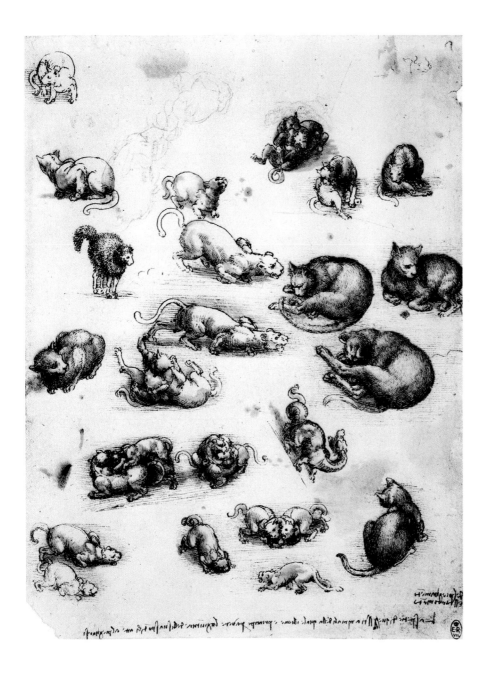

LEONARDO DA VINCI
(1452–1519)

Studies of Cats, c. 1513–15
Drawing, 11 x 8 in. (27 x 21 cm)
ROYAL LIBRARY, WINDSOR CASTLE,
ENGLAND

Leonardo was fascinated by every aspect of nature, but he had a particular fondness for horses and cats. While the horse bewitched him with its noble, statuesque proportions, the cat offered the Tuscan master endless opportunities for observation and surprise: elegant, flexible movements; sudden changes from deep sleep to watchful, alert wakefulness; shifting attitudes; and perfect proportions. The famous drawing in Windsor Castle is one of art's most fascinating homages to the cat. Here, one of the greatest masters of all time—simultaneously engaged in seeking out the secrets of human anatomy and the deepest mysteries of the natural world—observes and reproduces many different poses with a mixture of amusement and admiration. If we look very carefully at the drawing, we can observe that among the many cats there also lurks a monstrous little dragon, a fantastic creature clearly inspired by the "diabolic" spirit that always seems to hide beneath the soft suppleness of the cat.

ITALIAN SCHOOL

(attributed to Dosso Dossi, 16th century)

Youth with Cat and Dog, c. 1520–30

Oil on wood, 11 x 9 in. (28 x 24 cm)

ASHMOLEAN MUSEUM, OXFORD, ENGLAND

The rare depictions of cats in Italian secular painting of the sixteenth century are mainly endowed with an allegorical meaning associated with the senses or temperament. In this curious painting, variously attributed to Dosso Dossi, Domenico Mancini, or a follower of Giorgione, the mystery of the artist's identity is added to another enigma, the meaning of the bold way in which the image is framed. Given that part of the torso is excluded from the picture, the viewer cannot tell whether or not the youth is holding the two animals in his arms; this figure's timeless attire as well as the turban on his head place him in a different, or higher, sphere, consistent with the scene's symbolic nature. This pose might perhaps allude to a reconciliation of contrasting aspects of the human soul—represented by the docility of the dog and the insolence of the cat—perfectly brought together in this figure's placid, elegant bearing.

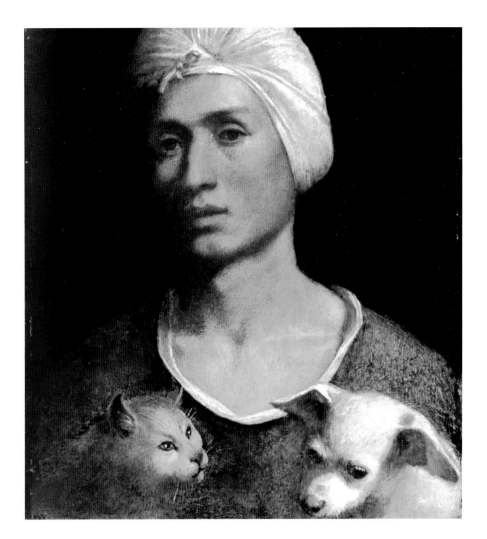

HANS BALDUNG GRIEN (1484/85–1545)

Allegories of Music and Prudence (or *Allegory of a Woman with Song Book, Viol, and Cat*; and *Allegory of a Woman with Mirror, Snake, and a Pair of Deer*), 1525

Oil on wood, each 32 x 14 in. (83 x 36 cm)

ALTE PINAKOTHEK, BAYERISCHE STAATSGEMÄLDESAMMLUNGEN, MUNICH, GERMANY

A superb artist from the Black Forest, and a protagonist in the brief but precious flowering of the German Renaissance, Hans Baldung Grien worked within the same cultural climate as Dürer, with whom he also collaborated for a time. Like the master from Nuremberg, Baldung Grien was a proponent of the theory of the "four humors," which held that a person's psychological and physical state was influenced by the heavenly bodies as well as by bodily fluids. He became an adherent of the Reformation, after which he abandoned painting to devote himself entirely to engraving, favoring mysterious subjects such as witches and sorcery. The secular allegories in Munich, which clearly demonstrate a knowledge of anatomy and classical models, depict elegant female nudes in the company of symbolic animals. A big, placid white cat, with long, thick fur, accompanies the girl who embodies Music.

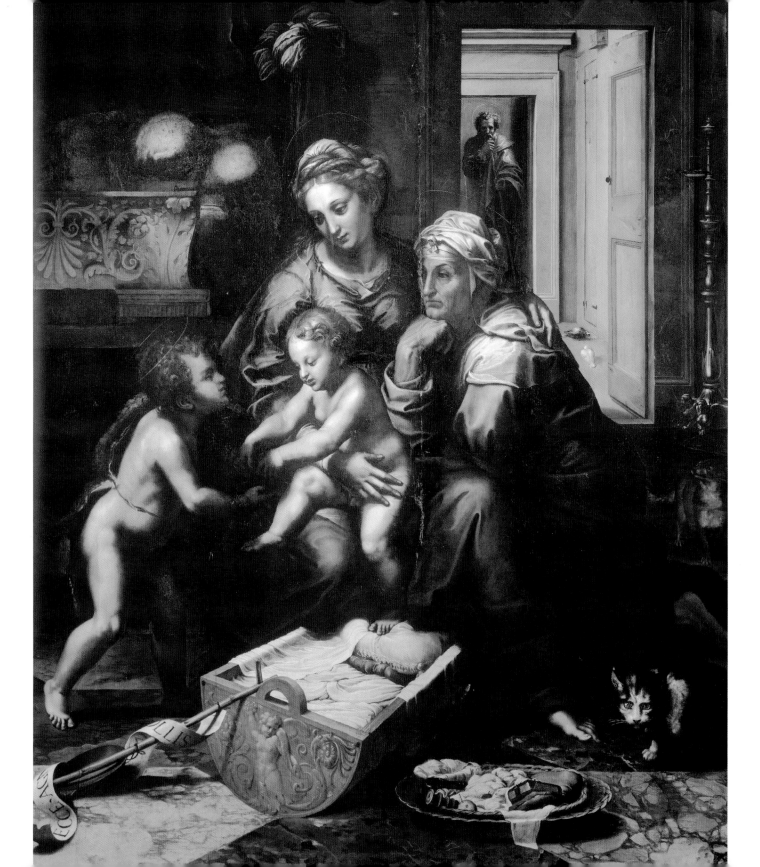

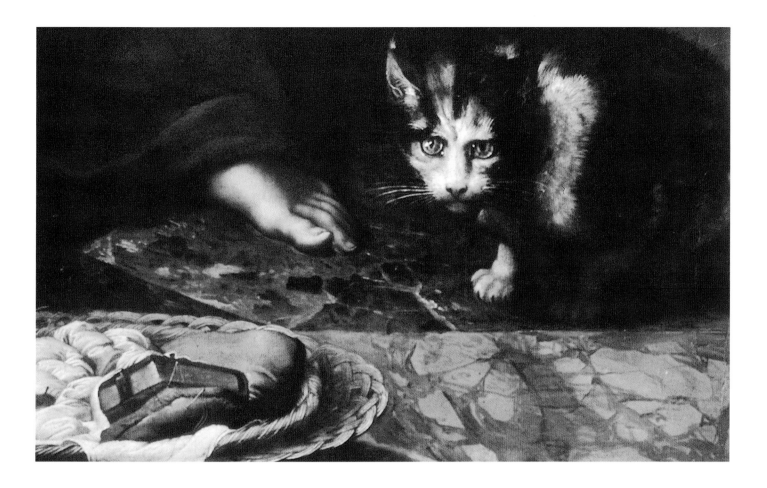

GIULIO ROMANO (1499–1546)

The Madonna of the Cat, 1522–23

Oil on wood, 67 x 56 in. (172 x 144 cm)

Museo di Capodimonte, Naples, Italy

This is one of the greatest masterpieces of Raphael's best pupil, who painted it shortly before leaving Rome for Mantua, where he was to limit his painting activities to devote himself chiefly to architecture. The painting combines two apparently contradictory tendencies: on the one hand, it is an intellectual, geometric composition in the form of a carefully studied pyramidal group of figures; on the other hand, it evokes a sense of tender, sincere ordinariness that embraces the Virgin, the infant Jesus, Elizabeth, and John. The fine details, such as the cradle and the sewing basket in the foreground, are brilliantly executed. The only figure in the entire scene that directly faces the viewer is the household cat, crouching vigilantly to the right. The magnetism of this animal—only apparently marginal and extraneous to the overall design of the composition—justifies the title by which the painting is traditionally known.

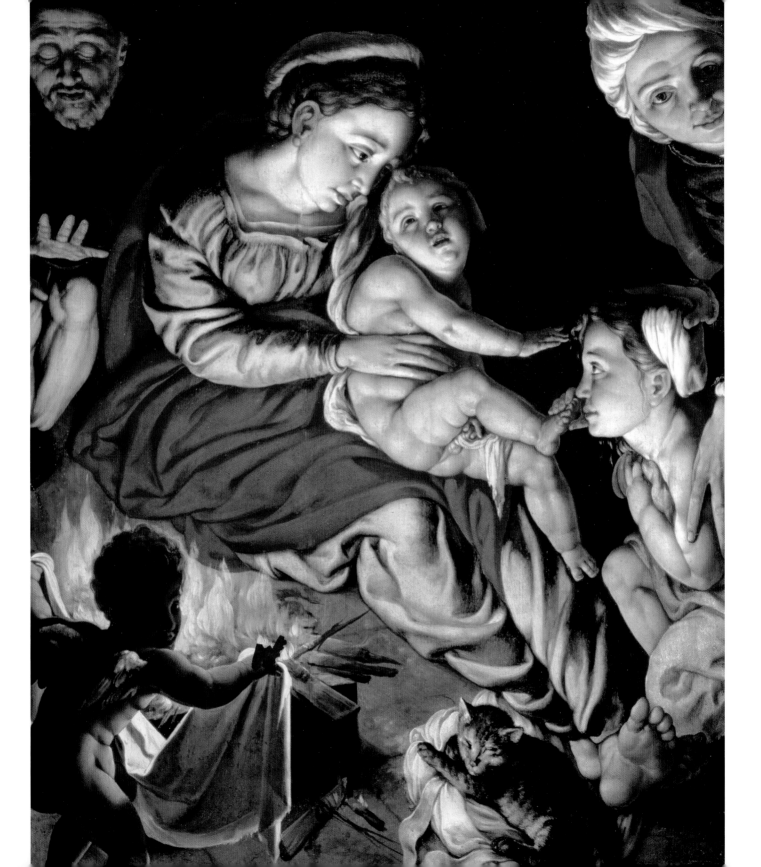

JAN CORNELISZ VERMEYEN (1500–1559)

The Holy Family Around a Fire, c. 1532–33

Oil on wood, 26 x 20 in. (66.5 x 50.5 cm)

KUNSTHISTORISCHES MUSEUM, VIENNA

Amid the multitude of so-called Italianists—Renaissance masters from the Low Countries who were influenced by Italian Mannerism—Vermeyen stands out for his close attention to the figures and faces of Michelangelo. Even in its brushwork and treatment of surfaces, his painting—marked by careful chiaroscuro and a precocious fondness for nocturnal effects and backlighting—evokes sculptural shapes. The close point of view emphasizes the striving for a somewhat forced composition, aimed at revealing the painter's classical background. This *Holy Family* displays the features typical of Vermeyen's art. Nevertheless, our attention is caught by the presence of a handsome tabby cat in the foreground. Our friend has chosen, as always, the best spot: reclining amid the comforting folds of a cloth, the cat basks in the warmth of the small fire, where a little angel is drying some material in which to wrap infant Jesus.

FRANS POURBUS THE ELDER (c. 1545–1581)

The Family of Adam and Eve, c. 1570

Oil on wood, 13 x 18 in. (33 x 47 cm)

RESIDENZGALERIE, SALZBURG, AUSTRIA

This is a painting of a truly singular subject, to the point that it could be considered almost an excuse for a classic Mannerist composition. The Italianate Flemish painter Frans Pourbus is one of the most elegant painters of the late Renaissance and also an acclaimed portraitist. The ample proportions of these nudes are inspired by classical sculpture, but the overall composition is highly original. Adam and Eve seem to look like two pagan gods, as the young Cain and Abel are pictured playing with a young goat. The anguish of the first man and woman on being driven out of Eden has been transformed into a serene primordial life. The various animals present include the splendid figure of a large cat in the bottom right-hand corner—almost reclining, yet also vigilant and on the alert, its staring eyes focused on the big, gentle dog found at the opposite edge of the painting.

JACOPO BASSANO (1510/18–1592)

The Supper at Emmaus, 1537

Oil on canvas, 92 x 98 in. (235 x 250 cm)

CITTADELLA CATHEDRAL, PADUA, ITALY

As we have noticed, cats are often present under the table in scenes from the Gospel painted during the Renaissance. It is not always necessary to seek symbolic meanings at all costs; sometimes they are simply realistic touches. Jacopo Bassano, a great and atypical master, was born, raised, and trained as an artist in the provinces, yet completely caught up with developments in international art. He brings a breath of fresh air to the second half of the sixteenth century, a whiff of freedom from the excessively restrictive norms governing the representation of sacred subjects. Here Bassano portrays, with pleasing good humor, the interior of an unpretentious inn, focusing almost more on the paunchy figure of the innkeeper in his apron than on the three sacred protagonists of Luke's account. The artist from the Veneto painted this composition at least three times, but the canvas in the Cittadella Cathedral is the best version. Underneath one of the benches, peering out like a predator from its lair, a cat is poised to seize a morsel that has fallen from the table. By contrast, the dog squats in a docile manner, awaiting his master's call.

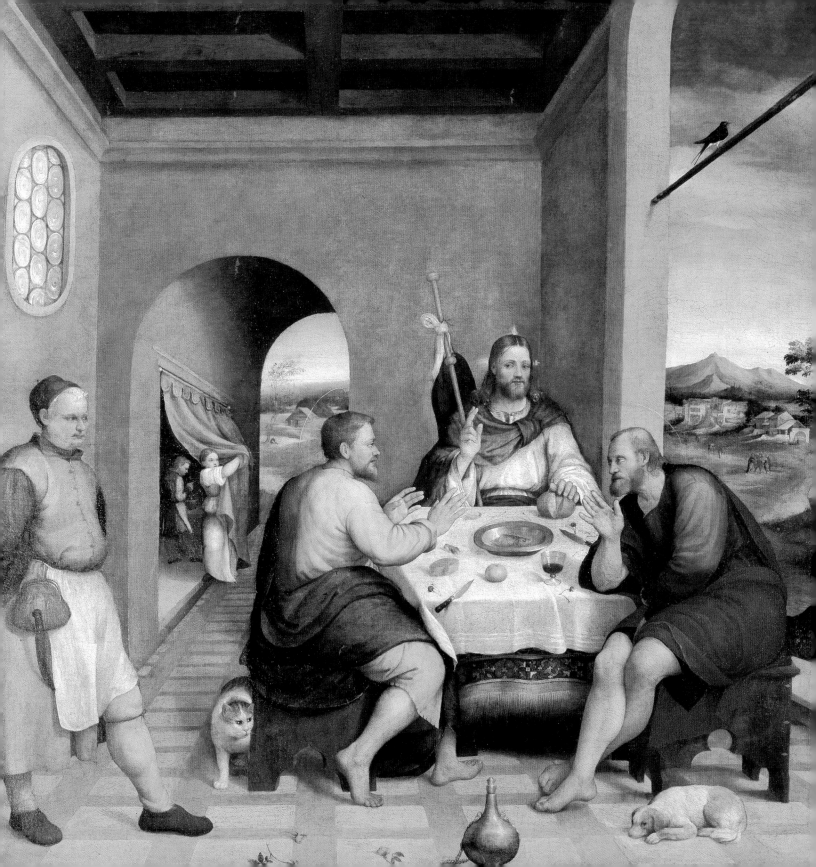

JACOPO BASSANO (1510/18–1592)

God Rebuking Adam, 1557

Oil on canvas, 74 x 112 in. (191 x 287 cm)

MUSEO DEL PRADO, MADRID

"And He saw that all things were good." Jacopo Bassano depicts a paradise teeming with animals to which, according to God's will, Adam gives names, thus taking possession of them. A passionate painter of nature, Bassano places fierce beasts and exotic animals farther back, almost in the background, leaving the foreground to a lovable crowd of domestic and farm animals. These are placid, docile; many of them are squatting and almost all face to the left, where God appears in the sky and Eve sits, half hidden, behind a tree. There is an exception, though: close to Adam, a large, handsome cat faces in the opposite direction, looking with interest at two little birds that hop, obliviously, on the grass. Even in Eden, the cat has not forsaken its independent hunter's instinct.

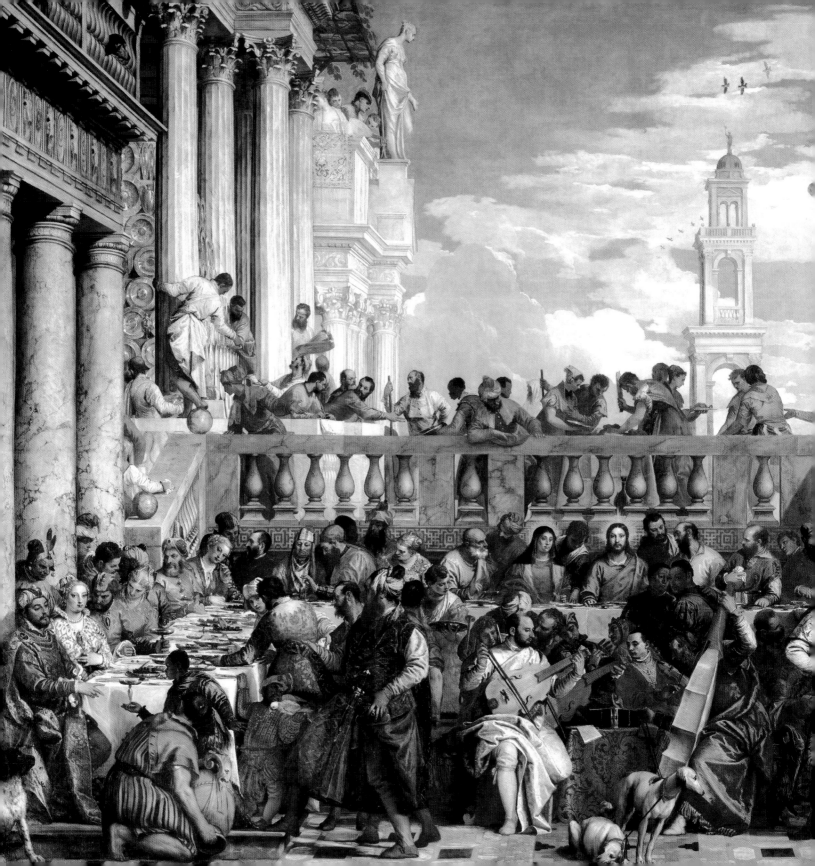

PAOLO VERONESE (1528–1588)

The Wedding at Cana, c. 1562

Oil on canvas, 21.9 x 32.8 ft. (6.6 x 9.9 m)

Musée du Louvre, Paris

Veronese's classic scenes are filled with merry crowds. In this masterpiece, the great painter from Veneto pours forth a boundless, joyous fantasy, rendering the sacred subject almost unrecognizable. True, Christ is at the center of the composition, with his traditional visage, even distinguished by a halo; but immediately in front of him a group of musicians (portraits, as it is well known, of the principal Venetian Renaissance painters) attracts the viewer's eye. Amid this riot of light, color, gaudy clothing, and magnificent figures is our friend the cat, in a place of honor: in the very foreground, a gray cat is performing a sort of somersault next to one of the pitchers in which water has been transformed miraculously into excellent wine.

Following page:

PAOLO VERONESE (1528–1588)

The Meal at the House of Simon the Pharisee, c. 1570

Oil on canvas, 9 x 23.3 ft. (2.7 x 7.1 m)

Pinacoteca di Brera, Milan, Italy

In this vast, regular, and symmetrical composition, with its two tables of diners arranged in an orderly fashion within a majestic setting—the terrace of a Palladian villa—an episode from the Gospel takes place on the far left of the painting. Christ is accepting the repentance of Mary Magdalene, who is kneeling at his feet after devoutly anointing them with a precious ointment. For those who expected to find the most important thematic element in the formal center of the painting, this is a highly unusual placement. And despite the classic nature of the scene—the rich clothing and the elegant tableware—the painter has not been able to resist the pleasure of surprising the viewer by placing two dogs and a cat right in the middle of the image. As the painter himself admitted, from time to time he liked to take "the liberties that poets and madmen take."

TINTORETTO (Jacopo Robusti, c. 1518–1594)

Birth of John the Baptist, 1554–55

Oil on canvas, 71 x 104 in. (181 x 266 cm)

HERMITAGE, ST. PETERSBURG, RUSSIA

A visitor to Venice is well aware that *La Serenissima,* formerly the Most Serene Republic, is also a free republic of cats. Venetian cats pop out more or less anywhere, from their secret routes and inaccessible passageways; so one can understand why Venetian art should have allowed them an unusually ample space. The independence and unpredictability of Venetian cats, accustomed to living as vagrants in the city's streets and little squares rather than in houses, mean that in Venetian painting the cat is rarely calm, sleeping, affectionate, or a symbol of domestic peace and harmony. What is more apparent is the nature of a small predator. In the paintings of Veronese and Tintoretto, the cat is completely uninterested in its surroundings, concentrating instead on what it is doing. An example can be found in this canvas by Tintoretto: taking advantage of the festive bustle filling the handsome home of Elizabeth and Zacharias on the occasion of the birth of John the Baptist, the cat advances with an indifferent air toward its possible prey.

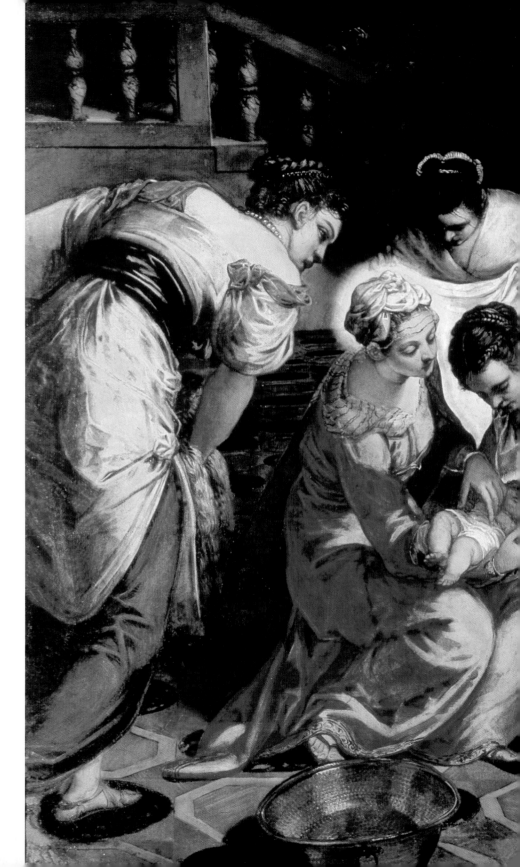

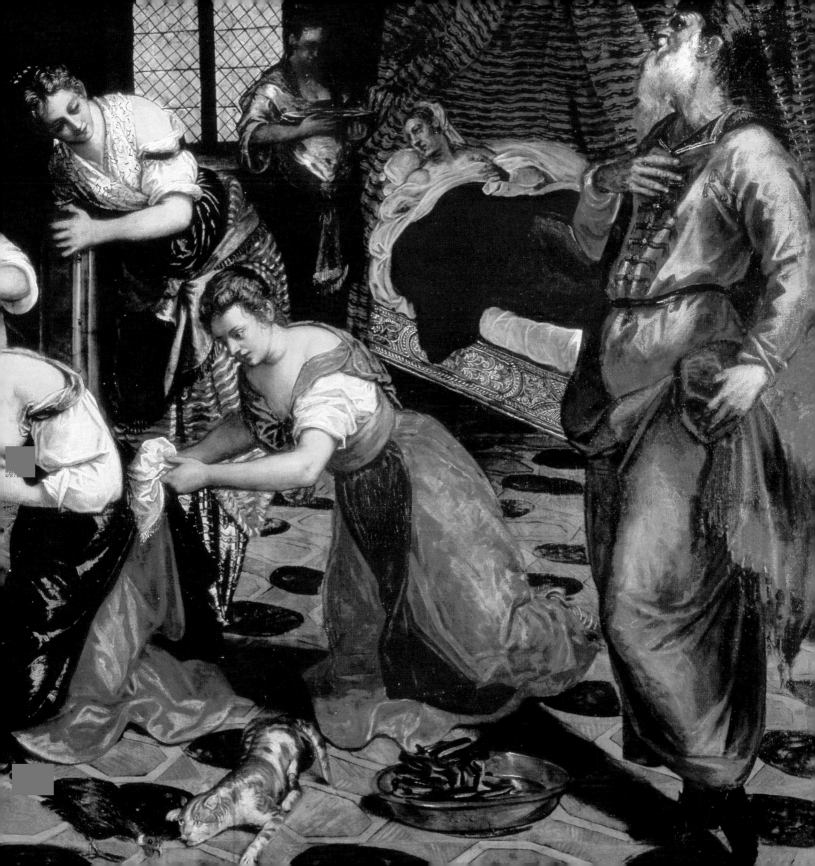

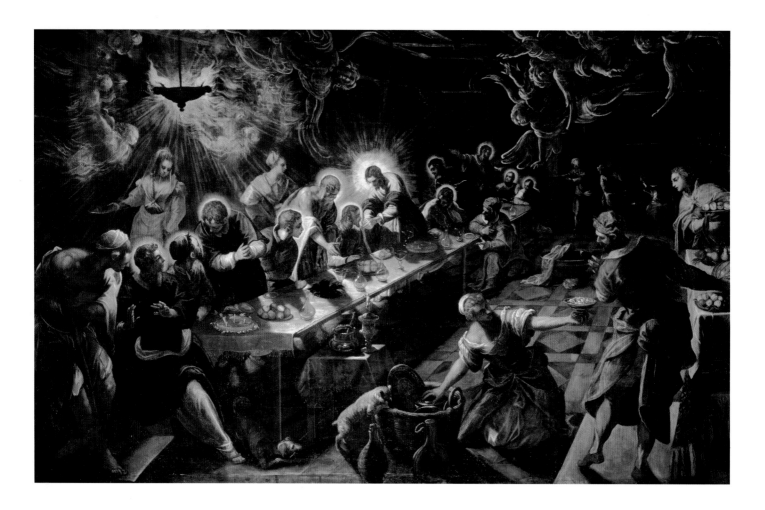

TINTORETTO (Jacopo Robusti, c. 1518–1594)

Last Supper, 1590–92

Oil on canvas, 12.3 x 18.9 ft. (3.8 x 5.7 m)

SAN GIORGIO MAGGIORE, VENICE, ITALY

This is Tintoretto's last work, and in a sense also the crowning masterpiece of the Venetian Renaissance. The elderly master concludes the extraordinary journey of sixteenth-century Venetian art with a mysterious, visionary painting dominated by jarring, oblique perspective; filled with shadowy presences that hover in the air, it is completely innovative with respect to the aesthetic conventions of the time. And yet, perhaps because of the highly experimental nature of the painting, which remains unique and inimitable, Tintoretto sensed the need to introduce, under the table, the reassuring presence of the cat, a link with nature and truth in an almost phosphorescent gloom.

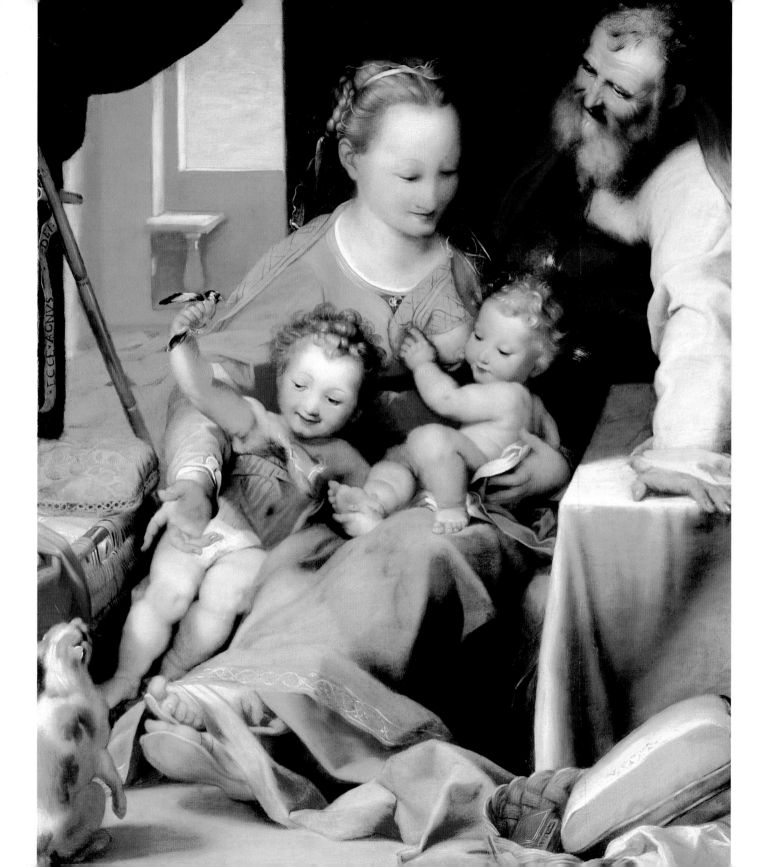

FEDERICO BAROCCI (c. 1535–1612)

Holy Family with a Cat, 1577–80

Oil on wood, 44 x 40 in. (112 x 102 cm)

MUSÉE CONDÉ, CHANTILLY, FRANCE

One of the first major painters to address the new assumptions of the Counter-Reformation, Barocci was certainly a cat lover, for cats appear in agreeable poses in many of his paintings. For Barocci, the cat is the very symbol of the family, domestic intimacy, peace; and even when it appears in sacred subjects (such as the Annunciation or the Madonna and Child) it takes on this significance. Very probably, Barocci "needed" the cat: notwithstanding the sense of joy and tenderness that pervades many of his works, painted in light pastel shades, the artist suffered from a severe form of depression, and could work for only a few hours a day. Barocci also experienced nausea, convulsions, and psychosomatic problems that forced him to put down his brushes. It is well known that stroking and looking after a cat are among the most effective natural ways to calm the nerves.

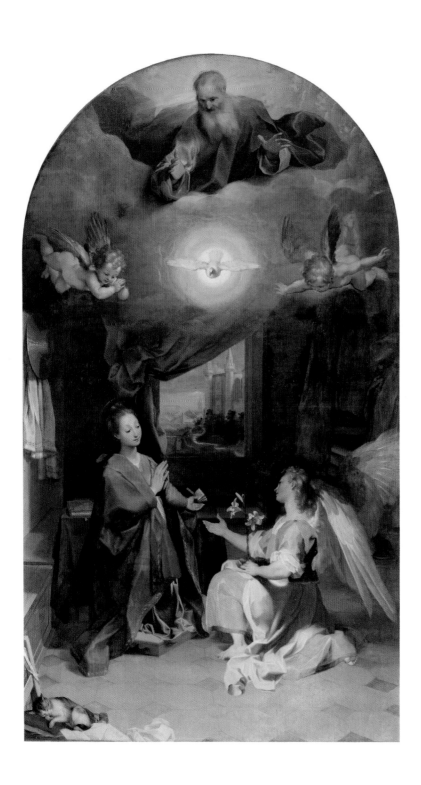

FEDERICO BAROCCI
(c. 1535–1612)

Annunciation, 1592–96

Oil on canvas, 109 x 66 in. (280 x 170 cm)

SANTA MARIA DEGLI ANGELI, ASSISI, ITALY

Only a few decades, and a few dozen kilometers, separate this Annunciation from the one painted by Lorenzo Lotto at Recanati (see pp. 340–41), but the difference between them is profound. Federico Barocci, one of the first painters of the Counter-Reformation, here returns to a calm, harmonious, happy feeling. Nothing terrible is happening in Mary's room; indeed, the cat is blissfully snoring by the sewing basket. The soundly sleeping pet is diametrically opposed to the possessed feline darting across the scene of Lotto's painting of the Annunciation, to the point that it becomes the very symbol of the domestic peace that was very dear to Counter-Reformation theologians. The sleeping cat reinforces the symbolic meaning of the scene: the Annunciation should not be seen as a unique, exceptional event, unable to be duplicated, but rather as an example of a "vocation" that can be replicated in the lives of each one of us without disturbing the ordinary pace of life. For this reason, in addition to the cat, Barocci has added another familiar element: in the background, rather than a generic image of Nazareth, is the unmistakable view of the ducal palace of Urbino, the painter's hometown.

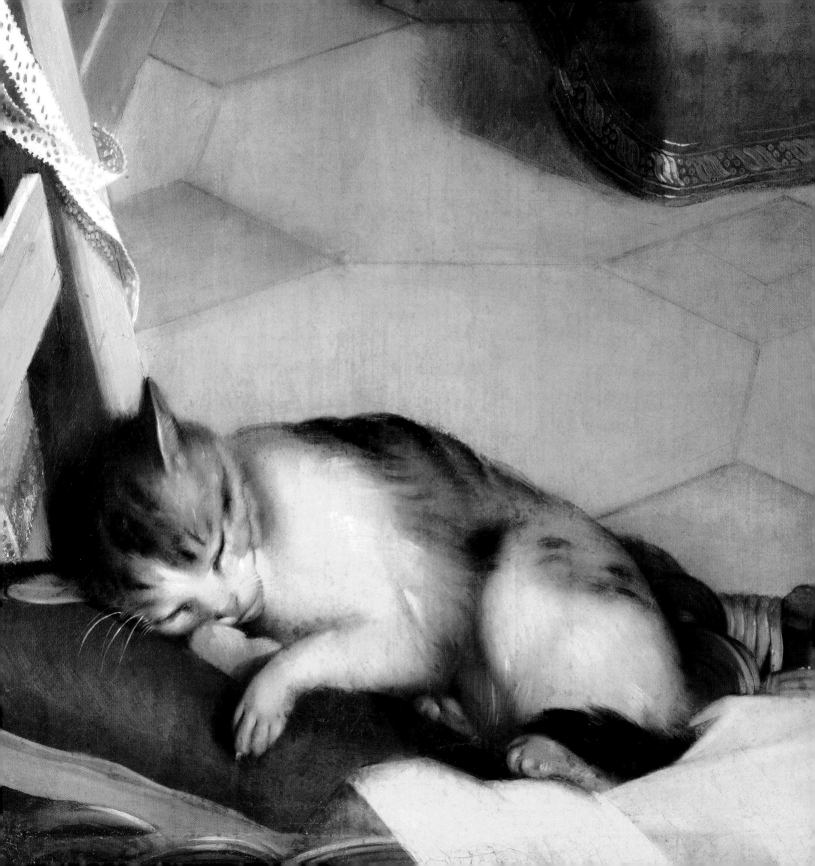

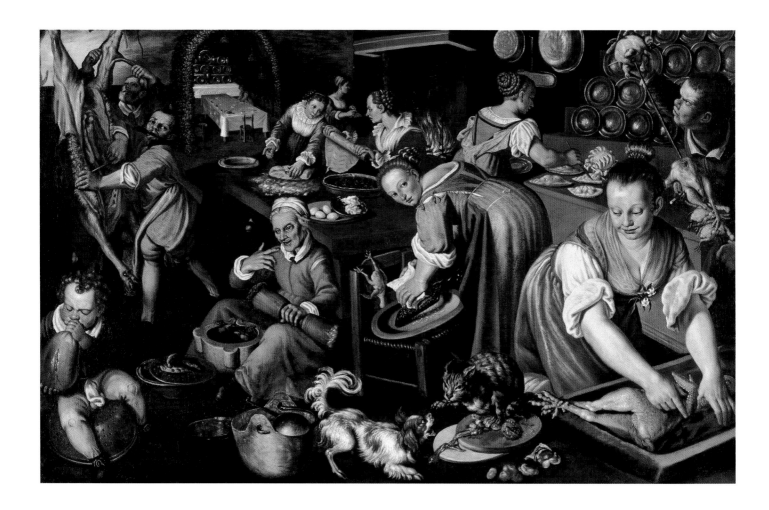

VINCENZO CAMPI (1536–1591)

Kitchen Scene, c. 1585

Oil on canvas, 57 x 86 in. (145 x 220 cm)

Pinacoteca di Brera, Milan, Italy

Everyone loves Caravaggio: no other Old Master is as popular. There is an entire field of ongoing scholarly research that aims to establish "precedents" for Caravaggio, tracing the roots of his revolutionary style, especially to sixteenth-century Lombard painting. Vincenzo Campi, a native of Cremona whose painting style is realistic and direct, is undoubtedly one of the key artists who provides insight into the cultural soil from which Caravaggio's prodigious talent grew. This painting is one of a series of four canvases—all depicting humble, everyday scenes—that together constitute the artist's masterpiece. Whereas other Italian and Flemish artists of the period portrayed similar scenes with a touch of caricature and humor, Campi tends to remain a faithful, if amused, observer of reality. The bristling cat that makes the larder its kingdom is perfectly suited to this approach.

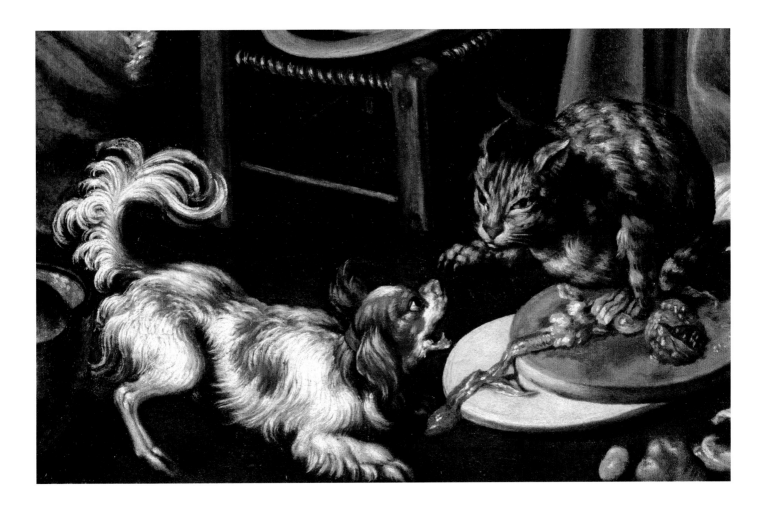

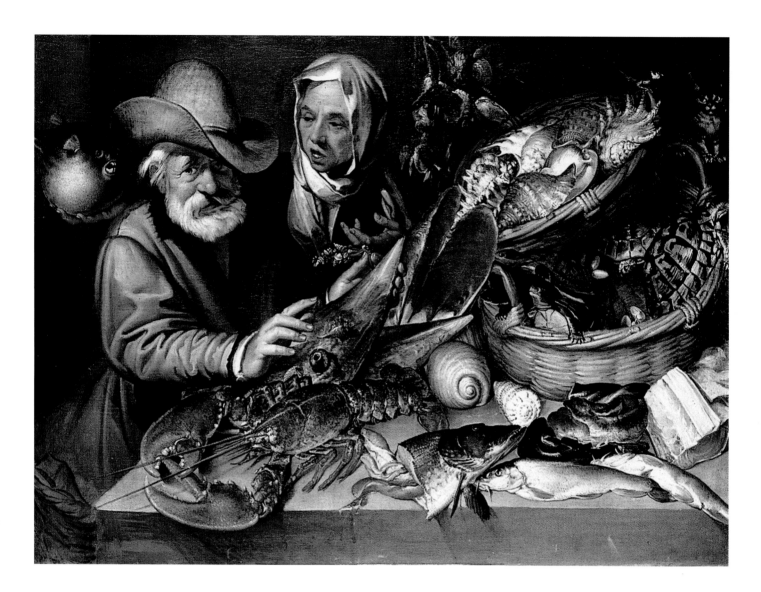

BARTOLOMEO PASSEROTTI (1529–1592)

The Fishmongers, c. 1580

Oil on canvas, 44 x 59 in. (112 x 152 cm)

GALLERIA NAZIONALE D'ARTE ANTICA
(PALAZZO BARBERINI), ROME

As the Renaissance drew to a close, profound changes were on the way in the world of art and learning. At the end of the sixteenth century "learned" Bologna, seat of one of Europe's oldest and most illustrious universities, was the home to avant-garde movements and important stylistic experiments. The likable Bartolomeo Passerotti painted portraits and scenes of everyday life and ordinary people with a taste for anecdote that frequently verges on caricature. It is interesting to compare his work with that of the painter from Cremona, Vincenzo Campi, who was his contemporary, lived in the same region, and depicted similar subject matter. A fishmonger's stall is highly attractive to cats, which hover furtively, with an indifferent attitude, in the hope of snatching at least an occasional anchovy. In Passerotti's painting, which is not without humorous allusions, the two elderly fishmongers are engaged in a lively discussion, and the cat takes advantage of their distraction to sight a succulent prize.

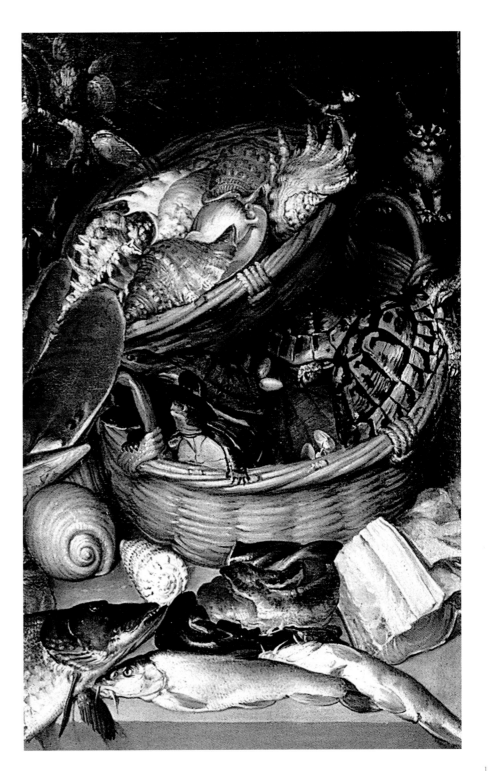

ANNIBALE CARRACCI (1560–1609)

Two Children Teasing a Cat, c. 1590

Oil on canvas, 26 x 34¾ in. (66 x 88.9 cm)

THE METROPOLITAN MUSEUM OF ART, NEW YORK

No one can predict the consequences of this mischief on the part of the two children. With that wicked expression on their faces, which is often seen in children, the two youngsters are trying the animal's patience with a crayfish. When the big placid tabby cat realizes what they are doing to it, it will almost certainly rebel and scratch its tormentors. Is this what Annibale Carracci's delightfully provocative canvas is alluding to—the fact that we are responsible for the effects of our actions, especially the rash ones? This painting, which gets exceptionally close to "reality," has roots in the realism of Sofonisba Anguissola, who painted what happened next—the pain of a boy bitten by a crayfish, a theme soon echoed by Caravaggio himself in a painting of a youth bitten by a large lizard. Likewise, from a technical point of view, this work is indebted to Venetian chromaticism, conveyed through vibrant brushwork bursting with color.

THE BAROQUE CAT

Inside European Households: Paintings of Interiors, Everyday Life,
and the Egalitarian Cat

PETER PAUL RUBENS

REMBRANDT VAN RIJN

DIEGO VELÁZQUEZ

JUDITH LEYSTER

GIOVANNI LANFRANCO

FRANS HALS

GIUSEPPE MARIA CRESPI

JACOB JORDAENS

DAVID TENIERS THE YOUNGER

NICOLAS MAES

JAN STEEN

CORNELIS DE MAN

THE LE NAIN BROTHERS

PHILIPPE DE CHAMPAIGNE

CHARLES LE BRUN

ALEXANDRE-FRANÇOIS DESPORTES

ANONYMOUS FLEMISH MASTER

FERDINAND VAN KESSEL

FRANS SNYDERS

JAN FYT

PAUL DE VOS

THE EFFORTS OF RENAISSANCE INTELLECTUALS TO REHABILITATE the cat and present it as a wholly "positive" animal were partly successful. The superstitious hounding of witches and their animal symbols—black cats first and foremost—continued and even increased during the seventeenth century. But, at the same time, Baroque art clearly shows how throughout Europe the cat had become an animal that crossed social boundaries, its presence linking rustic cottages, middle-class houses, and even, at least in part, the palaces of the nobility. It is true that the cat did not appear at court, for it was not an animal regarded as worthy of royal families and thus, unlike noble thoroughbreds and pedigree dogs, was not allowed into the presence of monarchs; but, with the exception of the steps leading up to the throne, the cat unhesitatingly crossed all thresholds and, significantly, accompanied humans at all stages of their lives, from earliest childhood to extreme old age.

The cat, in short, did not discriminate. In contrast, dog breeds proliferated and became more complex, with a division into true "castes," from the little mongrel to the aristocratic greyhound. In the absence of specimens of the exotic and haughty Persian or Siamese cat, which had yet to arrive from the Orient, the European cat confirmed its identity as essentially the same as it had always been: fur color, length, or type might vary, and certain physical details such as the ears, size of the eyes, the tail, and shape of the head distinguished different breeds; but, fundamentally, few striking differences developed among domestic cats.

The Counter-Reformation, in its search for a new type of sacred image that was closer to the personal and social experience of the faithful, eagerly adopted the cat. Many Annunciations were painted in which a sleeping or peaceful-looking cat emphasized the serenity of Mary's house in Nazareth and, as seen in the previous chapter, there was an increase in the number of paintings of the Holy Family in which the infant Jesus plays with a cat. It is not, of course, solely a question of quantity, given that this new phase in which the cat became an emblem of domestic peace encompassed even a giant of universal art such as Rembrandt. A further

PAGE 130: Philippe de Champaigne, (Detail) *Christ in the House of Simon the Pharisee*, c. 1656. Oil on canvas (see pp. 170–71). Musée des Beaux-Arts, Nantes, France.

impetus behind the cat's rising star in seventeenth-century European painting was the growth in popularity of the still life: often—especially when the subject is fish, game, or anything associated with cooking—an attractive cat makes its appearance, ready to commit theft.

The cat is patient and versatile, and although it continued to arouse demonic suspicions, during the seventeenth century it also found some powerful defenders, including Cardinal Richelieu, France's extremely powerful prime minister, according to whom God created the cat in order to give us the pleasure of stroking a small tiger every day. During a historical period that has shown the greatest love of contradictions and excesses, the Baroque cat is a fascinating, elusive animal: its presence can be disturbing or pleasing, but it has become indispensable. To come face to face with the cat is an intellectual pleasure. In his well-known *Iconologia* (Iconology), an immensely rich guide to visual symbols that offers a key to interpreting a large number of Baroque paintings, the erudite Cesare Ripa suggests using the cat, along with the dog, to allude to two opposing but pervasive characteristics of war-torn seventeenth-century Europe: "conflict" and "truce." The expression "to fight like cat and dog" thus finds noble confirmation. Now fully naturalized, the cat appears with increasing frequency in the coats of arms of noble families, especially in Germany and Italy, and above all as a symbol of freedom. The jargon of those who decipher heraldry finds itself enriched by a new term: on coats of arms a rampant cat, standing on its hind legs, is described as *illeonito*, that is, "like a lion," as if to confirm the view of Cardinal Richelieu.

During the Baroque era, the cat met with the most success in two artistic schools, the French and the Dutch. The reasons for the popularity of the cat in art during the era of the Sun King, as alluded to previously, were, first and foremost, the demands of realism (as in the case of the Le Nain brothers), the rich religious symbolism (for example, in the paintings of Charles Le Brun), and the prevalence of still life, which depicted foods that excite the curiosity and greed of cats, culminating in the masterpieces of Chardin, who was active well after the Sun King's reign.

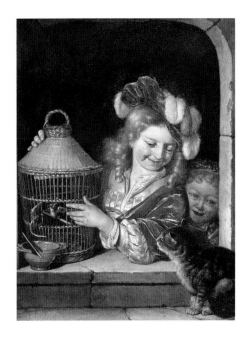

Eglon Hendrick van der Neer, *Children with a Birdcage and a Cat*, 1680. Oil on wood. Hermitage, St. Petersburg, Russia. The customary realism of the Dutch School, which always focuses on true-to-life depiction of everyday scenes, is combined with the theme of children playing with a cat, which is widespread in European painting since the late Renaissance.

Less well known, however, is the frequency with which cats appear in Dutch interiors and in the paintings of the Netherlands' "golden age." Peasants, more susceptible to superstition, continued to be wary of cats, and Calvinist preachers never tired of pointing the finger at cats as impure beasts that leave behind strong, unpleasant smells; possess obscene habits, forever striking repulsive poses while licking their own genitals; and provide a dreadful example of open indecency and sexual promiscuity. Manuals of good housekeeping practice, aimed at educated housewives and newly married women who did not want to cut a poor figure in front of their mothers-in-law, suggested that cats should be kept away—at least out of the kitchen and if possible away from the house altogether—so as to avoid paw prints on the floors that had been tirelessly swept and polished. Even today there is a Dutch expression "to wash like a cat," meaning to do so perfunctorily. Moreover, in a young, proud nation, the elusive, greedy, lazy, unpredictable, and anarchic cat represented the antithesis of the qualities of the ideal citizen. Another expression in the Netherlands is "to pinch a cat in the dark," denoting the reprehensible habit of sinning in secret. In short, there was almost a witch hunt against cats; yet Dutch art shows well-fed, satisfied cats, comfortably ensconced in the most snug corners of the household, ready to seize the tastiest morsels, enthusiastically stroked by children, curled up in happy slumber at the warm heart of the family, or as cheerful companions for the elderly.

Despite such moral prejudices and practical advice, the cat was an essential element in the balance of the household in the advanced, proud Netherlands of the seventeenth century, occupying a place at the heart of that industrious, cohesive society. The Dutch School of painting, constantly focused on day-to-day reality, offers a pleasing and unequivocal testimony to how right Mark Twain was when he wrote: "A home without a cat—and a well-fed, well-petted and properly revered cat—may be a perfect home, perhaps, but how can it prove title?"

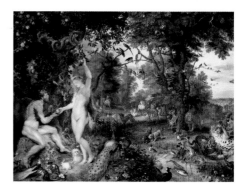

Peter Paul Rubens and Jan "Velvet" Bruegel, *The Original Sin*, c. 1615. Oil on wood. Mauritshuis, The Hague, the Netherlands. The two Flemish painters transformed the moment of Original Sin into a depiction of a fabulous garden filled with all sorts of animals, including a little white poodle and kitten peeping out from behind Eve's legs.

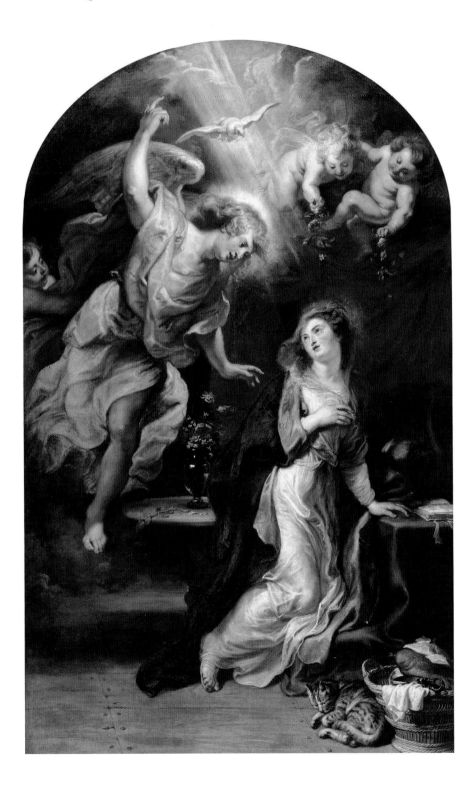

PETER PAUL RUBENS
(1577–1640)

Annunciation, c. 1628

Oil on canvas, 119 x 73 in. (304 x 188 cm)

RUBENSHUIS (RUBENS'S HOUSE),
ANTWERP, BELGIUM

Each painting by Rubens is a festive occasion: there is the joy of painting, the variety of colors, the richness of the material chosen, dynamism of movement, and the participation of the viewer. This *Annunciation* is a typical example of the Antwerp painter's mature style, and it has remained in the luxurious combined home and studio that Rubens had built in the heart of his native city. The Archangel Gabriel, the Virgin, and angelic cherubs are driven in a whirlwind of motion, with wide, circular gestures: the painting produces an impression of swirling movement, almost a visual symphony. And yet, in keeping with its reputation for imperturbability, the cat placidly maintains its siesta, crouched by the sewing basket.

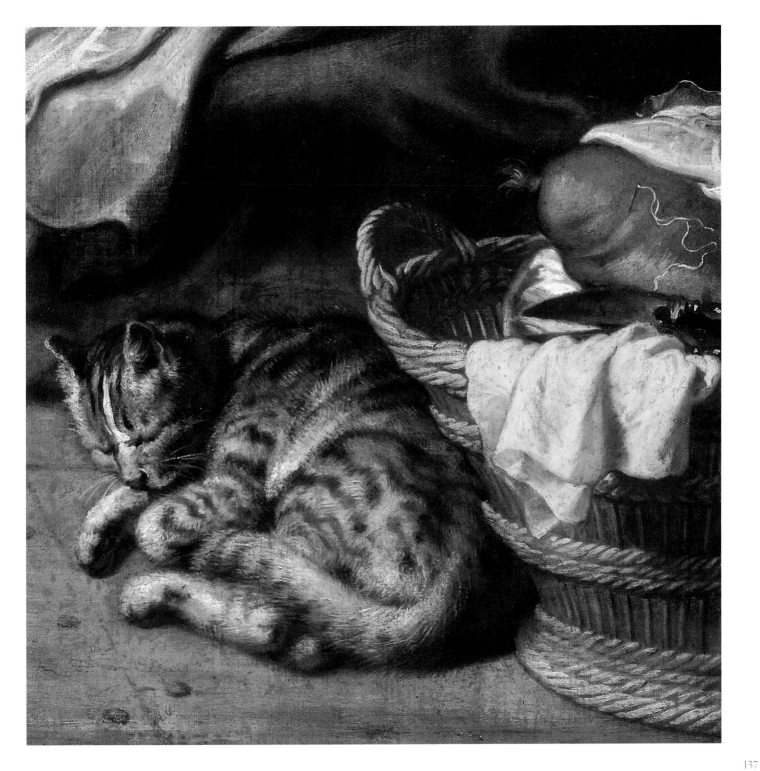

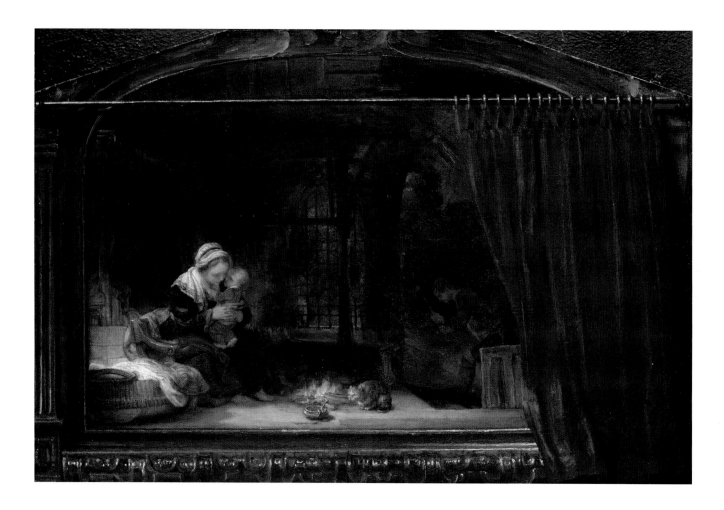

REMBRANDT VAN RIJN (1606–1669)

The Holy Family, 1645

Oil on wood, 18¼ x 26¾ in. (46.8 x 68.4 cm)

Gemäldegalerie Alte Meister, Kassel, Germany

This painting is truly unique among Rembrandt's works, and features trompe l'oeil, which was very fashionable at the time. The painter produces the illusion of a richly carved frame and a red curtain, only partly open, attached to the front of the canvas. The "internal" scene, almost a painting within a painting, shows the Holy Family in the dim light of evening: Joseph is finishing his work at the carpenter's bench and Mary is embracing the infant Jesus. But the center of the picture is occupied by a large, placid cat that looks half asleep. Rembrandt—after the death of his beloved wife Saskia following the birth of his equally beloved son Titus—was living in the midst of a difficult domestic situation. In this painting the cat becomes the symbol of relaxed, serene domestic harmony, a desire for peace that contrasts painfully with the everyday reality faced by the painter, then forty years old.

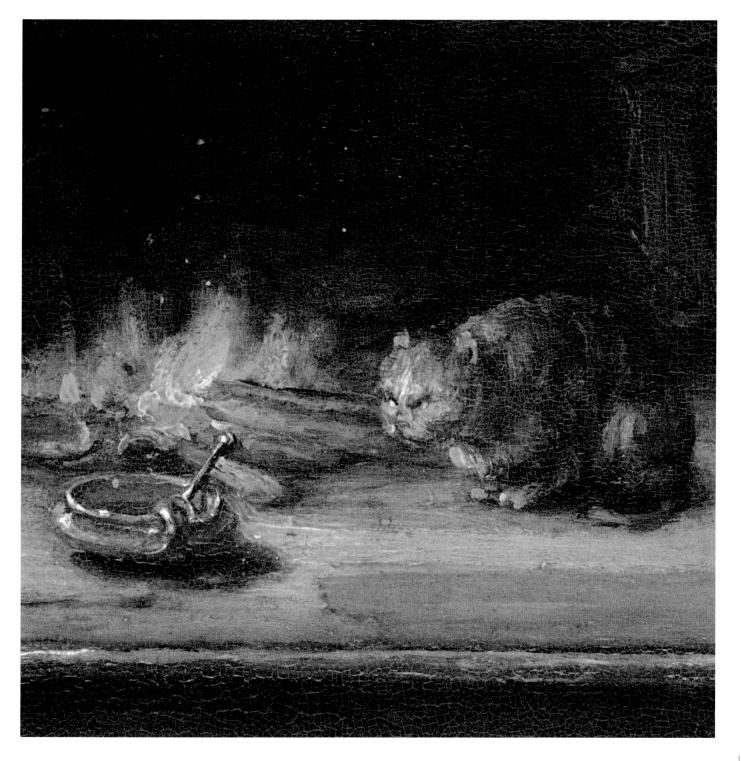

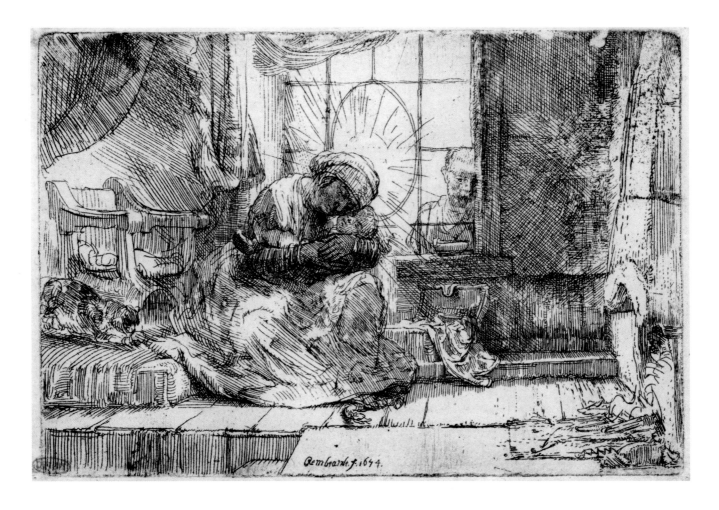

REMBRANDT VAN RIJN (1606–1669)

Madonna and Child (Madonna of the Snake), 1654

Engraving, 3¾ x 5¾ in. (9.5 x 14.5 cm)

MUSÉE DE LA VILLE DE PARIS, MUSÉE DU PÉTIT-PALAIS, PARIS

Amid Rembrandt's vast output of drawings and engravings, this Madonna has a particular significance. In the Calvinist Netherlands during the seventeenth century, sacred subjects, and especially depictions of the Virgin, were very rare. Here Rembrandt echoes faithfully the figures in an engraving by Andrea Mantegna, an artist whose entire output of drawings and engravings Rembrandt possessed, carefully catalogued and part of a print collection that had few rivals in Europe at the time. Mantegna's Madonna, seated on the ground and holding the infant Jesus tightly, stands out against a neutral background; Rembrandt, on the other hand, sets the scene in an interior full of light and shade, where tenderness and deceit, affection and menace, alternate. It is possible to read into this scene an echo of the painter's troubled family circumstances. The presence of a snake, unequivocal symbol of evil, is complemented by the much more reassuring and "normal" presence of a cat, conspicuous on the left of the picture.

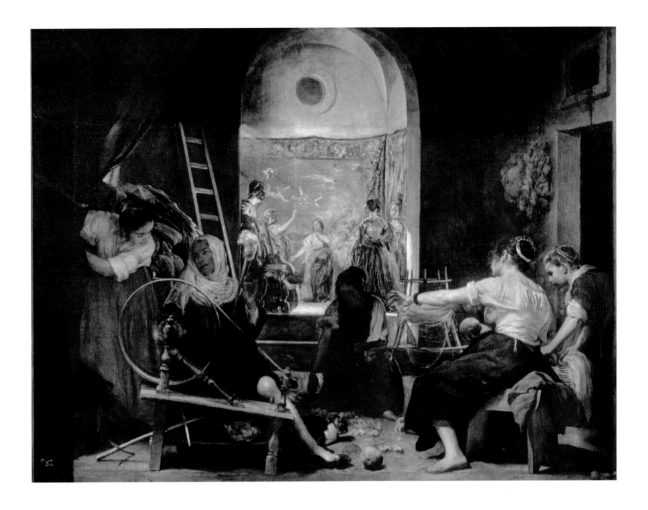

DIEGO VELÁZQUEZ (1599–1660)

The Spinners (The Santa Isábel Tapestry Workshop in Madrid), c. 1657

Oil on canvas, 86 x 113 in. (220 x 289 cm)

Museo del Prado, Madrid

The many interpretations put forward for this masterpiece—which, for some, sums up the whole of Western art on its own—have frequently overlooked the presence, and role, of the cat at the foot of the woman with the winder. Is it a mere decorative element, or is it a symbol of freedom, linked to loyalty to the Spanish crown (and, as such, a symbolic representation of the strong working and intellectual relationship between Velázquez and Philip IV)? Critics seem to disagree over these interpretations. In the meantime, the cat, confirming its ancient reputation for laziness and indolence, is the only living thing that is idle in this setting that, in contrast, is a hive of activity.

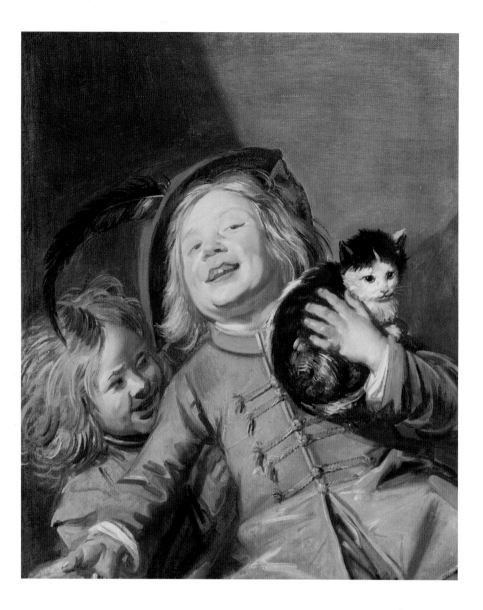

JUDITH LEYSTER
(1609–1660)

Laughing Children with a Cat, 1629
Oil on canvas, 24 x 20 in. (61 x 52 cm)
NOORTMAN, MAASTRICHT,
THE NETHERLANDS

Like her painter husband, Jan Miense Molenaer, only more so, Judith Leyster was one of the leading painters of the seventeenth-century Dutch school. She became famous and was in demand on the art market for her genre scenes, domestic interiors, portraits, and scenes from the lives of ordinary people. An illustrious and well-established member of a courageous group of women painters who tried to break the male dominance of the artistic profession, Leyster brought to her scenes featuring children a note of feminine sensitivity and an affectionate, perceptive gaze that reflected her experience as a mother. This painting, where we can detect an echo of the lessons imparted by the great Frans Hals, radiates an empathy and playfulness that are rare and delightful: the boy lifts the poor, bewildered kitten high in the air as if it were some quarry caught on a heroic safari, while his little brother, who would also like to hold the animal, laughs with a mixture of admiration, envy, and amusement.

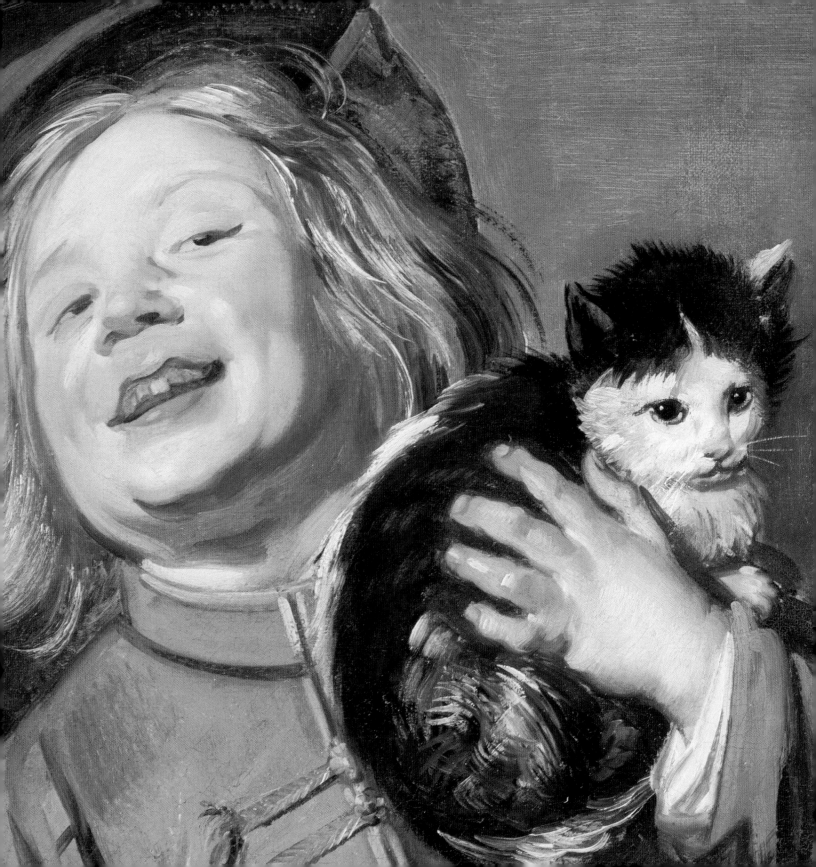

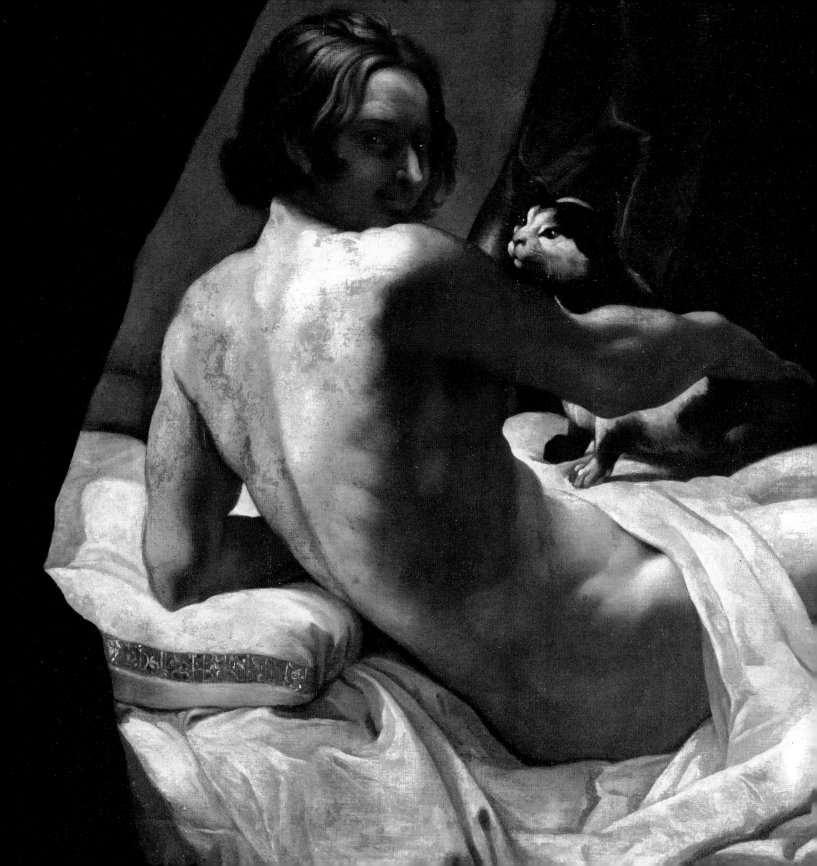

GIOVANNI LANFRANCO
(1582–1647)

Young Man Lying on a Bed with a Cat,
c. 1620–30

Oil on canvas, 44 x 62 in. (113 x 160 cm)

PRIVATE COLLECTION

The man is half naked and suggestive; the cat is sly and available. Images as enigmatic yet as explicit and provocative as this one are rare in Italian painting. Barely covered by a sheet and lying on an unmade bed, the young man—could it be the painter himself?—has his back turned to us (a precious anatomical study from Lanfranco); at the same time he watches us with a mocking smile, inviting us to share this intimacy. His playing with the cat, which is eager to be caressed and to offer affection in return, is perhaps intended to send a clear message: the animal here is the emblem of sensual, earthly love.

OPPOSITE PAGE:

FRANS HALS (c. 1580–1666) or a disciple

Portrait of a Man with a Cat, 1635

Oil on canvas, 17¾ x 17 in. (45.5 x 43 cm)

GEMÄLDEGALERIE ALTE MEISTER, KASSEL, GERMANY

Despite some doubts over its attribution—authorship of this work is often assigned to a disciple—the rapid, immediate, brilliant style of Frans Hals, one of the most fluent and fascinating of Baroque portraitists, is nevertheless clearly visible in this wonderful painting. This work belongs to a clearly defined period in the opus of the painter from Haarlem, a phase during which Hals alternated between painting true portraits and "character studies" of anonymous but lively, often smiling, ordinary people. It is a gallery of characters who have no name and no "history," but whom Hals nevertheless endows with a vivacious, extremely likable, identity. The young man with the wispy moustache and crude hairstyle gives us a knowing look while trying to soothe, with practiced caresses, a rather too lively kitten.

GIUSEPPE MARIA CRESPI (1665–1747)

Young Woman with Rose and a Cat, c. 1695–1705

Oil on canvas, 26 x 22 in. (66 x 56 cm)

Pinacoteca Nazionale, Bologna, Italy

This painting needs to be analyzed together with its counterpart, *Young Girl with a Dove* (City Art Gallery, Birmingham, England): the rose's thorns and the cat's claws are contrasted with the gentleness of the dove. The attractive young woman in the painting is teasingly prodding the little cat with the prickly stem of a rose. The animal seems to enjoy the attention, with the particular pleasure that cats experience in being caressed in sensitive spots, especially behind the ears, purring loudly in return. Yielding trustingly to its mistress, it is perhaps unaware that this instrument of pleasure could also wound it. Thus the individual must be cautious in the face of flattery, for the flowers that are offered may come with a bitter surprise . . .

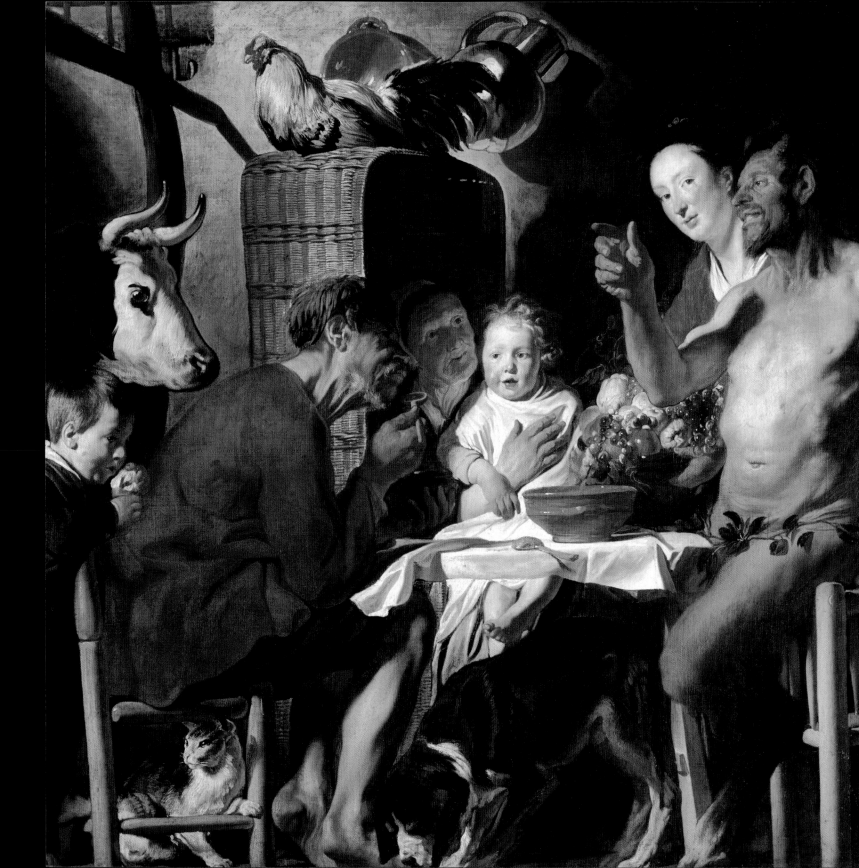

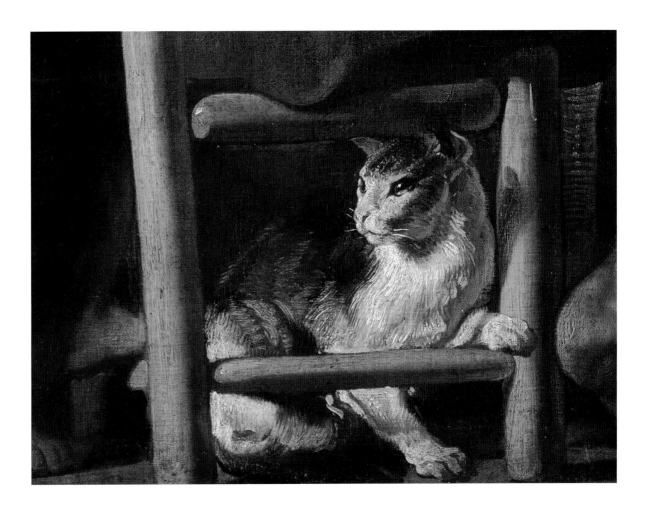

JACOB JORDAENS (1593–1678)

The Satyr and the Peasant, 1628

Oil on canvas, 68 x 79 in. (174 x 203.5 cm)

ALTE PINAKOTHEK, MUNICH, GERMANY

A very common subject in European Baroque painting is a Greek myth with a moral message. Accordingly, semi-divine creatures such as nymphs and satyrs lived among humans. This cohabitation ended when a satyr saw a peasant first blowing on his hands to warm them, and then blowing on a spoonful of soup to cool it, deducing from this that "duplicity" came out of the mouths of men. Jordaens, a superb master from Antwerp, painted various versions of this scene, playing on the contrast between the peasant's peaceful family and the semibestial figure of the satyr who philosophizes in the rustic interior of a poor country cottage. The sly-looking cat that witnesses the scene has clearly found an effective modus vivendi with humans, much sooner and more skillfully than the satyr!

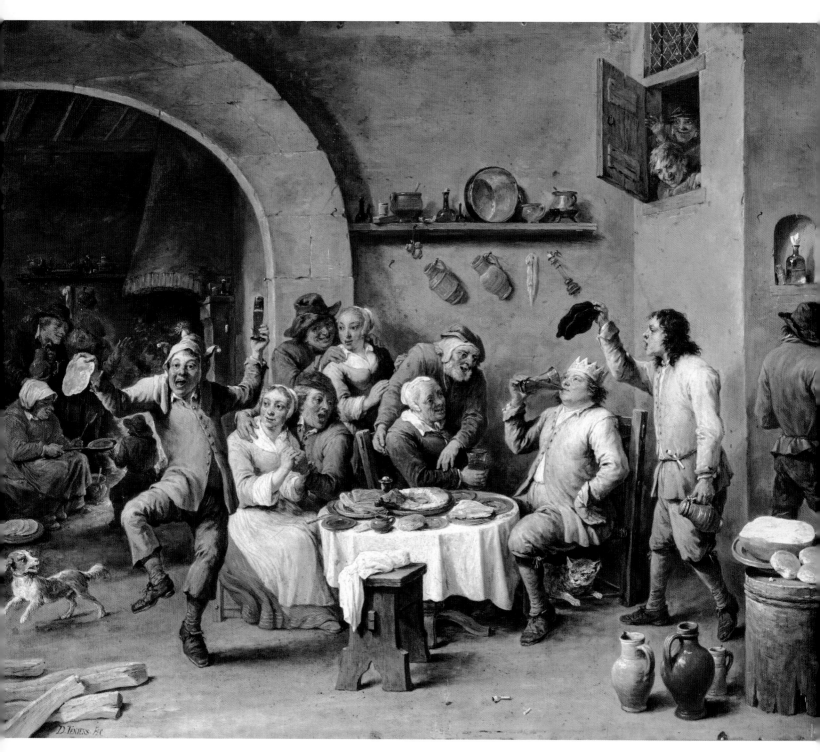

DAVID TENIERS THE YOUNGER (1610–1690)

"Twelfth Night" (The King Drinks), c. 1634–40

Oil on canvas, 27 x 23 in. (70 x 58 cm)

MUSEO DEL PRADO, MADRID

Teniers liked merry crowds of people and often set his scenes in inns that were far from refined. A typical subject of Teniers's work was the so-called Feast of the Bean King, a characteristic northern European custom. As the climax of a dinner for a large company, a cake was served in which a bean was hidden. Whoever found the bean in their slice was promptly proclaimed king of the feast, crowned with a burlesque paper crown, and then gave the sign for drinking to begin, amid general laughter. It was a rather undignified form of entertainment, favored by ordinary folk or, at most, the middle class, and certainly a long way from aristocratic etiquette, in which the role of the king was ironically caricatured. Amid the general descent into chaos, the cat does not lose its customary calm. Positioned under the very chair of the evening's mock king, it knows perfectly well that this is an opportunity to grab a juicy morsel, even at the cost of the odd inadvertent kick.

DAVID TENIERS THE YOUNGER (1610–1690)

Cat Having Its Fleas Removed by an Old Woman, c. 1640

Oil on canvas

PRIVATE COLLECTION

"While the cat's away, the mice will play," goes the well-known proverb. Here David Teniers, unconventional interpreter of Flemish popular traditions and an artist whose paintings combine imagination with a superb capacity for observation and realistic detail, seems to have been inspired by that very saying. In a poor, humble setting typical of Teniers's paintings, an elderly woman removes fleas from a cat's fur. In Dutch painting of the period, this operation was considered a symbol of morality and cleanliness, as if eliminating parasites from the body also indicated a desire to remove sins from the heart. In Teniers's case, however, it carries a very different meaning: taking advantage of the cat's enforced immobility in the old woman's grasp, a line of mice passes by unmolested.

NICOLAS MAES (1634–1693)

The Idle Servant, 1655
Oil on wood, 27 x 21 in. (70 x 53.3 cm)
NATIONAL GALLERY, LONDON

A versatile painter who created powerful images, Maes was one of the most talented of Rembrandt's many pupils. In the Netherlands art market that was moving toward considerable specialization, Maes retained a certain versatility, painting portraits, genre scenes, and figures charged with moral and symbolic pathos. Even his interiors, beneath the attractive appearance of simple, innocent images drawn from everyday life, often contain allusions to the Dutch values of order, temperance, and trustworthiness. This is one of the most explicit: if the cook falls asleep, many problems may arise, causing her dutiful colleague to smile (almost a secular version of the Parable of the Wise and Foolish Virgins). One such problem is the fact that the household cat, always on the prowl, is allowed free rein.

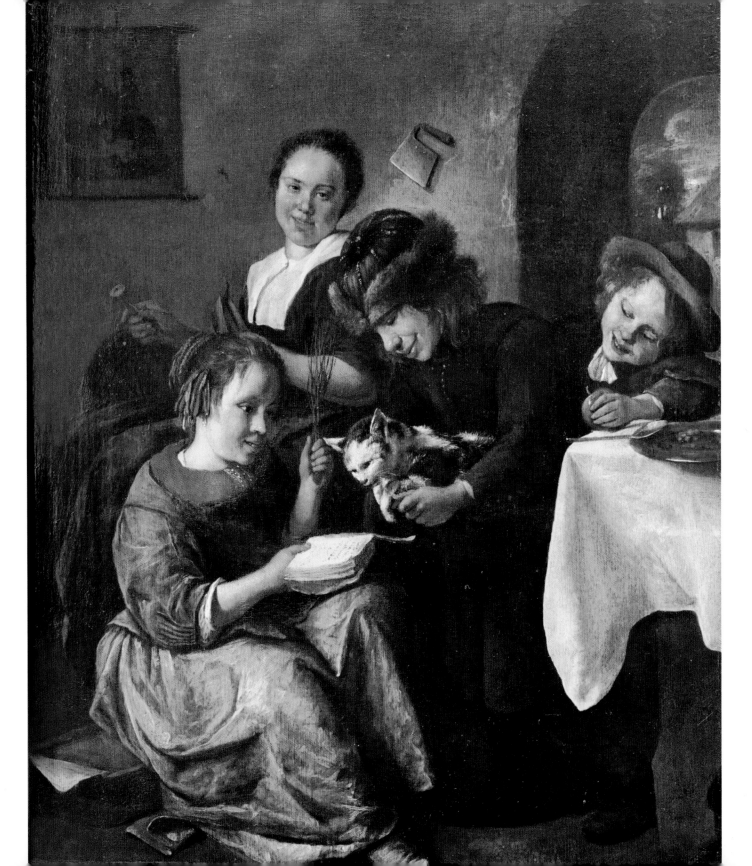

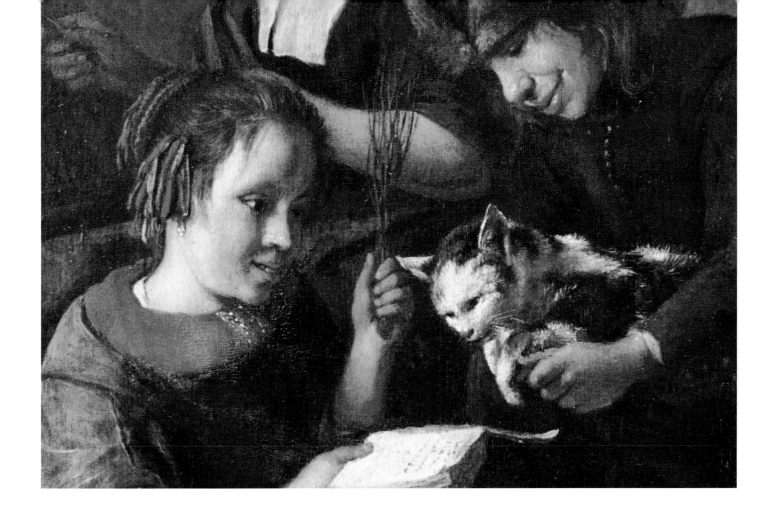

JAN STEEN (c. 1626–1679)

Children Teaching the Cat to Read, 1663

Oil on panel, 18 x 14 in. (45 x 35.5 cm)

KUNSTMUSEUM, BASEL, SWITZERLAND

A charming, amusing family scene: almost from a corner of the room, Jan Steen observes three children trying to teach a kitten to read. The oldest child holds the little animal, the young girl holds the book, and the third child watches with amusement and curiosity. Steen is always witty, often ironic, and sometimes even sarcastic. In this small painting, his inquisitive mind has focused on a theme that, as the pages of this book clearly demonstrate, recurs rather frequently in the history of art, especially from the late Renaissance on. The cat is the "victim" of a children's game, which makes it the center of attention. Let us have no doubts about the animal's reserves of patience; however, the game will certainly not last long. The cat will soon make clear its annoyance, springing free and perhaps scratching the children's hands.

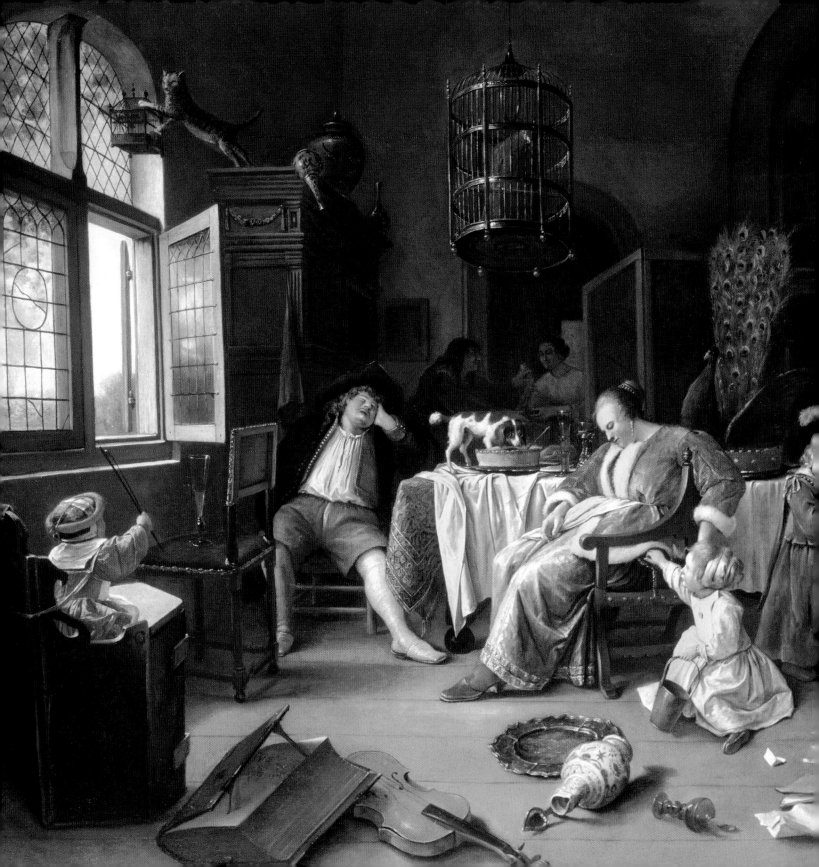

JAN STEEN (c. 1626–1679)

The Untidy House (or *The Effects of Intemperance*), 1665

Oil on canvas, 34 x 41 in. (86 x 106 cm)

PRIVATE COLLECTION

In a rather reductionist manner that does not do justice to his extraordinary talent for creating images, Steen has been described as the "storyteller" of seventeenth-century Dutch painting. In the midst of a comfortable, well-off society, reflected in spotless, meticulous images of perfectly orderly domestic interiors, Steen shows us another side of everyday life in scenes, such as this one, where disorder, drunkenness, and confusion reign. All trace of Calvinist moral rigor is erased, and every detail has its symbolic interpretation. In the upper left of the picture, a cat has triumphed, climbing to the top of a large cupboard and finally seizing the little bird's cage. Is the misdeed it has dreamed of in vain a thousand times about to be enacted? We will never know, but what is certain is that the cat's possible victory is to be perceived as the ultimate confirmation of the "world upside down," a household where nothing goes right.

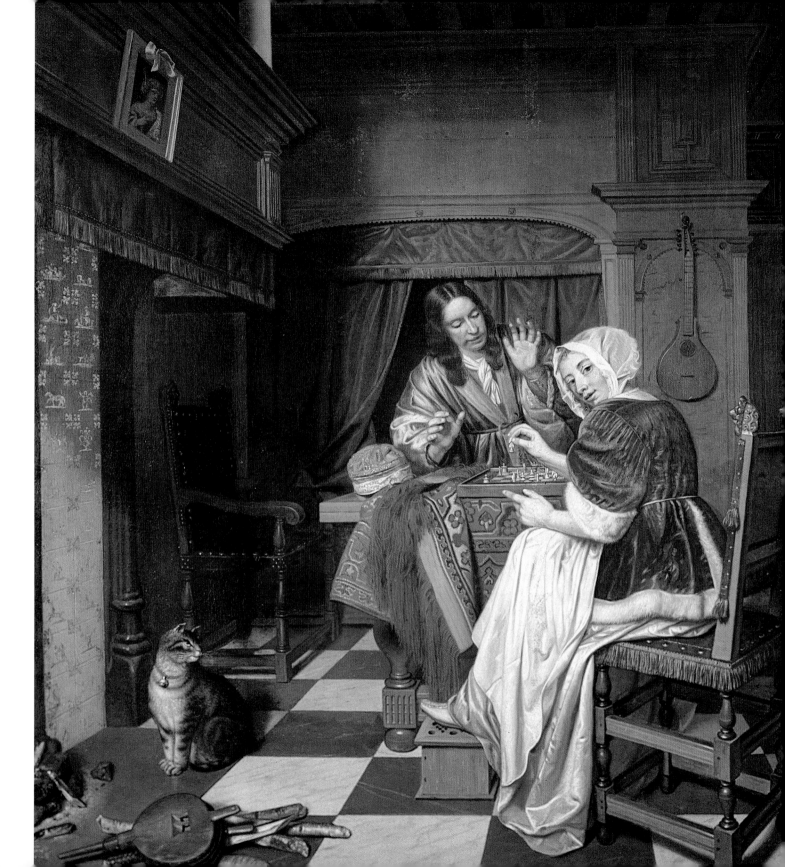

OPPOSITE PAGE:

CORNELIS DE MAN (1621–1706)

The Chess Players, c. 1670

Oil on canvas, 38 x 33 in. (97.5 x 85 cm)

MUSEUM OF FINE ARTS, BUDAPEST, HUNGARY

The depiction of interiors is perhaps the most characteristic and interesting aspect of the "golden age" of Dutch painting. The love of household, the taste for interior decoration, the fine décor, and the pleasure of beautiful, useful objects are reflected in clear, harmonious, carefully executed paintings that reveal attention to descriptive detail but also to subtle psychological conflict. In this home, a game of chess may mask an amorous "battle": as far as we can tell, the moves of the game are observed by a beautiful tabby cat, cared for and groomed to perfection. This is certainly the young lady's pet, and it wears a ribbon with a bell around its neck—a rarity, for cats usually cannot tolerate wearing a collar. The animal's pose is telling: before the fire, with its legs held elegantly side by side, but alert to what is taking place at the chessboard. This is one of the seventeenth-century works in which the cat's role as a domestic animal is most obvious.

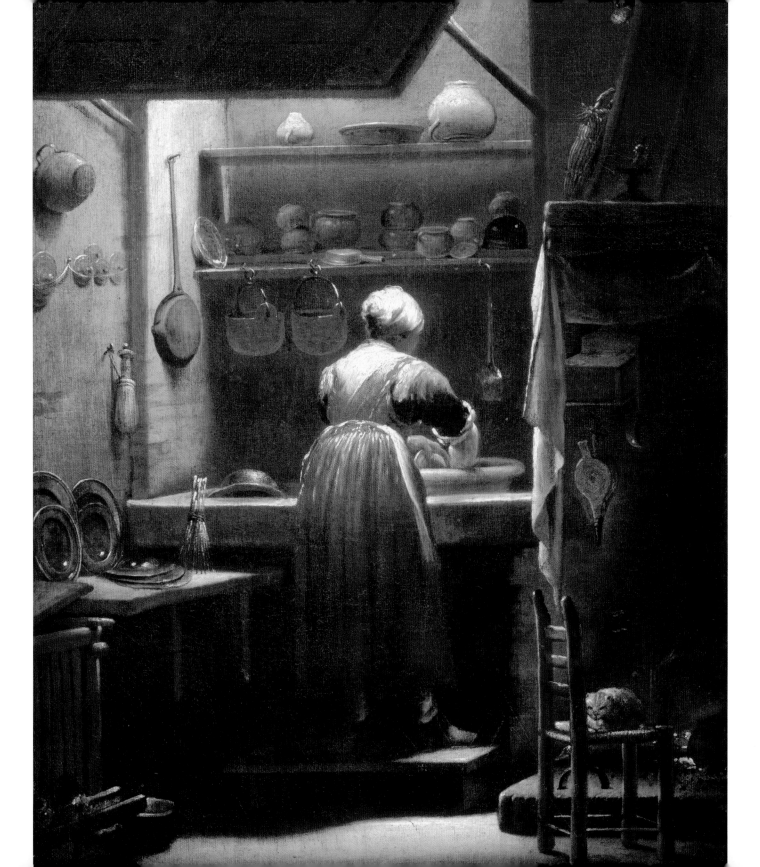

GIUSEPPE MARIA CRESPI (1665–1747)

The Scullery Maid, 1710–15

Oil on canvas, 16 x 12 in. (42 x 30 cm)

UFFIZI GALLERY, FLORENCE, ITALY.
CONTINI BONACOSSI COLLECTION

This small canvas—delightful and at the same time gently melancholic—belongs to the Bolognese painter's middle period. During the time he worked for the Grand Duke of Tuscany, Crespi came into contact with the Flemish-Dutch style and painted a series of small genre pictures that reveal his ability to portray settings, human encounters, and episodes drawn from real-life experience. The girl is relegated to a corner of the kitchen, where she is seen from behind washing the dishes—almost a symbol of a faceless existence. Yet, in the robust arms in their rolled-up sleeves and in the order that is gradually imposed around the sink, we can glimpse determination, meticulousness, and the desire to perform one's work well, however modest it may be. In the solitude of the kitchen, in the corner warmed by the hot coals that still glow in the fireplace, there appears the unmistakably rounded outline of a sleeping cat, a silent, discreet companion in the young scullery maid's life.

GIUSEPPE MARIA CRESPI (1665–1747)

The Farmhouse: Courtyard Scene, 1710–15

Oil on canvas, 30 x 35 in. (76 x 90 cm)

PINACOTECA NAZIONALE, BOLOGNA, ITALY

Moments and scenes of everyday life, captured with the lucidity and engagement of a seventeenth-century Dutch painter: this is the quality found in the many genre scenes painted by Crespi, for whom even an insignificant domestic episode could become a universal, eternal model. A great cat lover, the Bolognese painter introduced them in a variety of works with both secular and sacred themes, often giving them a leading role, rarely a merely decorative one. In this painting, too, the presence of cats in key positions—one lying above the portico, the other intent on getting the attention of the man who is relieving himself and thereby provoking a torrent of abuse from an old hag—has the power to draw the viewer's eye. And yet, despite the subject's banality, even grossness, this scene barely lit by twilight has its own intimate dignity, thanks to the composure of the women workers and the little girl, and to the extraordinary treatment the painter has given it.

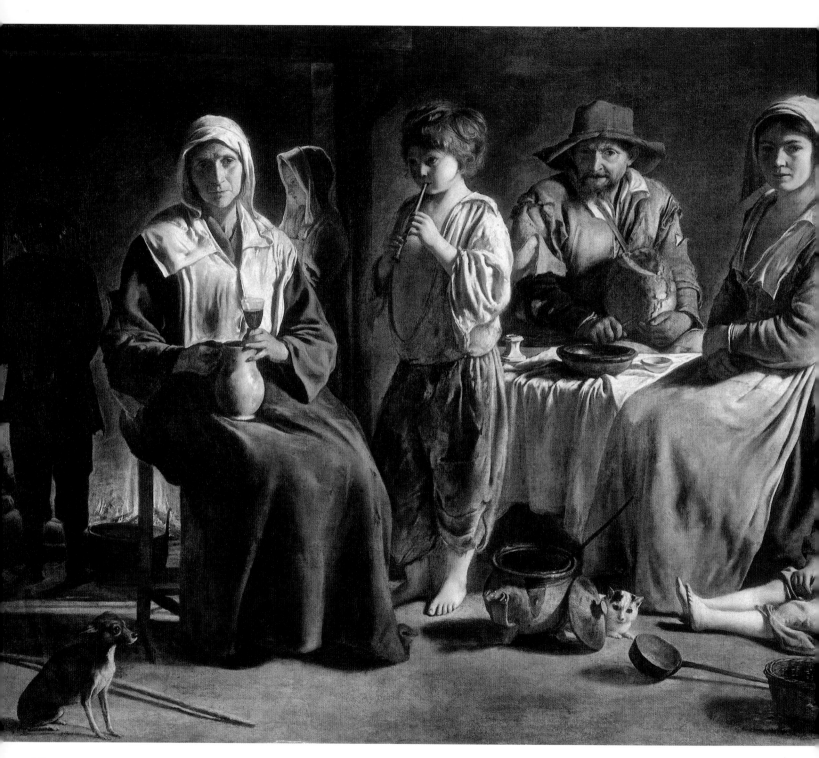

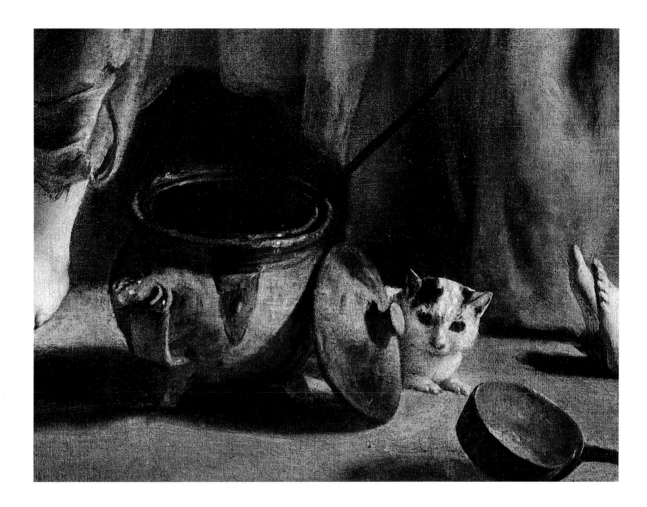

THE LE NAIN BROTHERS (Louis and Antoine, c. 1600–1648; Matthieu, c. 1607–1677)

Peasant Family in an Interior, 1648

Oil on canvas, 44 x 62 in. (113 x 159 cm)

MUSÉE DU LOUVRE, PARIS

The work of the Le Nain brothers is characterized by the poetry of humble folk and peasants—especially in the case of Louis, the most gifted—and cats are often companions in their simple lives. In an unadorned domestic interior, lit by the fire in the background and by an unknown exterior light source, the peasants are concentrating on the young piper's playing; at the same time, they look at us serenely, making us a part of their world. Even the little black-and-white cat, half hidden behind the lid of an earthenware pot, seems to be watching the viewer: Is it also listening to the music, or is it a bit frightened by it? Or is it simply hiding from the thin little dog, enraptured by the music like everyone else?

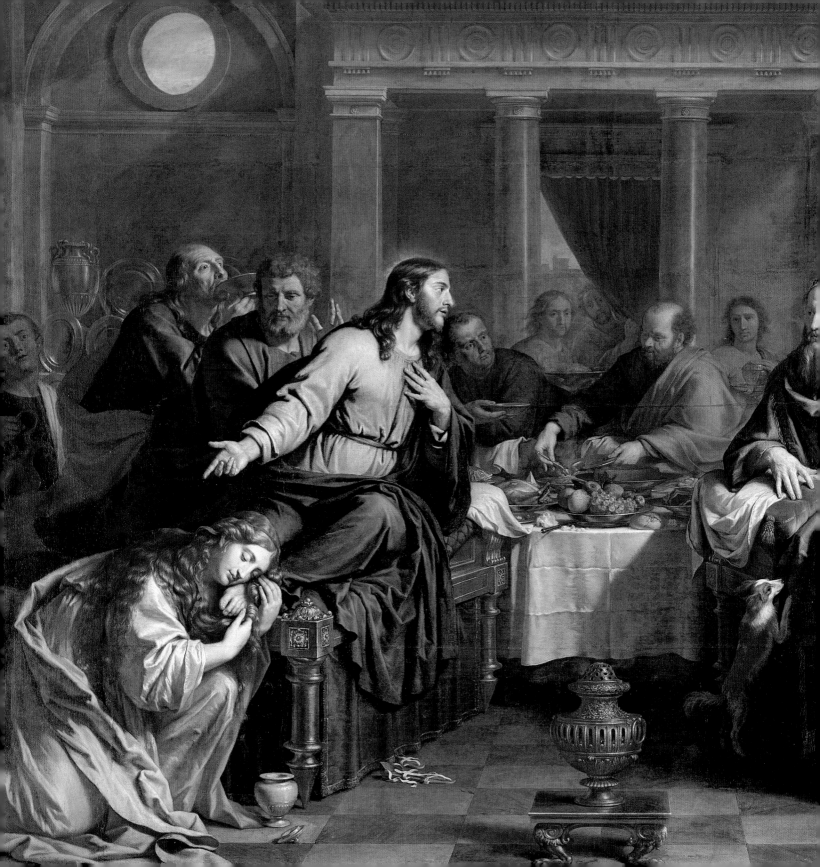

PHILIPPE DE CHAMPAIGNE (1602–1674)

Christ in the House of Simon the Pharisee, c. 1656

Oil on canvas, 9.6 x 13.1 ft. (2.9 x 3.9 m)

MUSÉE DES BEAUX-ARTS, NANTES, FRANCE

A charming little tabby cat often appears in the work of Philippe de Champaigne, who depicts the animal in minute detail and introduces it even in his most sacred paintings. The court artist and great portraitist of Richelieu perhaps intended in this way to pay homage to one of the powerful cardinal's passions—cats. As in the work of Charles Le Brun, the learned Jansenist of Port-Royal and an expert on Christian iconography, the presence of animals takes on a meaning that goes beyond that of a mere accessory. In this imposing work, painted for the Val-de-Grâce, the presence of a little dog, attempting to jump into its master's lap, cannot be accidental; neither can that of the little tabby cat, the only figure in the painting that looks directly at the viewer, although it is half hidden by the feet of the triclinium, the antique Roman couch on which the pharisee reclines. Both animals could be symbols of the conflict between Jesus and the pharisee regarding the episode of Mary Magdalene.

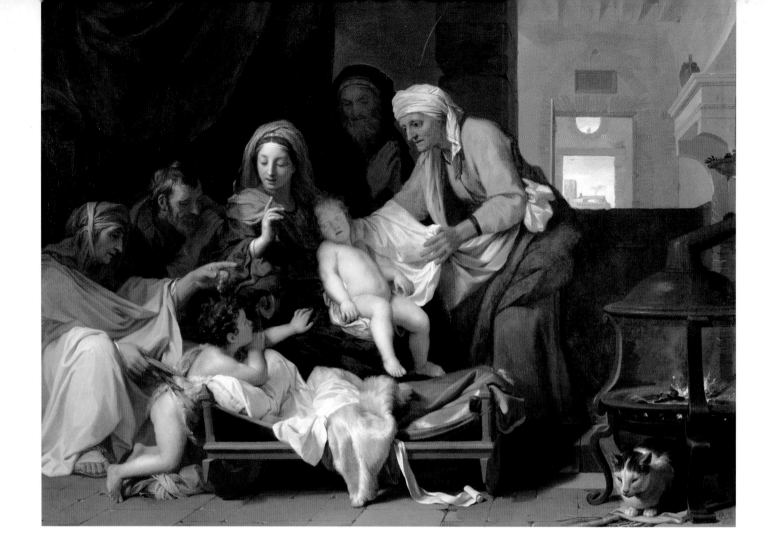

CHARLES LE BRUN (1619–1690)

The Sleep of the Infant Jesus, 1655

Oil on canvas, 34 x 46 in. (87 x 118 cm)

Musée du Louvre, Paris

A big, placid, white-and-gray striped cat seems to have fallen asleep by the warmth of a burning brazier; however, it is not quite asleep, for its ears are pricked up. Soon the room will be quiet. As St. Anne lovingly covers the child, the Virgin, with a gentle but firm gesture, asks the lively young St. John to be silent; perhaps the older cousin was gleefully poking Jesus as he slept. The cat's highly conspicuous position has led critics to suppose that its presence is not merely decorative—especially in the work of a theoretician of Le Brun's caliber—but is in some way connected with the painting's meaning: it relates to the "sleep" of Christ, that is, his unawareness of the Passion until the moment of Revelation.

CHARLES LE BRUN
(1619–1690)

Physiognomical Resemblances Between the Head of a Man and That of a Cat, c. 1670

From *Livre de portraiture pour ceux qui commencent à dessiner* (*Book of Portraiture for Those Who Are Beginning to Draw*)

Engraving

Bibliothèque des Arts Décoratifs, Archives Charmet, Paris

Beginning in 1667 Charles Le Brun, the Sun King's favorite painter, held a conference at the Royal Academy of Painting and Sculpture on the subject of "general and particular expression," that is, the human passions as reflected in facial expressions, and their modes of representation in painting. One of the most modern aspects of Le Brun's physiognomical theories is based on a psychological equivalence between human and animal. Acting as a link between Leonardo da Vinci's insights on physiognomy and the more modern fancies of Goya, Le Brun tried to arrive at a precise determination of both human and animal nature. According to this artist and theoretician, it was possible, utilizing geometric procedure, to calculate the type of emotion experienced based on a human or animal's face. Often a similarity in geometric lines led Le Brun to identify feline with human characteristics, as in these cat-humans.

ALEXANDRE-FRANÇOIS DESPORTES (1661–1743)

Two Studies of Young Cats, c. 1710

Oil on paper, 11 x 20 in. (27 x 51 cm)

FITZWILLIAM MUSEUM, UNIVERSITY OF CAMBRIDGE, ENGLAND

It is in his studies, most of them in oil on paper, that we can best observe the preliminary work for Desportes's more complex painted scenes. The anatomical study of cats, the analysis of movement, muscles, and expressions clearly point to careful observation from life. Desportes often took part in royal hunts in order to capture naturalistic images from life and transfer them onto canvas. All the animals depicted—from game to wild boar, from dogs to horses, and including cats—provided the basic elements used by the painter to produce grandiose hunting trophies, aimed at glorifying one of the Sun King's favorite pastimes.

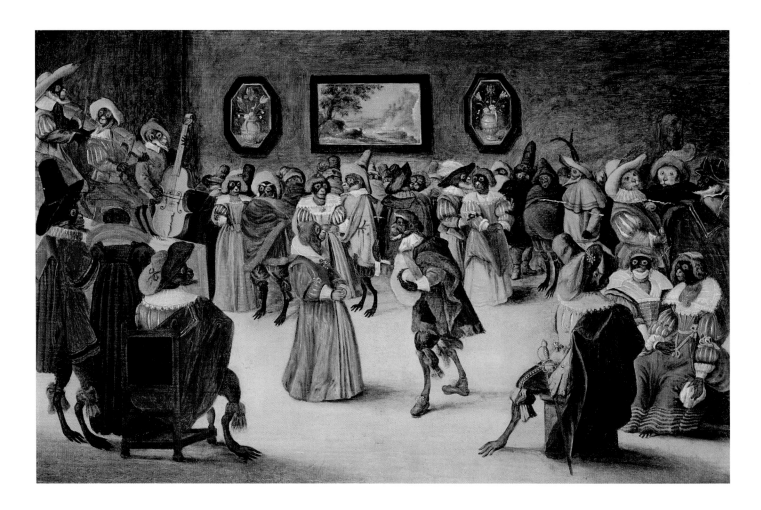

ANONYMOUS FLEMISH MASTER (17th century)

Monkeys and Cats at a Masked Ball, 1632

Oil on wood, 10 x 17 in. (25.7 x 42.6 cm)

PRIVATE COLLECTION

The immense richness of seventeenth-century Flemish and Dutch art allowed room for satirical paintings that car-icatured the customs, fashions, and fads of the time. In this singular painting, whose artist remains unknown, human characters are replaced by little monkeys in costume—a sort of "world upside down." The monkeys, indeed, are taking part in a masked ball disguised as humans, and in doing so have apparently failed to notice that some cats, similarly dressed, have joined them. The classic contrast between cats and monkeys—present in other works where the fortunes of the two animals vary—is represented here in a strange way that, despite the apparent play-fulness, is subtly disturbing.

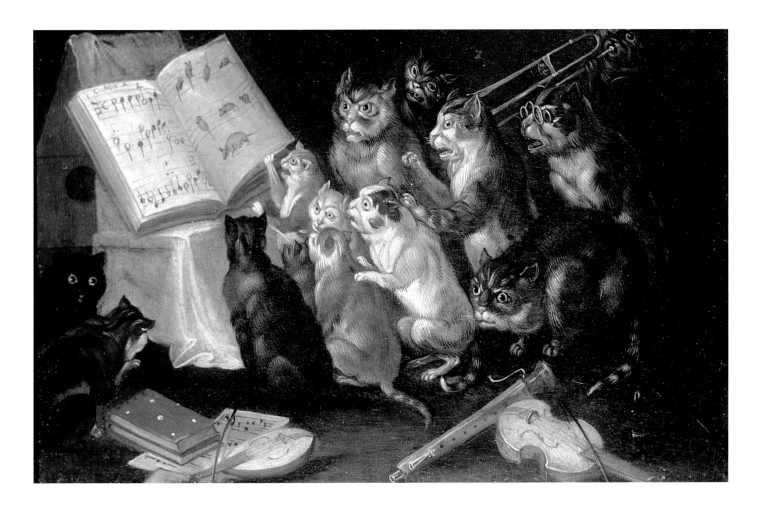

FERDINAND VAN KESSEL (1648–1696)

Cats' Concert, c. 1670

Oil on canvas, 16 x 32 in. (40 x 82 cm)

PRIVATE COLLECTION

What is noisier, the barking of dogs or the yowling of mating cats? In various languages and dialects, the words or expressions that denote jumbled and annoying noise derive from the "concerts" of cats and dogs. In this case, the supporters of dogs and cats are divided. However, there is no doubt that the cat, unexpectedly, can produce a repertory of song that is entirely worthy of respect. Nocturnal serenades (often interrupted by the hurling of some object on the part of exasperated, sleepless people) or furious fights reach very high decibel levels. Van Kessel, a witty painter of animals who usually specialized in multihued musical gatherings of songbirds, depicts cats brilliantly in this painting.

FRANS SNYDERS

(1579–1657)

The Larder, 1642

Oil on canvas, 5.6 x 9.5 ft. (170 x 290 cm)

Musées Royaux des Beaux Arts, Brussels

This is one of the most sumptuous canvases by the painter from Antwerp who specialized in still lifes. Showing the typically Flemish taste for the *kermesse*—the riotous peasant celebration—and for the abundance of good things, Snyders takes us into a larder filled with food, a feast for the eyes and the palate. This is a decidedly optimistic vision, in contrast to the difficult period in central northern Europe, which had been tormented by the endless and devastating Thirty Years' War. Whereas in other countries the still life was loaded with moral significance (for example, taking on the characteristic appearance of *vanitas,* the allegory of the transitory nature of worldly goods), the Flemish Snyders prefers an outpouring toward the viewer of a rich cornucopia of delicacies. Needless to say, such a place is a true kingdom, a bewitching playground for cats. Our friend, visible at the bottom center of the picture, is furtively hurling himself on to a plate filled with fish.

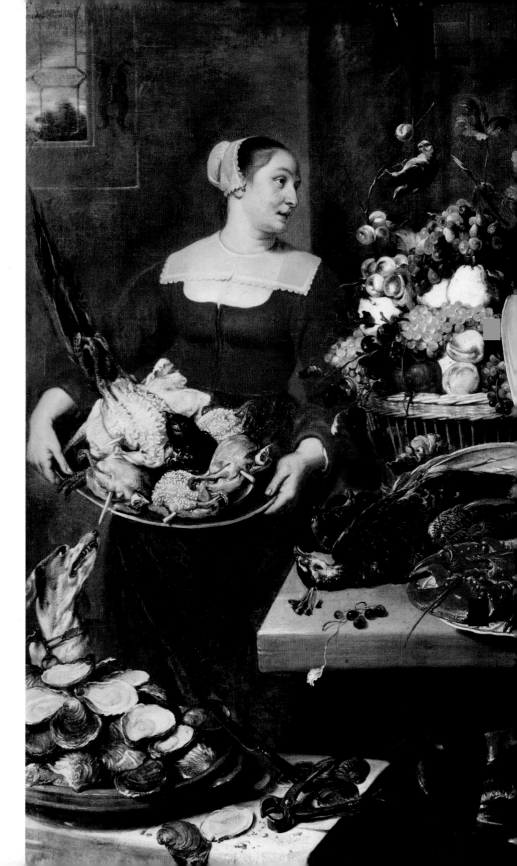

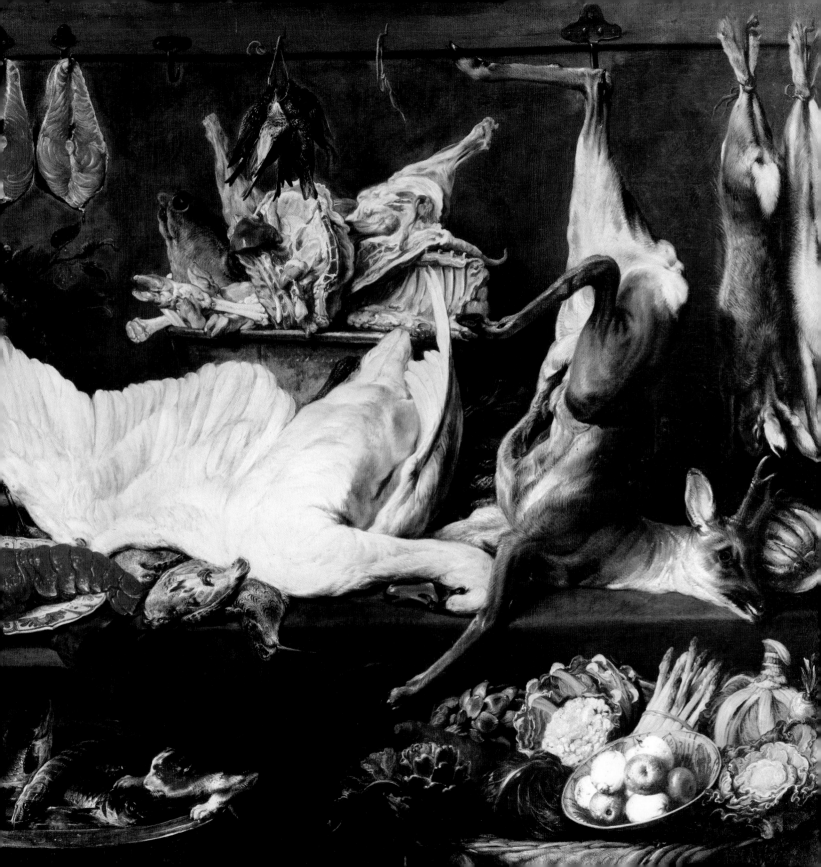

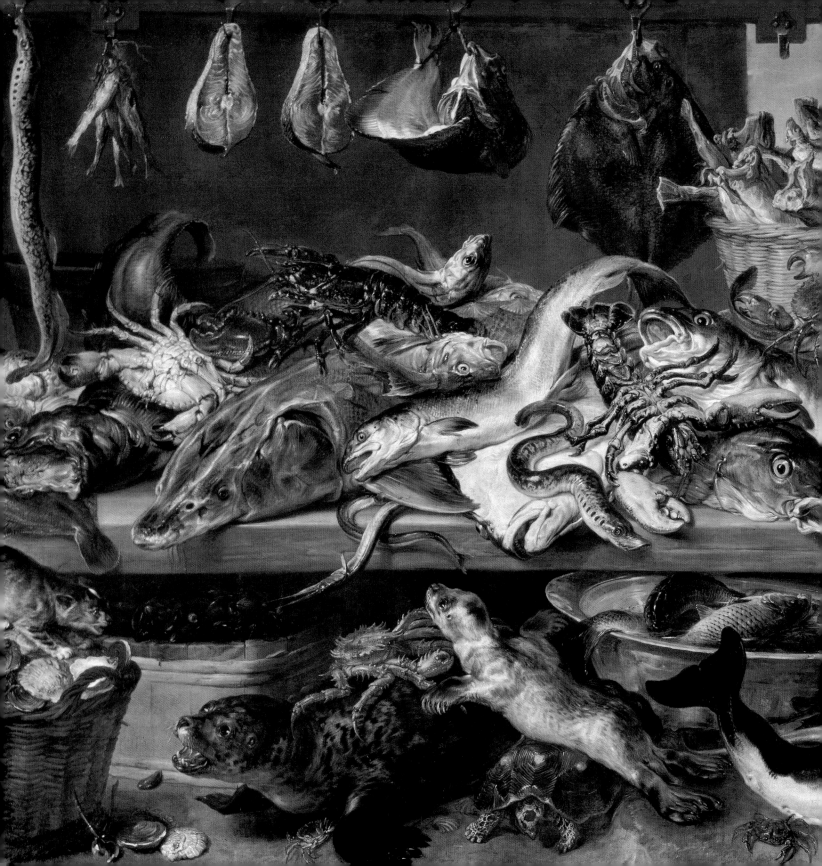

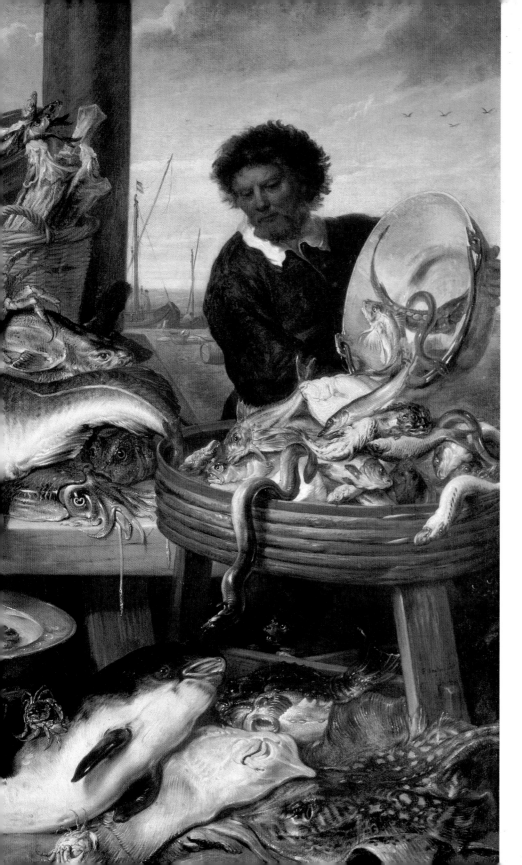

FRANS SNYDERS
(1579–1657)

The Fishmonger's Shop, c. 1640
Oil on canvas, 6.9 x 11.2 ft. (2.1 x 3.4 m)
HERMITAGE, ST. PETERSBURG, RUSSIA

In the history of painting, and naturally in our everyday experience, we can observe how fishmongers are a favorite haunt of cats. Generally, they are not welcome there: fishmongers watch out for their sly filching; and only in exceptional cases, perhaps resignedly making the occasional concession, they allow cats among the stalls, considering their presence an indication of the freshness of their wares. This offers an interesting opportunity for a great animal painter of the early seventeenth century—Frans Snyders, a close collaborator of Rubens in Antwerp—who shows himself here to be skilled in the portrayal of reality, demonstrating great virtuosity. It is a scene of Pantagruelian proportions—over three meters (more than ten feet) wide, a spectacular celebration of the riches of Neptune. It features not only fish, but also crustaceans, cetaceans (marine mammals), even seals. However astonishingly rich Antwerp's shops may have been, Snyders uses the market stall as a pretext for creating a Baroque representation of overflowing abundance. The cat, lying in wait on the far left of the painting, serves to restore some semblance of credibility to the scene.

JAN FYT (1611–1661)

Still Life with Gun and Cat, c. 1650

Oil on canvas, 37 x 48 in. (95 x 122 cm)

MUSÉE DU LOUVRE, PARIS

A trusted collaborator of Rubens, Fyt was one of the distinctive personalities of Flemish painting: his speciality was the still life depicting game, in which he could exhibit his extraordinary talent for painting fur and feathers. Indeed, it could be argued that Fyt was a pioneer of this peculiar genre, which was to become extremely popular during the seventeenth and eighteenth centuries. Yet, even though he specialized in one type of subject, Fyt was not a monotonous painter: with each new canvas he would devise an original approach, introduce unusual elements, or add new details. This "harlequin" cat, alive and active alongside the dead game, is a brilliant, credible presence, and analogous to similar cats in paintings of pantries and kitchens.

PAUL DE VOS (c. 1596–1678)

Cats in a Larder, 1663

Oil on canvas, 45 x 67 in. (116 x 172 cm)

MUSEO DEL PRADO, MADRID

De Vos's cats are truly wild! One after the other, they fling themselves from the small window of a pantry (it appears to be in a basement) and roll around indecorously, in poses that seem incompatible with the usual feline dignity and composure. On the other hand, fights between rivals in love or, as in this case, over food provide examples of how even the most placid household pussycats, on occasion, can let themselves go in rowdy commotion. This band of rough stray cats has been attracted by the presence of tasty birds. De Vos creates a lively image, verging on caricature: bulging eyes, flattened ears, and jaws gaping greedily. If we were not looking at the work of a Flemish Baroque painter, interested in creating a striking image, we could see in these cats an almost demonic incarnation of the deadly sin of gluttony.

ALEXANDRE-FRANÇOIS DESPORTES (1661–1743)

A Cat Attacking Dead Game, 1711

Oil on canvas, 48 x 42 in. (123 x 108 cm)

Rafael Valls Gallery, London

A great animal painter, Desportes studied under a pupil of Frans Snyders, a factor that greatly influenced his choice of subject. Before leaving for Poland, where he went into the service of King Jan Sobieski, he had already made contact with the court of the Sun King; but it was only after he had returned to his homeland that Desportes became the first French artist to devote himself entirely to hunting and animal scenes. He was appointed by Louis XIV as painter of his hunting lodge; and besides decorating many royal apartments, he specialized in various techniques, even providing designs for the tapestries produced by the Gobelins' tapestry manufactory. Although he devoted much of his output to the king's dogs that, thanks to his brush, have been immortalized, there are also scenes among his vast number of hunting pictures that feature cats as protagonists. Of these paintings, this is one of the most expressive: a lively cat is trying to snatch a bird from the pantry.

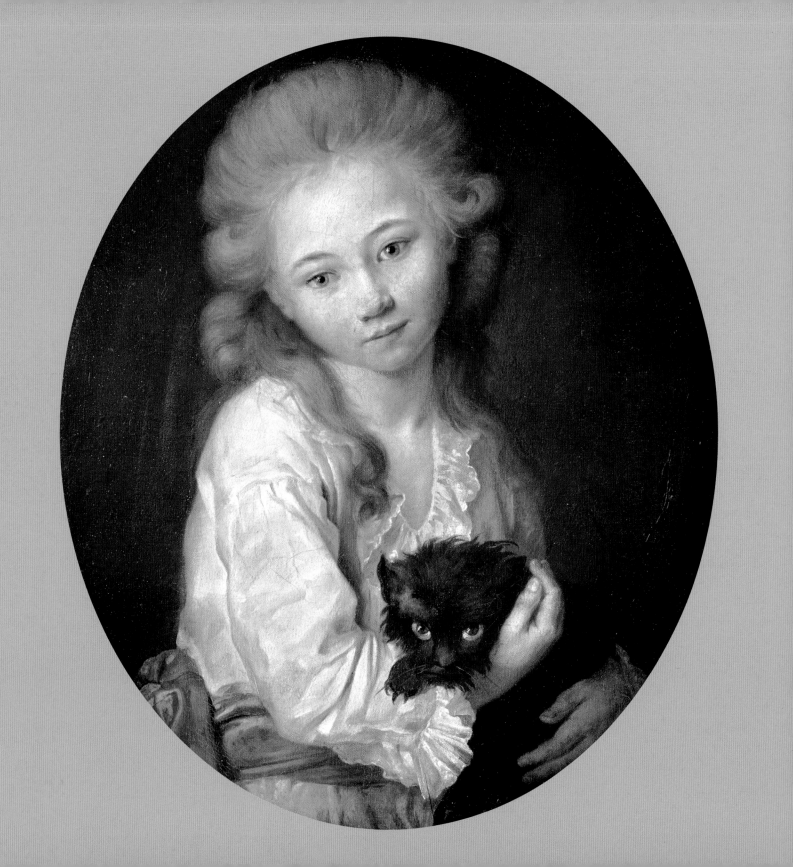

FROM THE ENLIGHTENMENT TO ROMANTICISM

Reason and Sensuality in the Nascent Bourgeois Europe

GIOVANNI REDER

JEAN-BAPTISTE SIMÉON CHARDIN

FRANÇOIS BOUCHER

JEAN-BAPTISTE PERRONNEAU

JEAN-HONORÉ FRAGONARD

WILLIAM HOGARTH

SIR JOSHUA REYNOLDS

THOMAS GAINSBOROUGH

JOSEPH WRIGHT OF DERBY

GIACOMO CERUTI

FAUSTINO BOCCHI

GIUSEPPE BALDRIGHI

JOSÉ DEL CASTILLO

GEORGE STUBBS

THÉODORE GÉRICAULT

JEAN ALAUX

JOHANN FRIEDRICH OVERBECK

SIR EDWIN LANDSEER

IN THE EIGHTEENTH CENTURY, THE IMAGE OF THE CAT ACQUIRED A new set of attributes: sensuality, malice, and seduction. Amid the rustle of Rococo sheets and women's underskirts, the complicit image of the cat insinuated itself: its lithe body, agile and at the same time cuddly form, flashing glance, the elusive yet magnetic expression of the almond-shaped eyes, even the sudden lashing out of claws, the indolent stretching, the demands to be caressed, and the fondness for playful nibbling aroused a titillating fascination. The refined eroticism and risqué allusions in eighteenth-century painting revealed, for the first time, the sensuousness of the feline's movements, opening up a vein that would prove highly popular in later centuries, culminating in the identification of "kitten" with femme fatale.

The range of symbolic allusions became even richer, rendering the domestic cat even more disturbing, enough to discomfit the philosophers and intellectuals of the Enlightenment, lovers of rationalism, order, and knowledge that can be classified. Diderot himself, founding father of the *Encyclopedia*, had to admit, in a pithy, eloquent phrase, that "there are cats and cats," and that any rigorous definition would be reductionist. On the other hand, the popular belief attributing nine lives to a cat also expresses its multifaceted nature; and it is nice to imagine Voltaire smiling at some trick played by the house cat.

A new phenomenon in the art of the second half of the eighteenth century—not relating, of course, only to cats—was the appearance and rapid growth of an English school of painting, starting with Hogarth and followed by the founding of the Royal Academy in 1768. This introduced a series of novelties to the international painting scene. Certainly one of the most interesting is a very special sensitivity to nature, a relationship with domestic animals, with gardens and the countryside rather different from that of continental Europe. The subjects depicted by the English school could not fail to include the cat, which often is not portrayed in its typical circumstances, for example, romping through rooms, about to pounce on something in the kitchen, or dozing by the

PAGE 190: Jean-Baptiste Greuze, *Espirit de Baculard d'Arnaud* (*The Son of François Thomas de Baculard d'Arnaud*), 1776. Oil on oval canvas. Musée des Beaux-Arts, Troyes, France. This boy, his hair and clothes in the style that was fashionable at the time, is portrayed by the French artist holding a kitten in his arms, in keeping with the new trend that had emerged in eighteenth-century English painting.

fireside. English cats—like those, it must be said, depicted in the love scenes of French paintings of the same period—are instead picked up and held by their masters, a gesture that today may seem commonplace but, on closer inspection, has few precedents in art. Cats appear in paintings by some of the greatest eighteenth-century English painters, such as Hogarth and Gainsborough, and are sometimes portrayed playing with children. A new cultural and social phase was emerging: the fruits of the Industrial Revolution provided the basis for the middle class's assertion; and the cat would soon also assert itself as a characteristic presence, almost the embodiment of the comfortable, "modern" household. In parallel, similar developments can be found in the nascent American school of painting, which was proudly autonomous for political reasons but, in fact, culturally very closely linked to the British. And these developments were to be confirmed, in the following decades, by writers and poets of the caliber of Mark Twain and Emily Dickinson.

The period spanning the end of the eighteenth century and the beginning of the nineteenth is unquestionably one of the most complex and interesting in Western history. The crisis of the ancien régime, American independence, the French Revolution, the development of technology and manufacturing, and the Napoleonic epic all followed one another in rapid succession, changing the world with each passing decade. The cat faced up to this age of revolution and change with its customary nonchalance and proverbial adaptability: we have already been able to appreciate its absolute, "democratic" crossing of social boundaries. Among other things, the new voyages that were being made (for colonial or simply for cultural purposes) toward Egypt and the Orient brought contact with new feline breeds of Asian origin.

The Grand Tour, a long journey undertaken for cultural education, was a widespread custom among European intellectuals and artists during the eighteenth and early nineteenth centuries. Writers and painters from France, the German states, England, Scandinavia, Russia, and other countries considered it essential to spend time in Italy to study

the ancient world and the Renaissance, to enjoy the Mediterranean light and climate, and to admire the balance between nature's beauty and ancient architecture. There emerged a particular genre of landscape—the "Italian view"—characterized by passion and luminosity, and often subtly nostalgic. The most important destination of these journeys to Italy was naturally Rome, which had reverted to being, once again, the international cultural model, especially during the Neoclassical period. Now, it is well known that Rome is a city with a large and proud feline population. The sturdy cats that frequent the Forum, Colosseum, and Theater of Marcellus, for example, form a sort of vagabond yet indisputably noble elite among the legions of cats that populate the ruins, markets, and squares of the Eternal City. The international horde of painters engaged in the Grand Tour could not, of course, ignore these cats; in studies and images, of gatherings in inns or scenes of working-class life in Rome, a cat, if you look carefully, is always present. Indeed, during the months or years they spent in Rome, some painters got into the habit of keeping a cat, thus discovering how therapeutic, soothing, and relaxing it is to spend a moment stroking a cat, along with the satisfaction of having been "chosen" by such an independent and self-sufficient animal. During the very years when Goya was painting demonic cats, with staring, flashing eyes, gripped by the horrible nightmares of madness, the painter Jean-Auguste Dominique Ingres—the supreme master of style for generations of artists and a longtime resident of Rome—would relax by playing the violin or stroking his tabby cat, applying to perfection the maxim of Albert Schweitzer, for whom music and cats were the best refuge from human misery.

Théodore Géricault, (Detail) *Portrait of Louise Vernet as a Child*, 1819–24. Oil on canvas (see p. 227). Musée du Louvre, Paris. Following the eighteenth-century fashion for depicting cats held in the arms of their owners, Géricault portrayed Louise, daughter of the well-known painter Horace Vernet, posed with an enormous cat.

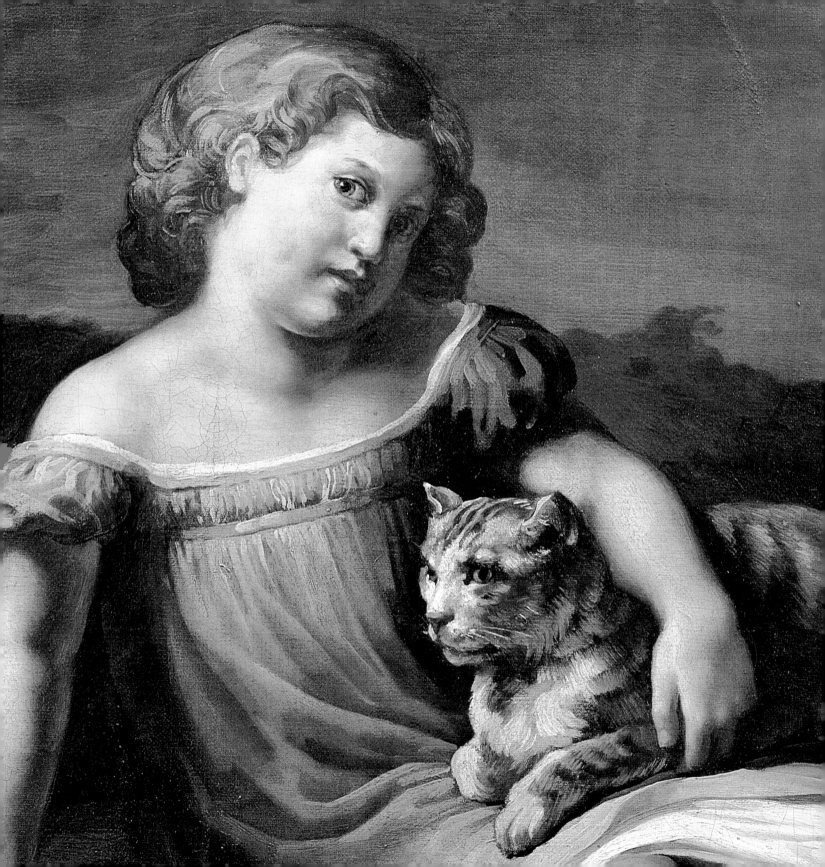

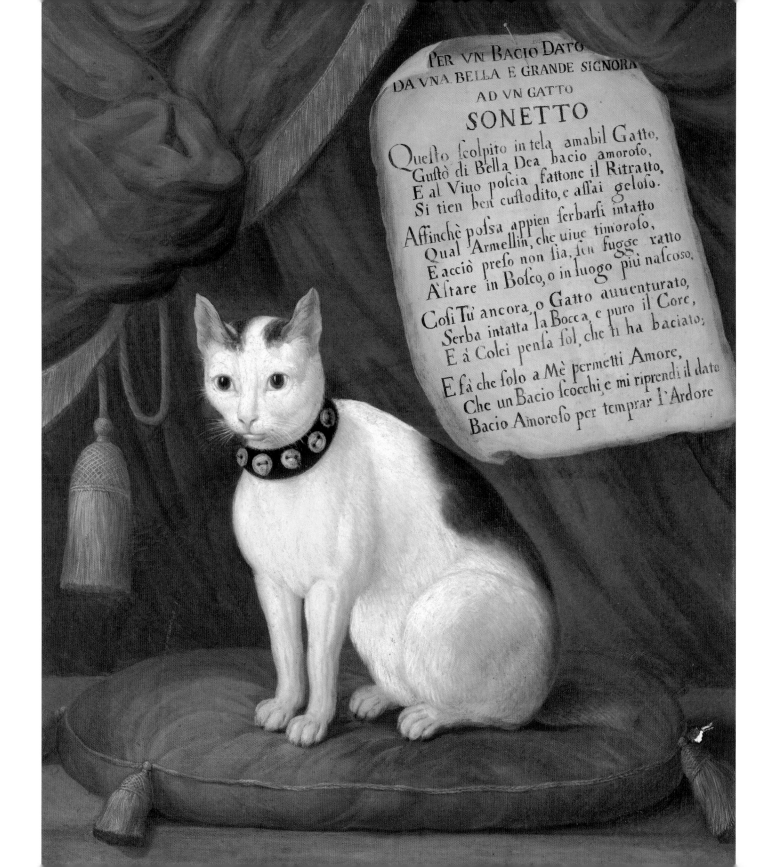

PER VN BACIO DATO
DA VNA BELLA E GRANDE SIGNORA
AD VN GATTO
SONETTO

Questo scolpito in tela amabil Gatto,
Gustò di Bella Dea bacio amoroso,
E al Viuo poscia fattone il Ritratto,
Si tien ben custodito, e assai geloso.

Affinchè possa appien serbarsi intatto,
Qual Armellin, che uiue timoroso,
E acciò preso non sia, sen fugge ratto
A stare in Bosco, o in luogo piu nascoso.

Cosi Tu ancora, o Gatto auuenturato,
Serba intatta la Bocca, e puro il Core,
E à Colei pensa sol, che ti ha baciato;

E fà che solo a Mè permetti Amore,
Che un Bacio scocchi e mi riprendi il dato
Bacio Amoroso per temprar l'Ardore

GIOVANNI REDER

(1693–after 1764)

Portrait of the Cat Armellino with a Sonnet by Bertazzi, c. 1750

Oil on canvas, 30 x 24 in. (76 x 62.5 cm)

MUSEO DI ROMA, ROME

Very few cats can boast that they have actually had their portraits painted, that is, that they have been depicted without any allegorical, moralizing, religious, esoteric, or simply decorative intent on the part of the artist. Unlike other animals regarded as more deserving of immortality (especially dogs and horses), our feline is very rarely considered a subject worthy of an individual portrait. If we exclude the splendid examples of Sir Henry Wyatt's cat, painted by Hans Holbein the Younger (in the Louvre in Paris), the cat Armellino deserves to figure among the rare, true portraits of the animal in the modern age. The pet of Alessandra Rospigliosi Forteguerra, an eighteenth-century Roman poet, Armellino, wearing an elegant little collar, has literally posed on a luxurious cushion; a sonnet by the abbot Bertazzi has even been dedicated to him.

For a Kiss Bestowed on a Cat by a Beautiful and Great Lady

SONNET

This lovable Cat committed to canvas
Enjoyed a loving kiss from a Beautiful Goddess
And thus having been portrayed from Life,
It guards itself most jealously.

In order that it may keep itself pure
Like Armellino, who lives in fear,
And in order not to be caught, it swiftly flees,
To dwell in a Forest or a more hidden place.

Likewise You, Oh fortunate Cat,
Keep your Mouth unsullied and your Heart pure,
And think only of She who kissed you.

And permit only Me to love you
So that a Kiss may be given, and that you may take this
Loving Kiss from me to temper your Ardor.

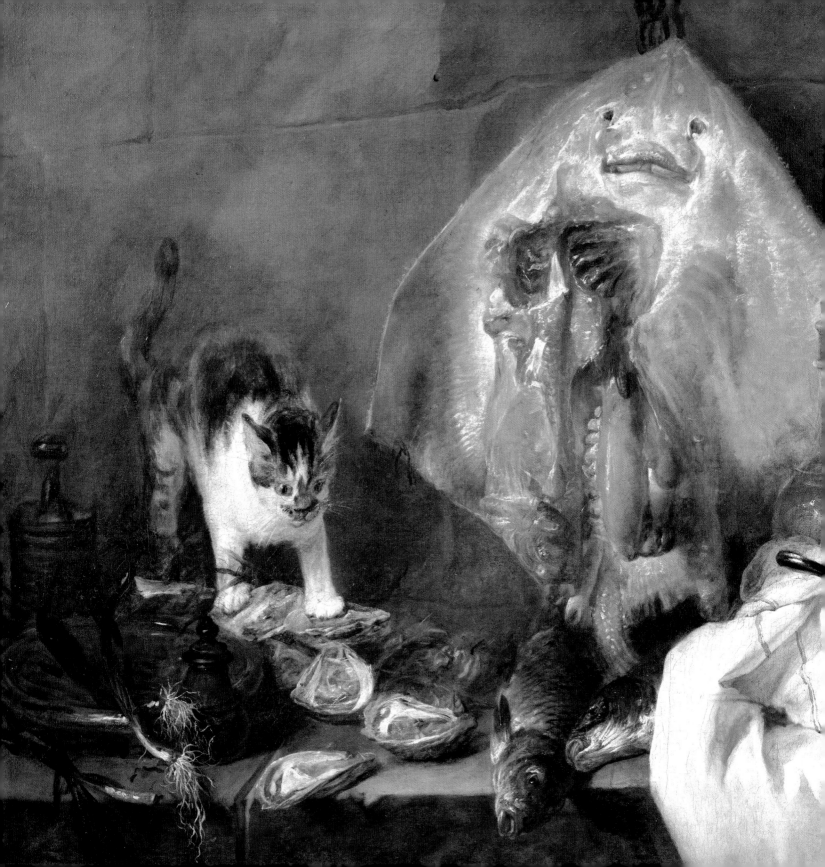

JEAN-BAPTISTE SIMÉON CHARDIN

(1699–1779)

The Ray, 1725–26

Oil on canvas, 44 x 57 in. (114 x 146 cm)

Musée du Louvre, Paris

Exhibited for the first time in 1728 in the Place Dauphin on the occasion of the Fête-Dieu procession, the painting elicited this astonished comment from Diderot: "It is the fish's very flesh, its skin, its blood!" After Rembrandt's *Slaughtered Ox* (1655), very few had applied themselves so assiduously to painting still lifes; not even Snyders, Oudry, or Desportes had taken realism so far. Diderot would observe how those objects were simply waiting to be seized, those foods eaten, those bottles opened and drunk. The secret and the magic of Chardin's paintings lie in their cold, sterile light, which seems to saturate objects, and in the intimate absorption that seems to endow them with a timeless existence. The only living presence—and it is very much alive, with its bristling fur and demonic eyes—is the cat, who is more interested in the fish placed on the table than in the huge sea monster in the background. The painting and its feline protagonist were also immortalized by Marcel Proust, who opens a memorable critique and reinterpretation of Chardin with a description of this canvas.

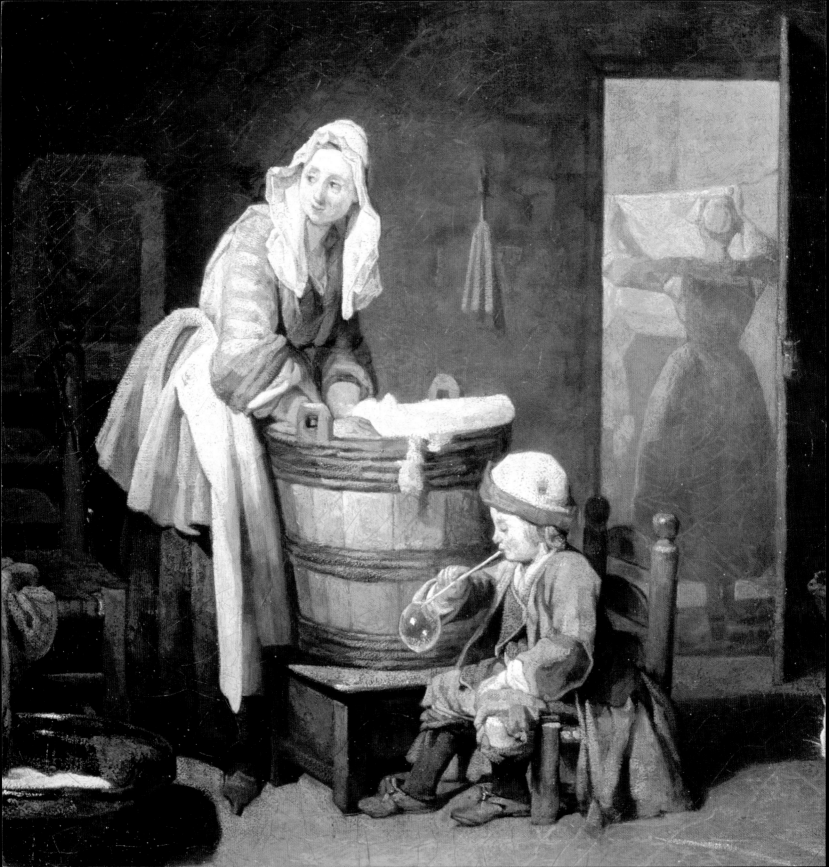

JEAN-BAPTISTE SIMÉON CHARDIN (1699–1779)

The Washerwoman, 1733

Oil on canvas, 14 x 17 in. (37 x 42.5 cm)

HERMITAGE, ST. PETERSBURG, RUSSIA

This docile three-colored cat belonged to the artist since 1728 (the year that *The Ray* was first exhibited) and often appears in his paintings. Crouched in an almost perfect oval shape, it too is part of that poetic, inner world that Chardin portrays in his genre scenes and still lifes: human beings and objects, animals and settings, the animate and inanimate live autonomous, almost crystallized lives. This is not, however, a metaphysical style of painting: in the canvases of Chardin, an alert observer of the Dutch painting tradition, there is humanity and palpable intimacy. In this case, the domestic interior of a laundry with a woman hanging the wash to dry, the boy engrossed in blowing soap bubbles, and the main figure, busily working and absorbed in her own thoughts all exemplify a dignified, composed humanity, depicted in an atmosphere far removed from the pathetic or sentimental.

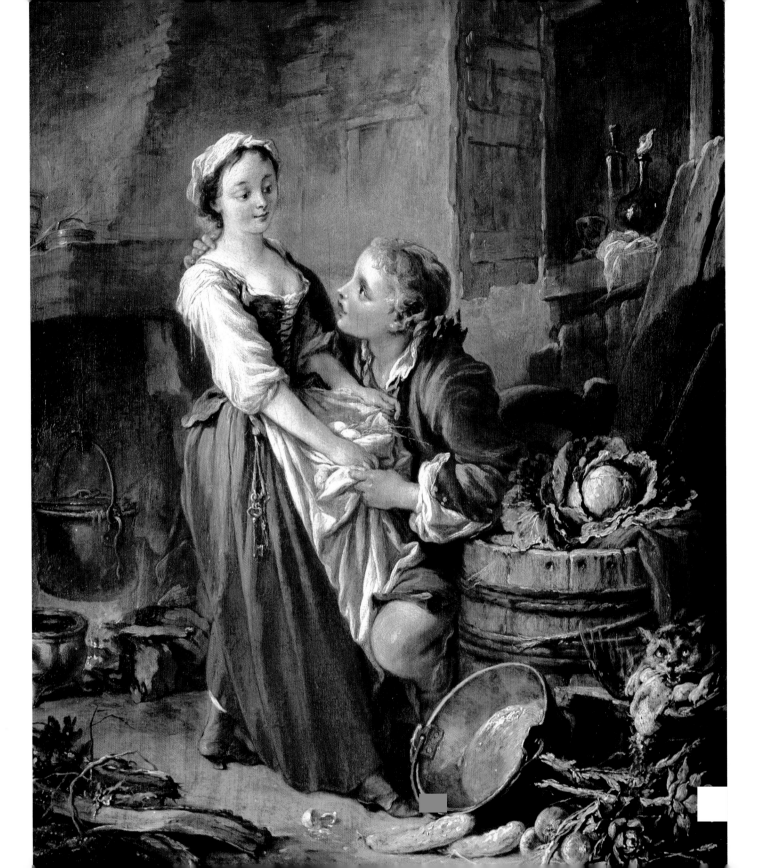

FRANÇOIS BOUCHER (1703–1770)

The Beautiful Kitchen Maid, 1732
Oil on canvas, 16 x 12 in. (41 x 31 cm)
Musée Cognacq-Jay, Paris

In the apparent simplicity of Boucher's paintings every element may contain an alternative meaning, chiefly connected to eroticism and gallantry, which the French artist became famous for portraying and sought after by the nobility of the time. The painter, as befits a perfect courtier, favored a particular type of woman: innocent and provocative, sensual and elegant, whose innate attractiveness leads every young man to make bold advances. Boucher's woman can only be accompanied by the domestic animal par excellence, which resembles her in its sensibilities and behavior, and is perhaps also a silent, harmless witness to her fêtes galantes. In this pantry there must therefore be a cat, a spectator and accomplice to the amorous idyll, but also a customary denizen of larders and food stores.

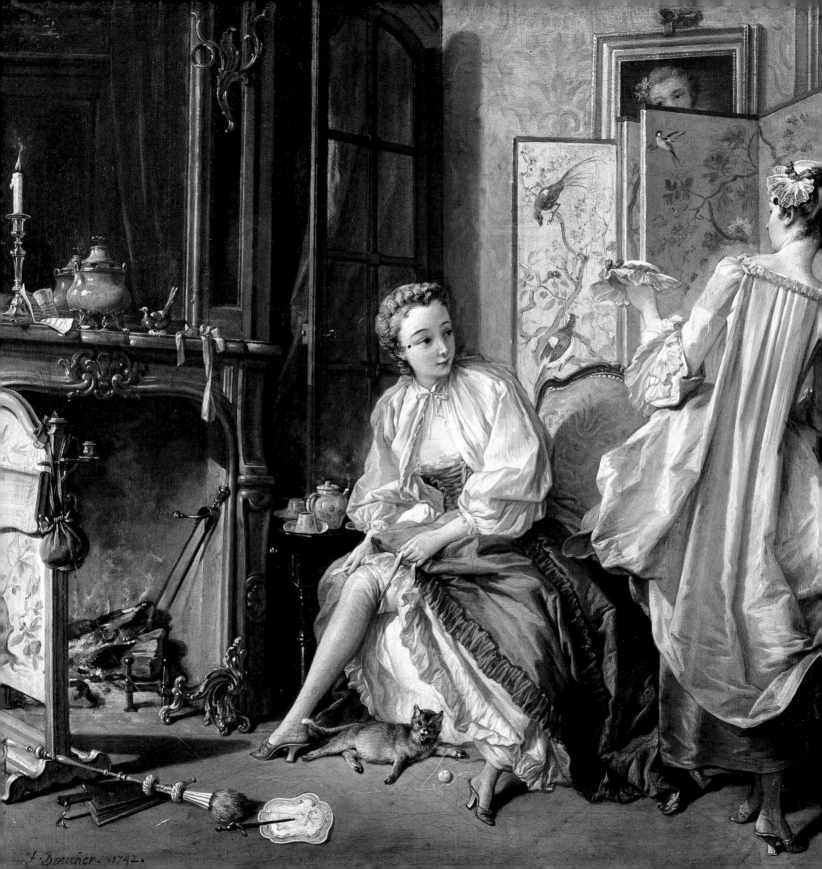

J. Boucher 1742.

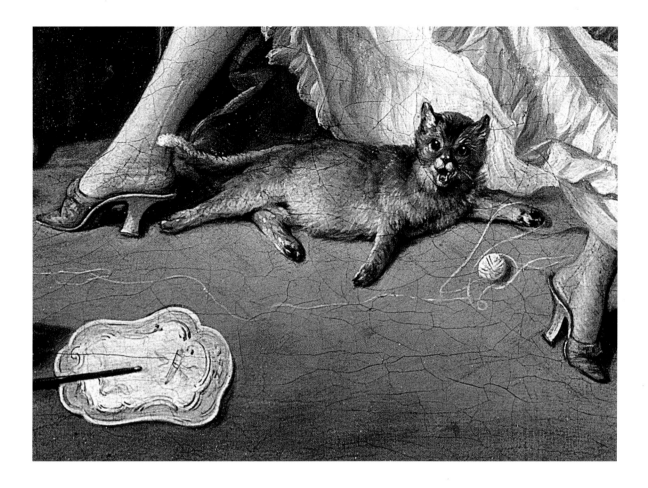

FRANÇOIS BOUCHER (1703–1770)

The Toilet, 1742

Oil on canvas, 21 x 30 in. (52.5 x 66.5 cm)

Museo Thyssen-Bornemisza, Madrid

In this painting, commissioned by Count Carl Gustaf Tessin, Swedish ambassador as well as devoted friend and admirer of Madame Boucher, every object is connected to the notion of cleanliness and order in preparing the morning toilet—from the little hat the maid holds in her hand to the steaming teapot, the Chinese screen to the dressing table containing the items needed for dressing and grooming. The cat, playing slyly with the ball of thread at the lady's feet, is one of the customary amorous touches of which the artist was fond, like the love letter and the garters left absent-mindedly on the mantelpiece. Its mewing—barely hinted at—is further confirmation of its complicity, but also a delightful device to indicate the presence of the painter who is portraying the lady and her maid. This scene is part of a series of four canvases depicting different intervals in the day of a noblewoman: morning, midday, afternoon, and night.

JEAN-BAPTISTE PERRONNEAU (1715–1783)

Girl with a Cat, 1757

Pastel on parchment, 18 x 15 in. (47 x 37.6 cm)

MUSÉE DU LOUVRE, PARIS

Throughout the history of art, Perronneau is undoubtedly one of the painters most fond of cats, which appear very frequently in his works, usually in the company of delightful young women with powdered faces. Only in the 1920s was the worth of this French artist finally recognized. During the nineteenth century he had been practically forgotten; and despite his considerable talent and his understanding of eighteenth-century fashion, even during his lifetime he never attained wide repute in Parisian cultural circles. In this work Perronneau displays all his talent as a colorist and portrait painter: attracted to the technique of pastel, he traveled tirelessly in France and other European countries in search of models for his portraits. In this adorable girl, and in the little gray cat that peeps out from a corner of the picture, Perronneau's gifts for intimacy and precise definition, along with the notable sense of color that characterize his work—second only to that of Maurice Quentin de la Tour—are clearly visible.

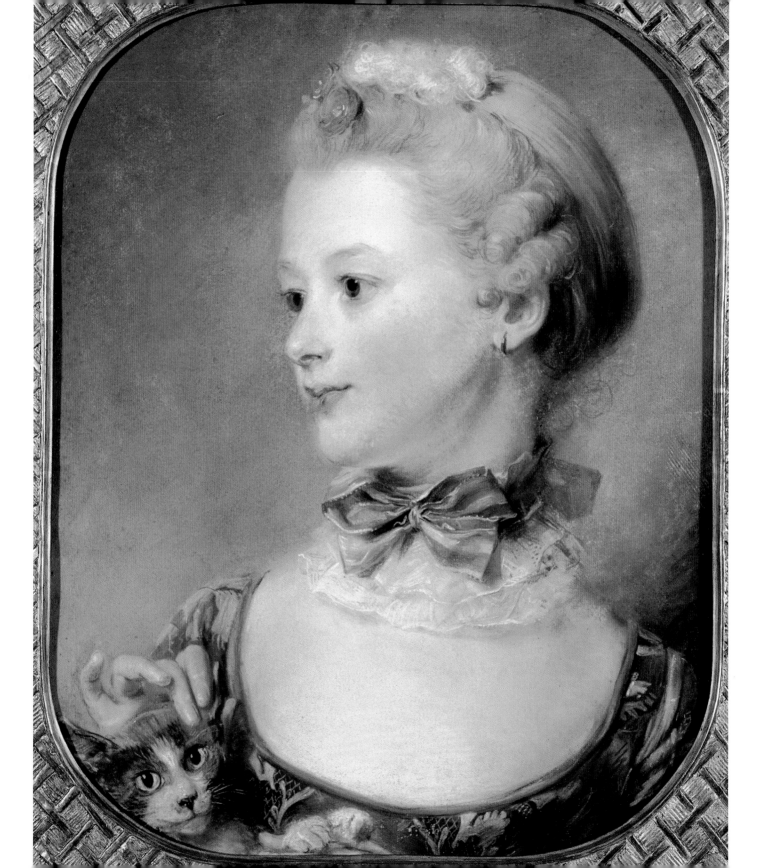

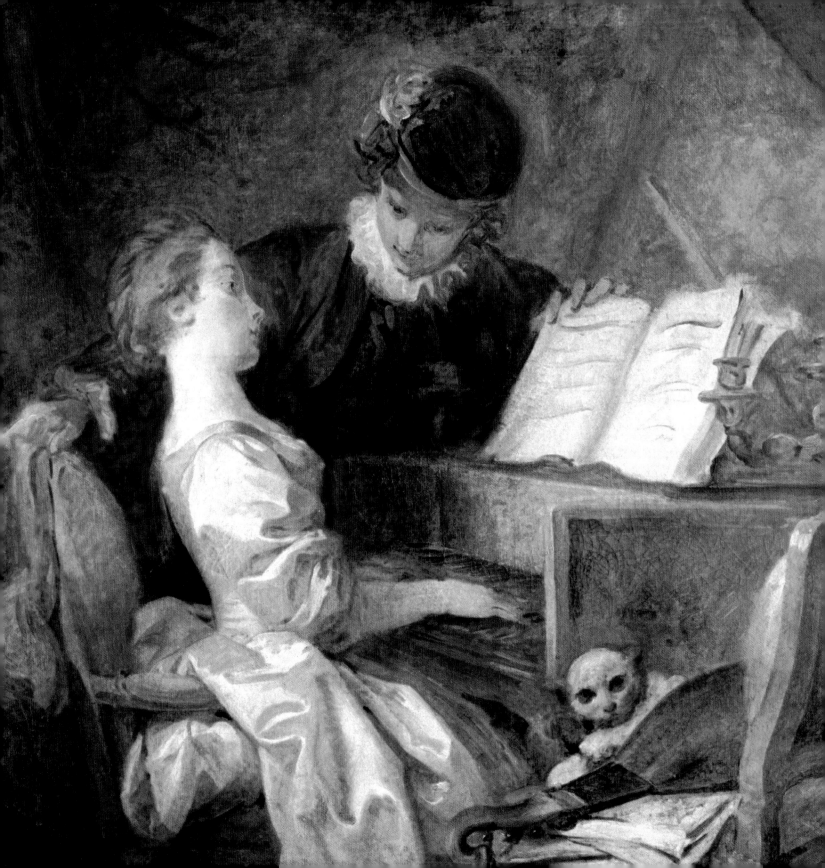

JEAN-HONORÉ FRAGONARD (1732–1806)

The Music Lesson, 1769

Oil on canvas, 43 x 47 in. (110 x 120 cm)

MUSÉE DU LOUVRE, PARIS

Is this a real music lesson, or is it just the usual pretext for depicting one of those boudoir scenes that made Fragonard, with Boucher, the master of Rococo amorous dalliance? Certainly, the music teacher seems more interested in the charms of the sweet young girl demurely intent on her musical exercises. The witness to this encounter is, naturally, the placid white cat that has taken its place in the chair holding a lute: its flattened ears, as if it wanted to close them, indicate the animal's irritation at the sounds produced by the musical instrument. The artist's free brushwork, which completely abandons any attempt at academic polish, endows the scene with the lively, immediate quality of an episode captured instantly, of a fête galante, flirtatious play in full swing, with our little animal a welcome guest.

WILLIAM HOGARTH (1697–1764)

The Graham Children, 1742
Oil on canvas, 63 x 71 in. (160.5 x 181 cm)
NATIONAL GALLERY, LONDON

In the history of English painting, cats, whether gentle or sly, are generally depicted in the laps of their rightful owners, who are women or girls. This painting by Hogarth is a clear exception, for in this family group the viewer's attention is taken completely by the scene that is taking place on the right, under the amused and perhaps slightly sadistic gaze of the only boy. The poor little caged bird is terrified by the appearance of the cat, who must have reached the top of the armchair in a single bound. Although it need not fear for its life as long as there is the cage to protect it, the bird cannot help but tremble at the diabolical greed of the cat, inflamed with desire, its claws out, ears pricked up, and mouth agape, baring its tongue and sharp teeth.

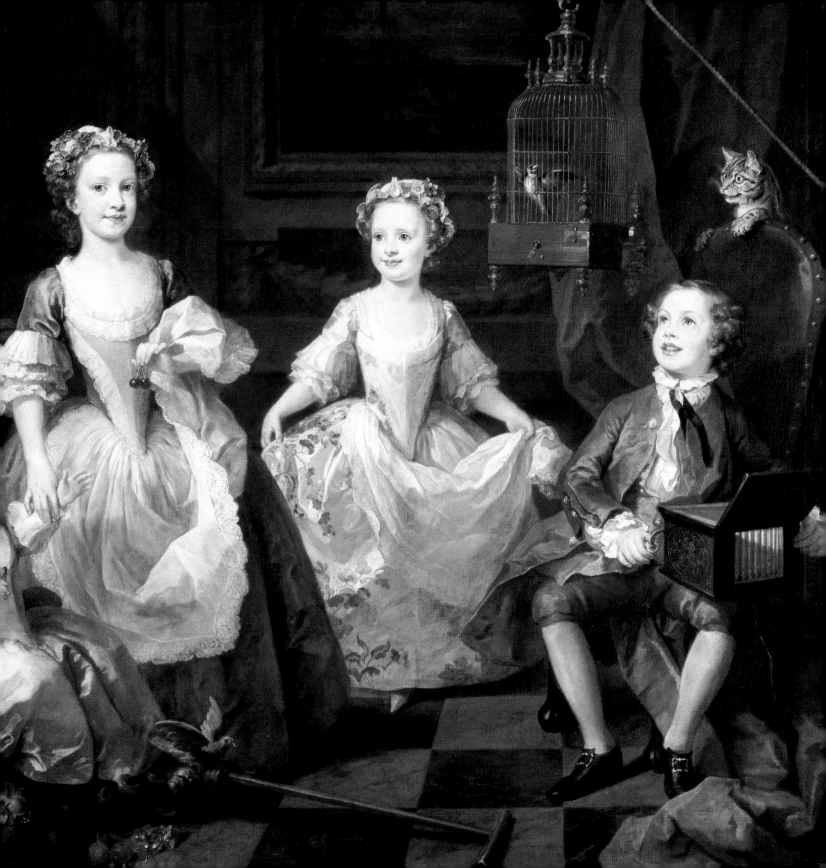

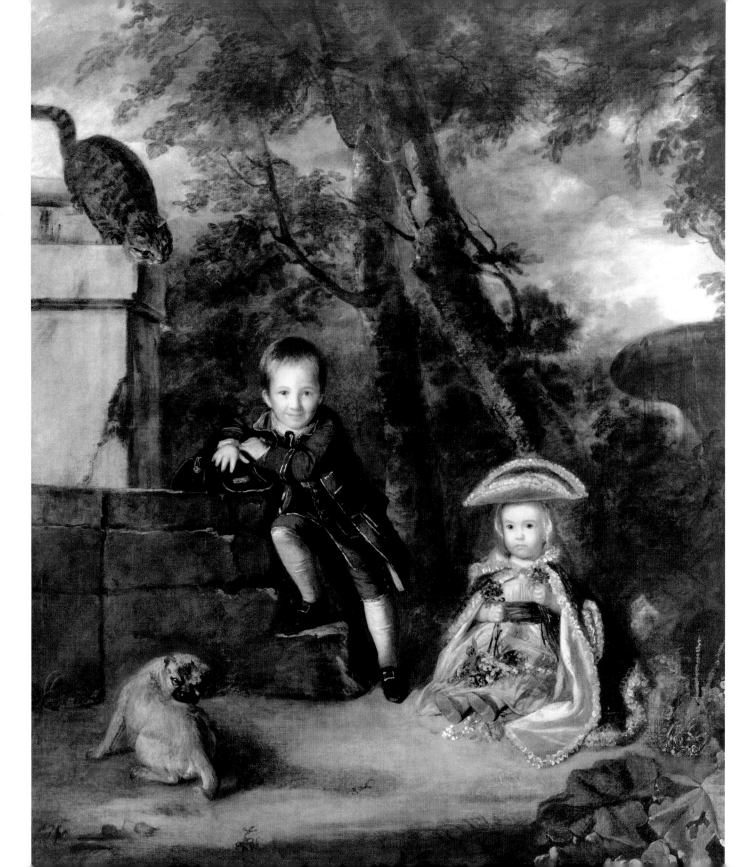

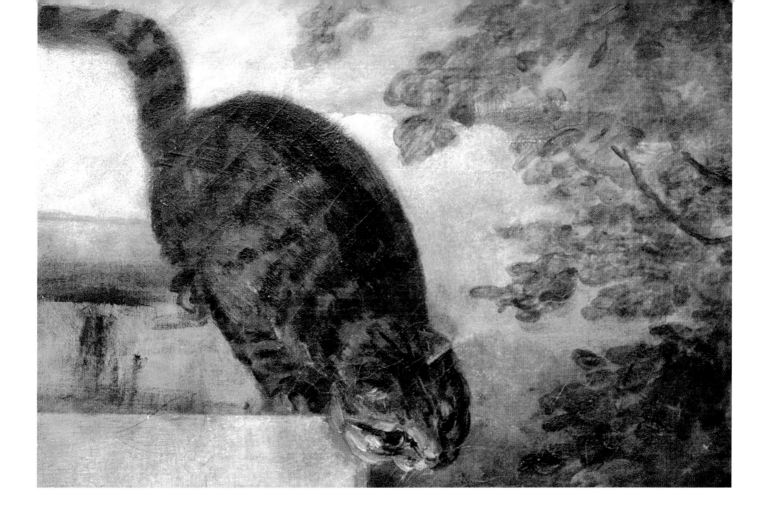

SIR JOSHUA REYNOLDS (1723–1792)

Paul Cobb Methuen and His Sister Christian, Later Lady Boston, 1755
Oil on canvas, 85 x 71 in. (217 x 182 cm)
CORSHAM COURT, WILTSHIRE, ENGLAND

Paul Methuen's sumptuous home, Corsham Court, is a classic example of an eighteenth-century English mansion. The heir of a powerful dynasty that made its wealth in textiles, Methuen decided to move the family's rich art collection from London to this locale in Wiltshire: the collection comprised sixteenth- and seventeenth-century Italian works, canvases by many Flemish painters, and a large number of plaster casts. Corsham Court's magnificent grounds were designed by the famous Lancelot Brown, known as "Capability Brown" because of his extraordinary capacity for reinterpreting nature. In Reynolds's painting the serious demeanor of the little girl, comically dressed as a small princess, is counterbalanced by her brother's spontaneous smile as well as by the charming little scene of the cat that does not dare to jump because of a fear of the height, while the dog seems unaware of its presence.

OPPOSITE PAGE:

THOMAS GAINSBOROUGH (1727–1788)

The Painter's Daughters with a Cat, 1760–61

Oil on canvas, 30 x 25 in. (75.6 x 62.9 cm)

NATIONAL GALLERY, LONDON

A cat is present even though it is not there: such is the effect of this unfinished work by a great master of English painting. Probably painted at Bath, shortly after the artist's arrival at the end of 1759, the picture is an excellent example of Gainsborough's sometimes free, relaxed style: far from the world of official portraiture, the painter is free to express himself in the airy spaces of compositional and emotional imagination. His two daughters are captured in a far from formal demeanor, in a natural pose that must surely have been familiar to him. The presence, barely hinted at, of the animal—which must have been reluctant to pose, judging from its angry expression—contributes to this re-creation of domesticity seen through a father's eyes.

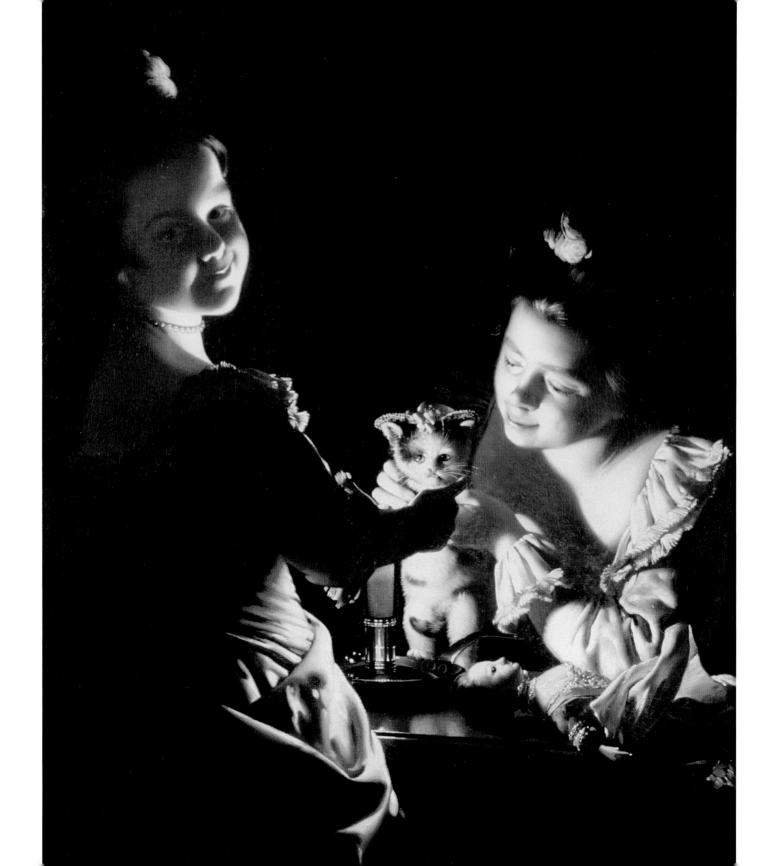

JOSEPH WRIGHT OF DERBY (1734–1797)

Two Girls Dressing a Kitten by Candlelight, 1768–70

Oil on canvas, 31 x 24 in. (79 x 61 cm)

KENWOOD HOUSE, LONDON

Joseph Wright of Derby, one of the most fascinating painters of the English Enlightenment, particularly enjoyed nighttime effects, with artificial light and deep shadows resembling those of Caravaggio. In this painting, the two girls have decided to dress a sweet, sad-looking kitten in the clothes of a doll, which lies discarded to one side. The painting is charming, a small wonder of virtuosity in its handling of light and subtle psychological insight. The theme of children playing with cats, which first appeared in art during the second half of the fourteenth century, is here reiterated yet again in a "modern" version. Whereas Annibale Carracci's painting portrays the slightly sadistic, almost improvised game with the crayfish (see pp. 128–29), these two little girls belonging to the eighteenth-century English middle class give life to a painting that fully conjectures a modern predicament.

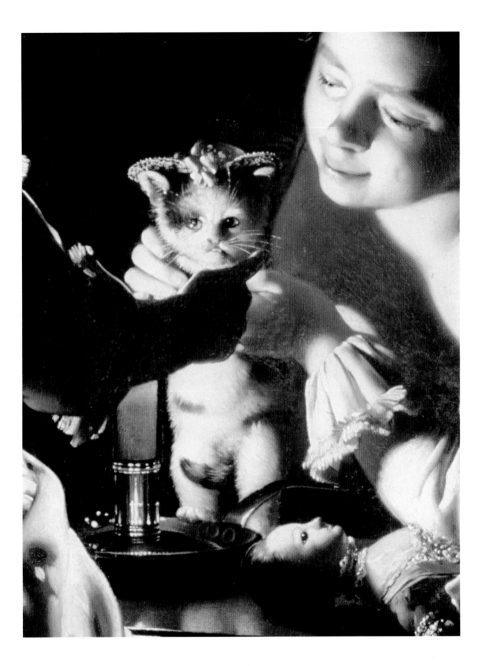

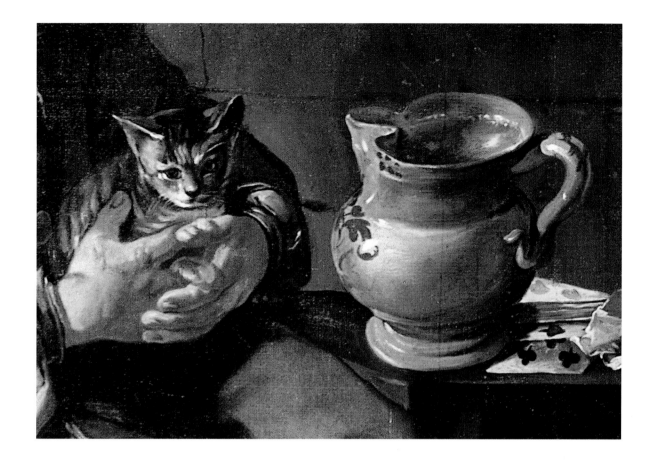

GIACOMO CERUTI (1698–1767)

The Two Beggars, 1730–34

Oil on canvas, 52 x 67 in. (134.5 x 173 cm)

Pinacoteca Tosio Martinengo, Brescia, Italy

Cats are often the companions of the poor folk that inhabit the world painted by *Il Pitocchetto*, "the little beggar," as Ceruti was known. Sad and emaciated like their owners, they nevertheless share the poignant humanity that the painter commits to canvas with few concessions to the pathetic or sentimental. These two poor fellows—barefoot and deformed, dressed in rags and seated at a table that is as modest in its construction as is the food upon it—offer themselves to the viewer in all their wretchedness. However, they are not lacking a cat, which the older of the two men grips in his disfigured hands, and which seems to blend into the mass of rags. This is perhaps the only sentimental touch in this truly cruel world. These three living creatures, perceived from a low point of view, gaze at the viewer with a mixture of melancholy resignation and human dignity. And if they are capable of loving a kitten—ragged and disheveled as they are—they have a heart like everyone else.

FAUSTINO BOCCHI (1659–1742)

The Bogey-Cat, c. 1740

Oil on canvas, 16 x 21 in. (42 x 55 cm)

GALLERIA PALATINA, FLORENCE

Faustino Bocchi's paintings depict a world turned upside down—absurd and thus even more biting and grotesque. His aim is to censure human misery and weakness, using subjects such as cats, as well as chickens, rabbits, and guinea pigs. The cats in Bocchi's paintings all resemble each other: with patchy coats and gloomy expressions, they are often the victims of a race of dwarfs, some wearing turbans, others on stilts. What emerges from these curious pictures—of dwarf humans and giant animals, of humans looking after animals—is a satire of the notion of "superior being."

GIUSEPPE BALDRIGHI (1722–1803)

Self-Portrait with His Wife, 1756

Oil on canvas, 49 x 63 in. (125 x 160 cm)

GALLERIA NAZIONALE, PARMA, ITALY

During the second half of the eighteenth century, the refined Bourbon court at Parma was an island of sophisticated and stylish French taste in northern Italy. Baldrighi, who was an excellent portraitist, was one of the personages who contributed to the small capital's cosmopolitan atmosphere, partly because he had married an Englishwoman. In this forceful double portrait Baldrighi depicts himself in his work clothes, in the process of posing his wife. The young woman is sitting a little stiffly, with a forced smile. On her left, with a vitality that contrasts with her bearing, the cat has focused on the little birds' cage, and has assumed the typical pose cats adopt before pouncing. In advance of the times and with a pleasing touch of humor, Baldrighi portrays the situation typical of "Sylvester the Cat" cartoons, where the cat perennially, and in vain, attacks the cage of the derisive canary, which it can never catch.

JOSÉ DEL CASTILLO (1737–1793)

The Painter's Studio, 1780
Oil on canvas, 41 x 63 in. (105 x 160 cm)
MUSEO DEL PRADO, MADRID

With its male torsos and marble busts, the painter's studio (and it may indeed be José del Castillo's studio that we see here) is traditionally a serious place devoted to laboring in the cause of art. Perhaps to amuse themselves, or perhaps because of the boy's unexpected arrival, the two onlookers are observing with curiosity and interest the amusing scene that is about to unfold before their eyes. His sketchbook still on his knees and a crayon in his hand, the painter and his guest are silently admiring a gigantic cat, with conspicuous white patches on its belly and forelegs, on which all eyes and expectations are focused. Disproportionately large compared to the boy, who extends his arms to make a hoop through which it is to leap, the presumed acrobat-cat is the painting's true protagonist. Probably the cat will never accomplish the small test of agility which the boy is inviting it to pass; or, if it does, it will be with a feeling of superior, regal condescension.

GEORGE STUBBS (1724–1806)

Miss Ann White's Kitten, 1790

Oil on canvas, 10 x 12 in. (25.4 x 30.5 cm)

ROY MILES FINE PAINTINGS, LONDON

Stubbs is one of the great animal painters of all time, and was highly popular in Britain for his ability to capture with great sensitivity not only the exterior "portrayal" of an animal but also its feelings, its instincts, its internal nobility. The great majority of his subjects were horses, which he observed and portrayed in all manner of different ways. This adorable kitten is a delightful exception, also from the point of view of painting technique, which is much softer and more delicate than is usual for Stubbs.

THÉODORE GÉRICAULT

(1791–1824)

Portrait of Louise Vernet as a Child, 1819–24

Oil on canvas, 24 x 20 in. (60.5 x 50.5 cm)

MUSÉE DU LOUVRE, PARIS

The daughter of the celebrated painter Horace Vernet features in several portraits now in the Louvre, including one painted by her father in which the girl, now grown up, shows all the elegance and brightness of a portrait by Ingres. The cultural climate in which this full-length portrait was conceived is entirely different: Louise is seen against a leaden sky, below which stretches an equally disturbing landscape. Both the young girl and the disproportionately large cat appear to be distracted by some event that is hidden from our view. It is well known that it is practically impossible to force a cat to behave like a model, and the cat in Louise's arms, which is truly enormous, is no exception. It seems as if the girl is trying to keep her grip on it to prevent it from escaping, and thus delaying completion of the portrait.

THÉODORE GÉRICAULT (1791–1824)

The Dead Cat, 1821

Oil on canvas, 20 x 24 in. (50 x 61 cm)

Musée du Louvre, Paris

Géricault's taste for the morbid side of human experience, from madness to illness to death, is well known: this culminated in the famous series *The Lunatics* (1822). He is not alone in having this "romantic" propensity. Messerschmidt in his *Character Heads* and Goya in a good part of his output had introduced the deviant, pathological element that is a part of human nature and therefore also worthy of appearing in a work of art. Rarely has the death of an animal been depicted in a more dignified way. On a bare bench, the cat's pale body is analyzed in all its stark reality, in the stiffness of death—its face contracted in a tragic grimace, its paws limp. It is true that whoever has seen his or her cat die cannot be happy with a replacement, so important is the individuality and character of the one that has passed away.

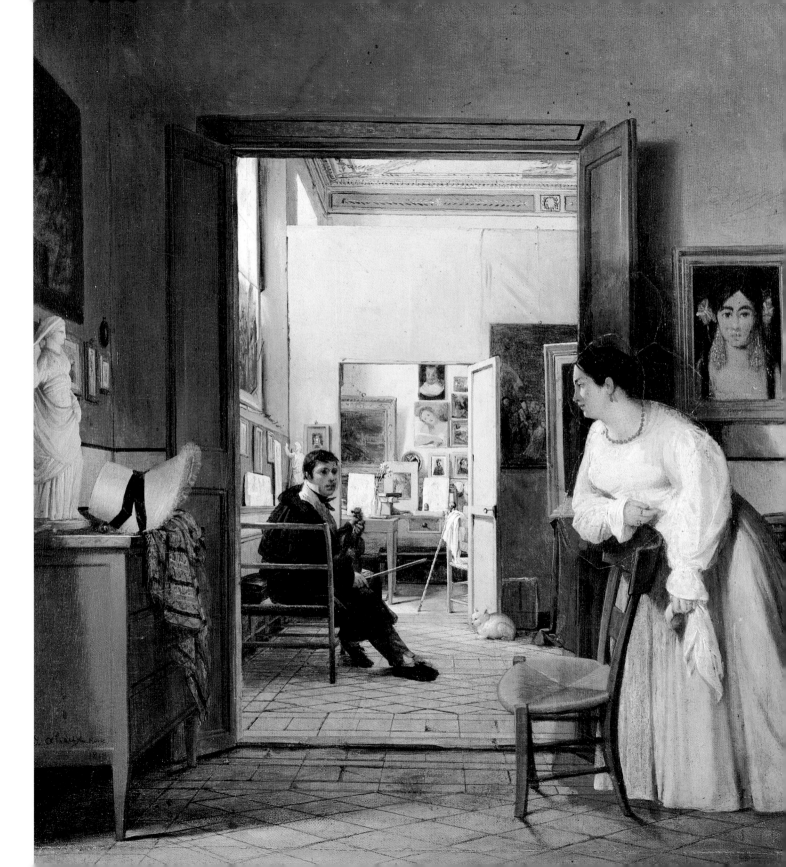

JEAN ALAUX (1786–1864)

Ingres's Studio in Rome, 1818

Oil on canvas, 21 x 18 in. (55 x 46 cm)

MUSÉE INGRES, MONTAUBAN, FRANCE

For many decades, Jean-Auguste Dominique Ingres was the undisputed leader of Neoclassicism and academicism in Rome. The painter, director of the French Academy housed in the magnificent Villa Medici, was not only a master of style but also a public figure, whose habits aroused curiosity and were the subject of gossip. For example, his passion for playing the violin was famous to the point that it became proverbial. In this elegant painting, with its deep perspective, Ingres's pupil Alaux turns a curious, almost indiscreet gaze into Ingres's studio and home: the viewer's eye runs through the rooms, and also pauses to look at a little cat, a privileged member of Rome's large and varied feline community.

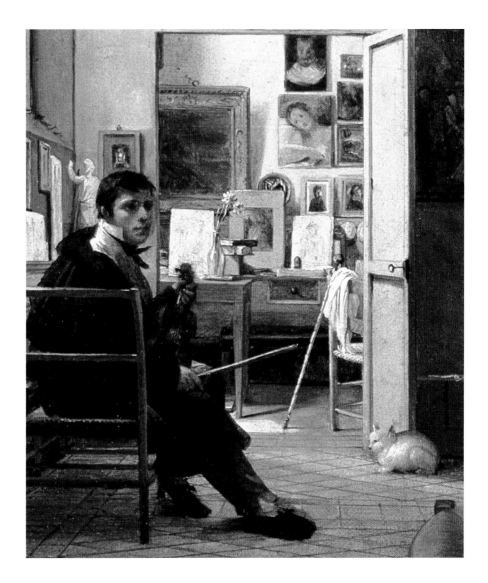

JOHANN FRIEDRICH OVERBECK (1789–1869)

Portrait of Franz Pforr, c. 1810

Oil on canvas, 24 x 18 in. (62 x 47 cm)

NATIONALGALERIE, BERLIN

This painting became a sort of touching "manifesto" for the so-called Nazarenes, a group of traditionalist German painters who moved to Rome in the early decades of the nineteenth century. With their clear, linear style of painting, avowedly inspired by the Middle Ages, they advocated a return to the past not only in stylistic terms but also in terms of morality. The Nazarenes—so called because of their long flowing hair worn over their shoulders—lived together, observing almost monastic rules. Overbeck was their leader, but Pforr was an emerging talent. Sadly, he died very young, and Overbeck dedicated to him this posthumous portrait, filled with symbolism and grief. The cat that rubs itself against its master, purring, adds a heart-rendering, intimate touch, and is a prominent part of this perfectly happy environment in which Overbeck wished to remember his dead friend.

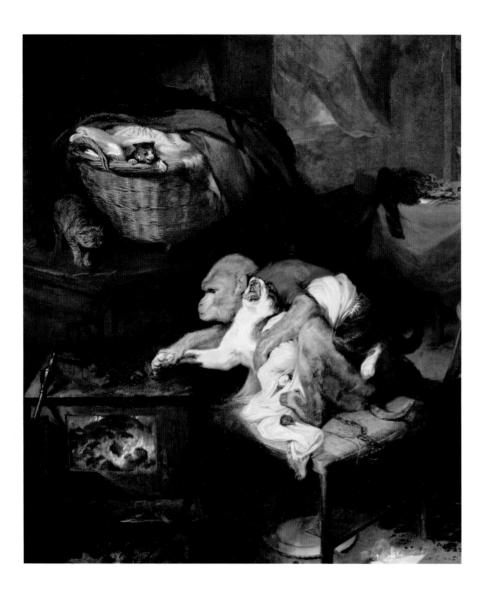

SIR EDWIN LANDSEER
(1802–1873)

The Cat's Paw, 1824

Oil on canvas, 32 x 29 in. (82 x 75 cm)

PRIVATE COLLECTION

A renowned artist of the early Victorian age, Landseer perfectly embodies the tastes and values of British aristocratic society. He was an excellent animal painter, and his canvases contain veiled political references sometimes superimposed upon a fond glance at reality. This painting, marked by subtle cruelty and inspired by proverbs and sayings on the relationship between the cat and fire, shows a monkey trying to burn the cat's paw by holding it over a brazier. Indeed, to pull something out of the fire "using the cat's paw" means taking advantage of someone to avoid unpleasant or dangerous tasks. The picture refers to a relationship between monkeys and cats that has interesting precedents in seventeenth-century Flemish painting. Along with the hapless protagonist, mewing in pain, the work includes other cats, observing the situation with interest and concern.

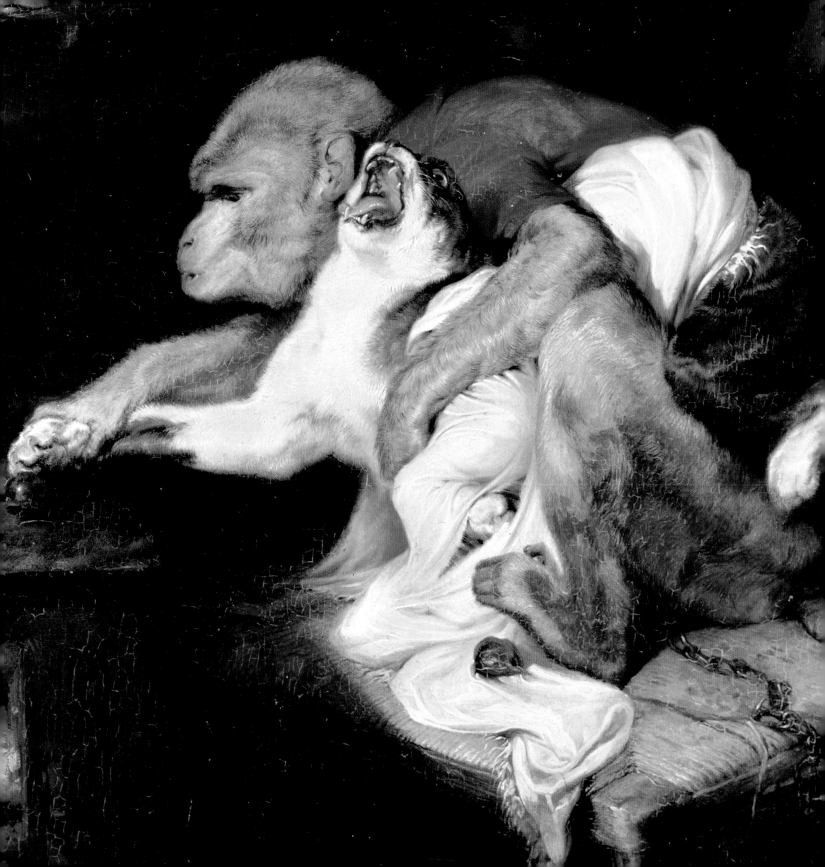

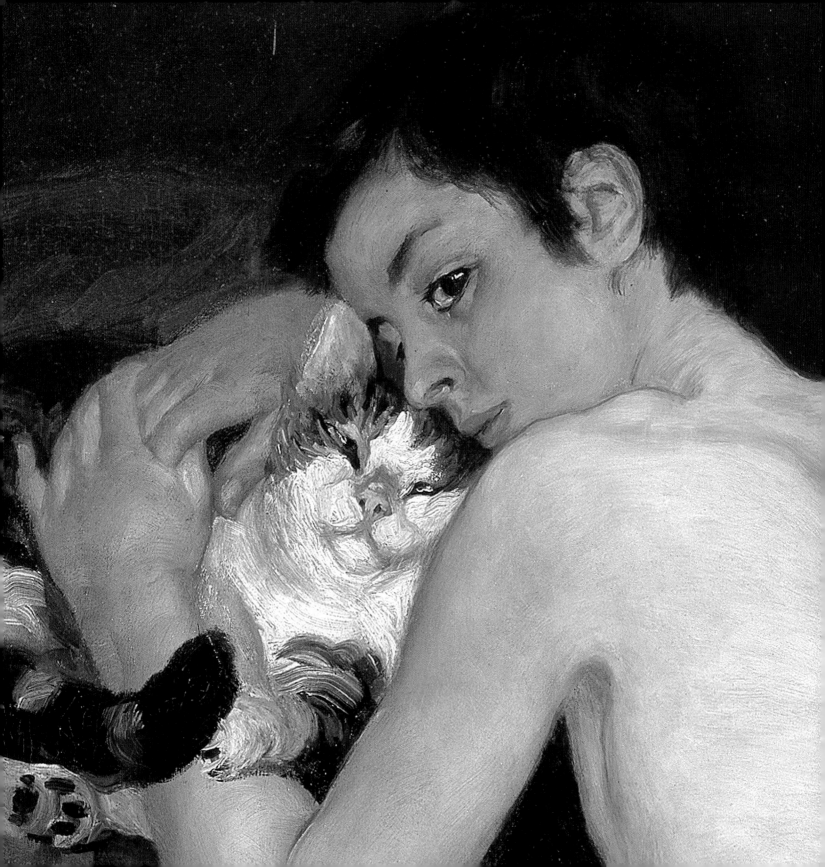

ROMANTIC AND IMPRESSIONIST CATS

From the Quest for Comfort to the Impressionist's Caresses

GUSTAVE COURBET

JEAN-FRANÇOIS MILLET

ANONYMOUS JAPANESE ARTIST

ANDO HIROSHIGE

UTAGAWA KUNIYOSHI

WILLIAM HOLMAN HUNT

SIR JOHN EVERETT MILLAIS

EDOUARD MANET

PIERRE-AUGUSTE RENOIR

SOPHIE GENGEMBRE ANDERSON

GIOVANNI BOLDINI

BERTHE MORISOT

GUSTAVE DORÉ

MAURICE DENIS

PAUL GAUGUIN

HENRI ROUSSEAU (LE DOUANIER)

EMILE GALLÉ

THÉOPHILE ALEXANDRE STEINLEN

FÉLIX VALLOTTON

By following the travelers on their Grand Tour we have entered the nineteenth century and, thus, are on the brink of the Romantic era. Once the Napoleonic whirlwind had passed, the nineteenth century got on with celebrating the triumph of the bourgeoisie, of domestic values, of the search for security and comfort. It was, so to speak, a "homebody" century, even though avid readers were fascinated by the exploits of explorers, the advances of science, and revisiting the chivalry of the past through Walter Scott or Alexandre Dumas. They were engrossed in the fantastic novels of Jules Verne; the imaginary, yet extraordinarily mesmerizing journeys of Robert Louis Stevenson, Herman Melville, and Joseph Conrad; and in the tales of crime and mystery by masters such as Edgar Allan Poe and E. T. A. Hoffmann. It is possible to dream of a Bengal tiger while stroking the household pussycat, and to imagine a fateful love affair by looking into a feline's shining eyes.

Nineteenth-century society and culture offered the perfect scenario for cats. Images of the adorable animals proliferated in European and North American painting, from the Biedermeier to Impressionist eras, naturally complementing rooms with their heavy brocade curtains, padded divans, decoratively engraved pianos, soft deep-pile carpets, weighty tomes, exotic ornaments, slightly dusty velvet, and the sewing baskets of lonely, industrious young girls. This was the ideal playground with its many hiding places for household cats; from the perspective of today's sharp, shiny, chrome-plated angles, those cats would probably look back wistfully on the luxuriously furnished houses of "respectable" nineteenth-century families, eulogized by writers of the time. The most lavish in their praise were writers in the English-speaking world, where the concept of "pet" was being established. However, French literature was not far behind: Théophile Gautier, a master thinker and mentor for whole generations, was an outspoken cat lover; and he led the charge for a distinguished company of cat-loving French writers, from Guillaume Apollinaire to Paul Léautaud, Jean Cocteau to François

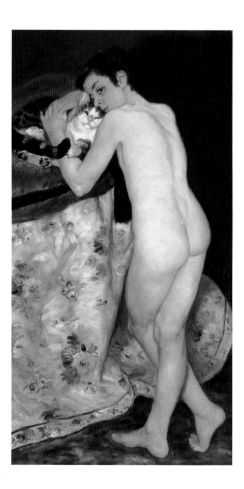

ABOVE AND P. 236 (DETAIL): Pierre-Auguste Renoir, *Young Boy with a Cat*, 1868. Oil on canvas. Musée d'Orsay, Paris. Renoir, one of the 19th-century painters who showed the greatest interest in cats, offers us this splendid portrait, filled with sensuality and affection for the animal.

Mauriac. Gautier readily celebrates the cat's supremely aristocratic nature and goes as far as imagining "a soul behind those shining eyes," describing the cat as a calm philosopher, a lover of decency and order, although not easy to make friends with.

In painting, too, starting with the English Pre-Raphaelite masters, adorable kittens appeared between the legs of walnut tables, peeped out from under long Victorian skirts, or walked nonchalantly through the drawing rooms of fashionable Boston and New York society, as if they were strolling across a page from a Henry James short story. Gioacchino Rossini, a fashionable musical genius, was inspired by the mewing of two kittens to write an amusing parody of a love duet; and cats were frequently seen in artists' studios.

There was another side to the coin, however. The cat's unflappable immutability, always faithful to its own nature, its calm attachment to habit and resistance to novelty, became a sort of obstacle to its integration into new middle-class customs. Nineteenth-century society was changing rapidly: new technical inventions enabled things to be done much more speedily and previously unthinkable distances to be covered; they imposed changes and favored healthier habits. Horses and dogs, certainly more malleable and amenable than cats, adapted quickly. Faced with the development of trains, the horse was "recycled" as a sporting animal par excellence, ready for gallops through the countryside, fox hunting, and the increasingly popular pastime of horse racing. The dog, in turn, consolidated its position as the favored animal of royal families, and its presence in literature and art became synonymous with the open air and outdoor walks, whether as a gentleman's noble greyhound on a leash or a long-haired poodle in the arms of an attentive lady sitting on a bench in a public park. The banal cat, essentially a lazy domestic animal, attached to the comfort of the home, soon found itself "demoted" in rank among pets: after all, even parrots in a cage offer the thrill of the exotic. Thus, the latter half of the nineteenth century saw a proliferation of syrupy paintings, verging on sketches or

Frank Paton, *Fairest of Them All*, 1887. Oil on canvas. Private collection. This charming painting by Paton bears witness to the proliferation of images of cats—some of them clumsy and verging on caricature--during the second half of the 19th century.

caricatures, in which cats are depicted, for example, among peasants in a farmhouse, among decrepit, elderly people, as the only plaything of poor children, or in the untidy garret of some third-rate philosopher. It is almost as if middle-class society had developed a sudden, brief revulsion for the cat, one of those periodic waves of unpopularity that seem to pass through our protagonist's millennia-old history, alternating with pinnacles of glory.

However, the glance of the Impressionist painters soon brought about a rehabilitation of the cat, starting from the very qualities that had caused its temporary eclipse. Synonymous with domestic intimacy, the cat is shown being picked up and held by lonely, romantic, and sweetly melancholy young girls; as the silent yet inspiring companion of painters and poets (although not necessarily third-rate ones, for it appears in pictures painted in homage to Cézanne and Pierre Loti); and it lets itself be cuddled or teased by the children of bourgeois families. This is the time when the vices and virtues of cat and dog are defined and practically polarized: the choice of favorite animal becomes almost a projection of the owner's psychology, as becomes evident in later decades, right up to the personality tests published by magazines. To confine ourselves to the best-known cases, the marvelous works of Manet and Renoir (a passionate painter of delightful cats, soft and begging to be caressed), as well as excellent works by female painters such as Berthe Morisot and Mary Cassatt, initiated a new scenario for the cat, portrayed as consoling the lonely, soft and malleable to the touch, and capable of inspiring serenity with its purring. With the arrival of Symbolism toward the end of the century, the dark, mysterious side of the cat, alluding to sin and seduction, would re-emerge. But the avant-garde cultural movements of the twentieth century would once again rehabilitate the cat's positive image, confirming the perennial seesaw of contrasting meanings.

OPPOSITE PAGE: Mary Cassatt, *Children Playing with a Cat*, 1908. Oil on canvas. Courtesy of John Surovek Gallery, Palm Beach, Florida. A refined American painter who was close to the Impressionists, Mary Cassatt paints this subject with a conventionally feminine sensibility: the tenderness shown for the cat merges with the animal's affectionate look at the children.

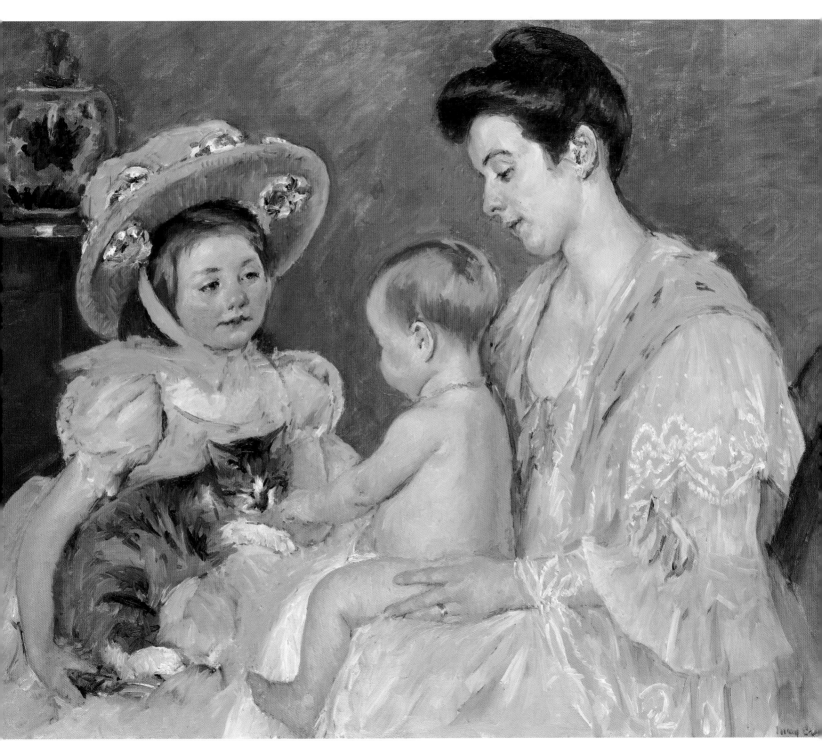

GUSTAVE COURBET

(1819–1877)

The Artist's Studio, 1855

Oil on canvas, 11.8 x 19.3 ft. (3.6 x 5.9 m)

MUSÉE D'ORSAY, PARIS

Many different interpretations, all of them fascinating, have been put forward for the presence of this magnificent white Angora specimen in the very center of one of Courbet's masterpieces. The most plausible seem to be those that refer to *Les Chats,* a book by Champfleury, a critic and friend of Courbet; or those connected to the cat's ability to see in the dark, which makes it an emblem of the power of sight, according to Cesare Ripa's *Iconologia* (Iconology). No less attractive is the theory that the cat is a symbol of freedom, a significance it acquired during the French Revolution, of which it became one of the emblems. Despite these possible underlying allusions, the cat in no way seems to diminish the painting's realism; indeed, it helps to brighten the room with its usual play (probably with an insect).

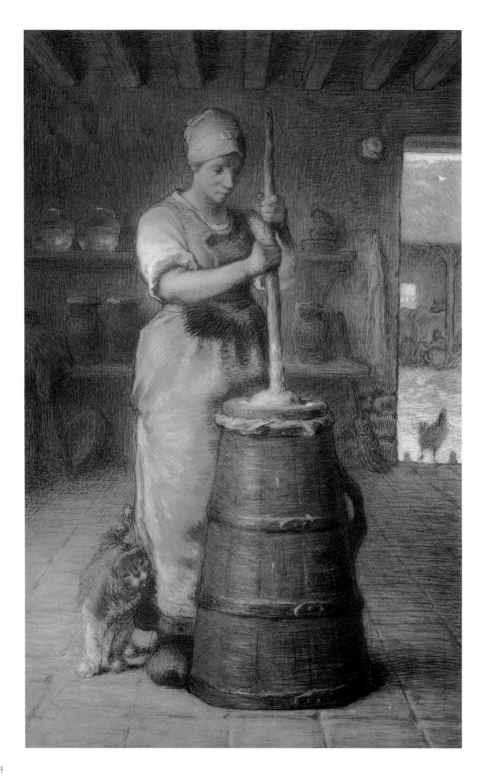

JEAN-FRANÇOIS
MILLET (1814–1875)

Woman Churning Butter, 1866–68

Crayon and pastel on paper, 48 x 33 in.
(122 x 85.5 cm)

Musée d'Orsay, Paris

The peasant world that inhabits
Millet's works is as far removed as
possible from the realism that
Courbet was presenting to the crit-
ics at that time. There is no harsh-
ness of style, no rough demeanor
on the part of the men and women
who are working, gleaning grain,
sowing, and praying in the fields. In
this painting, too, the French artist
softens the hard life of those who
work on the land, depicting an
inner contemplation mixed with a
touch of melancholy. Absorbed in
her task of churning butter in a tub,
the peasant woman almost does not
notice the affectionate presence of
a large, long-haired cat rubbing
itself against her ankle. She remains
suspended in the natural light in a
state that must seem immutable
and eternal, but is no less dignified
for all that.

ANONYMOUS JAPANESE ARTIST (19th century)

Sleeping Cat, c. 1850

Colored lithograph, 10 x 19 in. (25 x 38 cm)

PRIVATE COLLECTION

Commodore Perry's "black ships" have not yet appeared in the Gulf of Tokyo: in an imperial Japan still closed to the West for a few years to come, the magnificent story of painting and engraving of the Edo period is drawing to an end. This print, devoid of stamps or seals, has remained anonymous and, perhaps also for this reason, rather than displaying the style of a single artist, it has become almost the symbol of an entire school. The love of life's pleasures—public but especially private pleasures—is epitomized by the rounded, furry mass of this large, sated, satisfied cat: an amiable tiger in miniature, completely content with its own existence. The artist's capacity for suggestion—he has barely hinted at the outline of a leaf in the upper right-hand corner—also conveys to us that our friend has found a sheltered, secure place.

ANDO HIROSHIGE
(1797–1858)

Asakusa Rice Fields During the Festival of the Cock, c. 1857

Colored xylograph, 13 x 9 in. (33.7 x 22.5 cm)

FITZWILLIAM MUSEUM, CAMBRIDGE, ENGLAND

Ukiyo-e, or the "floating world," is the name given to the fascinating popular Japanese prints from the seventeenth to the nineteenth centuries, a period that is also referred to by the name of the new capital of the empire of the Rising Sun—Edo (now Tokyo). In contrast to the preceding austere, feudal phase of their history, the Japanese discovered the world of public and private pleasures, which included the wide circulation of artworks, especially colored prints by famous masters. Within a few decades, these prints were also exported to Europe, where they would have a powerful influence on Western art during the second half of the nineteenth century. In this delightful engraving the national icon, Mount Fuji, appears in the background; and a handsome white cat, which has climbed on to the windowsill, seems to gaze with romantic languor at the colors of the sky and countryside.

UTAGAWA KUNIYOSHI
(1797–1861)

Woman Holding a Cat, 1852

Colored xylograph, 14 x 10 in. (36.7 x 24.8 cm)

<small>PRIVATE COLLECTION</small>

A perfectly dressed and made-up geisha, wrapped in the silk of an embroidered kimono, attempts to ward off the excessive affections of a magnificent white cat. It is a pet, but also a sort of refined "domestic furnishing," as demonstrated by the knotted ribbon around its neck and its soft, carefully brushed fur, into which the young woman sinks her fingers with pleasure. There is an interesting contrast between the harmless cat's onslaught and the much more dangerous scene depicted in the background, in which a gigantic octopus is threatening a small fishing boat.

WILLIAM HOLMAN HUNT (1827–1910)

The Awakening Conscience, 1853
Oil on canvas, 29 x 22 in. (74.9 x 55.8 cm)
TATE GALLERY, LONDON

This painting, with its literary moralism, taste for opulent furnishings, and emotions held in check, has come to symbolize Victorian society. The "conscience" that is awakening is that of a young prostitute, who seems suddenly to have realized that she is on the road to perdition. The girl is seated on the knees of a young, pleasure-seeking libertine, who is singing a romantic song while playing the piano with his left hand; and just before yielding to his flattery, she seems to want to extricate herself from his clinging embrace. Among the knickknacks and decorations of the over-furnished room, meticulously portrayed in every detail, a cat is prowling furtively. Hunt, stressing the painting's inherent symbolism, directly links the young man's "courtship" with the hunting cat, ever ready to pounce on its prey. It should be added, too, that this style of interior decoration—stuffed with diverse textiles, upholstery, fringes, curtains, and drapes—seems expressly designed for cats, who can choose where to sharpen their claws, where to hide, what to play with, and which fabrics to tear . . . in short, the typical repertoire of domestic disasters.

SIR JOHN EVERETT MILLAIS (1829–1896)

A Flood, 1870

Oil on canvas, 39 x 57 in. (99 x 145 cm)

MANCHESTER ART GALLERY, MANCHESTER, ENGLAND

Inspired by a real event and using one of his daughters and a painter friend's cat as models, Millais creates a scene with a biblical flavor employing a rather modern painting style. After a flood in Sheffield, England, caused by a breach in a dam, a child was apparently saved from drowning because his cradle kept him afloat; and the animal, too, took advantage of this special craft to escape drowning. But whereas the child seems completely unaware of the real danger, showing interest in the birds on the branches (goldfinches, according to a religious interpretation), the cat, which is well known to dislike water, is paralyzed with fear and can only manage to howl with terror. Will the hapless animal succeed in attracting the attention of the boat that can be glimpsed in the background? Apparently yes, because the story had a happy ending.

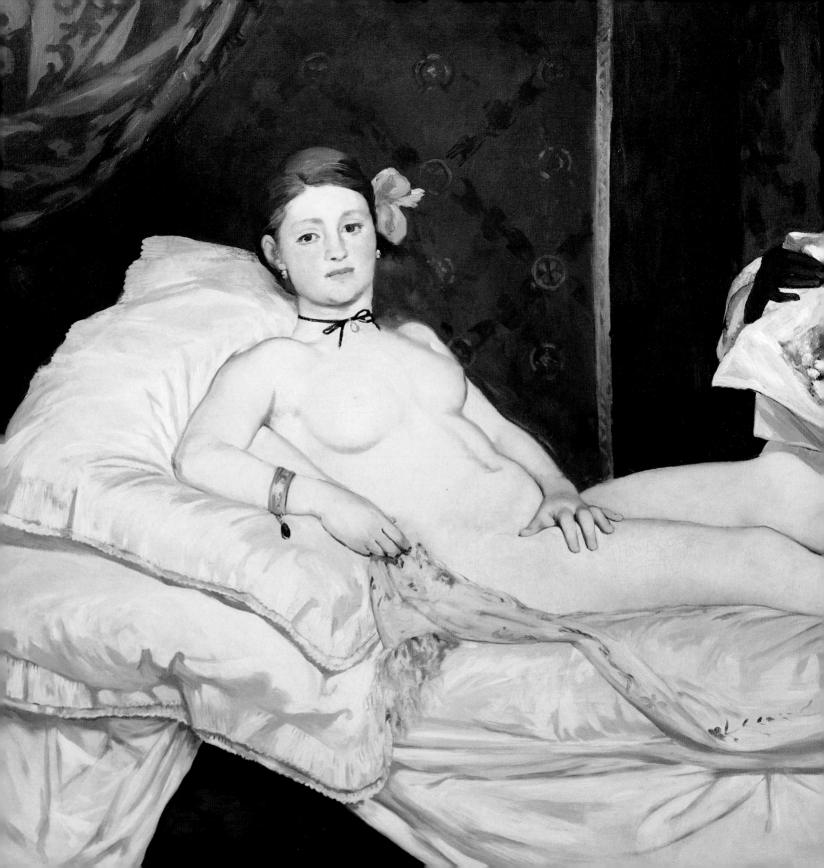

EDOUARD MANET (1832–1883)
Olympia, 1863
Oil on canvas, 51 x 74 in. (130.5 x 190 cm)
MUSÉE D'ORSAY, PARIS

It was enough for Manet to replace Titian's placid little dog with a demonic-looking black cat to completely change the meaning of this famous painting. Although the original inspiration for Manet's painting was an exemplary prototype such as Titian's *Venus of Urbino* (1538), in the Uffizi Gallery in Florence, the woman depicted by Manet no longer embodies the modesty and non-erotic grace of the original. Olympia's provocative pose, the challenging gaze directed at the viewer, the hand firmly pressed down, and the striking ornaments all reinforced, in the eyes of the critics who saw the work exhibited at the 1865 Salon, the impression that this is a prostitute, not the delightful nude commissioned in the fifteenth century by Guidubaldo della Rovere that for centuries had been the personification of womanly beauty. The black cat at the woman's (no longer naked) feet merely heightens an atmosphere already pregnant with sensuality. The two handmaidens who, in Titian's painting, stand behind Venus are replaced by a single, sturdy black woman holding a bouquet of flowers, perhaps a gift from the woman's lover, waiting in the antechamber behind the green drape. This painting is traditionally regarded as heralding the arrival of modern art: the black cat, which is also gazing fixedly at the viewer, is symbolically taking part in this revolution.

PIERRE-AUGUSTE RENOIR (1841–1919)

Portrait of Julie Manet (or *Girl with a Cat*) 1887
Oil on canvas, 25 x 21 in. (65 x 54 cm)
MUSÉE D'ORSAY, PARIS

Here is yet another twist in the cat's story: although it was seen as a malicious symbol of seduction during the eighteenth century, in the bourgeois nineteenth century the cat became the soft companion of blossoming young women, who loved to caress and cuddle it, receiving purrs and affection in return. Renoir, an observant interpreter of the feminine world, was the first painter to extol this aspect, which is entirely in keeping with his soft, mellow, sensuous style of painting. The cat being held by the girl is a completely ordinary tabby, not a sophisticated or show animal. Between the two there is an affectionate relationship that is direct, intense, emotional, and physical: Renoir's brushstrokes home in on the point of contact between the girl's hand and the cat's soft fur.

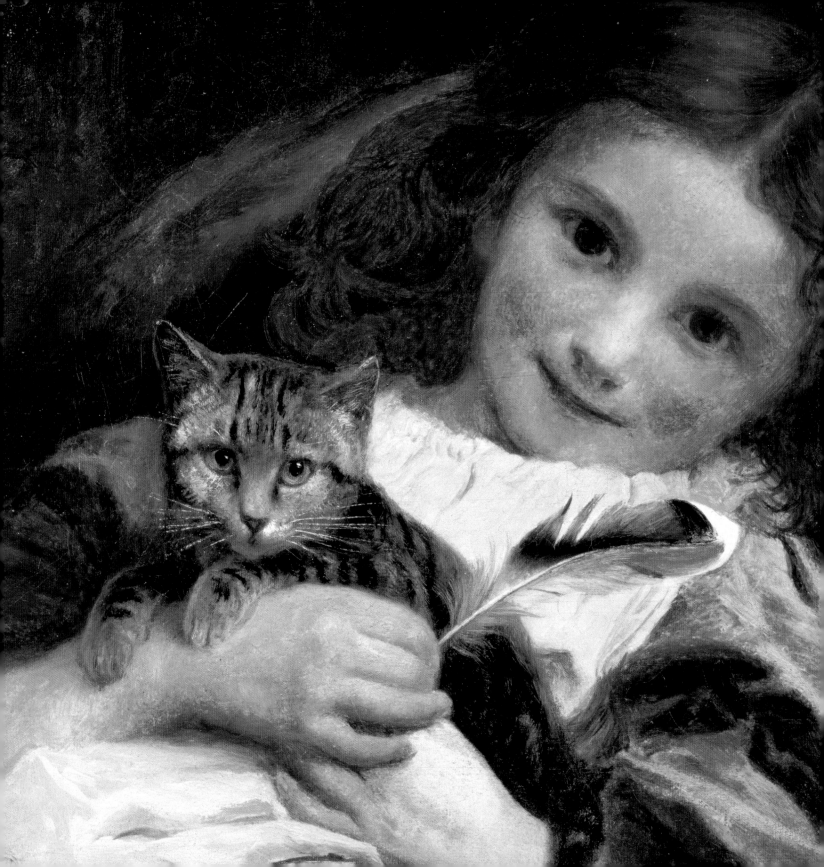

SOPHIE GENGEMBRE ANDERSON (1823–1903)

Awakening, 1881

Oil on canvas, 26 x 31 in. (67 x 80 cm)

PRIVATE COLLECTION

Born in France but married to an English artist, Sophie Anderson moved to London in 1854, where she became associated with the Pre-Raphaelite school. Her pleasant, highly enjoyable painting was adapted to meet the expectations of an upper-middle-class public, depicting, for the most part, figures in close-up, in direct contact with the viewer. In a few cases these are fairies or supernatural beings, according to late Victorian taste, but most of her paintings depict children's faces, highlighting their gaze. Here, the gaze is a double one: the girl has just awakened and is holding a kitten, which is also looking at us. This is a return to the old theme of a portrait with an animal; the historical precedent is *Lady with an Ermine* (1483–90) by Leonardo da Vinci, and the painter reinterprets it with a tenderness that engages the viewer.

GIOVANNI BOLDINI
(1842–1931)

Girl with a Black Cat, 1885

Oil on canvas, 22 x 16 in. (55.9 x 40.6 cm)

Istituto Matteucci, Viareggio, Italy

A leading portraitist to high society, and blessed with a magic touch with a paintbrush, Boldini is one of the best-known examples of the fashionable painter during the belle epoque and early twentieth century. His rapid, fresh brushwork is particularly effective in portraying female figures such as blossoming girls or bewitching young ladies. Highly prolific and always in demand—partly because of his looks—Boldini became a true "character" on the European artistic scene. Only occasionally could he allow himself some personal diversion, such as this painting, where the viewer's gaze is magnetically drawn by the wide eyes of the young girl and the big black cat that, with some effort, she holds in her arms. But while the girl has a vacant and rather absent expression, the cat is watchful, wary and alert. Here is yet another version of the old and always fascinating theme of a girl and animal, brought together by the painter in a double portrait.

BERTHE MORISOT
(1841–1895)

Young Girl with a Cat, 1892

Oil on canvas, 21 x 18 in. (55 x 46 cm)

PRIVATE COLLECTION

Among the many admirable qualities of the Impressionist movement was the participation of many skilled female painters, who could assert themselves at the highest levels in the group and offer a new, feminine perspective. Between cats and women, it has been said, there is an ancient, dark, and mysterious alliance, an enigmatic rapport, almost an intimate exchange of confidences. The beautiful, pensive girl, with a faintly sad smile and the long light-brown ringlet that falls lazily toward her breast, is stroking a docile cat that sits on her lap. The painter's treatment of color is marvelous, with brushstrokes that alternate between rich, dense impasto and ethereal lightness. In this interior scene, dominated by a sense of peace and relaxation, the cat's open, alert eyes add a touch of animation.

GUSTAVE DORÉ (1832–1883)

Illustrations for Puss in Boots by Charles Perrault, 1883 edition

Engraving

<small>PRIVATE COLLECTION</small>

The very welcome reappearance of Puss in Boots as a gentle yet formidable protagonist of the movie *Shrek 2* brought back to mind the character created in the seventeenth century by Charles Perrault. A highly effective parody of the epoch's cloak-and-sword stories of the king's musketeers, the fable of the crafty and courageous cat, who defeats the terrifying ogre, is world famous. Naturally, Perrault's tale (by the brother of the architect who designed the façade of the Louvre) has tickled the fancy of many illustrators and engravers: even the great Gustave Doré, tireless creator of images to accompany texts such as the Bible or the *Divine Comedy*, could not resist the fascination of one of the world's most famous cats.

MAURICE DENIS

(1870–1943)

Homage to Cézanne, 1900

Oil on canvas, 70 x 94 in. (180 x 240 cm)

MUSÉE D'ORSAY, PARIS

Impressionist and Post-Impressionist painters felt a secret sense of guilt about Paul Cézanne, who lived in voluntary exile in Aix. In this picture, a large group of painter friends, dressed in severe black, gather around a small but exquisite still life by the Provençal master, who was notable by his absence from the artistic scene in Paris. The painting is by Maurice Denis, who was perhaps a secondary figure in the movement but had an extremely receptive mind, and was, among other things, a driving force behind the Nabis group. Here, in an austere, controlled work, the presence of a tabby cat that has furtively slipped into the picture just below the easel—its eyes flashing like a small, angry wild beast—opens a chink of affectionate intimacy, a rush of freedom among all these serious, solemn-looking gentlemen.

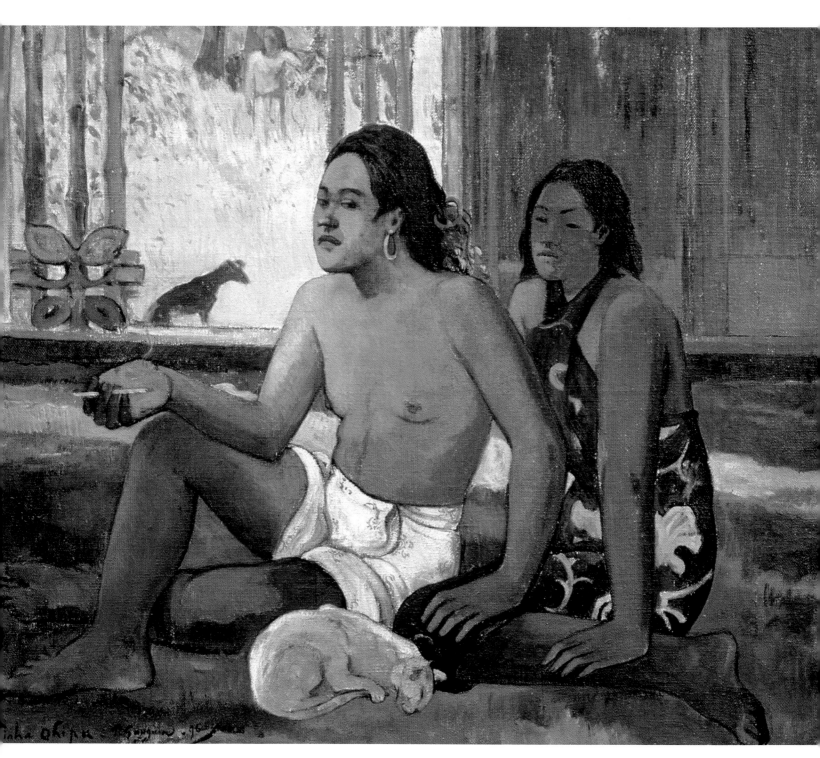

PAUL GAUGUIN (1848–1903)
Eiaha Ohipa (Not Working), 1896
Oil on canvas, 25 x 29 in. (65 x 75 cm)
PUSHKIN STATE MUSEUM OF FINE ARTS, MOSCOW

In his initially happy, but later increasingly anxious, search for uncontaminated beauty and purity, Gauguin produced some of his most famous masterpieces in Tahiti. Fascinated by the colors of the Pacific and by the serene atmosphere that seemed to reign among its inhabitants, the painter believed he had found an exotic paradise. An essential presence is always that of the cat, ensuring calm. The handsome white cat, sleeping at the very center of the painting, thus becomes a symbol of trusting abandon, of the peaceful Tahitian landscape.

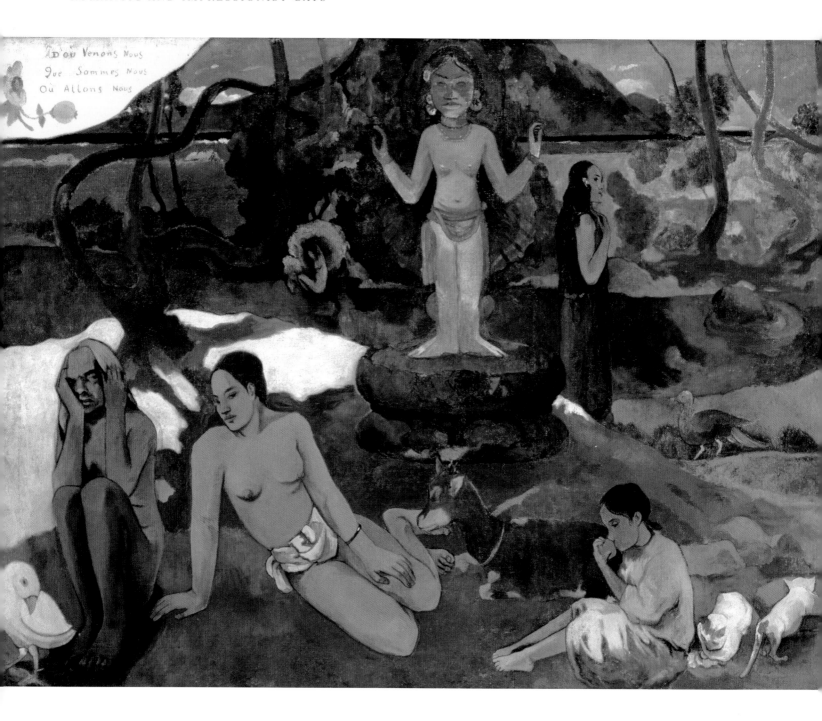

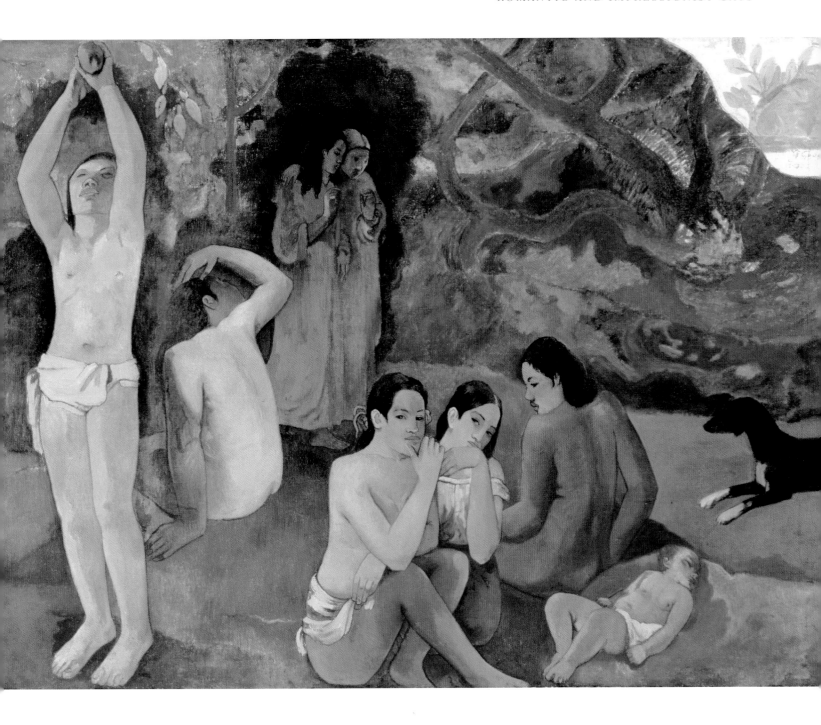

PAUL GAUGUIN (1848–1903)

Where Do We Come From? What Are We? Where Are We Going?, 1897–98

Oil on canvas, 4.5 x 12.3 ft. (139.1 x 374.6 cm)

MUSEUM OF FINE ARTS, BOSTON, USA. TOMPKINS COLLECTION, ARTHUR GORDON TOMPKINS FUND

This monumental painting is considered the painter's true spiritual testament. Unbound, unconventional, and a lover of travel and adventure, Gauguin was approaching the end of his life—in the remote islands of the Pacific, far from the modern world that he disliked. In Tahiti and generally in Polynesia, Gauguin found simplicity and authenticity in the people, and discovered exotic, fascinating settings and colors. But he did not completely lose touch with the world from which he came: his desires, doubts, and feelings remained the same, as did the profound unanswered questions about the human condition. In this consummate masterpiece—the deep and very sincere reflection of a man who never sought out abstruse philosophies, to the point that he described himself as a "dabbler"—it is a great comfort to find the familiar outline of the cat, our slightly mysterious but not unfaithful companion on life's journey.

PAUL GAUGUIN (1848–1903)

Te Tamari No Atua (Nativity), 1895–96

Oil on canvas, 37 x 50 in. (96 x 128 cm)

Neue Pinakothek, Munich, Germany

This is one of Gauguin's great masterpieces, perhaps the high point of his very personal form of mysticism, which fused Christian traditions with the exotic settings of the Pacific islands. The scene takes place in a Polynesian hut, where a young woman has just given birth to her child: the faint haloes around the heads of the very young mother and the newborn call to mind the iconography of the Virgin Mary and Jesus. The simplicity of the Tahitian house is comparable to that of the hut in Bethlehem, and the stable in the background is a further homage to the history of sacred painting. On the bed we can see the outline of a white cat, which makes its presence felt by gently brushing its soft fur against the smooth, dark skin of the girl's legs.

HENRI ROUSSEAU (LE DOUANIER) (1844–1910)

Portrait of Pierre Loti, c. 1891

Oil on canvas, 24 x 20 in. (62 x 52 cm)

KUNSTHAUS, ZURICH

An unusual figure, yet in his own way highly representative of international culture at the beginning of the twentieth century, Pierre Loti was an author in love with the Orient, who through his fluent and accessible writing popularized the scenes, situations, and atmosphere of distant Asia. However, Loti also should be remembered as a great cat lover. The Douanier Rousseau painted this famous portrait of him. With his unmistakably clear, simple line, which made him a pioneer among the naïve or primitive artists, Rousseau brings his personage close to the viewer, combining exotic elements such as the fez and the turned-up moustache with an ordinary, middle-class appearance. The tabby cat, captured in an attitude of noble detachment, is almost a "quotation" of the affectionate words the writer dedicated to his inseparable but also inscrutable feline friend.

EMILE GALLÉ (1846–1904)

Figure of a Cat, c. 1900

Enameled terra-cotta with details in glass, height 13 in. (34 cm)

<small>PRIVATE COLLECTION</small>

The undisputed master in the revival of the applied arts at the end of the nineteenth century, the multitalented Gallé was a glass-maker, cabinetmaker, ceramist, and even botanist. His passion for natural forms and the beauty of creation were perfectly in keeping with the aims of Art Nouveau—also known as Stile Liberty in Italy, Modern Style in Britain, and Jugendstil in Germany—that found its greatest creative stimuli in the beautiful designs of nature. It is said that the door to his studio bore the inscription "Ma racine est au fond des bois, au bord des sources, au-dessus des écumes": "My roots are in the depths of the woods, next to springs, floating on the foaming waves." This testifies to Gallé's visceral connection to Mother Earth, of which our animal is one of the exemplary "products."

THÉOPHILE ALEXANDRE STEINLEN
(1859–1923)

Two Cats: Poster for the Exhibition of Drawings and Paintings by T. A. Steinlen, 1894

Colored lithograph and watercolor, 23 x 19 in. (59.1 x 48.7 cm)

MUSEUM OF FINE ARTS, BOSTON, USA. BEQUEST OF W. G. RUSSELL ALLEN

This lithograph, clearly inspired by Japanese art, right down to the elegant calligraphic monogram and the grain of the neutral background, is the printer's proof for the poster of the first and most important comprehensive exhibition of the work of Steinlen, who was the first great poster artist in the history of art and advertising, working closely with Toulouse-Lautrec. Steinlen adored cats, and considered it a mark of destiny that he began his career working for a periodical entitled *Le Chat Noir* (The Black Cat). Indeed, his first collection of engravings was devoted to cats. For this reason, as the key image of his first retrospective exhibition, he chose the soft, elegant lines of two practically Art Nouveau cats; the image also plays on the chromatic contrast between a three-colored "harlequin" cat in the foreground and the extremely elegant, totally black cat in the background.

FÉLIX VALLOTTON (1865–1925)

Indolence, 1896
Xylograph on paper, 7 x 9 in. (17.3 x 22.1 cm)
Private collection

In proverbs, in sayings, and simply by virtue of its gaping yawns and deep naps taken in cozy places, the cat is a symbol of indolence. If, on the other hand, we are aware that the cat, according to a tradition dating from the Middle Ages, is also seen as the embodiment of the devil, we are forced once again to consider the qualities of elusiveness and duality as fundamental to our protagonist. The stylistic development of the Swiss painter Vallotton essentially resembles that of a cat: flexible and sinuous, it evolves through various avant-garde art movements, observing them with interest but without becoming too engaged. A free, independent spirit, in his painting Vallotton also alternates between moments of impetuous creativity and intervals of pleasant relaxation, such as this image of a woman stretched out on the bed who extends a practiced hand to stroke a handsome white cat between its ears.

THE MODERN CAT

From the Twentieth-Century Avant-Garde to Contemporary Portrayals

PIERRE BONNARD

PAULA MODERSOHN-BECKER

ERNST LUDWIG KIRCHNER

OSKAR KOKOSCHKA

MAX BECKMANN

FRANZ MARC

PAUL KLEE

MARC CHAGALL

CARLO CARRÀ

JOAN MIRÓ

FOUJITA

ALBERTO GIACOMETTI

ALEXANDER CALDER

FERNAND LÉGER

PABLO PICASSO

ANDY WARHOL

TOM WESSELMANN

FRANCIS BACON

LUCIAN FREUD

BALTHUS

DAVID HOCKNEY

DURING THE NINETEENTH CENTURY, AS WE HAVE ALREADY NOTED, the cat's progress through society was something of a roller coaster, passing from the middle-class interior to the peasant's farmhouse, the artist's studio to the arms of budding young girls, finally to emerge from an underground river of demonic superstition via Symbolism. Simultaneously, it is impossible to ignore the rapid rise of the dog, which in its various forms and breeds entered aristocratic circles and even the favor of royal families. It is nothing new, but certain dog breeds, such as the greyhound, alongside a diaphanous belle epoque lady, the whining packs of beagles and hounds hunting hares and foxes, or the legendary corgis of English monarchs, became synonymous with sophisticated elegance. In short, on the threshold of the twentieth century, the cat had to redefine its image in modern terms, or risk being marginalized and forced into a secondary role by competition from the more adaptable dog.

From this perspective, the cat's success during the twentieth century is truly surprising. What happened was not so much a proliferation of breeds or physical features that might become fashionable—although among European cats alone the tailless Manx cat, the "harlequin" with its three-colored coat, and the Scottish Fold with its flattened ears all rose to prominence. It was more a case of the domestic pussycat developing new aspects of its character, reasserting its multifaceted aspects, giving its name to famously shady or fashionable nightspots in Paris (Le Chat Noir) and Barcelona (Els Quatre Gats), and appearing more frequently in poems and paintings as well as the leading artistic and intellectual trends. A true, modern, feline renaissance was under way, which at times had the aura of an exclusive clique or private club: cat lovers felt "different" and privileged compared to dog lovers.

Part of the credit, initially at least, must go the Symbolist movement, which was fascinated by the cat's elusive dual nature, and the possibility of contradictory, mysterious interpretations. A sinuous, bewitching shape, glittering eyes, and ever-changing positions: during the first quar-

PAGE 276: Félix Vallotton, *Crouching Woman Feeding Milk to a Cat*, 1919. Oil on canvas. Private collection.

ter of the twentieth century, the cat experienced an extraordinary series of representations in painting—perhaps without precedent throughout the history of art until then. If we follow the cat's tortuous path, we encounter a number of artistic masterpieces that almost constitutes a miniature history of avant-garde art, from the Art Nouveau of the early twentieth century to the Surrealism of the 1920s and 1930s. These run from the glamour of the poster artist Théophile Steinlen and the soft curves of Franz Marc (probably the most unlucky animal painter of the twentieth century), who died in the trenches during the First World War); to the bony images of the German Expressionists of Die Brücke; the amiable domestic elegies of Marc Chagall; the geometric and graphic experiments of Paul Klee; the rapt immobility of Carlo Carrà; the witty and intense Cubist deconstruction of Pablo Picasso; the disembodied shadows of Alberto Giacometti; the contrasting interpretations of Fernand Léger and Joan Miró; and the erotic obsession of Balthus. Naturally, there was a parallel thread running through literature, which was especially rich with respect to French poetry and literary criticism. The theater critic Paul Léautaud, for example, would conclude his memorably withering reviews of productions staged in Paris by declaring, wearily, that he would much rather have stayed home with his numerous cats. In English literature, T. S. Eliot devoted his iconic long poem to the problem of finding a suitable name for the household cat.

The instinctual reactions of cats were widely studied by both psychologists and neurologists, and an infinite number of proverbs and sayings referring to cats were coined. In popular culture, comic strips and animated cartoons immediately picked up on the cat's newfound success. Whereas large movie companies such as Warner Brothers made the cat the true star of their cartoons, Walt Disney decided not to include it in its collection of anthropomorphic animals, with the exception of its feature-length cartoon *The Aristocats* and the film *That Darn Cat!* Disney's attitude is understandable; after all, its hero is Mickey Mouse. However, cartoons are not simply inhabited by lovable, bungling

Suzanne Valadon, *Study of a Cat*, 1918. Oil on canvas. Private collection. A late 19th- and early 20th-century painter, Valadon portrays the cat in a plain, linear style that emphasizes the simple ordinariness of the scene.

pussycats perennially engaged in the pursuit of astonishingly fast mice or mocking canaries at the same time that they try to escape from enormous mastiffs. The cat, or rather its image, makes its entry into comic strips intended for an adolescent and even adult audience, as reflected in the seductive figure of Catwoman, Batman's dangerous but bewitching opponent.

We are indebted to Winston Churchill (who was compared to a bulldog in caricatures) for one of the wittiest apologies for the cat, clearly asserting its superiority. According to the English statesman, the dog looks up to us, and the cat looks down on us; only the pig looks us in the eye as an equal. On the subject of pigs, George Orwell notes, in his novel *Animal Farm* (in which the government consists of pigs) that whenever there is work to be done, the cat finds a way to make itself scarce. Thus he revives the traditional image of the innate laziness (or cunning) of the domestic cat, always ready to shun any task.

During the second half of the twentieth century, and in recent decades, the cat has continued to consolidate its comfortable position in society. In painting, the works of Lucian Freud (where the magnetic parallel between the eyes of a tabby cat and a young girl's glance is unforgettable), Andy Warhol, and David Hockney are noteworthy. In other words, the great masters of contemporary figurative painting and Pop Art are also, in their turn, fascinated by the image of the cat. In the theater, the hit musical *Cats*, based on poetry by T. S. Eliot, was a true apotheosis: a depiction of an entirely feline world, it has been performed worldwide to wide acclaim. And in film, the first sequel in the cinematic transposition of Garfield—that indescribable, and extremely greedy, comic-strip cat—has already appeared. In short, throughout the arts and popular culture, the cat continues to be a loved, and slightly feared, protagonist, its sweetness always concealing a touch of mystery.

OPPOSITE PAGE: Raoul Dufy, *The Cat*, from Guillaume Apollinaire's *Le Bestiaire* (The Bestiary), 1909. Xylograph. The Stapleton Collection. Beneath Dufy's illustration is Apollinaire's poem dedicated to the cat, which is stunning in its simple, lyrical approach to the everyday:

Le Chat

Je souhaite dans ma maison:
Une femme ayant sa raison,
Un chat passant parmi les livres,
Des amis en toute saison
Sans lesquels je ne peux pas vivre.

The Cat

In my house I would like:
A woman in command of her senses,
A cat gliding among my books,
And always friends
Without whom I cannot live.

PIERRE BONNARD (1867–1947)

Bourgeois Afternoon (The Terrasse Family), 1900
Oil on canvas, 54 x 83 in. (139 x 212 cm)
MUSÉE D'ORSAY, PARIS

Three cats and a dog brighten the Terrasse family's country house; in their own way, they enjoy the sunshine and peace of a Sunday afternoon in the company of members of the family, including numerous children, spanning three generations; Bonnard's sister, shown at the right, is the wife of Charles Terrasse, on the far left. Bonnard's sunny intimacy is always ready to capture everyday small pleasures in a gentle way: the unmistakable, marvelous green used by the painter renders the entire scene attractive, even though some figures verge on caricature. One of these is certainly the cat, which unquestionably feels—and behaves—as if it were the true master of the house. Fat, sated, and satisfied, ensconced on the cool grass, the cat is the only living thing in the painting that looks in our direction, establishing with the viewer a surprising and effective mode of communication.

Opposite page:

PIERRE BONNARD (1867–1947)

Woman with a Cat, 1912

Oil on canvas, 30.4 x 30.1 in. (78 x 77.2 cm)

Musée d'Orsay, Paris

The twentieth century boasts, right from its start, a large number of great artists who sincerely loved cats, but perhaps none had as much sensitivity and discretion as Bonnard. For the French master, a delicate artist who took his cue from Impressionism, which he reinterpreted with lyrical intimacy, the cat is the animal to whom one confides the secrets of the heart: the cat is not a mysterious symbol or an elegant arabesque, nor a slightly disturbing presence, but a tender, discreet companion. This painting, which in its balanced simplicity is rightly considered one of the painter's masterpieces, offers a subtle psychological interpretation of the relationship between a solitary young woman and a cat that appears at her side like a mute witness to her inner secrets.

PAULA MODERSOHN-BECKER (1876–1907)

Girl with a Cat, 1905

Oil on cardboard, 28 x 19 in. (72 x 49 cm)

Private collection

An important figure of the international avant-garde, around the turn of the last century, Paula Modersohn-Becker forms a link between the German Expressionists and the Post-Impressionism of Gauguin. This solitary, adorable little girl, with her rather lost expression, seems to seek warmth and comfort from her kitten that, in turn, sinks into the girl's arms. The strange and mysterious solidarity between cats and children, to whom the animals grant privileges and allow caresses and cuddles that are unknown to adults, is one of the singular and still incomprehensible characteristics of cats.

ERNST LUDWIG KIRCHNER (1880–1938)

Marcella, 1910

Oil on canvas, 39 x 30 in. (100 x 76 cm)

BRÜCKE MUSEUM, BERLIN

This is one of Kirchner's master-pieces, and among the works that best convey the uneasiness of the German painter and his Expression-ists colleagues in the years leading up to the Great War. The young artist Marcella is depicted in a pose that calls to mind the traditional allegory of Melancholy. The paint-ing's green hues, skillfully laid on large, flat surfaces, render the color range intense, almost biting. Marcella is huddled on a divan, in a solitude that is emphasized by the liquor bottles on the table; her wide eyes gaze into the distance. Almost in the same pose, and on the same divan, is a white cat; but, unlike the girl, the cat is sleeping soundly. In the apparent similarity between the poses, Kirchner appears to want to stress their opposing attitudes: the pensive anxiety of Marcella, and the peaceful, almost philosophical abandon of the cat.

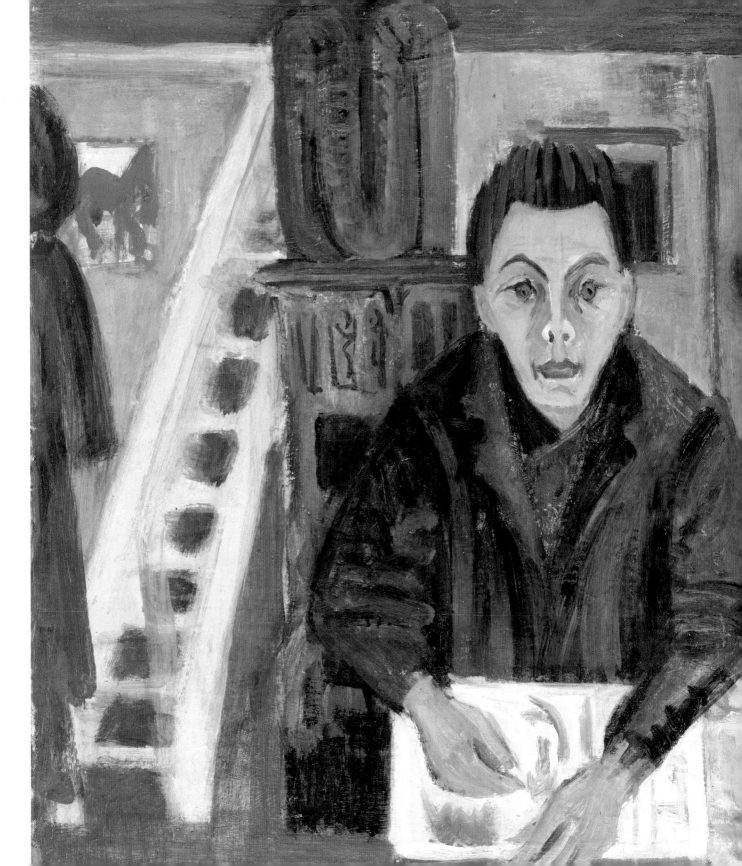

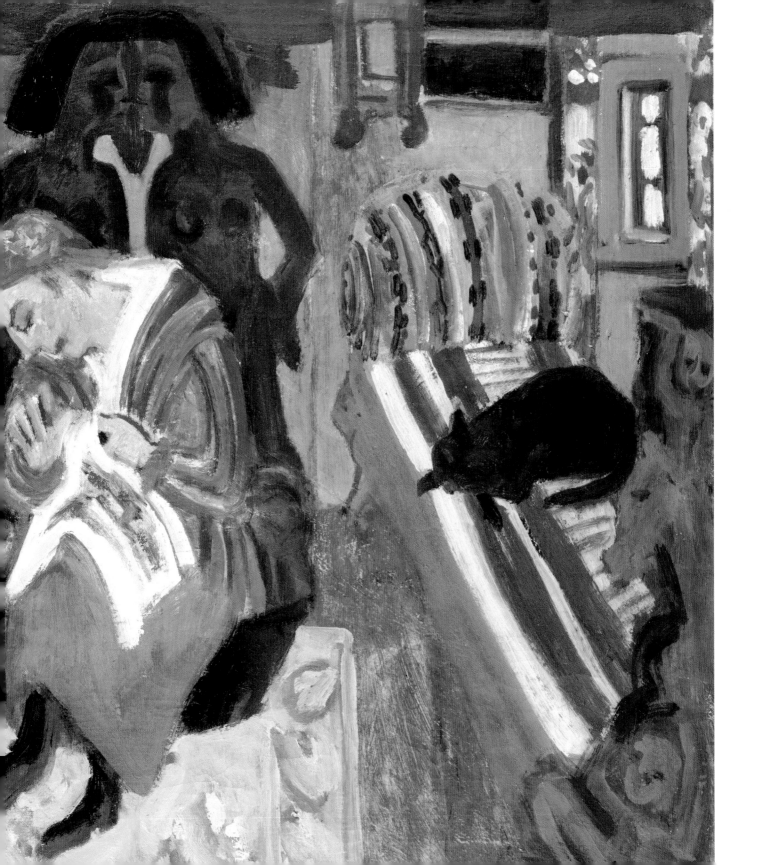

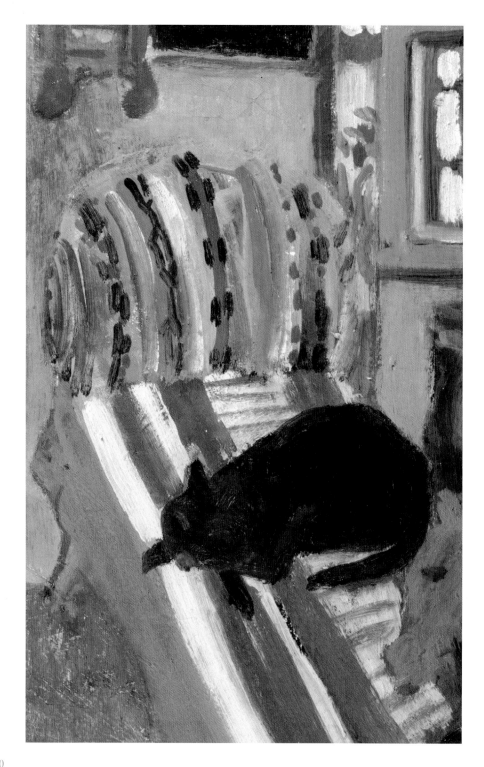

ERNST LUDWIG KIRCHNER (1880–1938)

The Living Room, 1920

Oil on canvas, 35 x 59 in. (90 x 150 cm)

HAMBURGER KUNSTHALLE, HAMBURG, GERMANY

A major exponent of German Expressionism, Kirchner often painted cats. In this domestic setting of apparent middle-class simplicity, the painter has imbued his canvas with an intensity that is the antithesis of academic painting. His love of hot colors, of intense creative energy, and of primitive art combine to produce a scene of explosive spontaneity. Even in this context, however, the black cat maintains its age-old indifference, calmly purring on the divan, impassive and reassuring.

OPPOSITE PAGE:

ERNST LUDWIG KIRCHNER (1880–1938)

Gray Cat on a Cushion, 1919–20

Oil on canvas, 31 x 27 in. (79 x 69 cm)

MUSEUM AM OSTWALL, DORTMUND, GERMANY

A comparison between Kirchner's works before and after the First World War highlights with dramatic effect the state of mind of a German intellectual. This cat is tense, the forward-pointing whiskers a clear sign of nervousness; and its tail looks as if it is about to beat against the cushion. The animal's glaring eyes and the violent colors in the background, where the fabric seems to evoke explosive flashes of light, add to this painting's sense of tension.

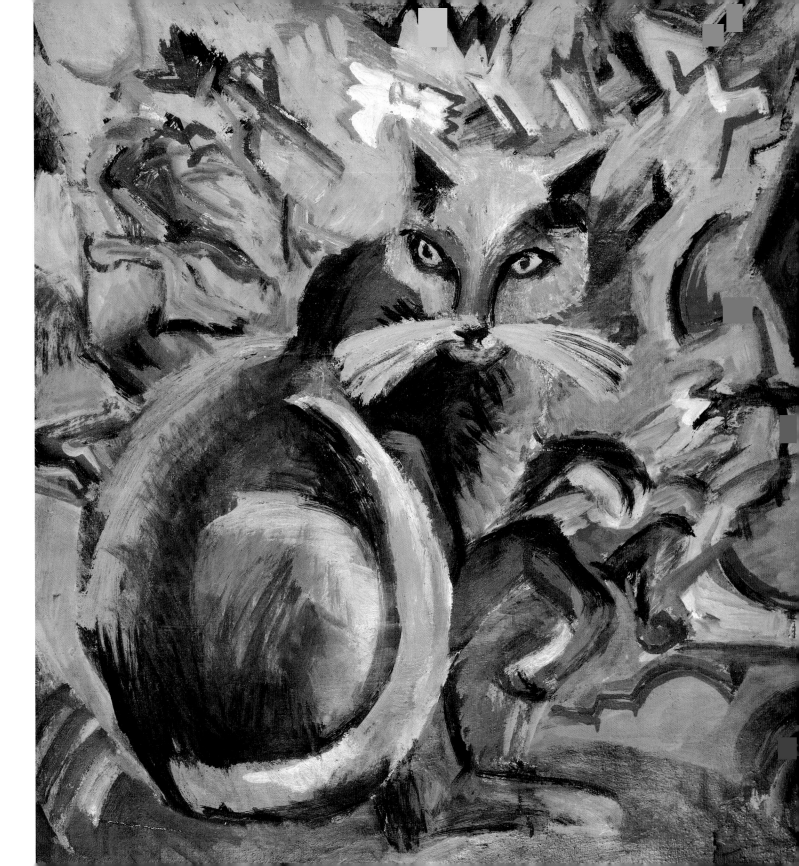

OSKAR KOKOSCHKA (1886–1980)

Lovers with Cat, 1917

Oil on canvas, 36 x 51 in. (93.5 x 130.5 cm)

Kunsthaus, Zurich, Switzerland

More than once decorated a hero during the First World War, the Austrian artist created his own personal version of Expressionism. His paintings—superficially blotched, aggressive, textured, and rich in material—reveal an intimate gentleness and a search for affection and love, as this splendid canvas clearly demonstrates. The feelings and poses of the two lovers, who simultaneously embrace and elude each other, reach out and withdraw, are symbolically emphasized by the silent presence of the cat.

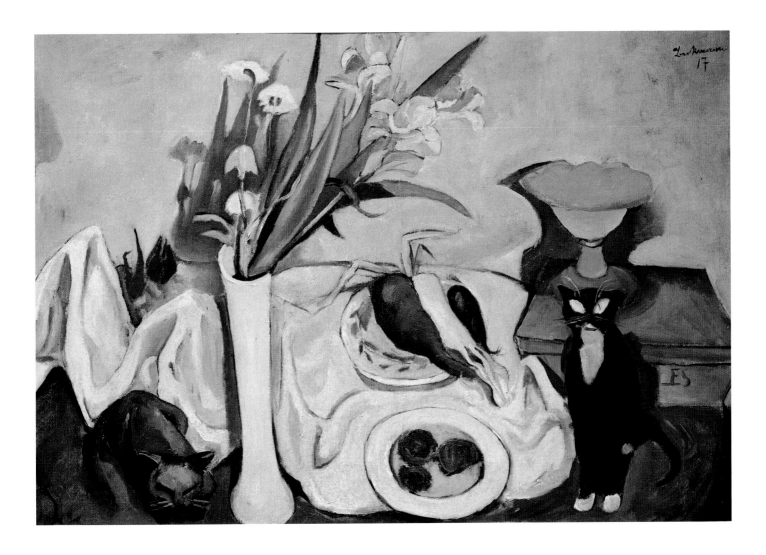

MAX BECKMANN (1884–1950)

Still Life with Cats, 1917

Oil on canvas, 25 x 39 in. (65 x 100 cm)

GALLERY PELS-LEUSDEN, BERLIN

In his typically sophisticated, cultured, and at the same time incisive manner, Beckmann here returns to the classic theme of the still life with cats that, as we have seen, runs through the history of art since the Baroque period. However, unlike the seventeenth-century paintings, which chiefly focus on the cat as "petty thief" of the pantry, this still life provides an opportunity to observe the placid calm of felines in a tranquil domestic environment, letting them pose for the artist amid the fruit and flowers. The two cats—one black with white paws and neck, and the other dark gray—have lost their mysterious symbolic meaning. The ordinariness of the scene is conveyed through a clear-cut composition with its curvilinear forms and strong outlines, revealing a broad and sophisticated range of colors.

FRANZ MARC (1880–1916)

Two Cats, 1912

Oil on canvas, 38 x 29 in. (98 x 74 cm)

OFFENTLICHE KUNSTSAMMLUNG, BASEL, SWITZERLAND

Perhaps the greatest of all modern animal painters, in 1911 Marc joined Der Blaue Reiter (The Blue Rider), an avant-garde Expressionist group formed in Munich comprising, among others, Paul Klee, August Macke, and Gabrielle Münter, and centered on the figure of Vasily Kandinsky. Marc's excessive attraction to nature drove him to depict animals almost exclusively, especially cats and horses; this passion lasted all of his short life, which was brought to a premature end in France during the First World War. From his early Jugendstil phase, through his discovery of Cézanne and Cubism, and finally verging on abstract painting, Marc's work is strongly pervaded by a "romantic" sentiment, derived from his early studies of the philospher Schelling. With the distinction between subject and background lost, these two cats by Marc are extraordinarily "expressionistic" in their pre-Cubist deconstruction.

OPPOSITE PAGE:

FRANZ MARC (1880–1916)

Two Cats, 1908

Drawing, 14 x 11 in. (36 x 28 cm)

STAATLICHE GRAPHISCHE SAMMLUNG, MUNICH

The artist treats the traditional animal theme with a studied compositional balance, based on contrasts of posture and color and heightened by a fluid, sure line, in which Art Nouveau influences can still be seen. Thanks to its movement the darker cat, in the foreground, highlights the illuminated cat behind: even their tails seem to take part in a delicate compositional interplay.

THIS PAGE:

FRANZ MARC (1880–1916)

Cat Behind a Tree, 1910

Oil on canvas, 27 x 20 in. (70 x 50 cm)

SPRENGEL MUSEUM, HANOVER, GERMANY

Around 1910 Marc's fluid, pure line became a recognizable stylistic trait of the Blaue Reiter (Blue Rider) group, which also emphasized the expressiveness of bold color. During the short flowering of this significant Expressionist movement, which was founded in 1911 by Kandinsky and took place in Munich and the Bavarian countryside, Marc captured the brilliant colors of medieval stained-glass windows, with their striking combinations of yellow and blue. The big, placid, tawny cat sleeps blissfully, half hidden behind a tree, in a composition where every shape is modeled in soft, curved, sinuous lines.

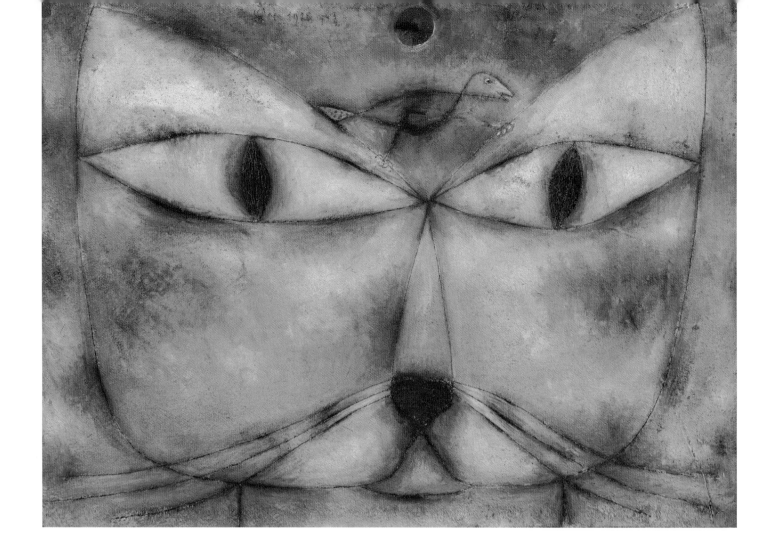

PAUL KLEE (1879–1940)

Katze und Vogel (Cat and Bird), 1928

Oil and ink on gessoed canvas, mounted on wood, 15 x 21 in. (38.1 x 53.2 cm)

Klee's magnificent big cat holds its prey in its head! It is its idée fixe, its obsession: to seize food in order to survive. With a single ink line, the major Swiss artist has succeeded in capturing the feline lust for succulent prey, capable of reawakening the cat's ancestral and never-suppressed hunter's instincts. The highly sophisticated range of colors—based on emerald green, ochre, and fuchsia—accentuates, especially in the fixed, concentrated stare and menacing dilated pupils, the sensation of an ambush about to happen. This picture belongs to a particularly rich phase in the art of Klee, who reanimates the motif of childhood creativity with expressiveness and an extraordinary balance of colors.

MARC CHAGALL (1887–1985)

Paris Through the Window, 1928

Watercolor on paper, 15 x 22 in. (38 x 56 cm)

NATIONAL GALLERY, PRAGUE

Immediately on arriving in Paris, Chagall was influenced by Cubism in its "Orphic" form. The Russian artist's debt to Robert Delaunay is tangible in this view of the city from the window: in the choice of iconographic theme—the Eiffel Tower is one of Delaunay's favorite subjects—and in the deconstruction of forms and use of color and movement that are unknown in mainstream Cubism. The cat on the windowsill bears witness to the artist's dual "identity," split between France and Russia and symbolized by the two-faced portrait. It was during Chagall's French years, from 1911 to 1913, that he created such paintings that later would be regarded as forerunners of Surrealism. Chagall painted city views from the perspective of memory and imagination. This work, which actually dates from 1928, revives imagery that Chagall had developed in Paris some fifteen years earlier.

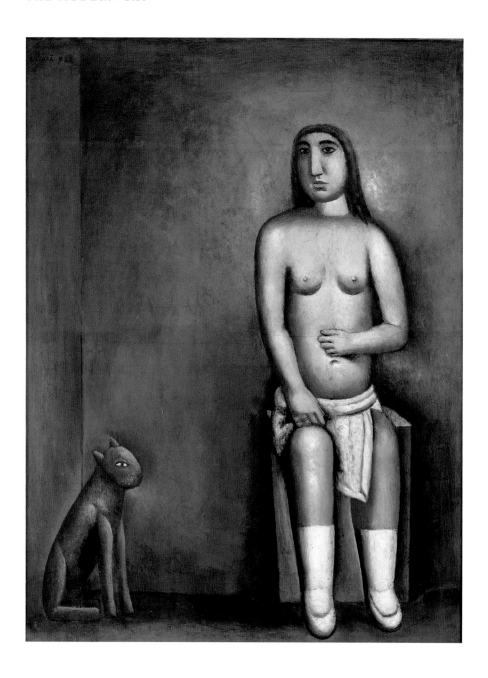

CARLO CARRÀ (1881–1966)

The House of Love, 1922

Oil on canvas, 35 x 27 in. (90 x 70 cm)

PINACOTECA DI BRERA, MILAN, ITALY.
COLLEZIONE JESI

Presented at the Venice Biennale of 1922—a crucial year in the painter's life—this work provoked fierce controversy over a style that was still far from fully understood. Carrà was one of the signers of the *Manifesto of Futurist Painting* (1910); and a month or two after that historic document's publication, he showed growing interest in the roots of Italian art. Years of intense study of the frescoes and works of Giotto and Paolo Uccello were to follow. In this cubic box, which even in its superficial treatment appears to be modeled on medieval mural decorations, a seminude woman awaits a customer: an atmosphere almost akin to magical realism pervades the place, laden with mystery and expectancy; the gray cat in the corner is like a sphinx, silently bearing witness.

JOAN MIRÓ (1893–1983)

Untitled, c. 1935

Stencil on cardboard, 20 x 18 in. (50 x 45 cm)

<small>PRIVATE COLLECTION</small>

It is not uncommon to encounter a large number of images of cats in the works of this great Catalan painter. In *The Farm* (1922–32), *Carnival of Harlequin* (1924–25), and above all in the series of drawings entitled *Constellations* (1941), we see a veritable triumph of the cat, depicted wagging its tail, as malicious—or even stellar. In this painting the stylistic features typical of Miró–the stylized line that seems to emerge from the subconscious, the flat surfaces of color, the neutral background, a feeling of agitation—convey a monstrous devouring figure, perhaps to protest the oncoming Spanish civil war. The composition is based on bold primary colors, black, and white on a dark background. In the bottom left-hand corner is a highly stylized, perhaps hybrid, cat—which some identify as a dog—evoked by a few skillful brushstrokes.

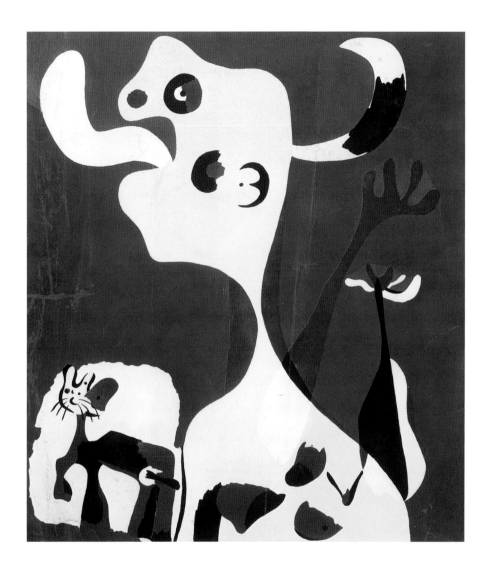

FOUJITA (Tsuguharu Léonard Foujita) (1886–1968)

Sleeping Cat, 1956

Ink and watercolor on paper, 13 x 16 in. (34 x 41 cm)

Private collection

Known as Foujita in France, where he moved in 1913, the artist was born Fujita Tsuguhuru (last name first) in Japan. Well established in the cosmopolitan School of Paris—a group of mostly foreign-born artists who lived and worked in Paris during the interwar period, among them Amedeo Modigliani, Chaim Soutine, and Marc Chagall—Foujita was a singular and exotic protagonist of the flamboyant, bohemian Montparnasse of the 1920s. Although his nudes and still lifes are a true homage to the land that welcomed and bewitched him, the last phase of his life was entirely devoted to regaining his Japanese heritage. One of the modern artists renowned for his images of cats, Foujita followed in the footsteps of the great Oriental drawing tradition, which has always attributed a fundamental importance to depicting nature. With his meticulous, impeccable style, this artist drew a vast number of cats, spending long periods of time observing those he owned to study the positions they adopted and their behavior. This sweet, delicate striped kitten shows that the artist was well acquainted with the work of Utamaro, Hiroshige, and Kuniyoshi.

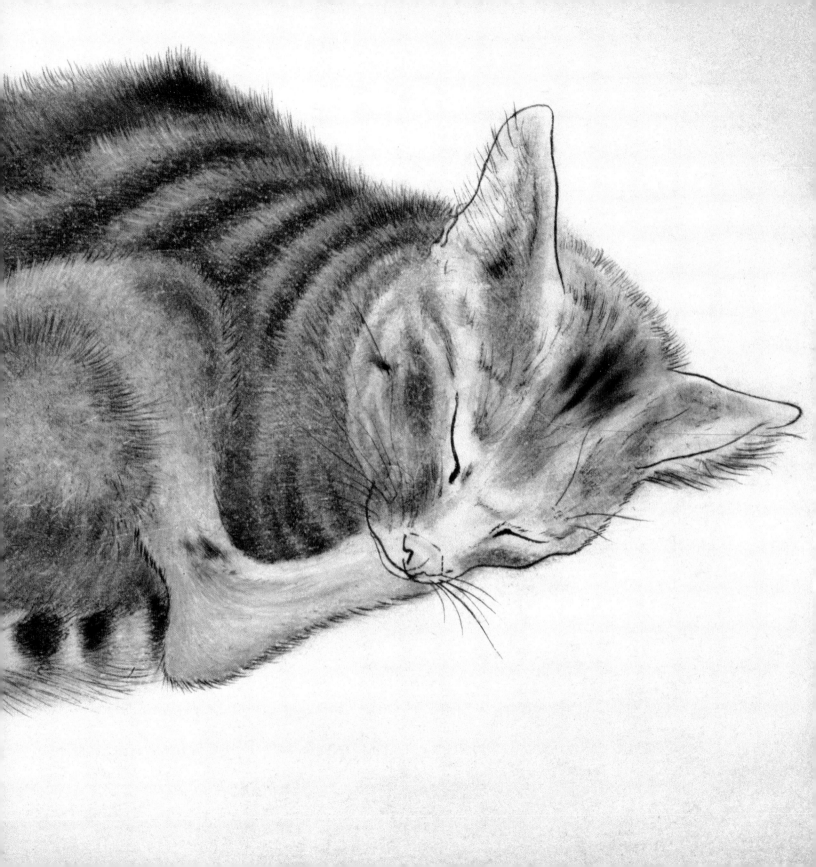

ALBERTO GIACOMETTI (1901–1966)

The Cat, 1951

Bronze, 12 x 32 x 5 in. (32 x 83 x 13 cm)

NATIONALGALERIE, MUSEUM BERGGRUEN, STAATLICHE MUSEEN ZU BERLIN, GERMANY

Stripped of flesh right down to the bone and impossibly elongated, Giacometti's *The Cat*, like all his "human figures," expresses a sort of mysterious spirituality, precisely because of the extreme simplification of shape and volume. In this sculpture, the animal's well-known independence is transformed into solitude, a metaphor for the existential condition that encompasses humans and animals alike. The treatment of the bronze surface helps to give the figure a certain primordial quality, as if it had not yet been given its final shape. Even in this extreme stylization, a friendly form is still discernible.

ALEXANDER CALDER (1898–1976)

The Rattle Cat, 1969

Sheet metal and paint, 8 x 34 x 7 in. (20.3 x 86.3 x 17.8 cm)

PRIVATE COLLECTION

Famous for his mobiles that perfectly balance line and surface, Calder here has allowed himself an amusing diversion, working his favorite material as if it were origami paper. From the folded, brightly painted sheet of metal emerge almost magically the unmistakable outline of the head and tail of a cat. This bright, almost Pop Art effect is part of the artist's ability to evoke the animal with just a few skilled lines. We can almost hear Prokofiev's ineffable musical portrayal of the cat's velvety footsteps in the orchestral piece *Peter and the Wolf*.

FERNAND LÉGER (1881–1955)

Woman with a Cat, 1955

Oil on canvas, 25 x 36 in. (65 x 92 cm)

PRIVATE COLLECTION

One of the most interesting developments in painting spawned by Cubism was Orphism, which Apollinaire identified with Robert Delaunay's method, around 1912, of deconstructing form in favor of pure color and dynamism. Whereas Delaunay developed a "Cubism of color," Léger devoted himself to "tubism"— as the critic Vauxcelles described his style—that is, a reconstruction of forms based on the cylinder. Perhaps Léger's fundamental stylistic trait does not appear to the full in this painting, but certainly the work displays a considerable simplification of volumes and surfaces, and the exclusive use of primary colors (with only the addition of green). The indispensable companion for a placid, bourgeois afternoon spent with a good book is, once again, our friend the cat.

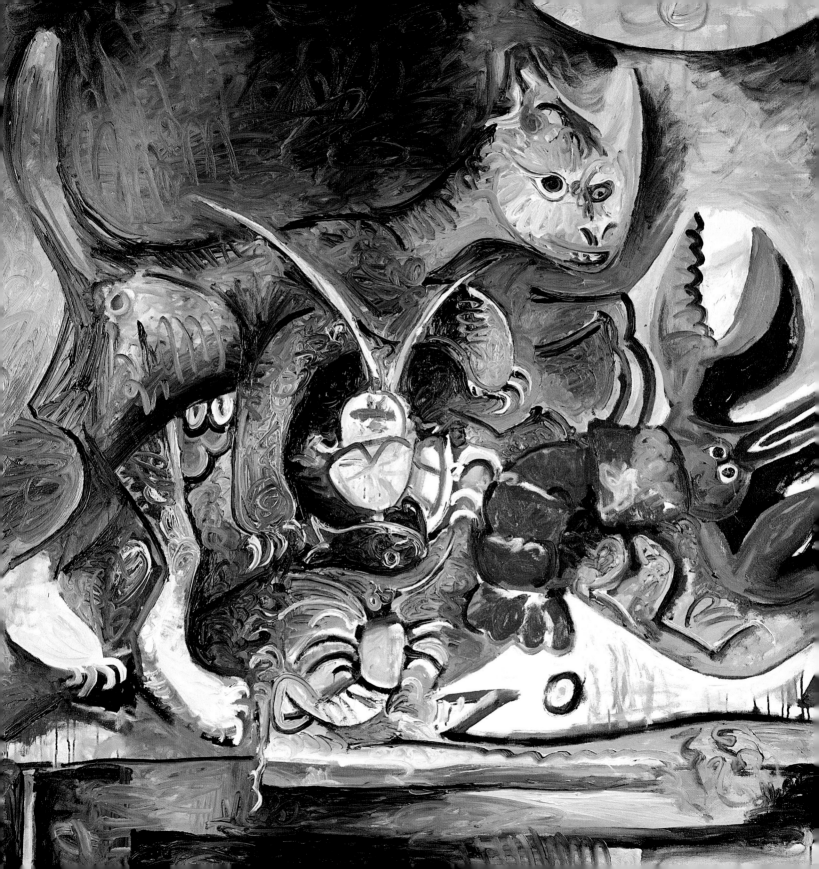

PABLO PICASSO (1881–1973)

Still Life with Cat and Lobster ("Technique"), 1962

Oil on canvas, 51 x 63 in. (130 x 162 cm)

PRIVATE COLLECTION

Picasso said of the cats depicted in some of his paintings: "I want to produce a cat like those we see in the street. They have nothing in common with household cats; their fur is ruffled and they run like devils." This painting, too, is inspired by the predatory cat, in the manner of the countless seventeenth- and eighteenth-century Dutch and French still lifes of game, showing cats in the pantry preparing to snatch quarries now drained of blood. Here, the artist's interest in the animal's wild, unconquerable nature is accompanied by a careful study of animal psychology (the "technique" of the title) that underlies the quest for food. Compared to the crystal-clear Flemish still lifes, however, "classic" form is lost; "modern" form is a continuous interlocking of geometric shapes and saturations of color, which are also perfectly capable of suggesting the cat's yearning confronted with such a banquet.

Sam

OPPOSITE PAGE:

ANDY WARHOL (1928–1987)

From *25 Cats Name Sam and One Blue Pussy*, c. 1954

Offset lithograph, watercolor, and pen-and-ink on paper, 9 x 6 in. (23.2 x 15.2 cm)

THE ANDY WARHOL FOUNDATION, NEW YORK

Cats are certainly not missing from the life and work of the inventor of Pop Art. Free and independent, sly and unscrupulous, they adapt well to Warhol's many-sided and effervescent personality. During the 1950s, Warhol made many drawings of his cats, often in frivolous and unusual poses. The album *25 Cats Name* [*sic*] *Sam and One Blue Pussy* was first printed in 1954 in 190 numbered copies, which Andy Warhol gave to clients and friends. This series of lithographs then entered the process of mass production in which Pop Art played a part; they were printed on T-shirts or engraved on cups produced in large numbers.

TOM WESSELMANN (1931–2004)

Still Life #28, 1963
Acrylic, collage, and TV on cardboard, 48 x 59 in. (121.9 x 152.4 cm)
ROBERT E. ABRAMS

Wesselmann was the last great exponent of American Pop Art, especially famous for his figures of sensuous women. In his still lifes he brings together objects, memories, images, words, and graphic symbols in montages that are always varied and vividly colored. With a sense of disenchantment, Wesselmann dismantles and reassembles shards of the American myth—the television, the icon of Abraham Lincoln, the Capitol in Washington in the background, the conspicuous star that calls to mind many North American symbols—in compositions that are nonetheless based on a classical structure, even making use of classical perspective. In this ironic but also affectionate collage, the American artist does not miss the opportunity to include a cat's face, which pops out from behind the image of Lincoln. This is a common household cat, which watches us with alert, slightly gaping eyes, establishing an immediate, firm contact with the viewer.

FRANCIS BACON
(1909–1992)

Portrait of George Dyer and Lucian Freud, 1967

Oil on canvas, 77 x 58 in. (198 x 147.5 cm)

KLAUS AND HELGA HEGEWISCH COLLECTION, HAMBURG, GERMANY

There were few certainties in Bacon's life. An existential restlessness was reflected in the extraordinary disorder of his studio (as photographs taken after the artist's death testify), but especially in his highly personal style of painting— tense, distorted, anxiety-provoking— in which a formidable visual sense is expressed in a totally original mode of representation. This painting highlights George Dyer, the artist's companion and model; but notice, on the left, that a cat enters the scene, providing an element of emotional stability, almost a sweet respite.

LUCIAN FREUD (1922–)

Girl with a Kitten, 1947

Oil on canvas, 15 x 12 in. (39.5 x 29.5 cm)

In *Girl with a Kitten* the artist portrays Kitty Epstein, daughter of the sculptor Jacob Epstein, whom he would marry in 1948 only to divorce a few years later. However, this period was long enough for him to paint Kitty's portrait several times: she was always accompanied by a different element—a rose, one of the bull terriers that had been a wedding present, or a kitten. The almost Dutch style of this period of Freud's painting heightens the most minute details, such as the rather shaggy hair. Nervous, with her lips slightly apart and an anguished expression, Kitty conveys a sensation of discomfort. The kitten, oddly gripped by the neck, contributes to the feeling of anxiety projected to the viewer: its wide-open eyes, like those of the woman, allow a pale light to be reflected in their gaze.

BALTHUS (Balthazar Klossowski de Rola) (1908–2001)
Mediterranean Cat, 1949
Oil on canvas, 50 x 72 in. (127 x 185 cm)
PRIVATE COLLECTION

In the art of Balthazar Klossowski de Rola, known as Balthus, the cat always fosters a great sense of ambiguity and tension. In *Mediterranean Cat,* this French artist of Polish origin seems to realize one of the cat's dreams: not having to make an effort to obtain food. From a rainbow over the sea, the lavish meal that this ravenous man-cat is preparing to devour descends directly on to the set table; a gigantic lobster is already on the tray. The crystalline purity of the geometric forms and the rarefied light that permeates the surfaces bear witness to Balthus's passion for Italian Renaissance painting, from Masaccio to Piero della Francesca, as filtered through the many avant-garde movements—especially Metaphysical painting and Surrealism—with which his art has been associated, although it always remained true to itself.

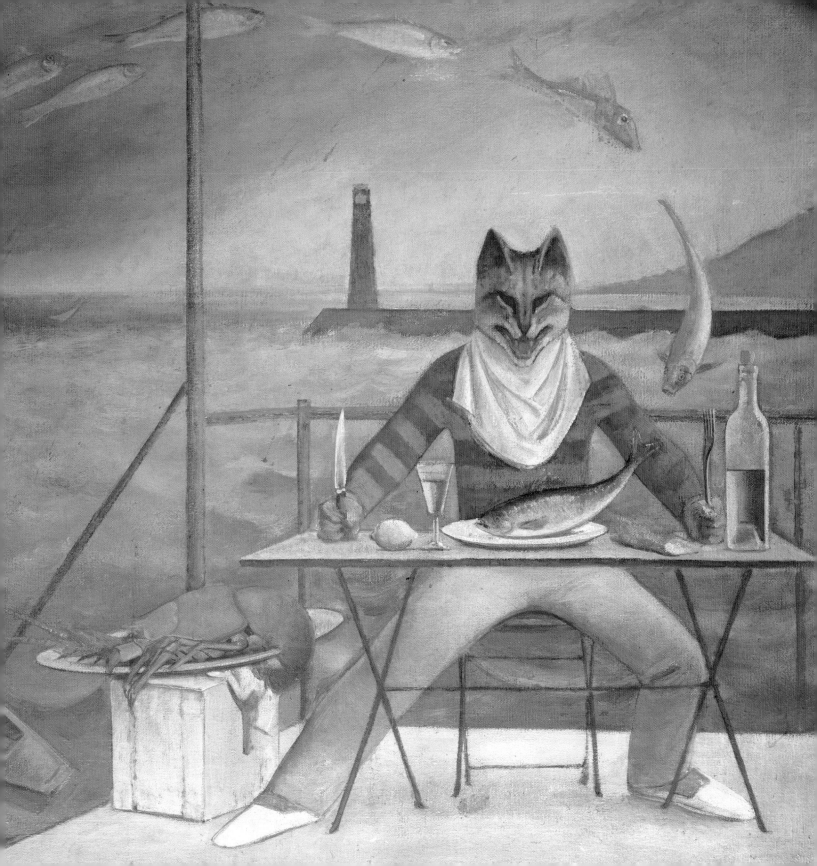

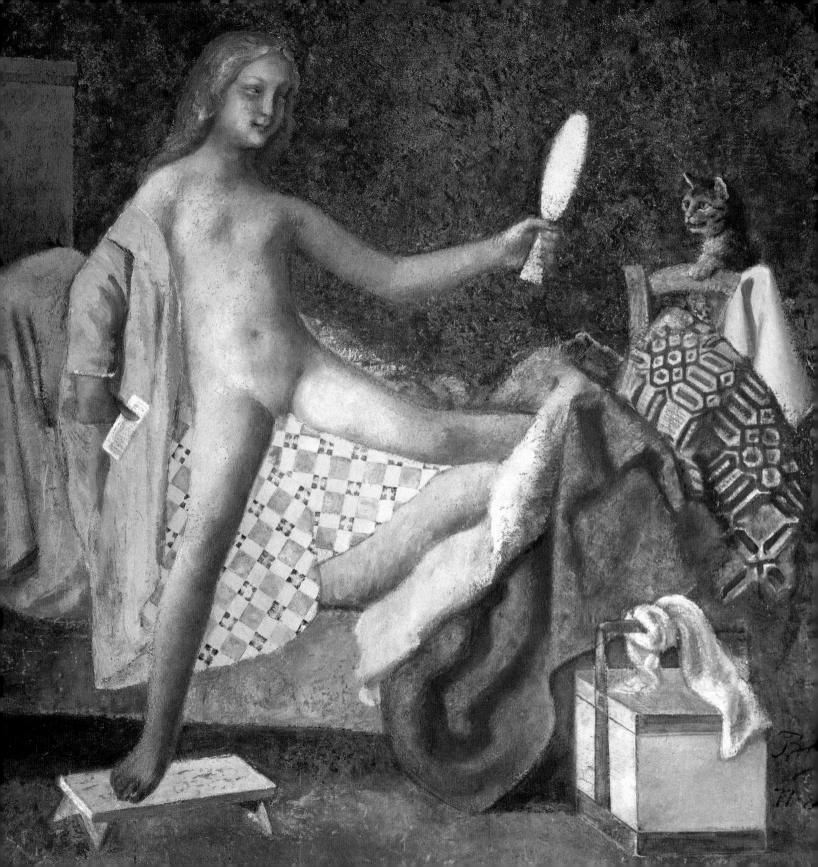

BALTHUS (Balthazar Klossowski de Rola) (1908–2001)

Cat with Mirror, 1977–80

Casein and tempera on canvas,
70 x 66 in. (180 x 170 cm)

The turmoil of childhood and adolescence is one of Balthus's favorite subjects; in this he was following in the footsteps of a long line of artists, first and foremost—among the avant-garde—Egon Schiele. It is no accident that Antonin Artaud, the poet and theorist of Surrealist theater, described his painting as "seismic," that is, innocent at first sight but filled with interior tension and disturbing psychological impulses. The perfidious girl is getting the hapless cat to look in the mirror: note how it is perfectly modeled on the malignant feline in Hogarth's *The Graham Children* (pp. 210–11), perhaps to underline the wickedness sometimes inherent in childhood. The cat must be disconcerted and frightened by its own image, even if it succeeds in identifying it as something outside itself. Here, too, the painter's treatment is closer to a fifteenth-century Italian fresco than to the work of an artist who was a singular, prominent figure throughout the twentieth century.

DAVID HOCKNEY (1937–)

Mr. and Mrs. Clark and Percy, 1970–71

Acrylic on canvas, 83 x 119 in. (214 x 305 cm)

Tate Gallery, London

Since the 1960s, after a trip to California, Hockney has painted in acrylic to obtain an almost plasticized surface that enhances the hyperrealism of his images. This produces a unique effect, combining a search for expressiveness, a taste for detail that is found in a glossy magazine, and the prominence of everyday objects in keeping with Pop Art taste. This famous portrait depicts one of the most glamorous couples of the day, the stylist Ossie Clark and his wife, the model Celia Birtwell. These are handsome, well-known people, their poses and look worthy of a magazine cover, surrounded by particular references to furnishings and taste. Yet the painting's true protagonist may be the white cat, Percy, that, in deference to the millennia-old habits of his species, sits on his master's knees but is supremely uninterested in the scene, turning his back on the painter to gaze out the window.

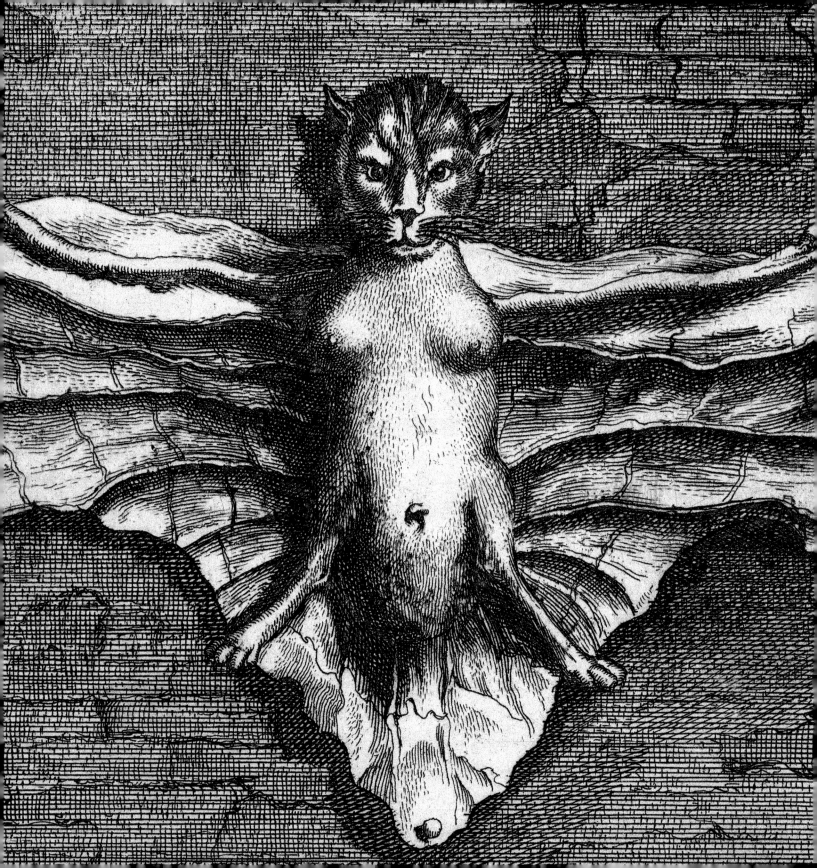

THE CAT POSSESSED

A Devil Meant for Stroking: Diabolic Prejudices and Images from the Middle Ages to the Present

MINOAN AND CRETAN ART

LUCA SIGNORELLI AND IL SODOMA

HIERONYMUS BOSCH

ALBRECHT DÜRER

HANS BALDUNG GRIEN

LORENZO LOTTO

GIOVANNI STRADANO

PIETER BRUEGEL THE ELDER

NICOLAS MAES

FRANCISCO GOYA Y LUCIENTES

THÉOPHILE ALEXANDRE STEINLEN

OTTO MUELLER

PABLO PICASSO

ACCORDING TO HONORÉ DE BALZAC, IN A CAT'S EYES THERE IS heaven, in its heart hell. Actually, it was but a short step from deification in ancient Egypt to demonization during the Middle Ages—the latter shared, moreover, with various cultures outside Europe.

Archaeological finds have confirmed a gruesome custom in medieval Europe, particularly in France: for centuries, they would bury a live cat in the foundations of cathedrals or other important buildings. This is an example of the superstitions directed at cats, especially black cats, which remains widespread even today, though in milder forms.

Already in the late Roman period the cat was associated with Diana, goddess of the moon, in Celtic religion. Later, in medieval Christianity, the cat was imbued with malignant qualities, to the extent that it was seen as an incarnation of the devil: this was a total reversal of the Egyptian worship of the cat-goddess Bastet.

The cat's flashing, changeable eyes; its mysterious nocturnal habits, including the ability to hunt in the dark; the sparks produced by static electricity in its fur; its sudden changes of mood; its extreme agility; and its cruelty to captured prey: all these traits were inexplicable and profoundly disturbing to medieval society. After the collapse of the Roman Empire, when it became impossible to maintain and repair plumbing as well as public and private waste-disposal systems, cats were absolutely indispensable in controlling mice in towns and villages with crumbling infrastructure; moreover, the cat's irrepressible attachment to its own freedom made it appear faithless and deceitful, attracting ever greater suspicion.

In the religion of the Germanic tribes, cats drew the chariot of the goddess Freya who had a dual nature, both positive and negative. It was not unusual among these tribes to offer a cat as a sacrifice. This ritual was also observed in certain Christian cities as a protection against witchcraft, as demonstrated even in modern times by the brutal *Kattenstoet*, the custom of hurling cats from the top of a tower in the important Flemish town of Ypres. Only in recent decades have real cats

PAGE 322: (Detail) *A Bat Known as a Flying Cat*, from *China Illustrated* by Athanasius Kircher (1601–1680), 1667. Engraving, 17th-century Dutch School. The Stapleton Collection.

been replaced by puppets made of plush. There are harrowing accounts, too, of cats beaten to death after the harvest, or burned alive to produce "magic" ash. In addition, X rays and anatomic examinations of the mummies of Egyptian cats have revealed that those cats were killed, usually by breaking their necks.

According to an interesting psychological interpretation, the cat represents a number of stereotypically feminine characteristics: malice, attachment to the home, and nocturnal habits involving the moon. These were all incomprehensible to a society that had long been firmly male dominated and therefore unable to penetrate the subtleties of female (or feline) character. As a result, as early as the Middle Ages the cat was considered the faithful companion of witches, the demonic animal par excellence. Art soon grasped, and reflected, this aspect of the animal.

Emanation from hell, demonic incarnation, collaborator of witches, and companion of heretics: the cat was an easy target for superstition. Romanesque bas-reliefs showing mice taking their revenge on cats are perhaps not intended simply to be taken humorously, but also as a type of spell. Cats' daily, repeated washing was seen as obscene, and the exposure of their genitals as a sure sign of diabolic debasement.

Sacred literature wasted no time in identifying the cat as a formidable demonic symbol and disseminator of heresy. As early as the twelfth century the theologian Alain de Lille condemned the association of the heretical Cathar sect with the cat in his bold assertion: "Cathari dicuntur a cato," or "They are called Cathars from 'cat.' " He even alluded to a supposed Cathar custom of kissing the behind of a demonic black cat.

From that time, and during the following five centuries, the black cat (sometimes described as being of enormous size) became a permanent presence in the trials of supposed heretics and witches. Even the Knights Templar were accused of cat worship, and the act of kissing a black cat's behind was condemned in a bull issued by Pope Gregory IX in 1233. Two centuries later, the theologian St. Bernardino of Siena was

Ernst Ludwig Kirchner, *A Mountain Walk with an Approaching Storm*, 1921. Xylograph. Private collection. A leading figure in the German Expressionist Die Brücke (The Bridge) movement, Kirchner gives us an anguished, modern interpretation of the cat's image, perhaps derived from the traditional view of the animal as foretelling unfortunate events.

convinced that witches had the power to change themselves into cats, thanks to ointments obtained from herbs gathered during the night of Christ's ascension. The demon in the form of a cat is all the more fearsome precisely because it is present in every home in the form of an inoffensive animal that can make itself adorable. The respected Dutch doctor Johannes Wier, one of the most important demonologists of the sixteenth century, lists no fewer than sixty-nine different demons in the appendix to his 1577 treatise *De lamiis* (On Ghosts). Two of these demons, called Bael and Haborim, take the form of a hybrid creature, part human and part cat. At the same time, the famous inquisitor Bernardo da Como, in his brief 1584 treatise *De Strigiis*, which aimed to educate and give practical advice to judges and clergymen called to pass sentence on witches, describes their capacity to change themselves into she-cats, thus revealing a link to those women of antiquity who worshipped Diana by night.

There are plenty of famous instances in art history of attributing a diabolic nature to cats. For example, the frequent presence of cats under the table in art depicting the Last Supper or the Supper at Emmaus is viewed as a symbol of betrayal or conflict. Without wishing to force this interpretation, there are obvious, indisputable references to this theme in paintings by Hieronymus Bosch, Lorenzo Lotto, and Francisco Goya—three renowned masters of painting, and also indefatigable investigators of the human soul and its primitive fears, superstitions, and the "sleep of reason."

The proverbial bad luck following a black cat's crossing our path is a clear and widespread remnant of medieval superstition. The elusive, ironic magic of the Cheshire Cat that fascinated Alice on her journey through Wonderland is derived directly from necromantic tradition. And the cat's identification with the devil is revived, for example, in Mikhail Bulgakov's absurdist masterpiece *The Master and Margarita* (1967): Satan's chief assistant is an enormous cat named Behemoth.

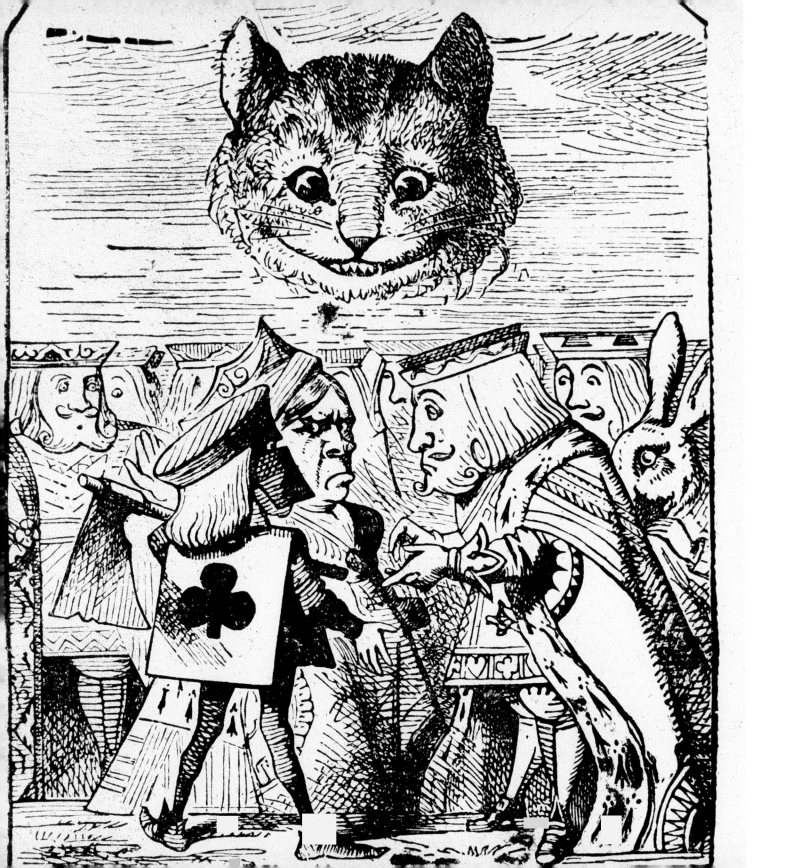

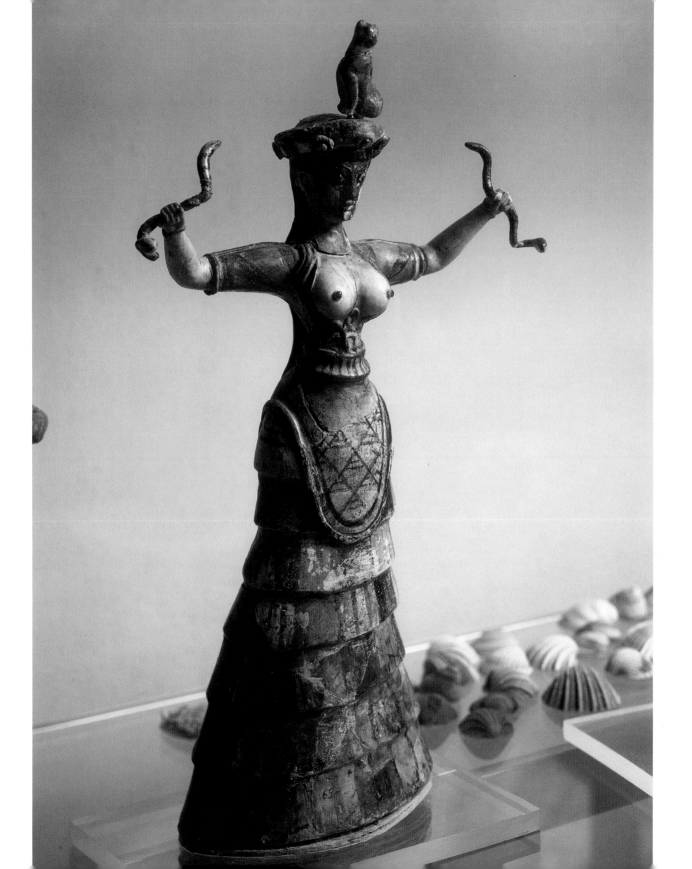

MINOAN AND CRETAN ART

The Goddess of Serpents, 1600 BC

Statuette in majolica, height 13 in. (34 cm)

ARCHEOLOGICAL MUSEUM, HERAKLION, CRETE, GREECE

The tradition of the cat's diabolic image dates chiefly from the Middle Ages, and is documented by many historical records from the period. However, there exist even earlier significant precedents. Although a true interpretation remains a mystery, the image of this fascinating and magnetic idol has become almost the very symbol of Cretan civilization, because of the close and mysterious connection between human and animal, also embodied in the myth of the monstrous Minotaur. The powerful confidence of the figure who grasps the snakes while baring her breasts—an obvious reference to strength and fertility—creates a truly unforgettable image. But wait: on the headdress of the presumed goddess (or sorceress? or witch?) we can discern a crouching cat, appearing on the scene with customary nonchalance. This ancient statuette is one of the cat's first mysterious, bewitched manifestations, contemporary with, or even preceding, the benevolent Egyptian images of the goddess Bastet.

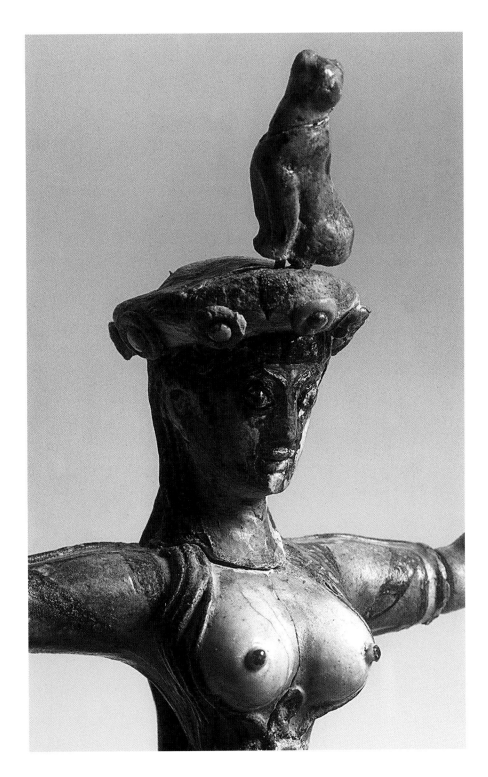

LUCA SIGNORELLI (c. 1441–1523)
IL SODOMA (Giovanni Antonio Bazzi, c. 1477–1549)

(Detail) *Stories of the Life of St. Benedict*, 1495–99

Fresco

CLOISTER OF THE ABBEY OF MONTE OLIVETO MAGGIORE, ITALY

Begun by Luca Signorelli and completed by the artist known as Il Sodoma around the year 1500, the frescoes in the large cloister of Monte Oliveto Maggiore constitute one of the most fascinating cycles of frescoes from the Italian Renaissance. Judging by the many images of cats in various parts of the abbey, depicted using a wide variety of techniques, cats were well cared for in the main abbey of this religious order; and the monks must have been very attached to their feline companions, as demonstrated elsewhere in this book by the wonderful inlaid lectern by Fra' Raffaele da Brescia (see pp. 96–97). Here, though, the cat's presence is anything but positive: a black cat arches its back and bristles, flattening its ears and hissing threateningly at a dog much larger than itself. This diabolical whiff, in the very foreground, is closely connected to the fresco's theme—a sin committed by a monk at the instigation of the devil. In the refectory, during a time of scarcity, the monk in the foreground is stealing a loaf of bread from his neighbor.

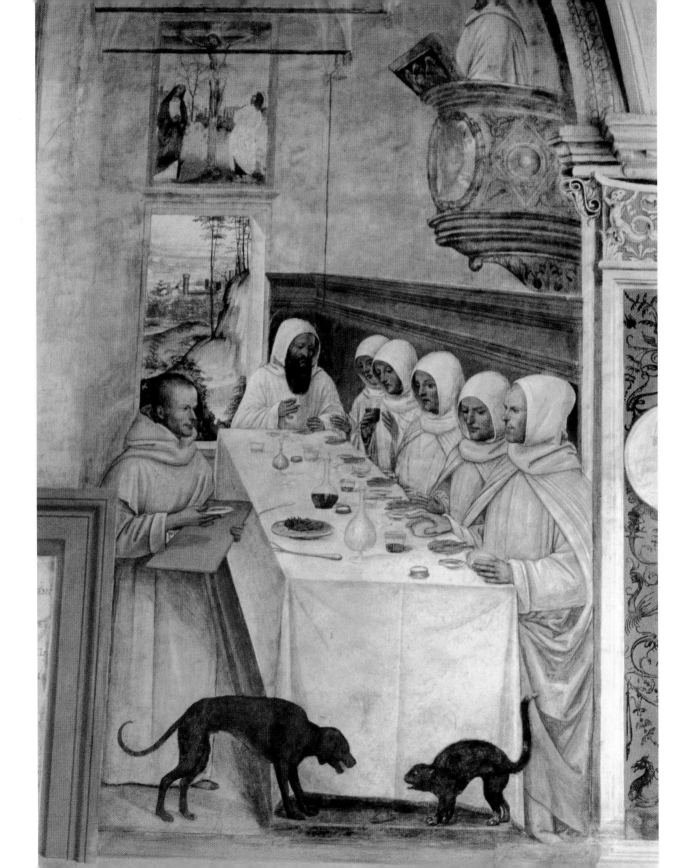

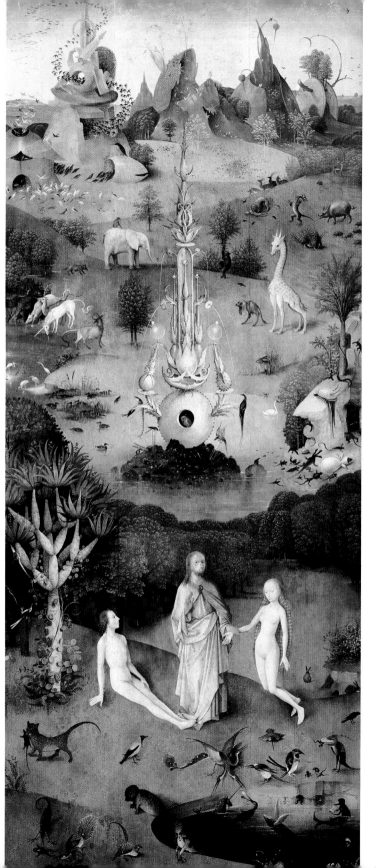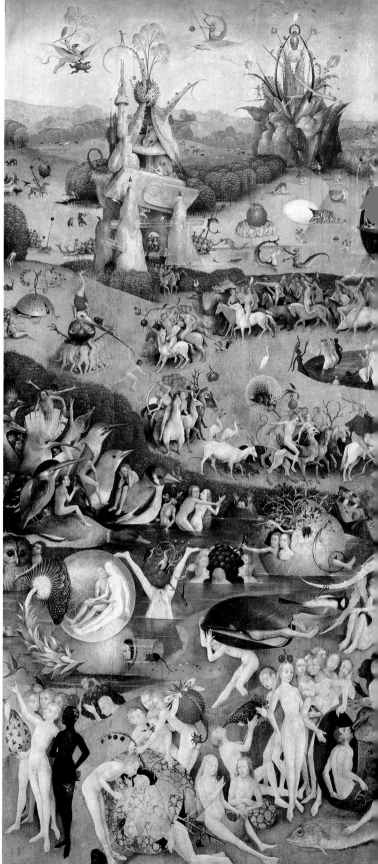

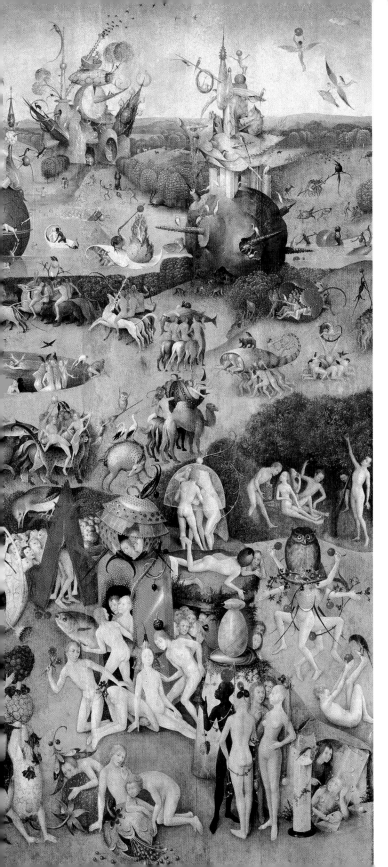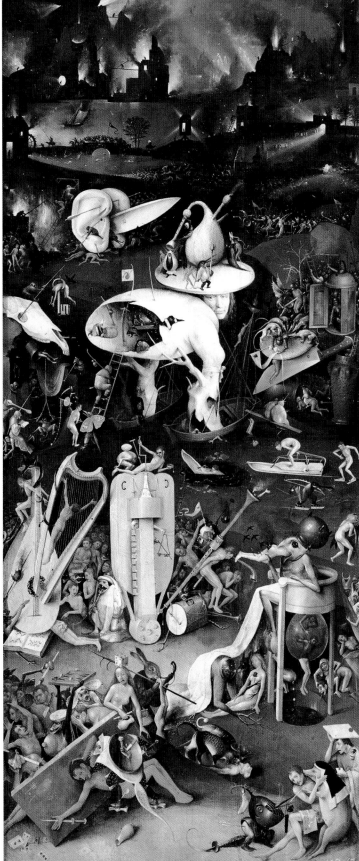

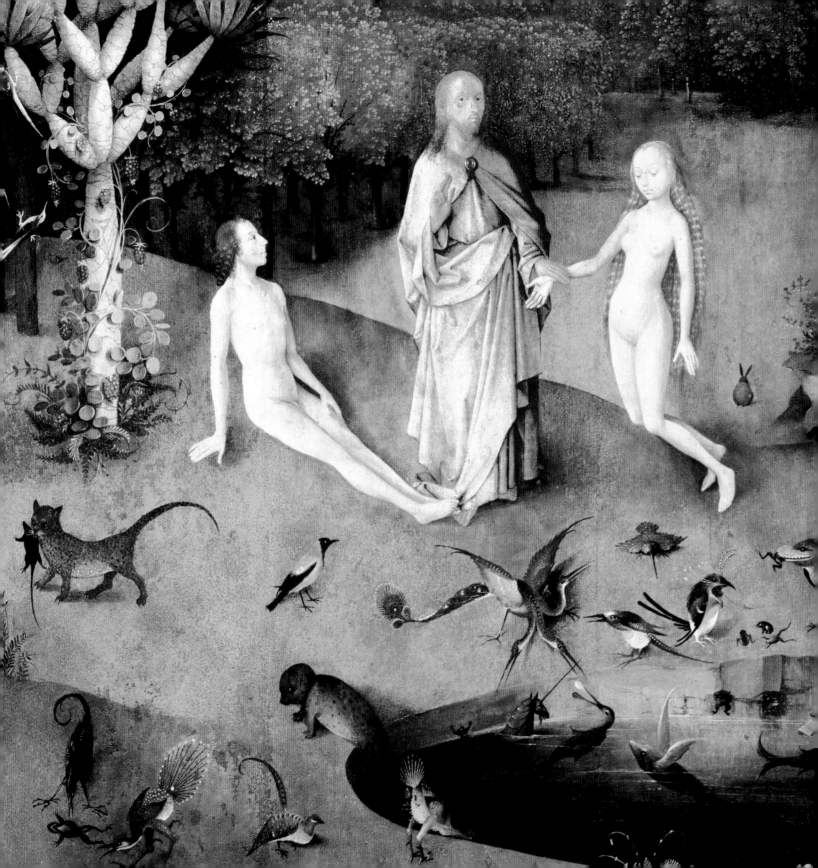

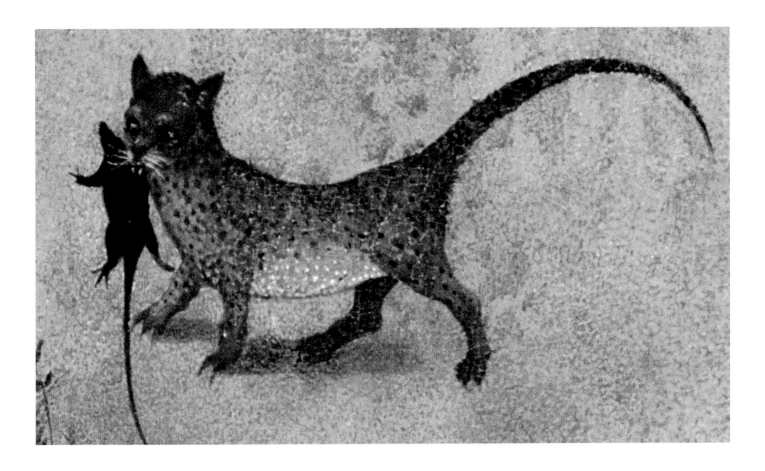

HIERONYMUS BOSCH (c. 1450–1516)

The Earthly Paradise (Garden of Eden)

Left-hand section of triptych *The Garden of Earthly Delights*, c. 1500 (seen in its entirety on preceding pages)

Oil on wood, (overall dimensions) 7.2 x 12.7 ft. (220 x 389 cm)

MUSEO DEL PRADO, MADRID

Bosch's most complex compositions are the great triptychs, in which he recounts the human journey between divine influence and diabolic temptation, between salvation and eternal damnation. *The Garden of Earthly Delights*, packed with symbolic references that even today have not been fully deciphered, is the greatest masterpiece by this painter, who was certainly one of the most singular artists of the European Renaissance. In the Garden of Eden, in the culminating and final moment of Creation, a young, confident God is delicately lifting the fragile figure of Eve before the astonished eyes of Adam. The entire scene ought to inspire love and harmony, as well as wonder at a virgin world that does not know sin: instead very close to the main scene walks a big spotted cat (perhaps Dante's "leopard") carrying prey in its mouth. Its bristling whiskers indicate the predator's satisfaction with a successful hunt. In Bosch's *Earthly Paradise*, the cat symbolizes the arrival of evil, even before the tempting serpent appears on the scene.

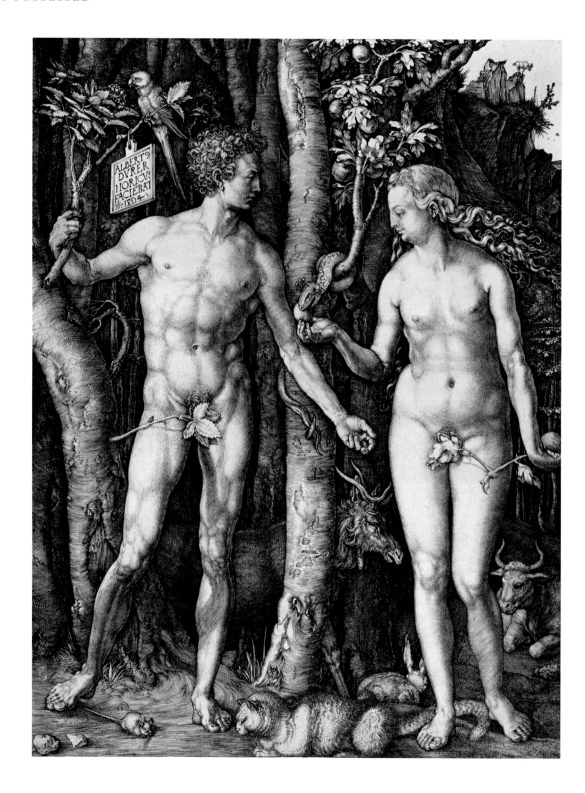

ALBRECHT DÜRER (1471–1528)

Adam and Eve, 1504

Engraving on copper, 10 x 7 in. (24.8 x 19.2 cm)

BRITISH MUSEUM, LONDON

We are looking at one of the most complex masterpieces of the engraver's art, in which this great German artist brings together highly advanced research on the male and female anatomy with the traditional "doctrine of the four humors," a combination of astrology and medicine that seeks to explain human character and physical appearance. The big cat is the symbolic representation of the choleric temperament: with its half-closed eyes and relaxed pose, it seems lazy, indolent, and indifferent. However, if we look closely we discover that it may be keeping an eye on a little mouse, whose tail has gotten caught under Adam's foot. At the right moment the cat will suddenly pounce, leaving its hapless prey no escape. Thus, at the moment of Original Sin, the Garden of Eden is enhanced by an additional dramatic dimension.

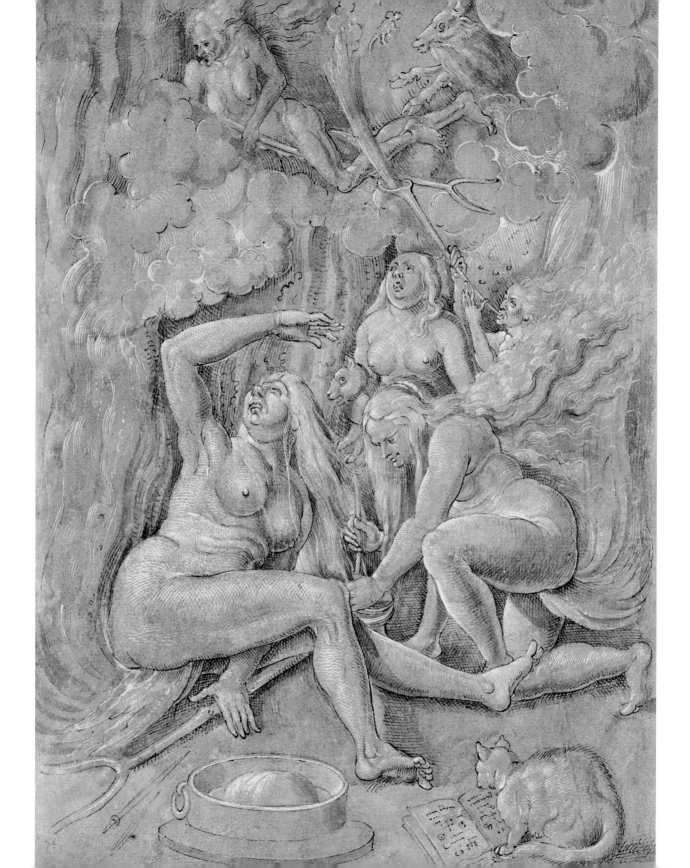

HANS BALDUNG GRIEN (1484/85–1545)

The Witches' Sabbath, c. 1515

Pen-and-ink and gouache on paper, 15 x 10 in. (37.8 x 25.8 cm)

MUSÉE DE L'OEUVRE DE NOTRE-DAME, STRASBOURG, FRANCE

A pupil of Dürer in his youth, Baldung Grien later had a long career in his own right. He is one of the most inter-
esting artists of the German Renaissance, not just for the quality of his paintings but also because of his tormented
personality and obsession with the nocturnal world of witches and mystery. After becoming a Lutheran, Baldung
Grien stopped painting religious subjects and devoted himself almost exclusively to drawings, prints, and paint-
ings that depict meetings of witches and diabolic apparitions. The cat is frequently present, being identified in super-
stition and art as the demonic animal par excellence. In fact, the cats that accompany Baldung Grien's witches
are usually very placid and indifferent to the shamelessness of the female figures.

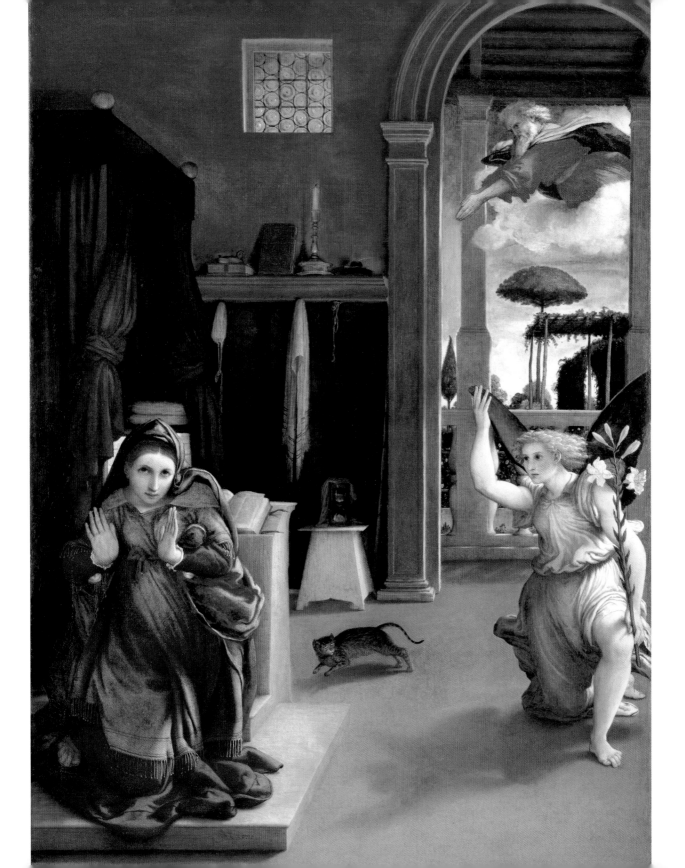

LORENZO LOTTO (1480–1556)

Annunciation, c. 1534–35

Oil on canvas, 65 x 44 in. (166 x 114 cm)

MUSEO CIVICO, RECANATI, ITALY

God clasps his hands together, and the strong, muscular, imperious archangel bursts into the room. The Virgin Mary is troubled and frightened. She turns toward us, almost as if she were seeking help. She evokes our tenderness with her big, dark, wandering eyes, her fragile little hands raised, and her immaculate, carefully ironed clothes, along with the symbols of a life that is suddenly changing—the book on the lectern, the stool with the hourglass on it, the chaste bed with its canopy, the towel, nightcap, and candlestick. Feeling free from all convention, Lotto abandons the poetic, contemplative tone of many earlier Annunciations, choosing to represent instead a moment of high drama. Fundamental to his vision is the darting cat, fleeing with its back arched in the luminous center of the scene: as domestic peace is being shattered, the tabby with the blazing eyes introduces a disturbing, ambiguous note. Lotto captures precisely one of the fits of apparent madness that suddenly ignite the placid days of household pussycats, superimposing on his depiction ancient superstitions about a demonic shudder provoked by the intrusion of the divine into everyday life.

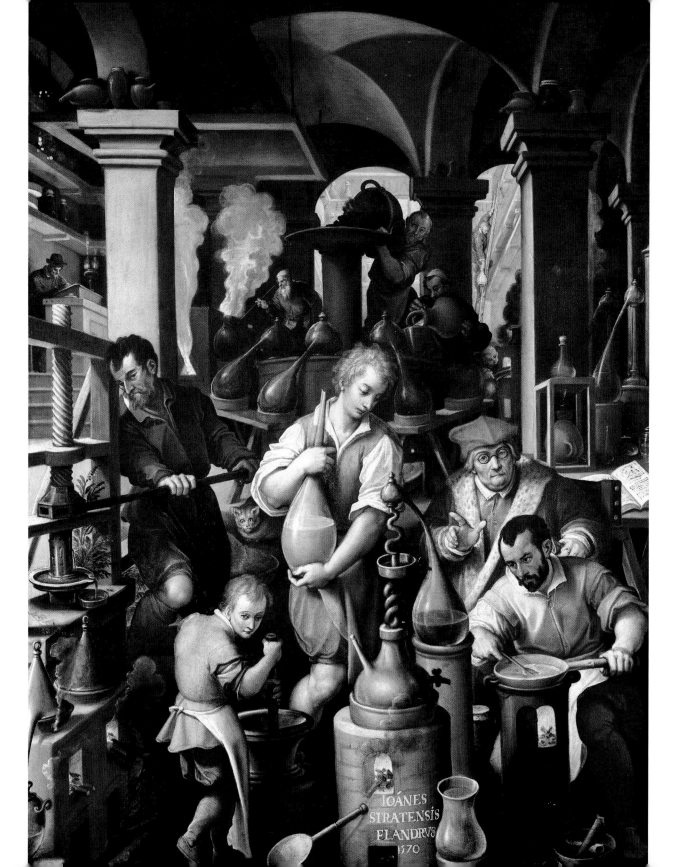

IOÁNES
STRATENSÍS
FLANDRVS
1570

GIOVANNI STRADANO

(Jan van der Straet, 1523–1605)

The Alchemist's Laboratory, 1570

Oil on canvas, 46 x 29 in. (117 x 75 cm)

STUDIO OF FRANCESCO I, PALAZZO
VECCHIO, FLORENCE, ITALY

In a workshop bursting with stoves, alembics, pots, and instruments, the Grand Duke of Tuscany, Francesco I, dressed as an alchemist, is busily stirring a green liquid (vitriol) in a pan on the stove. He is surrounded by helpers, one of whom, behind him, stands out: an old master alchemist more intent on holding forth than working. Conspicuous at the very center of this crowded composition is an enormous, crouching cat, observing the scene intently with dilated pupils: no other animal could have better represented the "alchemical value" of the experiment. The epitome of a nocturnal creature, the cat was associated with such experiments, traditionally conducted at night in collusion with the moon, which appeared to have an influence on the animal's power of sight. Whereas for the Egyptians the cat represented the moon and philosophical Mercury, alchemists appropriated the cat as a symbol of the experiment itself.

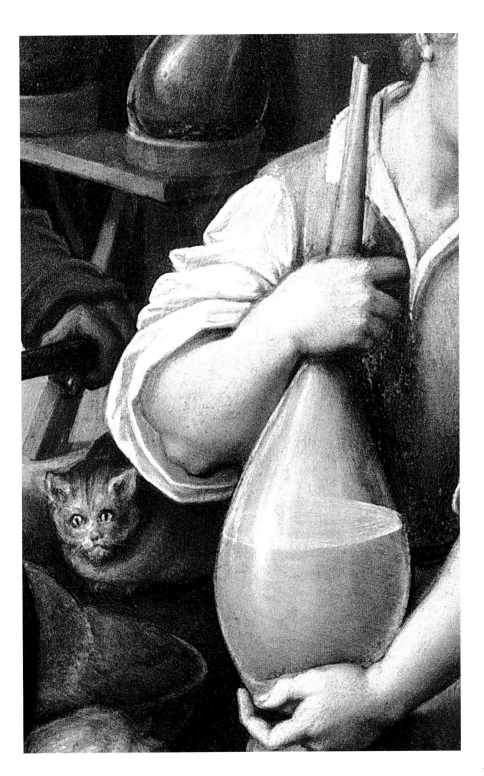

PIETER BRUEGEL THE ELDER (1528–1569)

Flemish Proverbs, 1559

Oil on wood, 46 x 64 in. (117 x 163 cm)

Gemäldegalerie, Staatliche Museen zu Berlin, Germany

In his merciless condemnation of the moral and political disorder of his country, which he represented through more than 100 Flemish proverbs, sayings, and aphorisms, Bruegel could not avoid including a cat. On the wall by the house on the left, a man is engaged in a foolish attempt to "put a bell on a cat." There are several reasons why such an undertaking makes no sense, notably the difficulty of soothing the animal, although this cat seems rather docile and the man in armor has amply protected himself from its claws. Once fitted with a bell, and therefore advertising its presence from a distance, the cat is no longer able to perform its chief function, that of catching mice, thus bringing loss and misfortune to its owners. With this episode Bruegel seems to be urging us to refrain from risky and essentially vain undertakings, while at the same time censuring those cowards who need to arm themselves to acquire courage.

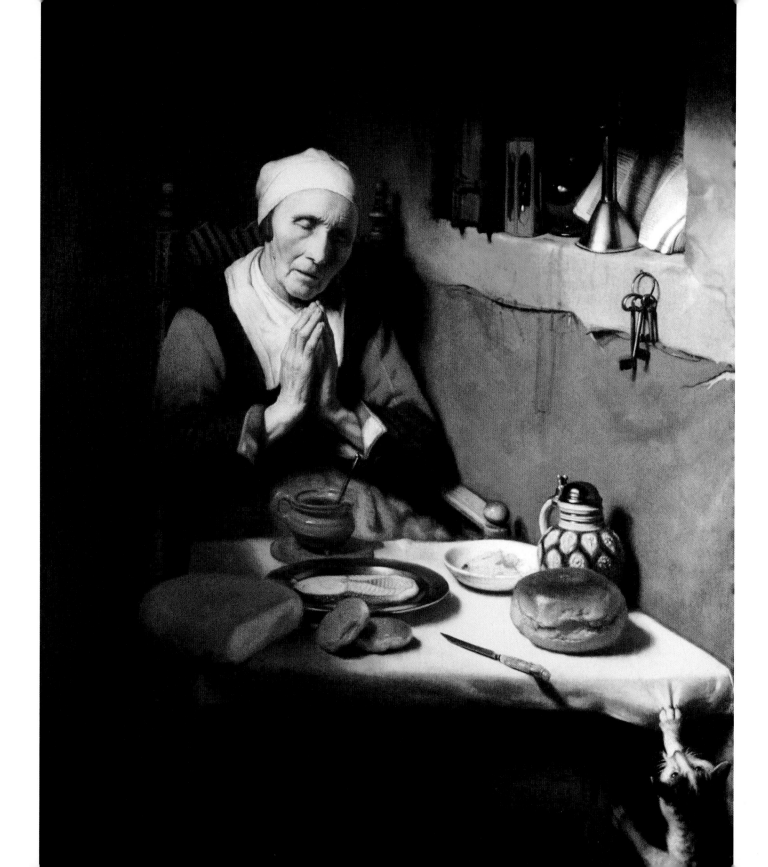

NICOLAS MAES (1634–1693)

Old Woman Praying (Prayer Without End), 1655

Oil on canvas, 52 x 44 in. (134 x 113 cm)

RIJKSMUSEUM, AMSTERDAM

This justly famous canvas is considered to be Maes's masterpiece, and one of the most moving paintings of seventeenth-century Dutch art. Maes was a gifted and original pupil of Rembrandt. In keeping with Calvinist moderation and piety, an elderly woman is absorbed in prayer before partaking of a frugal, solitary meal. The modest yet neat simplicity of the table, and the woman's sincere religious ecstasy create an image of exemplary virtue. But the painting contains a surprise, which may elude viewers who are concentrating on the protagonist's intense devotion: a large cat peers out from the lower far right of the canvas, tugging at the tablecloth with its claws. While the woman is saying her silent evening prayer, the greedy, predatory spirit of the hungry cat makes its appearance. We need not think of this as a symbol of the sin that lurks in the minds of even the most devout; but the contrast between the expression on the face of the praying woman and the sudden gesture of the preying cat is undeniably powerful.

FRANCISCO GOYA Y LUCIENTES (1746–1828)

Portrait of Don Manuel Osorio Manrique de Zuñiga, 1788

Oil on canvas, 50 x 40 in. (127 x 101.6 cm)

METROPOLITAN MUSEUM OF ART, NEW YORK

The three large cats, more reminiscent of modern Japanese manga cartoons than of real creatures, seem almost hypnotized by the magpie, held on a leash—very close to them—by the boy. In a subtle humorous touch, the painter has given the bird a note bearing his signature. The cat on the left—a female, judging by the three-colored coat—has eyes that glitter with yearning. The tabby on the right is more muted, while the black one in the background is almost invisible, except for the two yellow "lamps" focused on the prey. It is difficult to arrive at a definitive interpretation of Goya's famous painting, which is thick with symbolic and even Christological hints. What is certain is that in the artist's incisive work, dense with meaning, the cat always has negative connotations, linked to evil and the demonic.

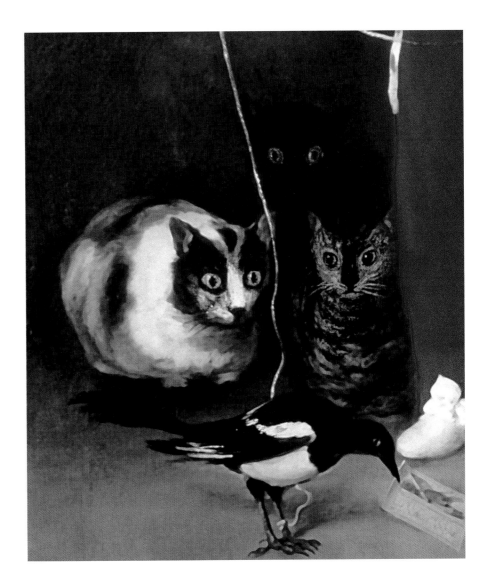

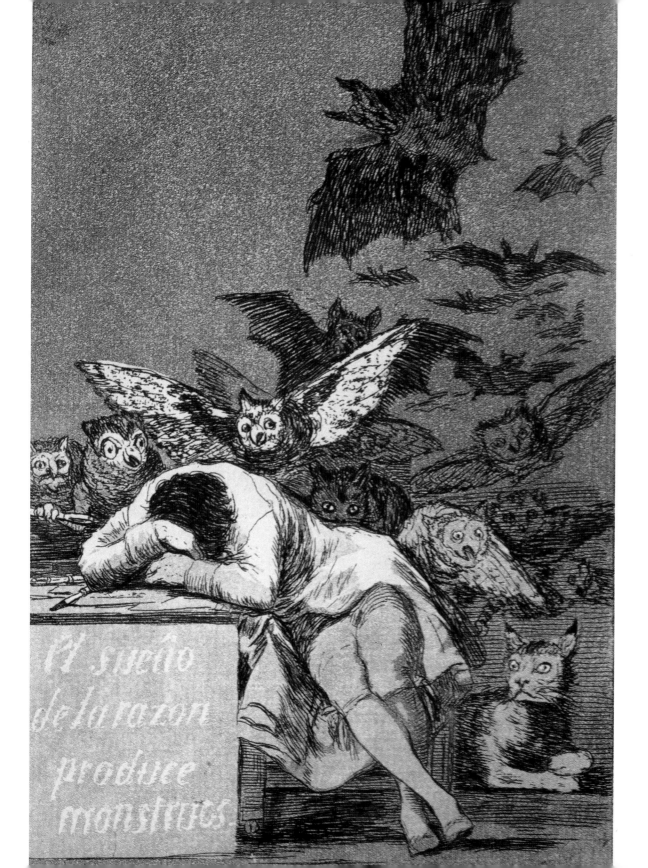

FRANCISCO GOYA Y LUCIENTES (1746–1828)

The Sleep of Reason Produces Monsters, from *Los Caprichos* (plate no. 43), 1799

Etching and aquatint, 8 x 6 in. (21.6 x 15.2 cm)

Private collection

Among the most famous "sorcerer" cats, along with those of Hans Baldung Grien, the demonic creatures that inhabit Goya's engravings often take on feline form. The origin of the associations between the forces of evil and cats—primarily black cats—is lost in the mists of ancient popular belief that, over the centuries, often led to bloody persecution of cats. More striking than the enormous reclining feline, resembling a lynx, is the black cat in the very center of the picture, behind the back of the artist who, asleep at his desk, is visited by terrifying nocturnal visions. This is an autobiographical image: Goya himself spoke of monsters and ghosts that troubled his sleep. Bats and owls, the pre-eminent nocturnal creatures, wheel above him, out of control. But we cannot evade the gaze of the animal at the center of the picture, the only one whose large, wide-open eyes are fixed on us and on our fears.

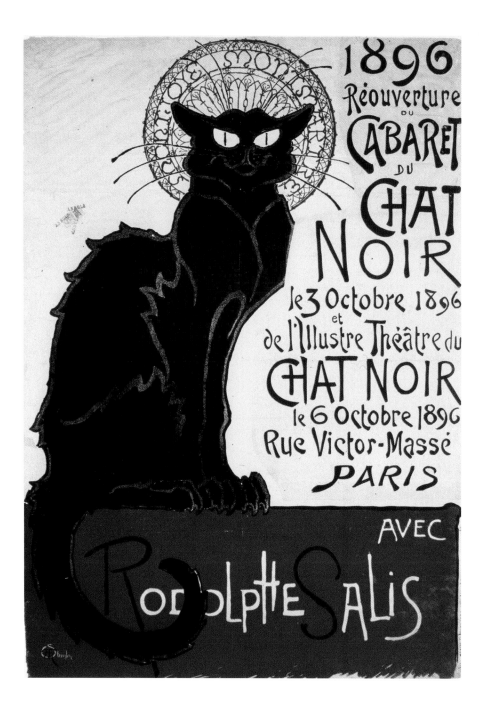

THÉOPHILE ALEXANDRE STEINLEN
(1859–1923)
Poster for the reopening of the cabaret
Le Chat Noir, 1896
Colored lithograph, 35 x 24 in. (91 x 61 cm)
<small>PRIVATE COLLECTION</small>

As we have seen, the iconography of the cat pervades thousands of years of the history of art; in literature, however, the golden age of the domestic cat begins in the nineteenth century, predominantly in France. An unbroken sequence of poets and writers celebrate the cat, with a particular concentration in the Symbolist movement. Part of the credit can go to the posters of Steinlen—true masterpieces of their kind—devoted to the cabaret theater called Le Chat Noir (The Black Cat). The artist employs astrological and alchemical motifs, surrounding the cat's head with a symbolic halo, a sort of medieval rose window, while the animal's darting yellow eyes glow in a disquieting way.

OTTO MUELLER

(1874–1930)

Two Gypsies with a Cat, 1927

Oil on canvas, 27.5 x 19.6 in. (70.6 x 50.3 cm)

MUSEUM LUDWIG, COLOGNE, GERMANY

Considered one of the greatest exponents of Die Brücke (The Bridge), Europe's first avant-garde group, founded in Dresden in 1905, Otto Mueller joined forces with Ernst Ludwig Kirchner, Erich Heckel, and Karl Schmidt-Rottluff only in 1910. His art, profoundly influenced by the lively, ornamental Jugendstil, soon displayed similarities with the Expressionism of the sculptor Wilhelm Lehmbruck and the elongated, "charged" figures characteristic of German Expressionist art. Mueller often painted nudes and Gypsy women: in this painting, two seminude Gypsy women in a humble interior setting are accompanied by the inevitable cat—companion of fortune-tellers and necromantic séances—that is visible in silhouette on the windowsill. Four centuries later, Hans Baldung Grien's image of the demonic cat reappears—in the same German context.

PABLO PICASSO (1881–1973)

Cat Devouring a Bird, 1939

Oil on canvas, 38 x 50 in. (97 x 129 cm)

<small>Victor W. Ganz Collection, New York</small>

"This subject obsessed me. I don't know why," declared Picasso who, though he liked cats, painted very few of them (one being the black cat belonging to his wife Jacqueline). In the first version of this painting (in the Musée Picasso, Paris, and also dating from 1939), a large dark cat, without whiskers, has just seized its prey, which is trying in vain to struggle free. The painting in New York further develops this theme: the striped cat is already tearing apart the bird, now dead, holding it firm in its strong claws. The furious eyes bulging in their sockets, the bristling whiskers, the shreds of flesh torn from the bird, and the overall agitation of the scene cannot fail to remind us how Picasso was profoundly affected by the events of the Spanish Civil War at the time.

Bibliography

Alberghini, M. *Jacopo Bassano e il suo gatto*. Milan, Italy: Mursia, 1992.

Auf leisen Pfoten: die Katze in der Kunst. Exhibition catalogue. Karlsruhe, Germany: Kunsthalle, 2006–2007; Heidelberg, Germany: Kehrer Verlag, 2006.

Bluhm, D. *Impronte di gatto: Nella letteratura, nell'arte, nella vita dell'uomo*. Milan, Italy: Corbaccio, 2006.

Bobis, L. *Elogio del gatto: Miti, storie, leggende*. Rome: Newton Compton, 2000.

Centini, M. *Le bestie del diavolo: Gli animali e la stregoneria tra fonti storiche e folklore*. Milan, Italy: Rusconi, 1998.

Cwalinski, V., ed. *Animali nell'arte: dalla preistoria alla nuova figurazione*. Milan, Italy: Skira, 2004.

Donald, E. *Storia del gatto: L'affascinante storia del più prezioso alleato dell'uomo*. Casale Monferrato, Italy: Piemme, 2001.

Franz Marc. Exhibition catalogue. Munich: Lembachhaus, 2005–2006; Munich: Prestel, 2005.

Gatti nell'arte: il magico e il quotidiano. Exhibition catalogue. Rome: Palazzo Barberini, Galleria nazionale d'arte antica, 1987; Rome: Multigrafica editrice, 1987.

Giordano, M. *Leonardos Katze*. Berlin: Aufbau Verlag, 2006.

Hausman, G., and L. Hausman. *Il mio gatto è un mito: Storie, leggende e favole del mondo a quattrozampe*. Milan, Italy: Baldini Castoldi e Dalai, 2003.

Mezzalira, F., with essays by G. Cavallo and D. Mainardi. *Bestie e bestiari: la rappresentazione degli animali dalla preistoria al Rinascimento*. Turin, Italy: Allemandi, 2001.

Uze, M., ed. *Il gatto nella matura, nella storia e nell'arte*. Novara, Italy: De Agostini, 1951.

Walter, E. Foucart, and P. Rosenberg. *Il gatto nell'arte: il gatto nella pittura occidentale dal XV al XX secolo*. Milan, Italy: Mondadori, 1987.

Photography Credits

PROJECT MANAGER, ENGLISH-LANGUAGE EDITION: Magali Veillon

EDITOR, ENGLISH-LANGUAGE EDITION: Sheila Friedling

DESIGNER, ENGLISH-LANGUAGE EDITION: Shawn Dahl

JACKET DESIGN, ENGLISH-LANGUAGE EDITION: Neil Egan

PRODUCTION MANAGER, ENGLISH-LANGUAGE EDITION: Tina Cameron

LIBRARY OF CONGRESS CATALOGING-IN-PUBLICATION DATA

Zuffi, Stefano, 1961–
 The cat in art / by Stefano Zuffi.
 p. cm.
 ISBN 13: 978-0-8109-9328-0 (hardcover jacket)
 ISBN 10: 0-8109-9328-7 (hardcover jacket)
 1. Cats in art. 2. Cats—History. 3. Painting. I. Title.

 ND1380.Z84 2007
 704.9'432—dc22
 2007000569

THE ART OF BOOKS SINCE 1949

115 West 18th Street
New York, NY 10011
www.abramsbooks.com